TIME
LIFE

GREAT PHOTOGRAPHS OF
WORLD WAR II

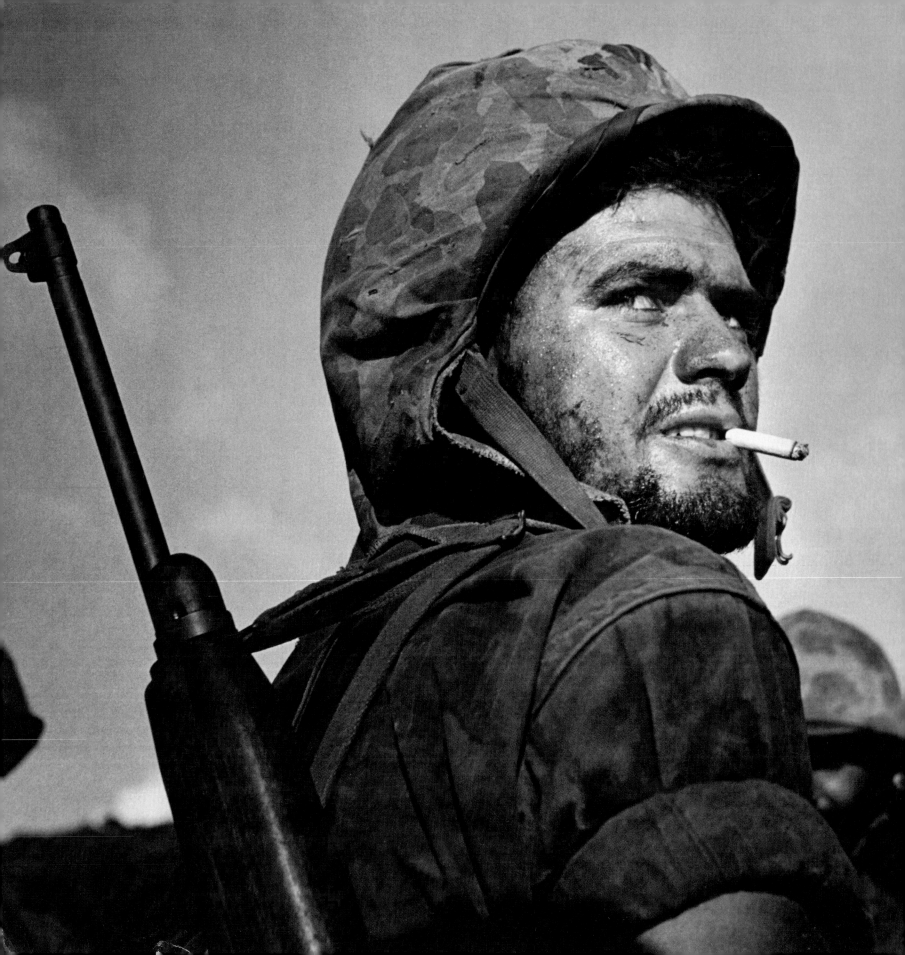

TIME
LIFE

GREAT PHOTOGRAPHS OF
WORLD WAR II

Edited by Neil Kagan
Introduction by Stephen G. Hyslop

OXMOOR HOUSE — BIRMINGHAM, ALABAMA

Oxmoor House.

© 2003 by Oxmoor House, Inc.
Book Division of Southern
Progress Corporation
P.O. Box 2463, Birmingham, Alabama 35201

This book is a compilation of material pre-
viously published by Time Life Inc. © 1970,
1976, 1977, 1978, 1979, 1980, 1981, 1982, 1983,
1998, 1999, 2000, 2001, Time Life Inc.

FIRST EDITION

Library of Congress Control Number:
2003108544
ISBN 0-8487-2818-1

PRINTED IN THE UNITED STATES OF AMERICA

Great Battles of World War II
was prepared by:

Kagan & Associates, Inc.
Falls Church, Virginia

President/Editor-in-Chief: Neil Kagan
Vice President/Director of Administration:
 Sharyn Kagan
Writer/Editor: Stephen G. Hyslop
Designers: Antonio Alcalá, Mary Dunnington,
 Mike Dyer
 Studio A, Alexandria, Virginia
Associate Editor/Copyeditor:
 Mary Beth Oelkers-Keegan
Indexer: Susan Nedrow
Special Contributors: Isabelle Babington,
 Susan Finken, Naomi Izakura, Angelika Lemmer,
 Ann L. Natanson (rights and permissions)
Prepress Services: DigiLink, Inc.,
 Alexandria, Virginia

Front Cover: Lieutenant Walter Chewning scram-
bles toward the cockpit of an F6F Hellcat that has
just crash-landed on the flight deck of the USS
Enterprise in early November 1943. Miraculously,
the pilot, Ensign Byron Johnson, escaped with
only minor injuries.

Page 2: An embattled U.S. Marine looks warily
to his rear on the Pacific island of Saipan in this
classic shot taken in 1944 by photographer
W. Eugene Smith.

Neil Kagan is the former Publisher/Managing Editor
and Director of New Product Development for
Time-Life Books. Over his 26-year career, he created
a wide range of Time-Life Books series, including the
award-winning *Voices of the Civil War, What Life Was
Like, Our American Century,* and *The Time-Life Student
Library.* As an accomplished photographer and cre-
ative director, Kagan brings a strong vision to select-
ing images and combining them into photographic
essays that tell compelling stories.

Stephen G. Hyslop is a writer and editor who has
contributed to many volumes on American history
and World War II for Time-Life Books, including *An
Illustrated History of World War II* and *World War II: War
in the Shadows.* He is the author of *Bound for Santa Fe:
The Road to New Mexico and the American Conquest,
1806-1848,* selected as a finalist for the 2003 Western
Writers of America Spur competition. His articles
have appeared recently in *American History* and *The
History Channel Magazine.*

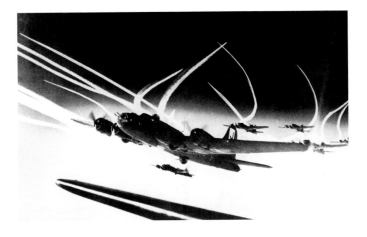

Contents

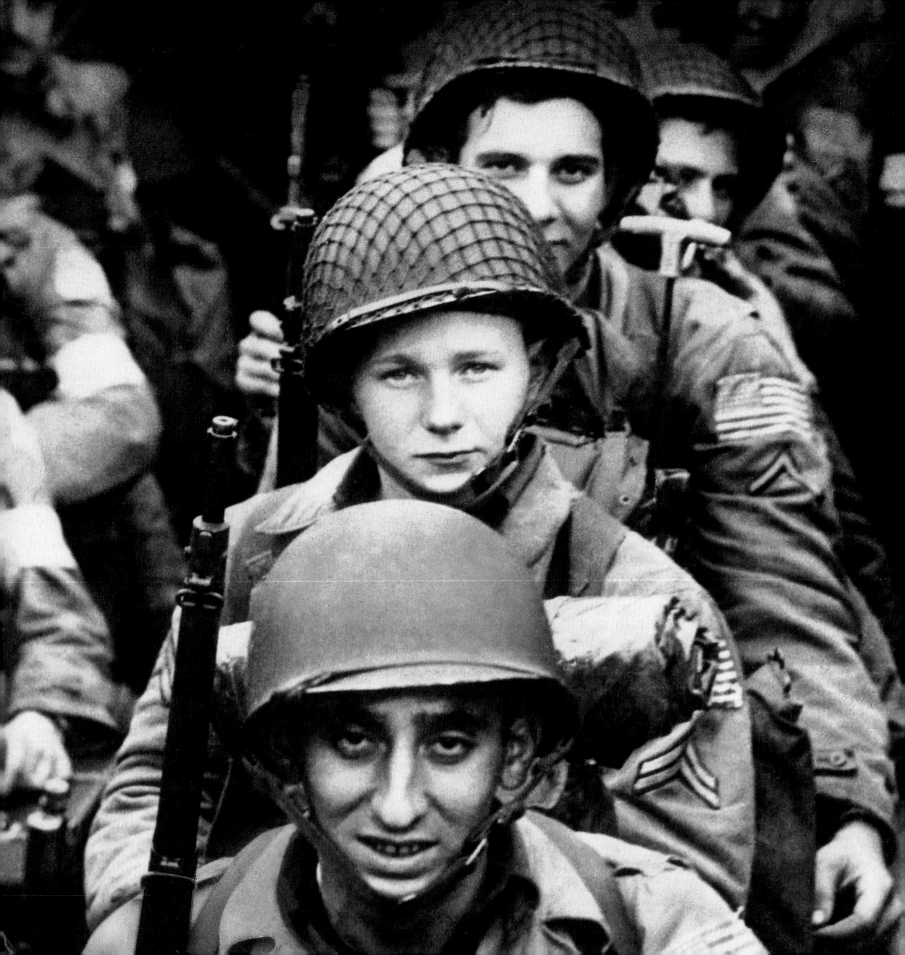

Images of War

WHEN I BEGAN WORK ON THIS VOLUME, I faced the overwhelming challenge of assembling the greatest photographs of the most significant event of our time. After poring over thousands of images taken by photographers from both sides of the conflict, I realized that they told an amazing story in black and white, the story of my parents' generation and the epic conflict they endured, a war of stark moral contrasts between the urge to dominate and destroy and the will to survive and be free.

What constitutes a great photograph? Action alone does not make a photograph great. To be great, a photograph must capture a critical moment—the faces of young men going into battle for the first time, the silent cry of an abandoned baby in a bombed-out railway station, a lone French resistance fighter facing death before a Nazi firing squad. Such photographs capture the emotional essence of a fateful moment and leave an indelible impression on the viewer.

Some great photographs are so charged with emotion and meaning that they have come to represent something larger than the event portrayed. The U.S. Marines raising the flag on Iwo Jima and the joyous couple in Times Square sealing peace with a kiss have become emblems of triumph that transcend the war, while the living skeletons staring out at us from Nazi concentration camps or Japanese POW camps are haunting reminders of the human capacity for hatred and brutality that we can never afford to forget.

In *Great Photographs of World War II* we have assembled over 280 of these gripping images into 25 chronological photo essays. When viewed together, they offer you the opportunity to experience the emotional history of the war that changed the world forever.

Neil Kagan
Editor

AMERICAN DEBUT
New to battle, U.S. soldiers prepare to go ashore during Operation Torch, the invasion of North Africa, in November 1942.

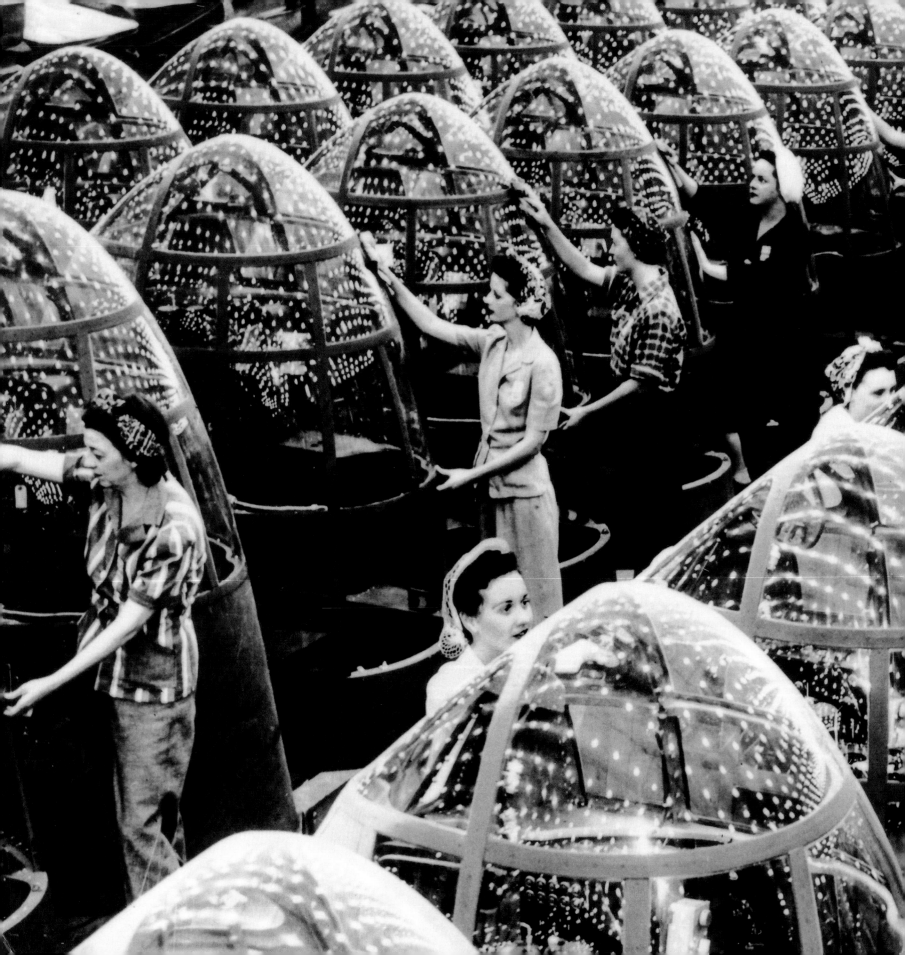

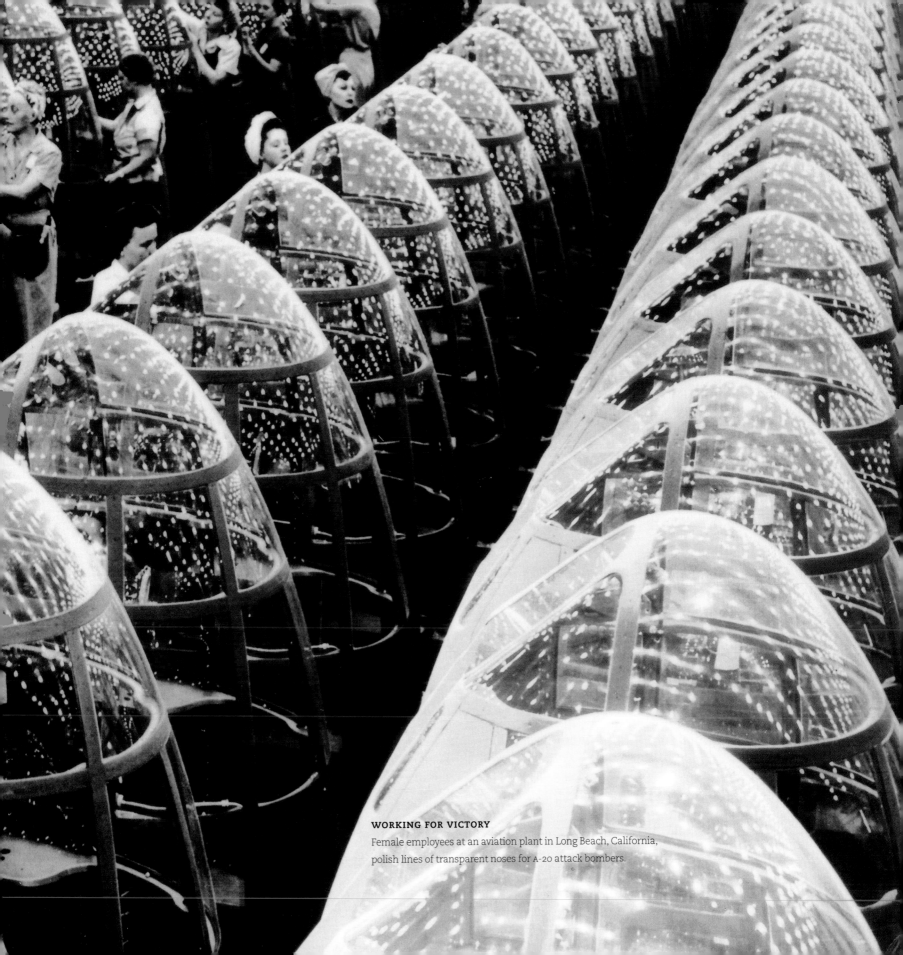

WORKING FOR VICTORY
Female employees at an aviation plant in Long Beach, California, polish lines of transparent noses for A-20 attack bombers.

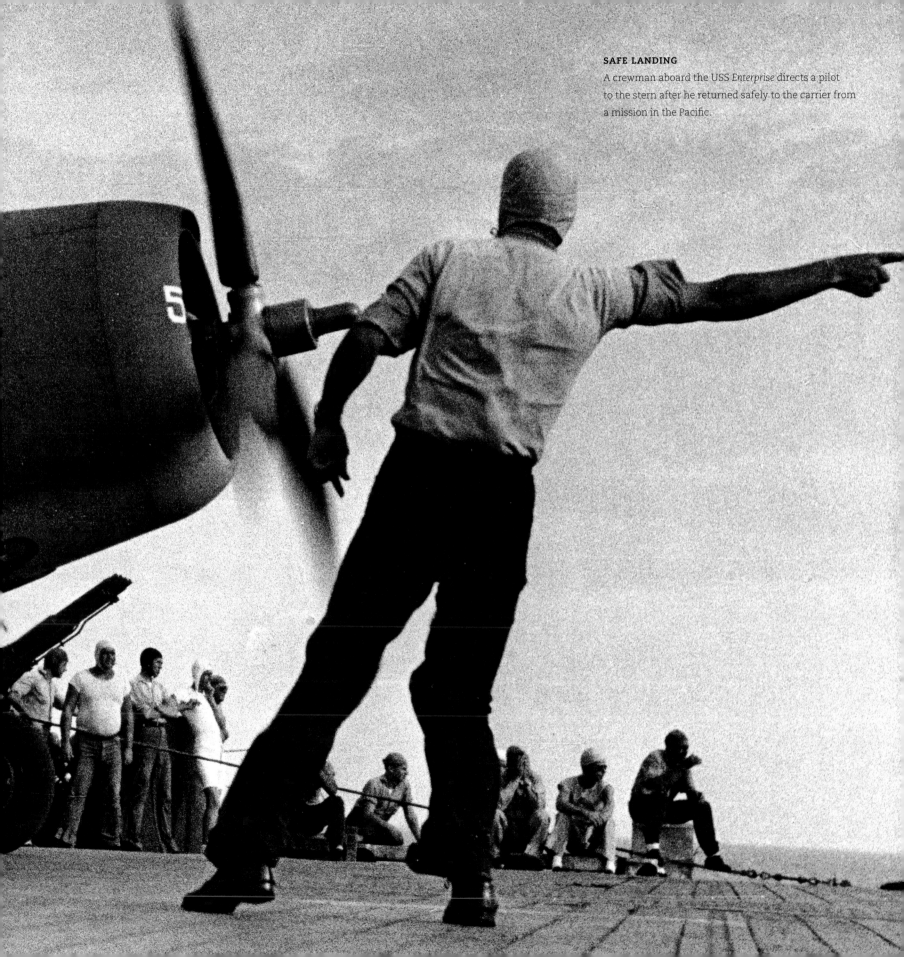

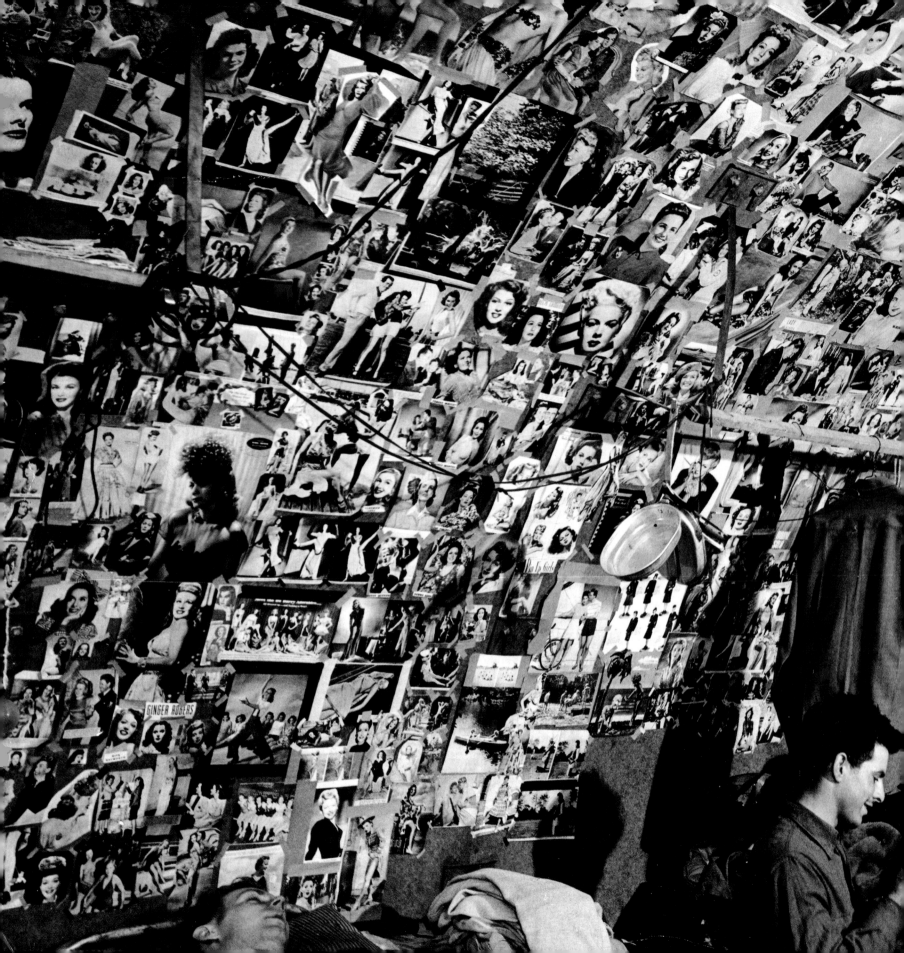

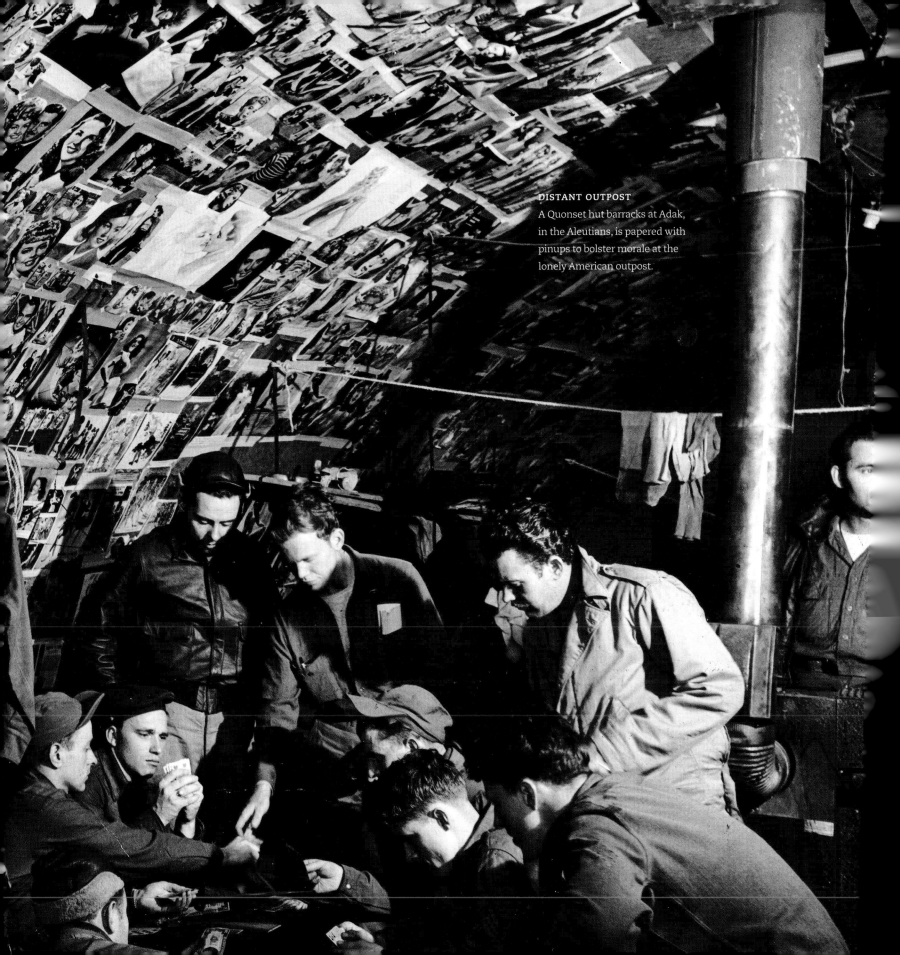

DISTANT OUTPOST
A Quonset hut barracks at Adak, in the Aleutians, is papered with pinups to bolster morale at the lonely American outpost.

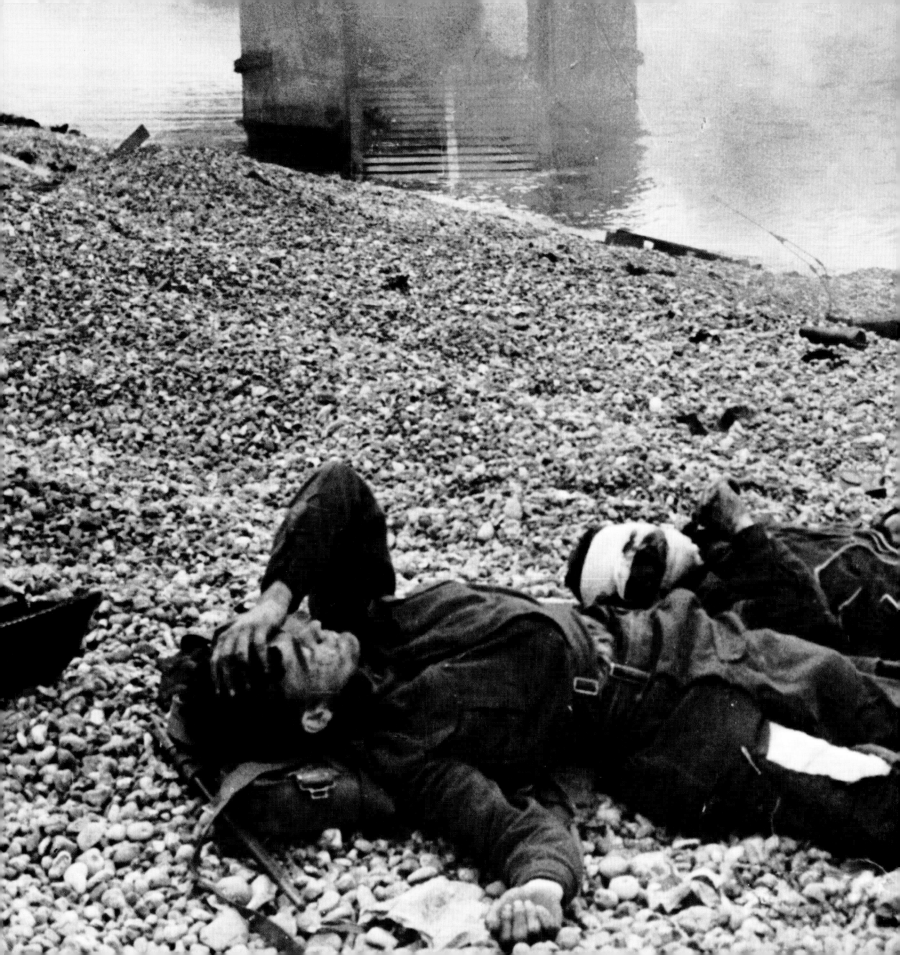

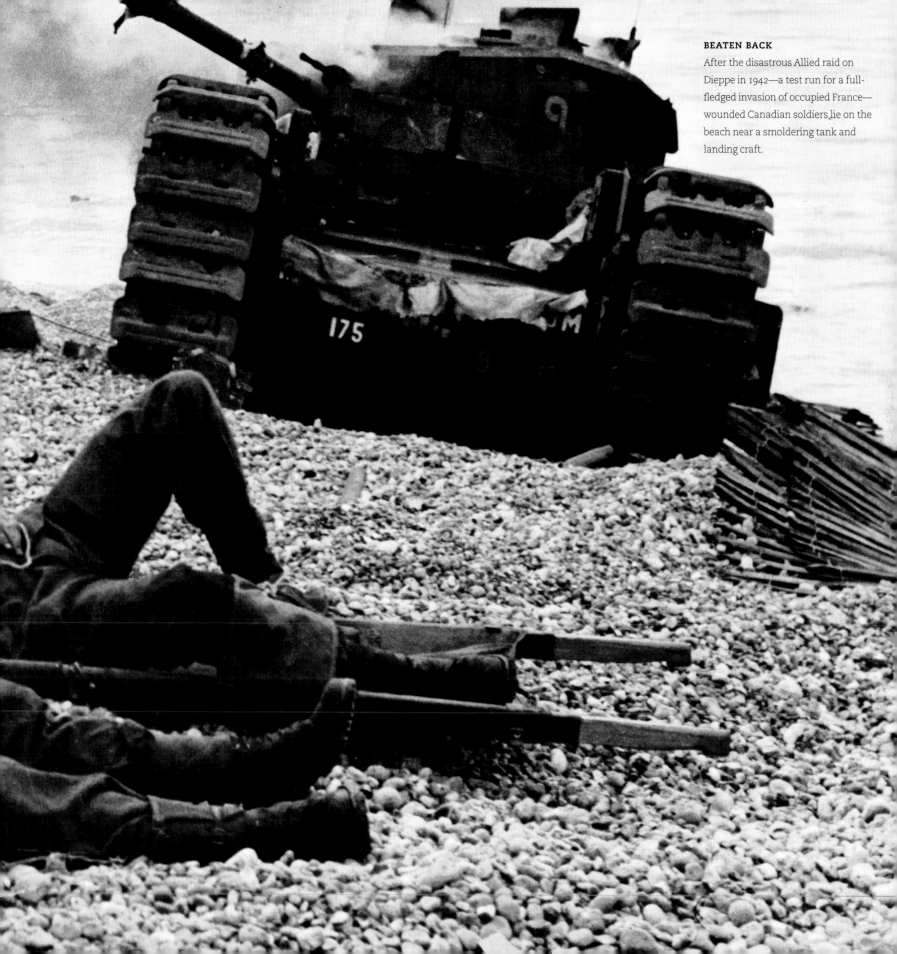

BEATEN BACK
After the disastrous Allied raid on Dieppe in 1942—a test run for a full-fledged invasion of occupied France—wounded Canadian soldiers lie on the beach near a smoldering tank and landing craft.

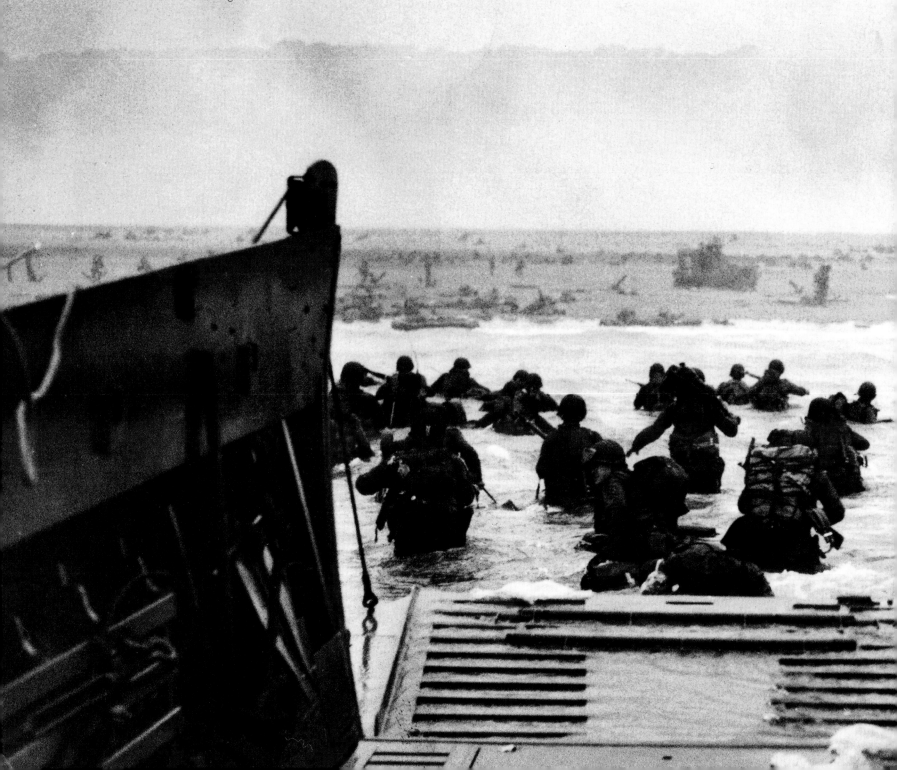

GIs WADE TOWARD OMAHA BEACH
Leaving behind their landing craft, GIs laden with combat gear wade toward obstacle-lined Omaha Beach on D-Day. German defenders on the bluffs beyond poured machine-gun and mortar fire upon the invaders. Soon, said Sergeant John Robert Slaughter of the 116th Infantry Regiment, there were "dead men floating in the water and there were live men acting dead."

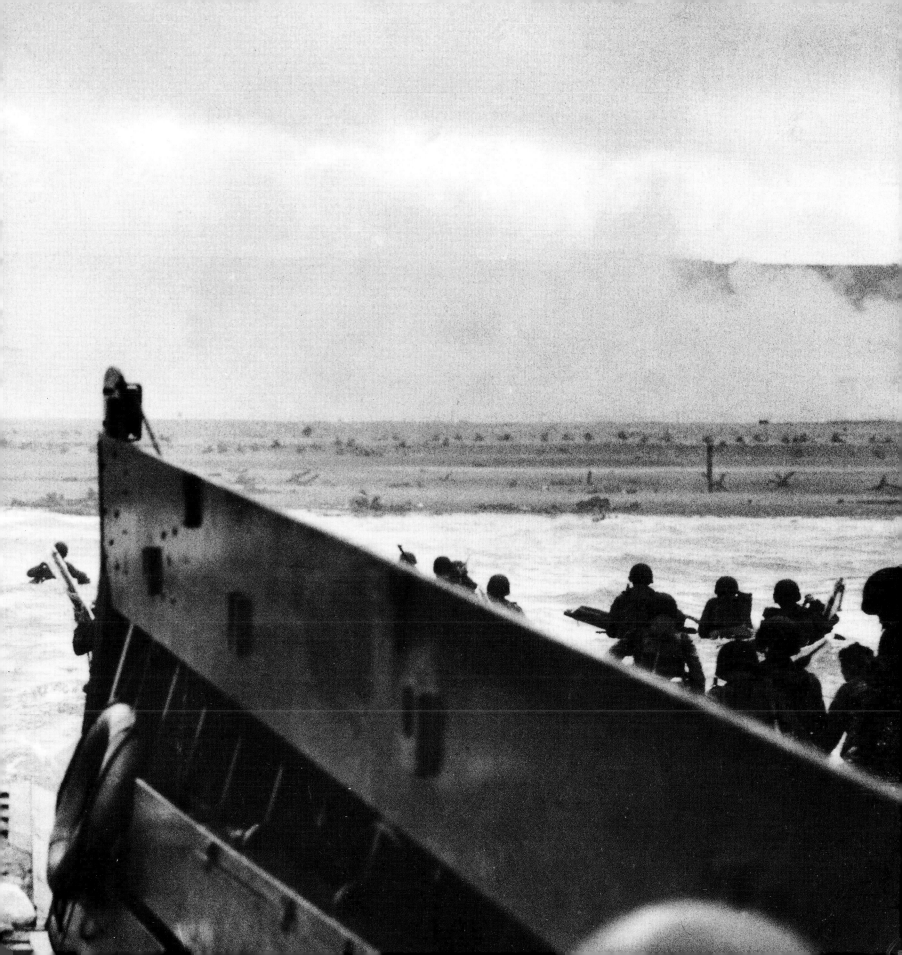

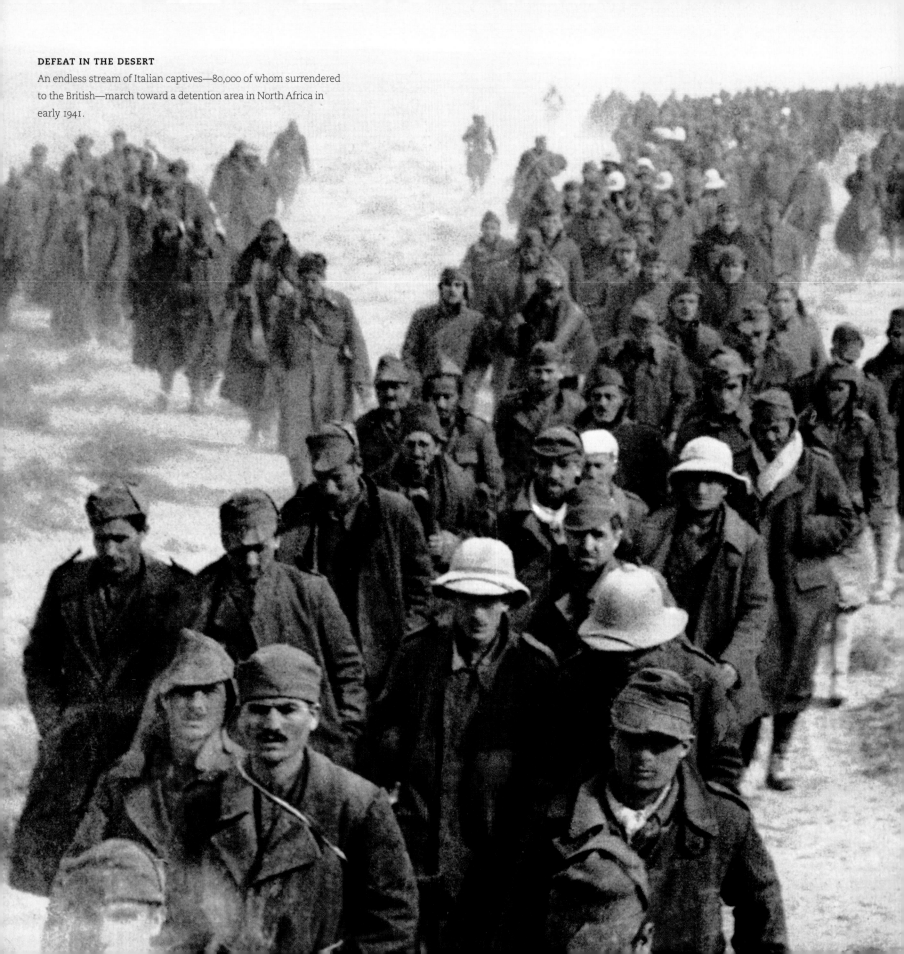

DEFEAT IN THE DESERT
An endless stream of Italian captives—80,000 of whom surrendered to the British—march toward a detention area in North Africa in early 1941.

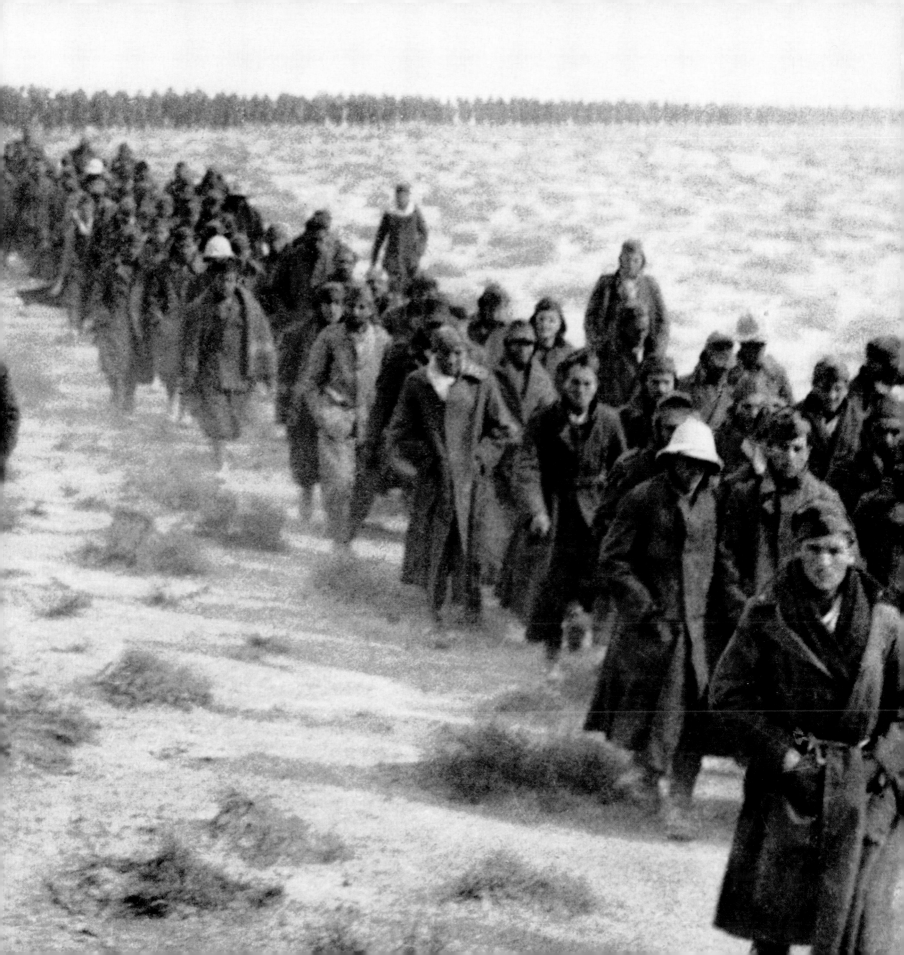

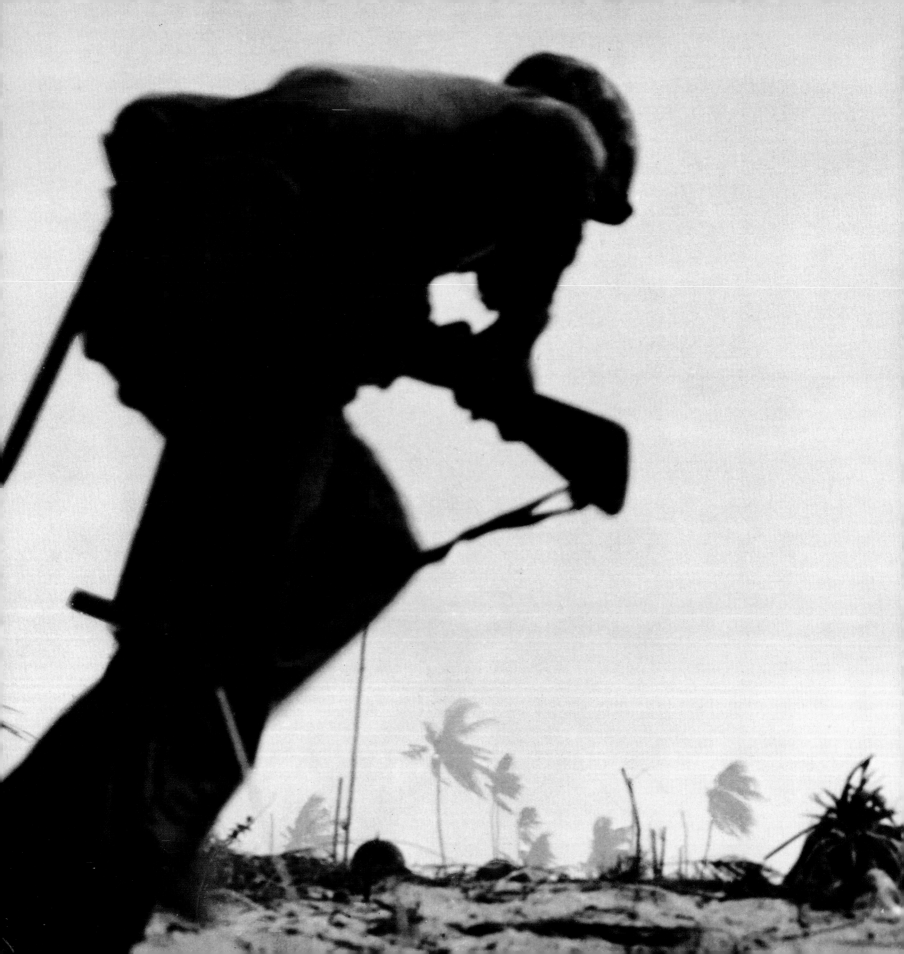

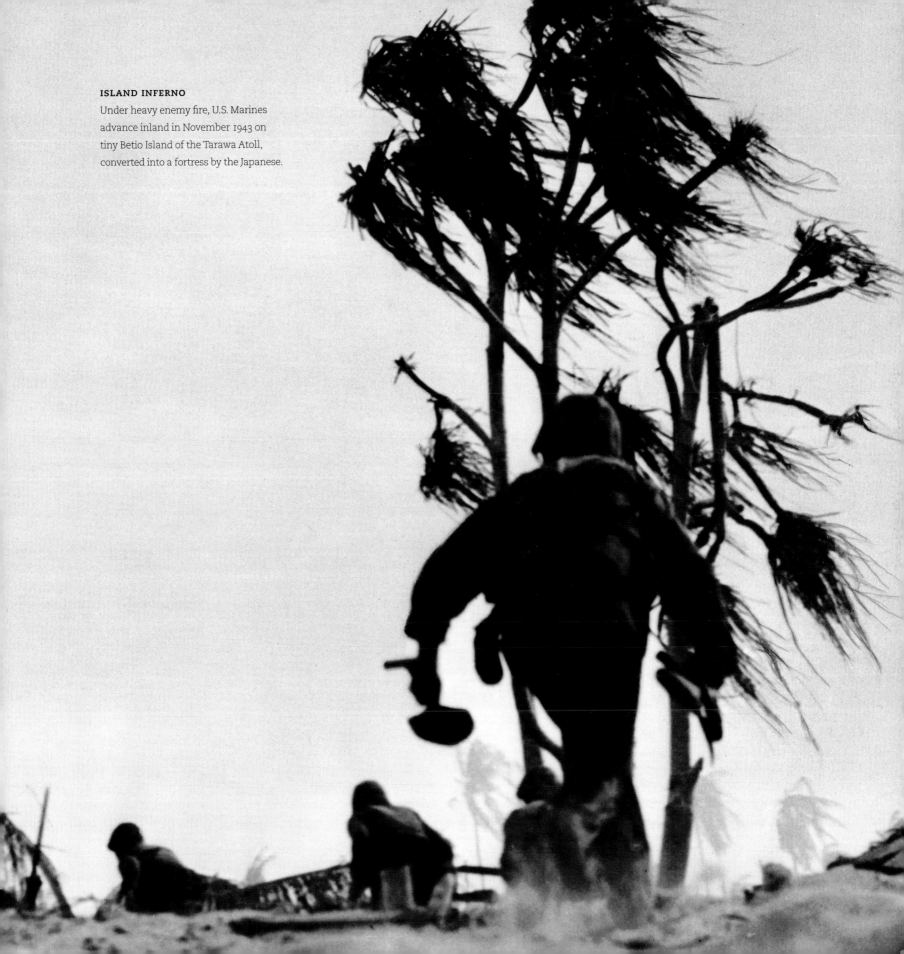

ISLAND INFERNO
Under heavy enemy fire, U.S. Marines
advance inland in November 1943 on
tiny Betio Island of the Tarawa Atoll,
converted into a fortress by the Japanese.

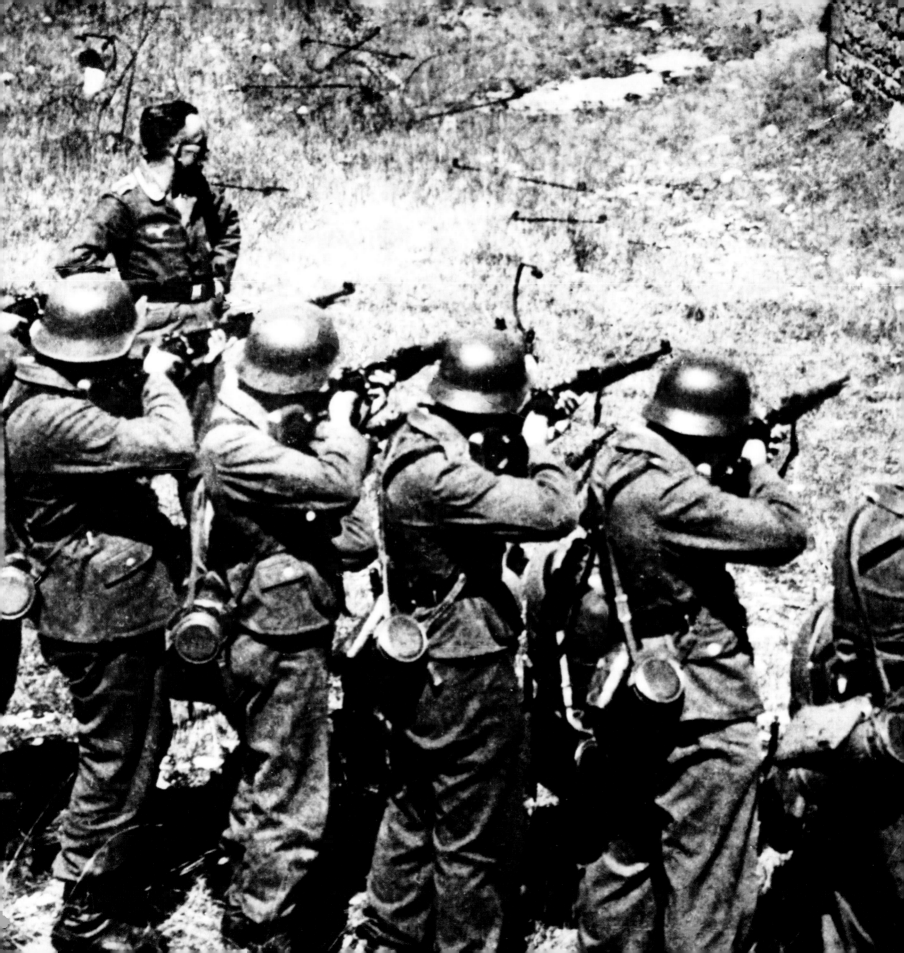

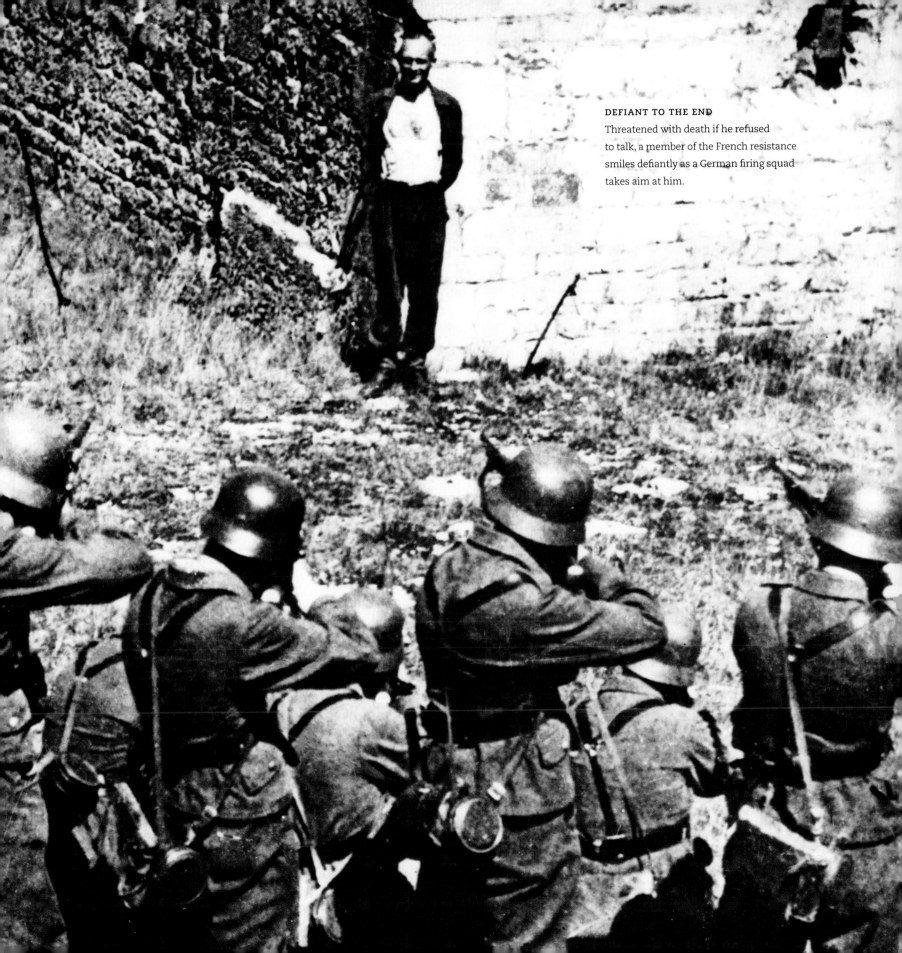

DEFIANT TO THE END
Threatened with death if he refused
to talk, a member of the French resistance
smiles defiantly as a German firing squad
takes aim at him.

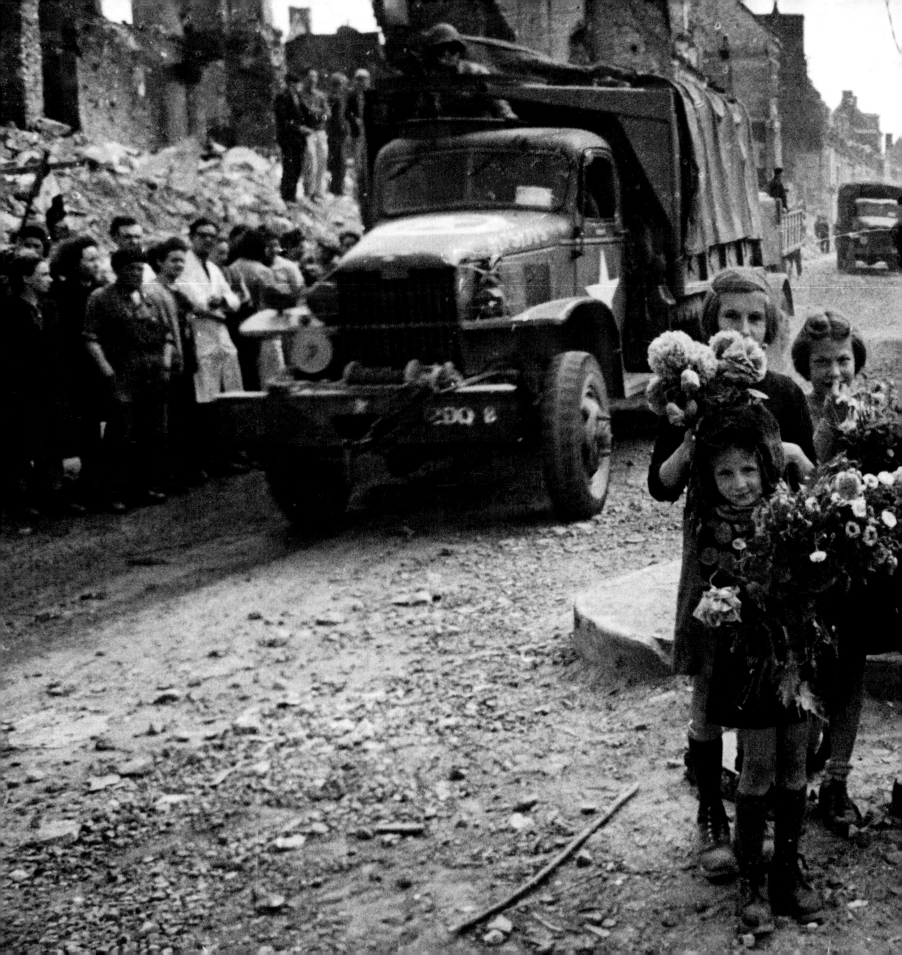

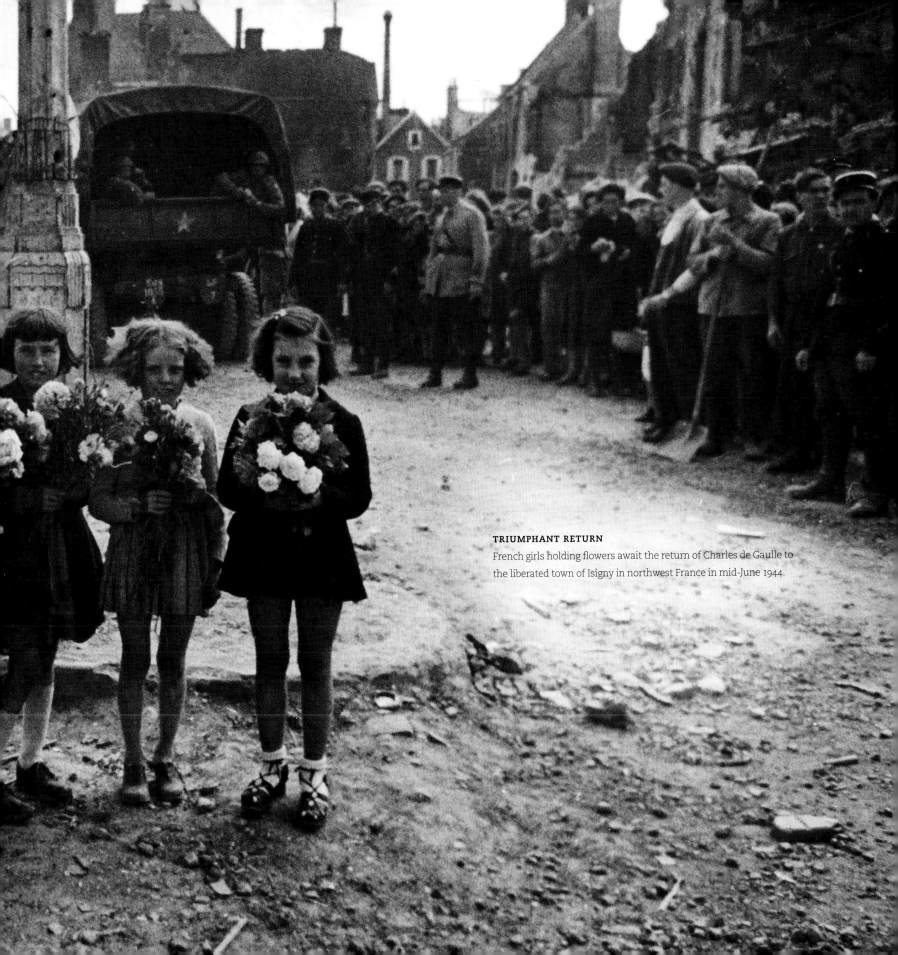

TRIUMPHANT RETURN

French girls holding flowers await the return of Charles de Gaulle to the liberated town of Isigny in northwest France in mid-June 1944.

Photographers under Fire

FEW OF THOSE WHO LANDED ON THE BEACHES of Normandy with the first wave of Allied invasion forces on the fateful morning of June 6, 1944, were there by choice. Most were soldiers who had no way of knowing when they enlisted that they would end up at the forefront of one of the most dangerous operations undertaken in the bloodiest war ever fought. One notable exception was photographer Robert Capa, covering D-Day for *Life*. An infantry commander offered him the option of coming ashore with regimental headquarters soon after the initial assault. "If I went with him, I wouldn't miss the action," Capa recalled, "and I'd be a little safer." Instead, he chose to go in with the first wave. The bigger the risk, the greater the reward for a man who prided himself on getting close to the action. "If your pictures aren't good," he insisted, "you aren't close enough."

Capa was a seasoned combat photographer who had seen battle during the Spanish Civil War and parachuted into Sicily with airborne infantry in 1943. But he had never experienced anything like the ordeal that awaited him as he stepped from his landing craft into the churning surf off Omaha Beach. "The water was cold, and the beach still more than a hundred yards away," he wrote. "The bullets tore holes in the water around me." He took cover where he could find it—behind steel girders the Germans planted offshore to impede the invasion and a shattered amphibious tank at the water's edge. All the while, he snapped shots of soldiers slogging forward under murderous artillery and machine-gun fire, repeating to himself a saying from his Spanish Civil War days: *"Es una cosa muy seria. Es una cosa muy seria."* ("This is a very serious business.")

For the troops, the main business was to reach the beach in one piece. Determined to keep up with them, Capa scurried from behind the tank and joined a group of soldiers laying flat "on a small strip of wet sand between the sea and the barbed wire." Without raising his head, he aimed his 35-mm Contax camera at the incoming forces, shooting from what he called "the sardine's angle," or near water level. "The foreground of my pictures was filled with wet boots and green faces. Above the boots and faces, my picture frames were filled with shrapnel smoke; burnt tanks and sinking barges formed my background."

Within 30 seconds, he had used up a roll of film. He tried to insert more, but his hands were shaking too badly and he ruined it. He was spent. Moments later, he saw a landing craft about to depart and made a dash for it, holding his equipment above his head to keep it dry. "I knew that I was running away," he wrote. "I tried to turn but couldn't face the beach."

Capa had nothing to be ashamed of. His job was not to remain with the troops at all costs but to move quickly in and out of combat zones and capture stirring images for publication. As it turned out, most of the shots he took on D-Day were ruined by a careless film developer in London. Fewer than a dozen of his images survived that mishap, but as shown here, they came as close as any pictures taken during the war to capturing the chaotic essence of battle.

Capa returned to Normandy a short time later and followed the advancing American troops as they liberated France and invaded Germany, exposing himself to further dangers. He survived the war, only to die in 1954 when he stepped on a landmine while covering the Vietnamese rebellion against the French. Like other war photographers, he never saw himself as much of a hero compared to the troops he was with. For all their skill and daring, these chroniclers of war were witnesses to acts of bravery and sacrifice that

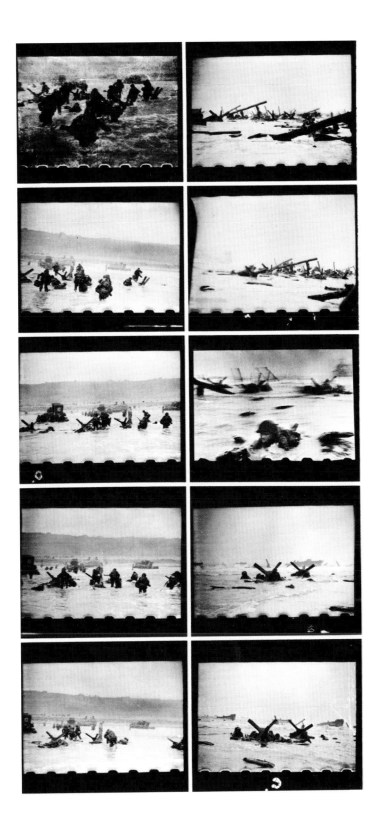

Robert Capa

CHRONICLER OF D-DAY

The 10 shots at left, showing embattled American troops struggling ashore at Omaha Beach, are the only surviving pictures taken on D-Day by photographer Robert Capa (*above*), who like other civilian correspondents wore a uniform when he accompanied soldiers into battle.

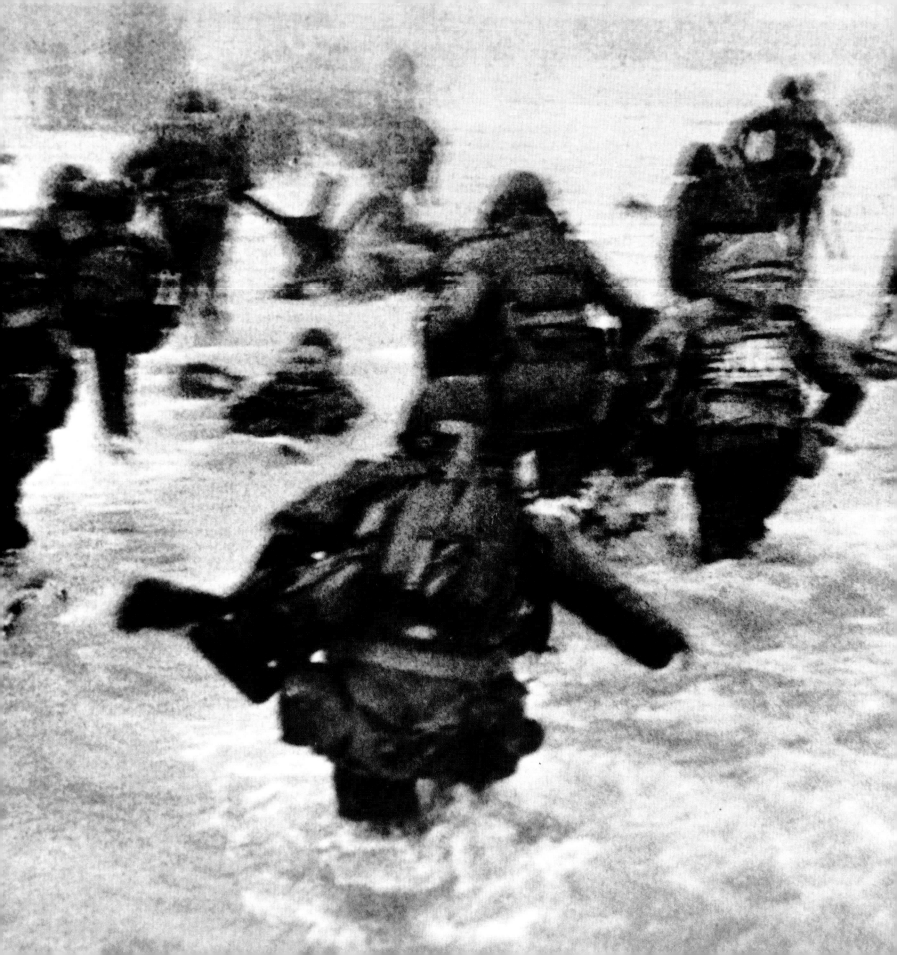

transcended their own efforts, making the pictures themselves more important than those who took them.

Few war photographers had the freedom Capa did to choose when and where to enter battle. Many served in the U.S. Army Signal Corps or the photo sections of the navy or marines and were attached to combat units for entire operations. Soldiers in those units were astonished at the risks they took simply to get good pictures. Indeed, the casualty rate for photographers and correspondents was four times greater than for the military as a whole.

Most war photographers relied on the Speed Graphic camera, a favorite of the American press corps with a lightning-quick shutter for fast-action shots. The camera's bulk made it a unwieldy in combat, however, and many took to carrying compact 35-mm cameras such as the Contax or Leica. Photographer Margaret Bourke-White, assigned by *Life* to cover Russia on the eve of the German invasion, brought with her a custom-made Speed Graphic with five interchangeable lenses, but it failed to impress people in Moscow, who much preferred their own Russian-made Leicas. "Anything larger than the palm of your hand," she observed, was considered "an antique."

The wide availability of compact cameras helped transform photography into an international craze by the time the war began. All the major powers involved in the conflict documented the fighting on film in great detail, and their military and civilian photographers yielded nothing to Americans when it came to getting close to the action. In Moscow, a daring photographer for *Izvestia,* Dmitri Baltermants, produced one of the war's classic images when he rushed to the trenches outside the capital in December 1941 and captured Russian troops from ground level leaping into battle against the invading Germans (*pages 104-105*). On the opposing side, skilled photographers from Joseph Goebbels' Propaganda Korps accompanied U-boat raids at sea and panzer offensives on land, producing arresting images of Hitler's war machine in action that played well in official magazines like *Signal*.

Democracies gave the press more freedom in covering the war, but every nation with a stake in the conflict tried

> ## "If your pictures aren't good, you aren't close enough."
>
> ROBERT CAPA

to control public perceptions of it. U.S. officials sought to calm fears early on by banning pictures of dead American soldiers and delaying the release of photos dramatizing American defeats. Not until December 1942—a year after the event—did *Life* and *Newsweek* publish the now-famous shot of shattered U.S. warplanes on an airfield at Pearl Harbor with smoke billowing in the background (*page 113*). In 1943, President Roosevelt eased restraints on war coverage, reasoning that people would be more willing to make sacrifices on the home front if they witnessed some of the horrors American soldiers endured in battle.

Few photographers did more to show the harsh reality of combat than W. Eugene Smith. A perfectionist who destroyed his early pictures because they had "great depth of field" but "little depth of feeling," Smith found in war a subject whose visual impact was matched by its emotional power. Some of his photos of the bloody island fighting in the Pacific between American and Japanese troops were considered too disturbing for publication even after censorship was relaxed. But one of his finest pictures, showing a U.S.

NIGHTMARE AT OMAHA

As revealed by this blow-up, Capa had a hard time focusing as he followed the troops ashore—a fact that only adds to the nightmare-like intensity of the image.

Marine holding an infant found near death on the embattled island of Saipan, was featured prominently in *Life* in August 1944 and caused a sensation. The caption accompanying the photo noted that the baby almost smothered before soldiers found him and "rushed him to hospital," offering readers hope for the infant's survival. In his own account written later, however, Smith offered a bleaker view of the incident: "Hands trained for killing, gently worked the sod away from the small lopsided head and extricated the infant. The eyes were sockets of pus, covered with the clinging flies. The head was obviously mashed to one side in its softness, and the little body was covered with scratches—but it was alive, and though death was almost sure, we used precious time to carry it back to the Jeeps for medical care. Several said it would be more merciful to shoot it in the head."

Some viewers found cause for hope in Smith's haunting image and others responded with horror. But for a photographer seeking to convey the emotional intensity of battle, almost any reaction was better than none. The enormity of the conflict could have a numbing effect on civilians. Photographs personalized this seemingly impersonal conflict and brought war home to the public as never before. For Edward Steichen, who took charge of the navy's aviation photo unit, the great challenge was to humanize a war dominated by machines. "Above all, concentrate on the men," he told his staff. "The ships and planes will become obsolete, but the men will always be there." He knew, of course, that many of those men might die in combat before

W. Eugene Smith

WOUNDED INFANT AT SAIPAN

Photographer W. Eugene Smith *(inset above)* brought the traumatic war in the Pacific home to Americans with his wrenching picture of a U.S. Marine on the island of Saipan holding a critically wounded infant *(right)*.

"Hands trained for killing, gently worked the sod away from the small lopsided head . . ."

W. EUGENE SMITH

the war was done, but they would live on as part of a great human epic preserved in words and pictures long after the last ships were scrapped.

Dramatizing the conflict in this way required more than getting close to the action and sensing its emotional impact. Photographers needed expertise and perfect timing to capture those rare moments when everything came together to produce a great picture. One such golden opportunity came at war's end to Alfred Eisenstaedt, a leading portrait photographer. For all his experience in the studio, his most memorable shot was produced on the move in Times Square during the wild celebration on V-J Day in August 1945. "I saw a sailor running along the street grabbing any and every girl in sight," he recalled. "I was running ahead of him with my Leica looking back over my shoulder. But none of the pictures that were possible pleased me. Then suddenly, in a flash, I saw something white being grabbed. I turned around and clicked the moment the sailor kissed the nurse. If she had been dressed in a dark dress I never would have taken the picture. If the sailor had worn a white uniform, the same." For an instant, the composition was just right, and he captured that perfect moment for posterity *(page 299)*.

Another example of great photographic timing resulted in an image that summed up the entire American war effort —Joe Rosenthal's classic picture of marines raising the flag on Iwo Jima on February 23, 1945. It was a moment Rosenthal nearly missed. Assigned to cover the battle for the Associated Press, he learned in the morning that the marines had raised a small flag atop Mount Suribachi after fighting their way to the summit. That first flag raising was

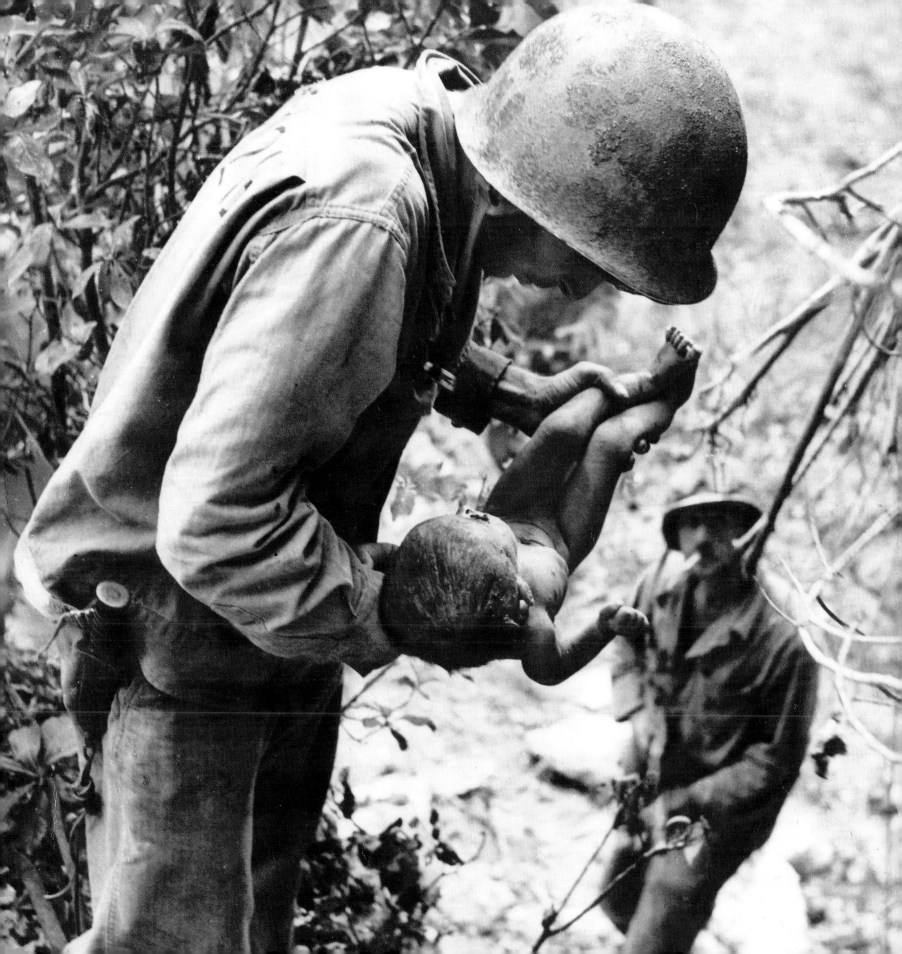

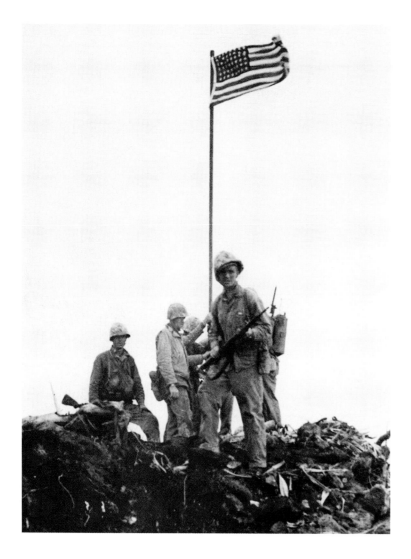

recorded at some risk by photographer Lou Lowery for the service magazine *Leatherneck*. Subsequently, the soldiers decided to replace the first flag with a larger one, and Rosenthal reached the summit just in time to document the second flag raising. With him was marine photographer Bob Campbell, who caught the first flag being lowered as the second was being raised.

Campbell and Lowery produced strong images, but only Rosenthal captured the defining moment of the ceremony *(right)*. His insight was to portray the marines as a unit in the act of raising the second flag—a scene that summed up their fighting spirit and solidarity. He had little time to prepare and one chance to get it right. "When you take a picture like that you don't come away saying you got a great shot," he wrote afterward. As it turned out, the picture was perfect—too perfect for some skeptics, who suspected him of arranging the flag raising and having the marines pose for him. "Had I posed the shot," he responded wryly, "I would, of course, have ruined it."

Seizing that splendid, spontaneous moment brought Rosenthal fame, but he graciously deflected credit to the men in the picture. Like others who took the great photographs assembled here, he recognized that the power of his work lay in the stirring events he documented. Three of the six marines in his photo died in action before the war ended that August. When men sacrificed all to defend their flag, he wondered, did it really matter who took the picture that symbolized their efforts? "I took it," he concluded, "but the Marines took Iwo Jima."

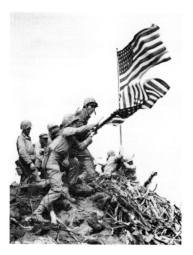

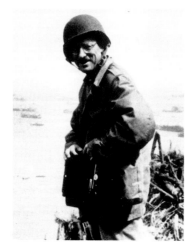

FLAG RAISING AT IWO JIMA

Joe Rosenthal *(left)*, who took the classic picture of marines raising the flag on Iwo Jima on February 23, 1945 *(right)*, was one of three photographers on the summit of Mount Suribachi that day. Earlier, Lou Lowery recorded marines standing guard around the first flag they raised *(above)*. Bob Campbell later photographed the men as they were replacing that small flag with a larger one *(far left)*, which Rosenthal captured on film as it was going up.

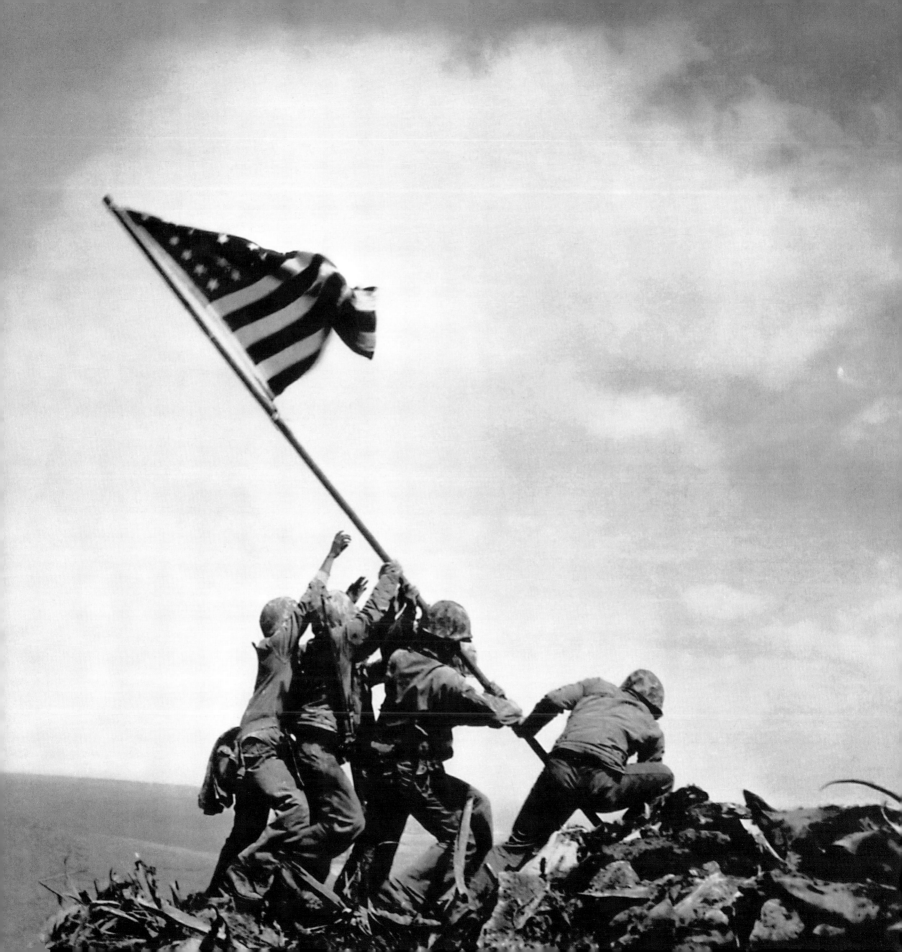

The Gathering Storm

FOR MANY WHO LIVED THROUGH THE EPIC CONFLICT THAT ENDED IN 1918 with the surrender of Germany, it was the war to end all wars. But for Adolf Hitler, dedicated to avenging that defeat, the Great War was merely the prelude to an even greater struggle against the forces he blamed for Germany's humiliation. Chief among them were Communists inspired by the Bolshevik revolution in Russia who had joined in an uprising that rocked Germany on the eve of surrender. German troops could have won the war, Hitler claimed, but they were stabbed in the back by Marxists and Jews—two groups he lumped together as enemies of the Reich, the German state he hoped to expand into an empire. By scapegoating Jews and other non-Aryans and promising to restore German might, Hitler's Nazi party won broad support in a defeated

country devastated by the Great Depression. In 1933, he seized power and prepared his armed forces for conquest, entrusting his sinister racial agenda to his elite guard, the SS.

Hitler found an eager ally in Italy's Fascist dictator, Benito Mussolini. In 1936, the two threw their support to another right-wing strongman, Francisco Franco, who toppled Spain's Republican government and set off a civil war that served as a dress rehearsal for the larger conflict to come, with the Soviet Union backing the Republicans. Meanwhile, Japan—which would join Italy and Germany in 1940 to form the Axis—was engaged in a brutal occupation of China. Such aggression would ultimately lead to American sanctions against Japan.

The United States and other democracies hoped to avoid war. But in 1939, Hitler's relentless program of expansion, capped by the occupation of Czechoslovakia, impelled Britain and France to pledge opposition if Germany attacked Poland. The stage was set for the showdown Hitler had long anticipated—a second world war that would settle the explosive issues laid bare by the first.

NURTURING AN ARYAN NATION
Beneath an SS banner, a student nurse, or "little blond sister," wheels a pram into the sunlight. Student nurses were carefully screened, for they too had to "fulfill a lofty duty to the nation."

BOLSHEVIKS UNDER FIRE
Survivors of a crowd fired upon by machine gunners flee along the Nevsky Prospekt in Petrograd, or St. Petersburg. Confused fighting raged through the Russian imperial capital in mid-July of 1917 as the Bolshevik takeover momentarily faltered.

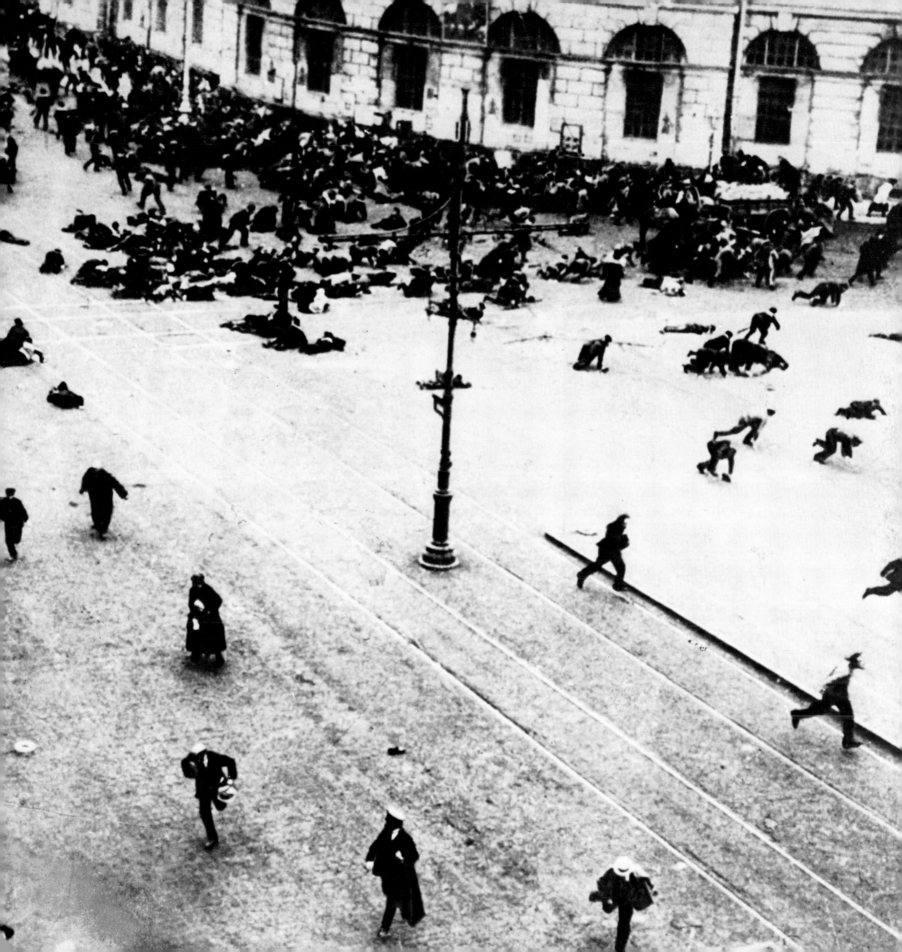

"The character of the Italian people must be molded by fighting."

BENITO MUSSOLINI

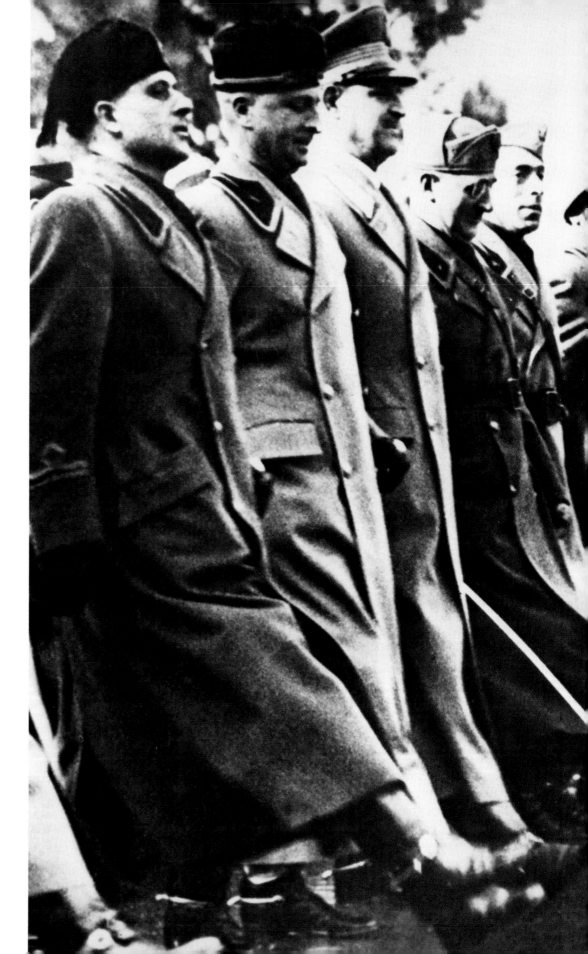

LEADING ITALY TO DISASTER

Benito Mussolini teaches the stiff-legged goose step to high-ranking Fascist officers in Rome in January 1938. Obsessed with military trappings and determined to build an empire, Mussolini committed Italy to a Pact of Steel with Nazi Germany and in 1940 dragged his country into a war that it was fatally unprepared to fight.

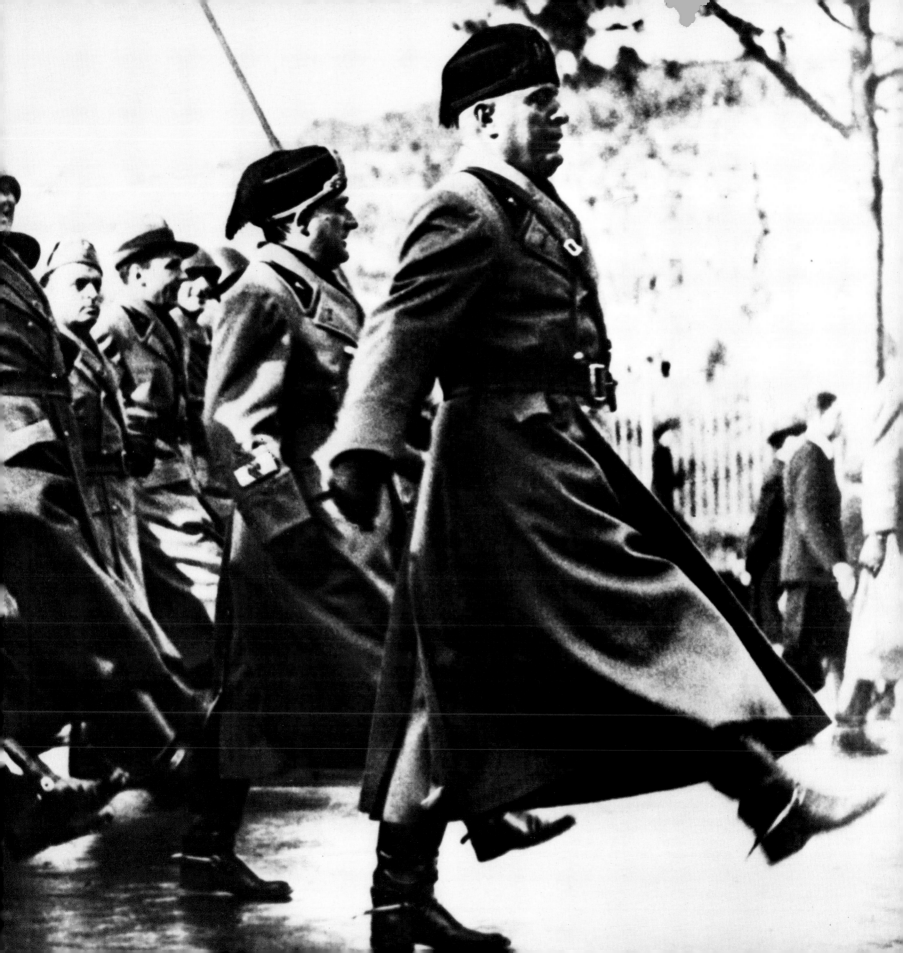

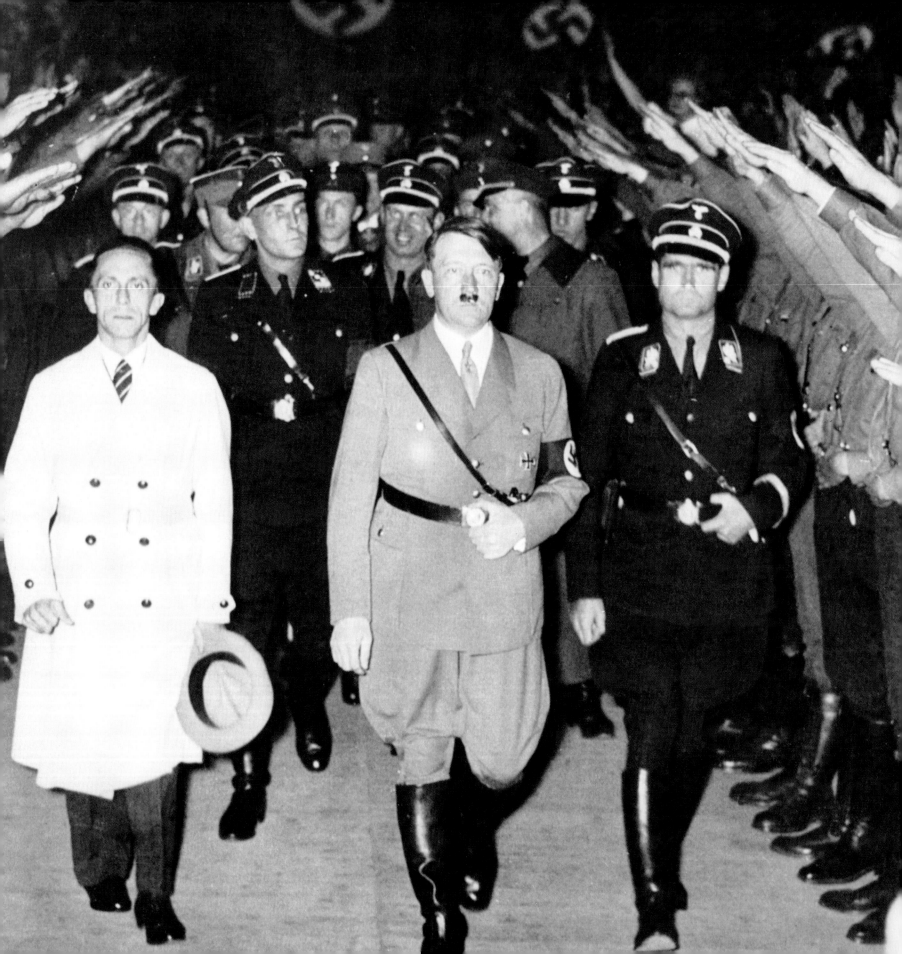

DISPENSING WITH THE STORM TROOPERS

At a party gathering in late 1933 *(left)*, stiff-armed storm troopers hail Hitler, flanked by Propaganda Minister Joseph Goebbels to his right and Deputy Führer Rudolf Hess to his left. Unruly storm troopers helped Hitler muscle his way to power, but he soon replaced them with the fanatically loyal SS and eliminated their leader in a bloody purge known as the Night of the Long Knives.

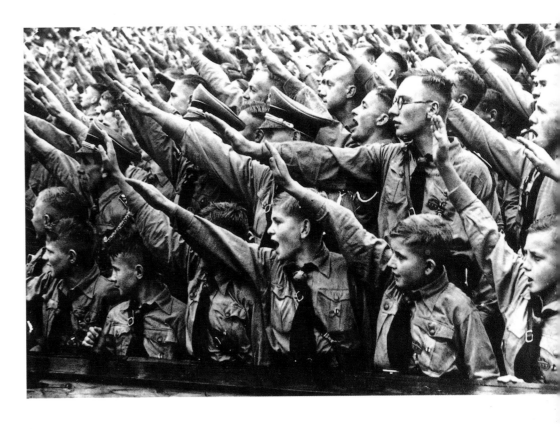

TRAINED TO OBEY

For Hitler Youth like those gathered here to greet their Führer at Nuremburg in 1937, the Nazi salute was an automatic response, instilled through years of ideological conditioning in classrooms and training camps.

FIRE STORM OF INTOLERANCE

Shouting Nazi slogans, German university students fling "racially alien" books into a roaring bonfire in a Berlin square in May 1933. The Nazis went on to purge German libraries and bookstores of the unacceptable writings of Sigmund Freud, Thomas Mann, and others.

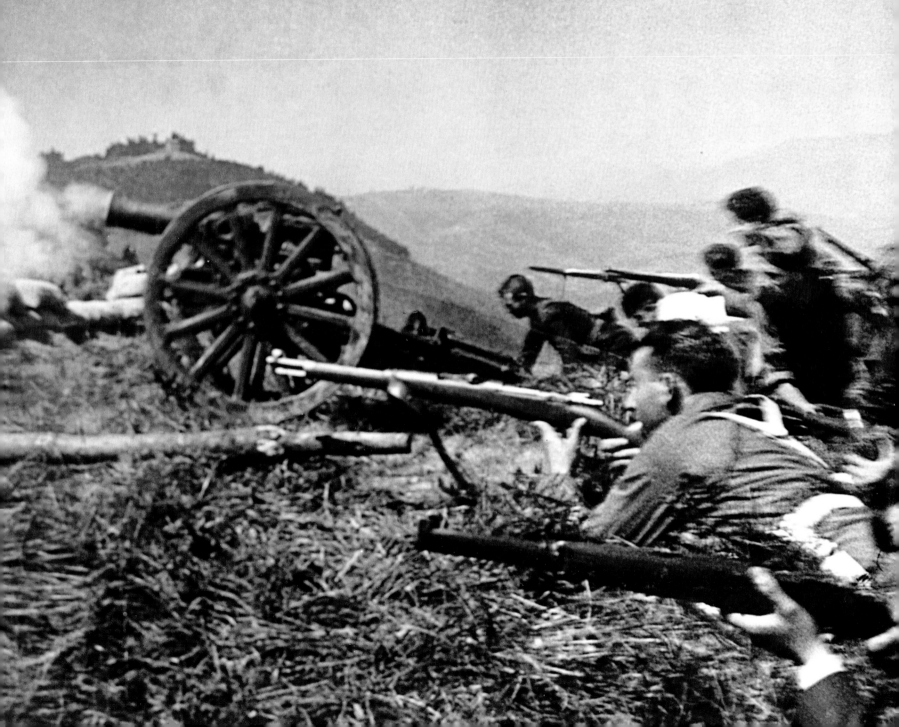

OUTGUNNED BY FRANCO
Republican forces, shown here fighting around an antiquated cannon, were outgunned and outmaneuvered by Franco and his allies despite receiving military aid from the Soviet Union and volunteers from various countries.

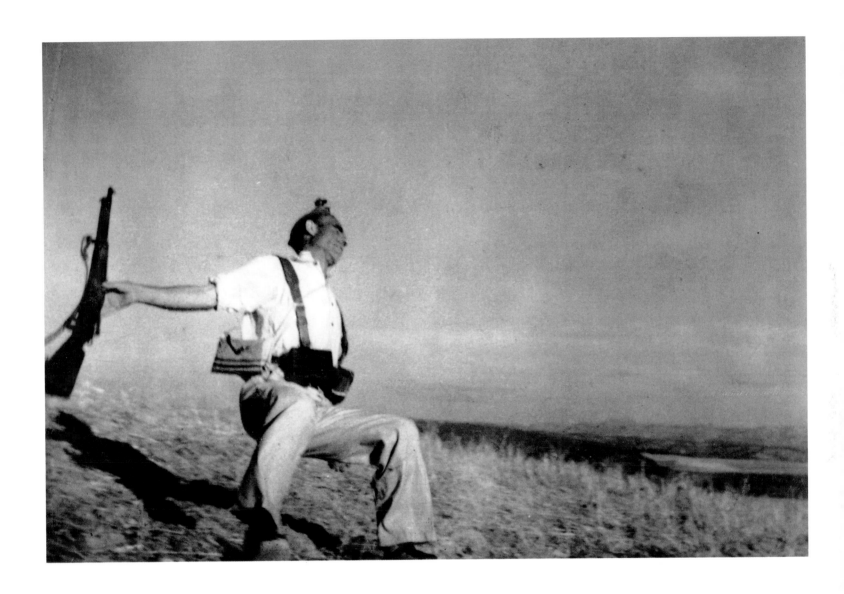

SACRIFICE FOR A LOST CAUSE
A Republican militiaman is shot dead in a haunting photograph taken by Robert Capa in
September 1936 that came to symbolize the determined but ultimately futile struggle of Spanish
Loyalists against Franco's Nationalists, bolstered by support from Hitler and Mussolini.

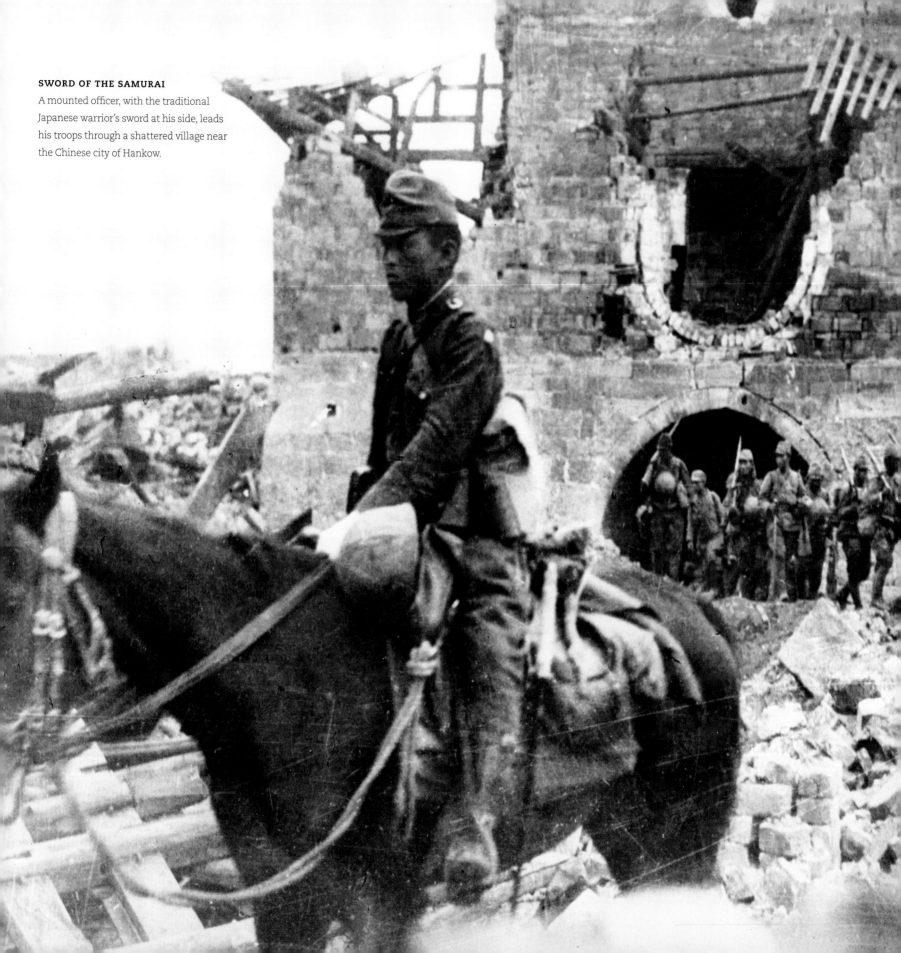

SWORD OF THE SAMURAI
A mounted officer, with the traditional Japanese warrior's sword at his side, leads his troops through a shattered village near the Chinese city of Hankow.

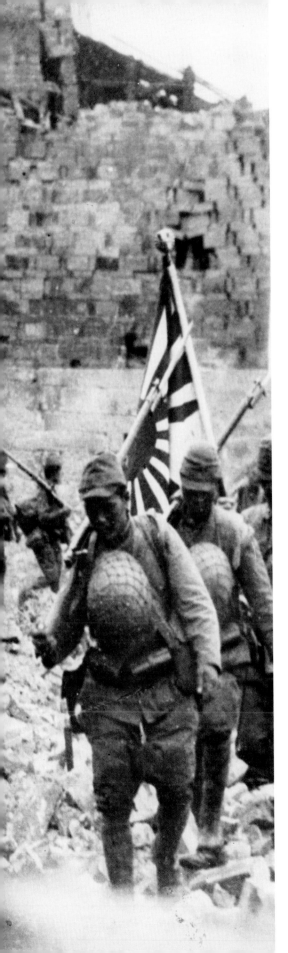

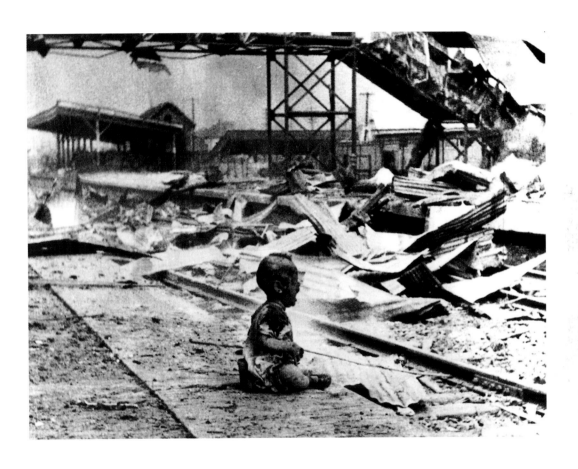

A MERCILESS ASSAULT
This chilling picture of a bloodied and abandoned infant in a bombed railway station in Shanghai in 1937 alerted the world to the punishing Japanese assault on China.

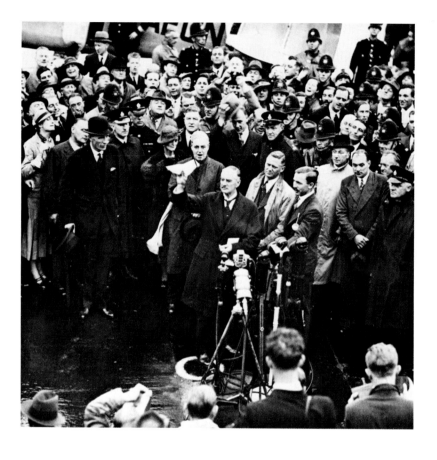

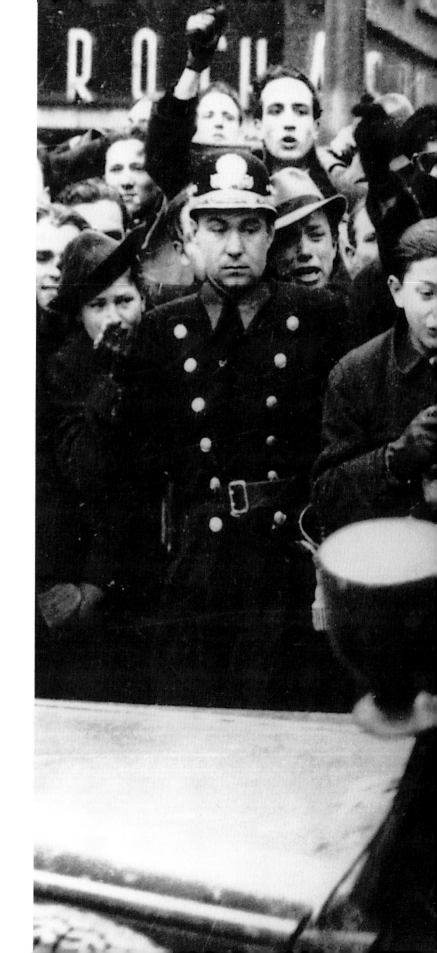

"PEACE FOR OUR TIME"

Prime Minister Neville Chamberlain, after making concessions to Hitler in Munich in 1938, stands before a welcoming British crowd and waves the short-lived Anglo-German accord that Chamberlain touted as promising "peace for our time."

OVERTURE TO WAR

Shocked and angry Czechs, some waving fists, watch German troops enter Prague on March 15, 1939, after the Czechoslovakian government capitulated. The German occupation violated the Munich Pact and led the British to abandon appeasement and prepare for war.

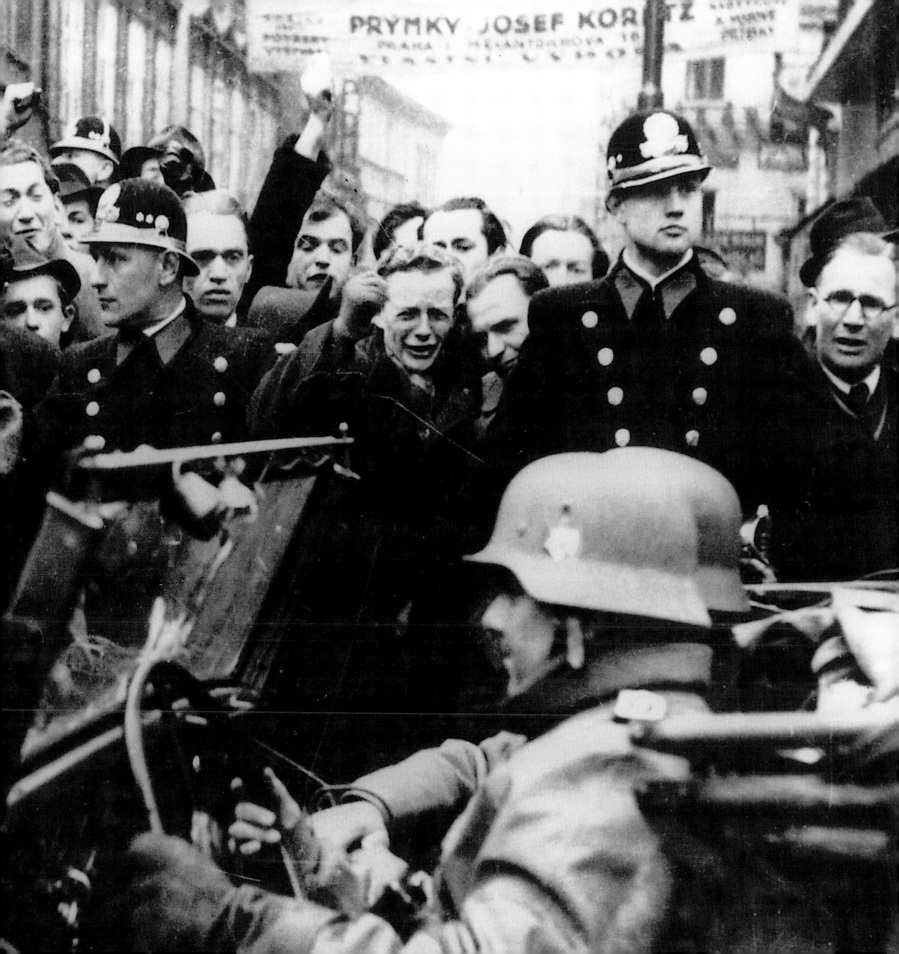

Destiny in Their Hands

Master of Persuasion

The numbers were staggering: well over 50 million troops under arms around the globe, and hundreds of millions of lives affected in one way or another. But in another sense, World War II was a struggle among a mere handful of men—the leaders of the major powers in conflict. They held destiny in their hands, and the fate of entire nations hinged on their decisions.

Hitler started the war and welcomed it, but the man who did most to determine the outcome regarded the conflict as a regrettable necessity. Like Hitler, Franklin Delano Roosevelt made a career of overcoming obstacles, fighting back from a crippling bout with polio in 1921 and working as president to revive a nation paralyzed by the Depression. But his serene confidence in the face of adversity was altogether different from Hitler's fanat-ical urge to dominate. Roosevelt responded to crises by appealing to the best in people rather than the worst, coaxing Americans away from their isolationism by reminding them that the world was now their neighborhood and that threats to freedom and security abroad could no longer be ignored.

To sell the concept of lend-lease, a program to keep Britain supplied with war materiel, this master of persuasion used a simple analogy: "Suppose my neighbor's home catches on fire, and I have a length of garden hose, I don't say to him: 'Neighbor, my garden hose cost me $15; you have to pay me $15 for it.' No, I don't want $15—I want my garden hose back after the fire is over." Americans were won over—and were soon fighting that fire alongside their neighbors.

War will be a greater danger to us if we close all the doors and windows than if we go out in the street and use our influence to curb the riot.

FRANKLIN DELANO ROOSEVELT

Roosevelt's patented grin and nonchalance reassured Americans through two of the biggest challenges in the nation's history—the Great Depression and the world war that followed.

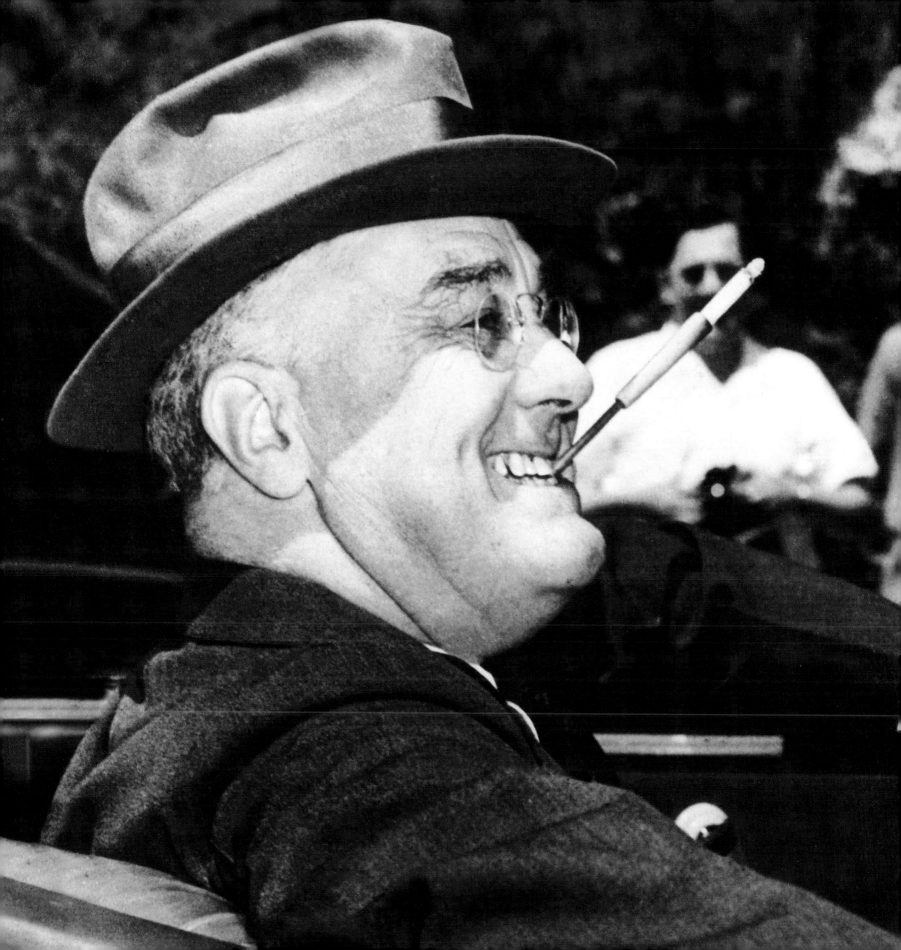

Champion of the Realm

Winston Churchill had much in common with Roosevelt and forged a strategic partnership with him that altered the course of the war. Both came from privileged families, both were capable of stirring oratory, and both used that eloquence to rally their respective nations in times of utmost peril. Churchill saw earlier than many in Britain the danger posed by Hitler—an awareness that made him a political outcast in the 1930s, when the public favored the appeasement policy of Prime Minister Neville Chamberlain. "Chamberlain has a lust for peace," Churchill scoffed in 1937. Three years later, after repeated aggressions by Hitler, Churchill took charge of a nation whose very survival was at stake. He was just the tonic the British needed—a champion with nerves of steel and an iron will to brace them for the bombs that would soon rain down on London.

In his partnership with Roosevelt, Churchill provided the spark, encouraging the president to take a strong stand against Axis aggression despite the qualms of the American electorate and to embrace the policy of Europe First by giving the war against Germany priority over the struggle against Japan. Roosevelt, for his part, exerted a calming influence on the fiery Churchill. When the Anglo-American alliance expanded to include Stalin—whom Churchill heartily detested—FDR served as intermediary. But it was Churchill who set the combative tone for the Allied war effort by standing up to Hitler when he seemed unstoppable and encouraging others to do likewise. "Victory at all costs," he vowed in 1940, "victory in spite of all terror, victory however long and hard the road may be; for without victory there is no survival."

Never give in. Never give in. Never, never, never, never, never—in nothing great or small, large or petty—never give in except to convictions of honour and good sense.

WINSTON CHURCHILL

Often stern when Roosevelt was genial, Churchill infused the Anglo-American alliance with a sense of urgency.

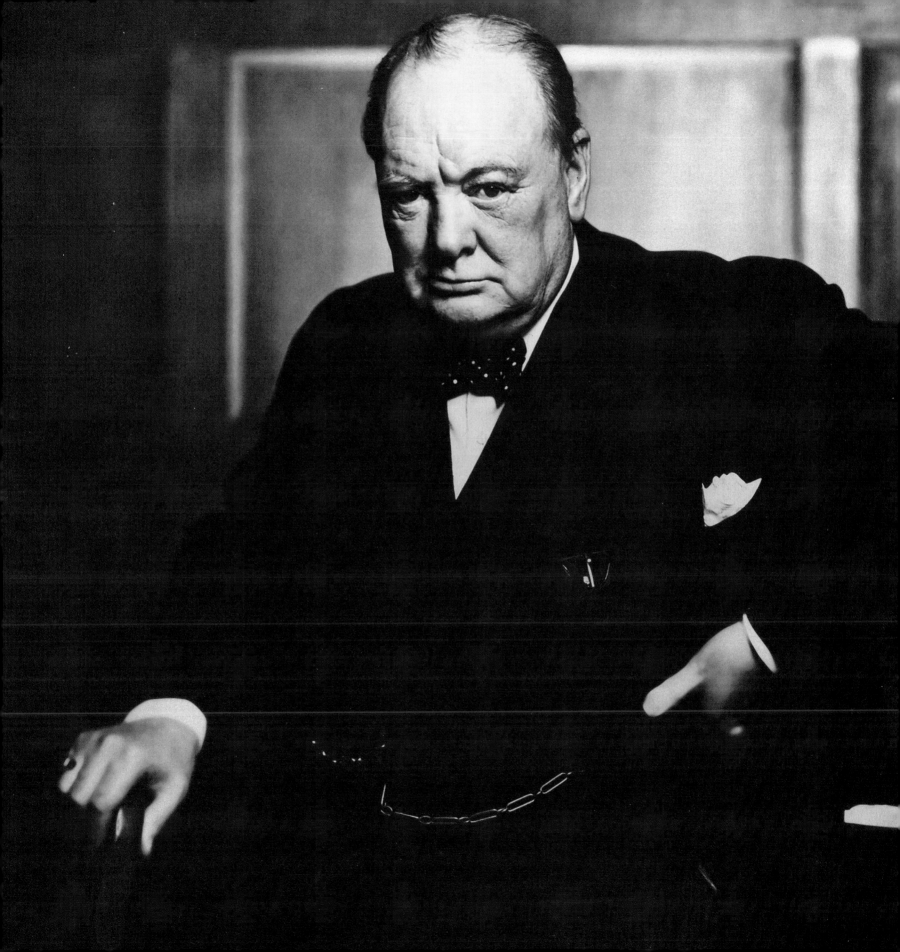

The Terrible Simplifier

Adolf Hitler gained prominence by prescribing deceptively simple cures for the devastating ills that plagued Germany after World War I, a conflict in which he was twice wounded and won the Iron Cross for bravery. Like other embittered veterans, he ignored the extent to which Germany brought defeat on itself and railed against the "death sentence" imposed by the victorious Allies at Versailles. Jailed after an abortive attempt to overthrow Bavaria's republican government in 1923, he spent a leisurely confinement composing *Mein Kampf*, the dense Nazi tome that blamed Germany's humiliation on Jews and Marxists—scapegoats he would also hold responsible for the severe depression that hit Germany in 1929, a calamity that added fuel to his rhetorical fires. The blind certainty with which he advanced his venomous arguments heightened his appeal in a country hungry for bold leadership.

Hitler's meteoric rise to power in the 1930s and his initial successes at forcefully expanding the Third Reich led him to the conclusion that his judgment was infallible, so he blithely ignored the advice of his top commanders. "I do not ask my generals to understand my orders," he remarked, "but only to carry them out." He believed that victories could be achieved through sheer willpower and dismissed formidable opponents like the Russians as racially inferior. His view of the United States was derived in part from Hollywood—films such as *The Grapes of Wrath* led him to opine that Americans were an uprooted mob of "miserable and degenerate farmers" who would easily be defeated. Germany's military mastermind reduced a complex world to simple formulas. It would prove to be his undoing.

I shall stand or fall in this struggle. I shall shrink from nothing and shall destroy everyone who is opposed to me.

ADOLF HITLER

Hitler rails against the enemies of Germany in a prewar speech, using gestures calculated to overawe his listeners and reduce them to adoring submission.

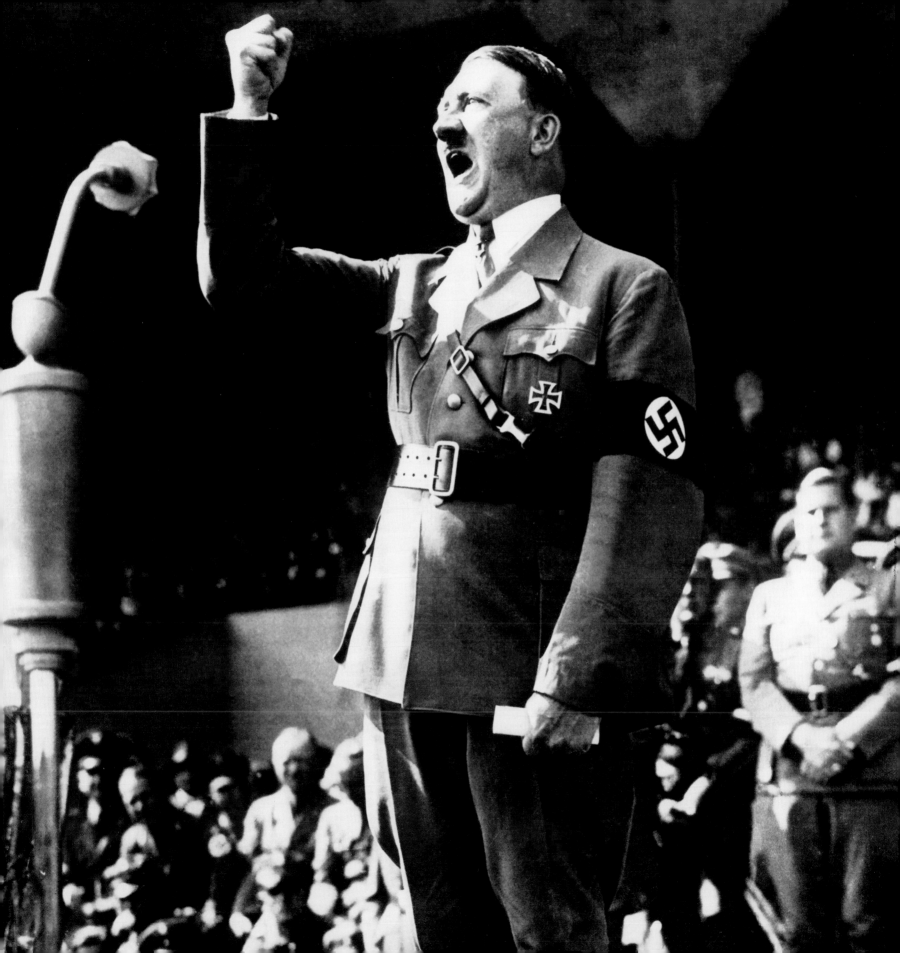

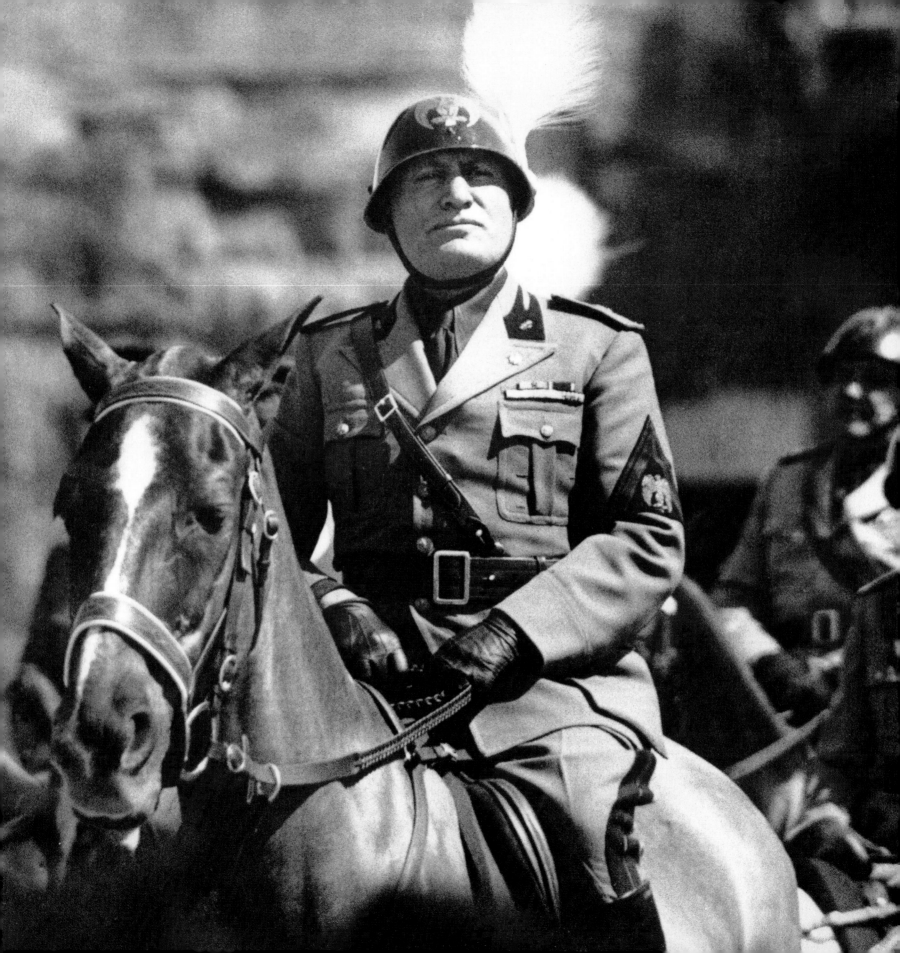

Caesar the Second

The fact that Mussolini came to power 11 years before Hitler proved to be more of a curse than a blessing for Il Duce, however much he claimed credit for being the father of Fascism. Both men felt that their nations had been cheated at Versailles and hoped to build empires through conquest that would surpass those of Britain and France. But while Hitler created a formidable war machine that was primed for conquest in 1940, Mussolini's army peaked prematurely with a less-than-impressive conquest of Ethiopia in 1936 and declined thereafter as its equipment grew outdated and morale lagged. "We have buried the putrid corpse of liberty," Mussolini proudly declared. But his own dictatorial regime would putrify as he neglected problems festering within the army and the nation's economy while continuing to act like the leader of a great power.

Obsessed with his own imperial prestige, Mussolini fancied himself Caesar the Second and showed up for his first meeting with Hitler in Venice in 1934 wearing spurred boots, a fringed fez, and a blaze of medals across his chest. By the time the two dictators formally joined in their so-called Pact of Steel in 1939, Italy's strength had declined significantly in relation to Germany's. But Il Duce stubbornly refused to play a subordinate role. More than once, Mussolini launched campaigns that went ruinously awry, forcing Hitler to bail out his Axis partner with German divisions that were badly needed elsewhere. Their fruitless alliance was a grim parody of the productive partnership that developed between Roosevelt and Churchill and would end with Hitler attempting to prop up Mussolini against assaults by his own disaffected populace.

Italy! Italy! Entirely and universally Fascist! The Italy of the blackshirt revolution, rise to your feet; let the cry of your determination rise to the skies.

BENITO MUSSOLINI

A gaudy plume topping his immaculate uniform, Mussolini leads a military parade in his capacity as Il Duce—a leadership role that often emphasized style over substance.

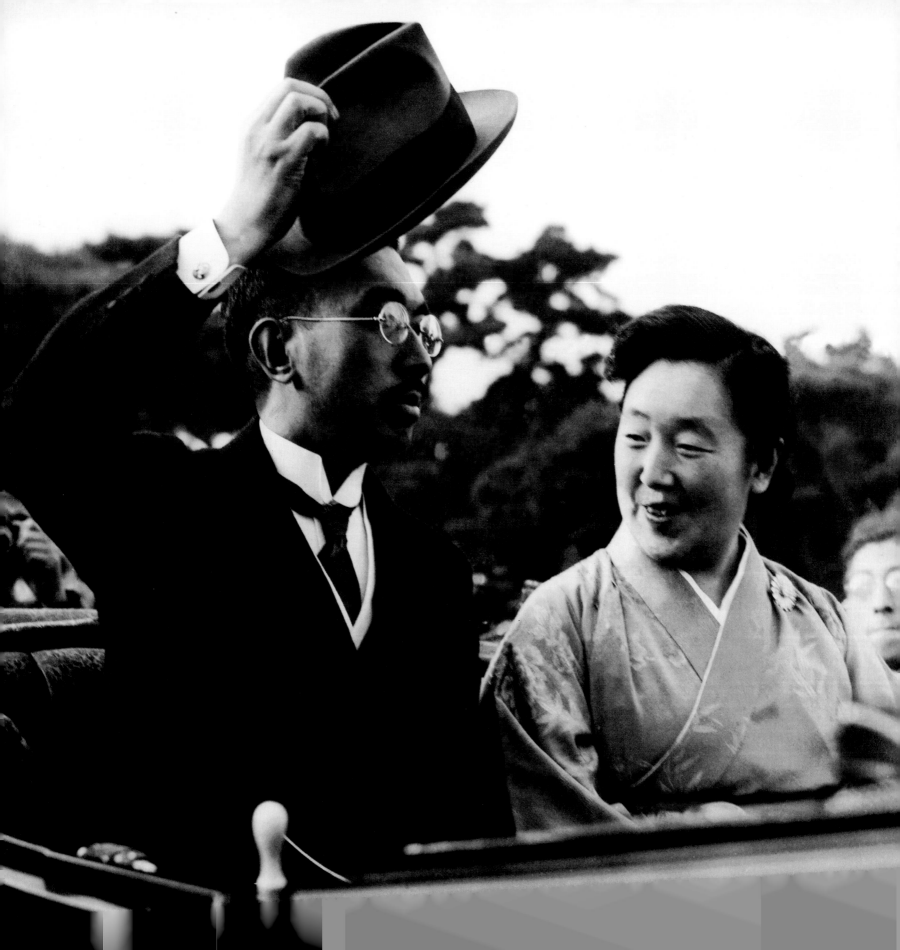

The Powerless God

At a meeting in 1941, as Japan's ministers pressed for an offensive that would include attacks on U.S. bases in the Pacific, the nation's soft-spoken monarch, Emperor Hirohito, quoted a poem by his grandfather: "Why do the winds and waves of strife disrupt peace?" His question went unanswered. A clique of militarists led by General Tojo Hideki, who became prime minister in 1941, controlled the government and were intent on waging war. In need of a figurehead who would inspire their troops to valor, they had restored the emperor's traditional quasi-divine status and encouraged his veneration. The Son of Heaven was the ideal pawn: untouchable, blinding to behold—and all but impotent.

Born in 1901 and whisked from his parents' arms 10 weeks later, Hirohito spent his childhood under the guidance of a string of tutors, who drummed imperial duties into his head. At the age of 20, showing a glimmer of independence, he became the first emperor to set foot outside Japan when he made a tour of Europe that inspired a lifelong taste for Western suits, sports, and breakfasts of toast and eggs. For the most part, however, he bowed to imperial traditions and played his assigned role. Although fearful of war and appalled by the excesses of the Japanese army in China and other occupied countries, he agreed with Tojo in 1941 that Japan would be humiliated if it yielded to pressure and made peace on American terms. Not until August 1945, when Hiroshima and Nagasaki lay in radioactive ruins, would Hirohito openly defy the military leaders by announcing Japan's surrender.

I cannot bear to see my innocent people suffer any longer. Ending the war is the only way to restore world peace and to relieve the nation from the terrible distress with which it is burdened.

EMPEROR HIROHITO

Revered even after his nation's defeat, Hirohito and the empress Nagako ride through the Imperial Plaza in Tokyo in November 1946.

"Nothing Human to Get Hold Of"

During a toast at the Tehran conference in 1943—the first meeting of the Allied leaders known collectively as the Big Three—Soviet dictator Joseph Stalin suggested menacingly that 50,000 German officers should be rounded up after the war and shot. Britain, Churchill retorted sharply, would never stand for such butchery. With tempers flaring, Roosevelt chose to take Stalin's remark as a bad joke. Perhaps it would be sufficient, he quipped, if only 49,000 were executed.

Roosevelt spent most of the war trying to woo Stalin with breezy goodwill. His effort was largely wasted. Deeply suspicious, Stalin felt his Western allies were in league against him and proved to be single-minded in pursuing his agenda. Roosevelt ultimately despaired of reaching him on a personal level, commenting that in Stalin he could find "nothing human to get hold of."

The frightening truth was that executing 50,000 Germans would have been no great matter for Stalin, who had killed or imprisoned millions of his own people in terrifying purges during the 1930s that crushed even the mildest forms of dissent and tightened his grip on power. Vladimir Lenin, whom he had succeeded as leader of the Communist Party and master of the Soviet state, called him a "coarse, brutish bully." But Joseph Stalin was also a man of great cunning and resolve who transformed the Soviet Union into an industrial powerhouse that churned out weaponry at a remarkable pace even while large parts of the country were under German occupation. In that fearful reckoning between two murderous dictators, Stalin proved himself to be superior to Hitler as a war leader and sealed the fate of the Nazi regime.

To choose one's victim, to prepare one's plan minutely, to slake an implacable vengeance, and to go to bed—there is nothing sweeter in the world.

JOSEPH STALIN

Stalin, shown here in his Kremlin office beneath a portrait of Karl Marx, often projected the deceptively genial look of a predator happily contemplating his next kill.

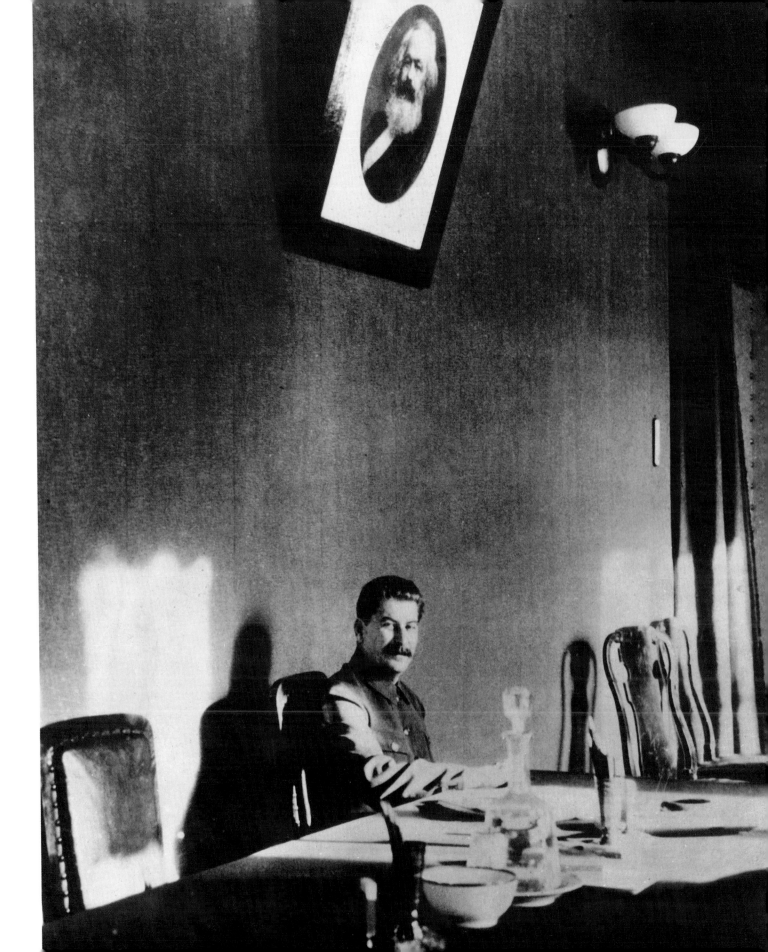

Blitzkrieg

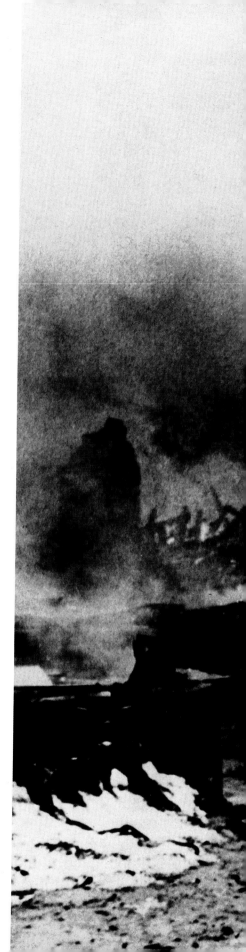

"FURTHER SUCCESSES ARE IMPOSSIBLE WITHOUT THE SHEDDING OF BLOOD," Hitler declared to his commanders in May 1939. Thus far, he had managed to seize territory through acts of intimidation that went unchallenged—reoccupying the Rhineland in 1936, annexing Austria in 1938, and grabbing Czechoslovakia the following spring. But the next step in his quest for a Greater German Reich meant war. He ordered his generals to prepare for an invasion of Poland, an assault sure to trigger hostilities with Britain and France, if not with the Soviet Union. Cynically, he postponed a showdown with the hated Soviets by signing a non-aggression pact with Stalin in August. That freed Hitler to reckon with Poland, which he planned to wipe off the map before Britain and France could mobilize. Then he would deal with the Allies as he did with all who stood in his way—by attacking them first.

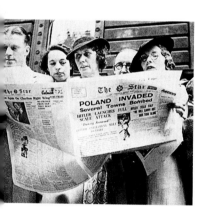

Hitler's obliging generals had long been planning for a replay of the First World War. This time, they would not get bogged down in trench warfare. They had retooled the Wehrmacht for blitzkrieg, or lightning war, involving quick, deep thrusts by fast-moving armored divisions, closely supported by air power.

All went as planned. Poland—pounded from above by the Luftwaffe and penetrated by motorized panzer units—fell in little more than a month. In the lull that followed, Hitler refined plans for striking at Paris through the vulnerable Low Countries. After invading Denmark and Norway in April 1940 to seize raw materials and ensure his fleet access to the Atlantic, he unleashed his lightning war against France on May 10. Six weeks later, he was basking in victory at Paris. Only one setback marred his triumph—failure to halt the evacuation of Allied forces from the port of Dunkirk, an escape that encouraged Britain to carry on the fight.

WAR HITS HOME

Londoners read Friday morning's news on September 1, 1939: Germany had invaded Poland before dawn; Parliament would convene at 6 P.M.

RACE TO CONQUEST

German soldiers dash into the smoldering ruins of a Norwegian town readied for them by a half-hour bombardment. Taking town after town in this manner, the Germans secured 60,000 square miles of southern Norway in 25 days.

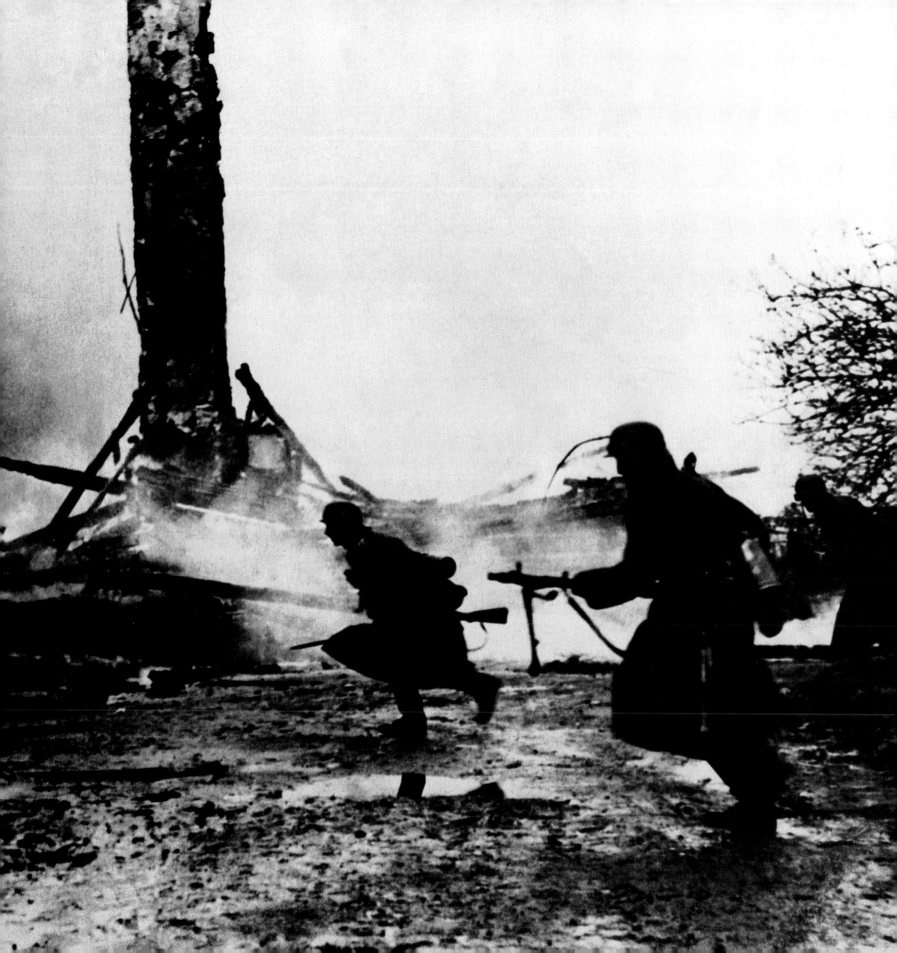

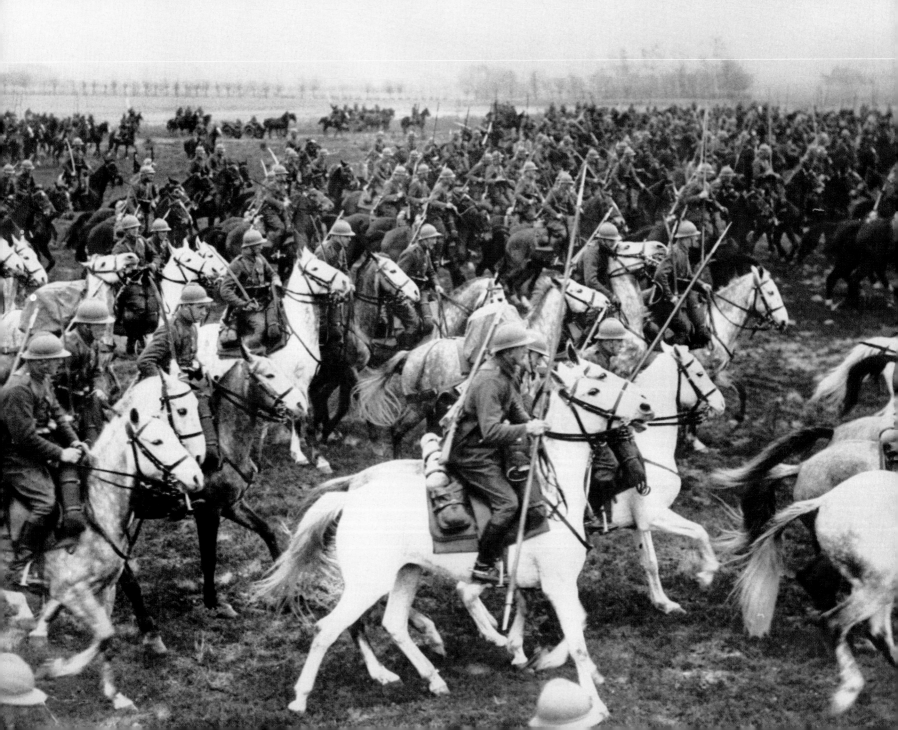

A DOOMED BRIGADE
Polish cavalry units like the one shown training here
before the invasion offered gallant resistance to
the Germans but were torn apart by armored forces.

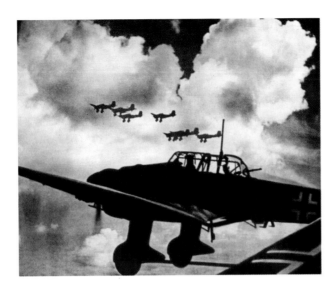

STUKAS OVER POLAND
Slashing into Poland, the tight formation of a squadron of Stukas is recorded in this shot taken by the wing mate of the plane in the immediate foreground. The Stuka, a dive bomber flying in close support of ground troops, played a major part in the blitzkrieg tactics that defeated Poland in just 35 days.

BLASTING AHEAD
During an infantry assault in Poland, a German soldier, supported by two of his comrades, cocks his arm to throw a "potato masher" hand grenade.

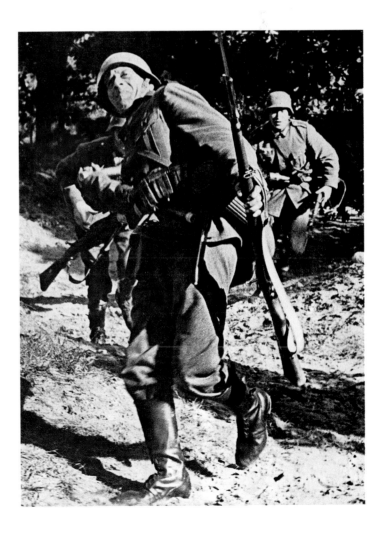

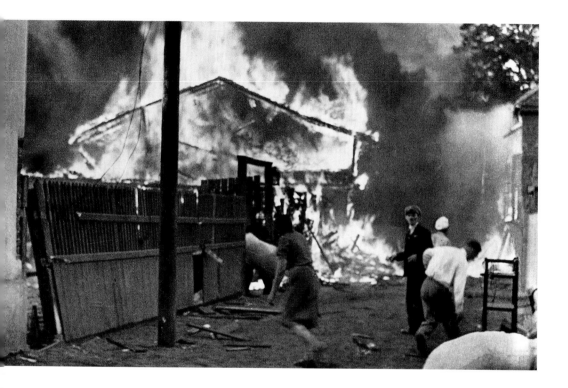

FIREBOMBING WARSAW

Poles race for cover moments after German firebombs hit houses in a working-class neighborhood. Luftwaffe pilots, engaging in virtually nonstop raids, destroyed one-fourth of the city of Warsaw in just four days.

TARGETING THE CAPITAL

A machine gunner takes dead aim from the nose turret of a German warplane swooping over the outskirts of Warsaw during the invasion.

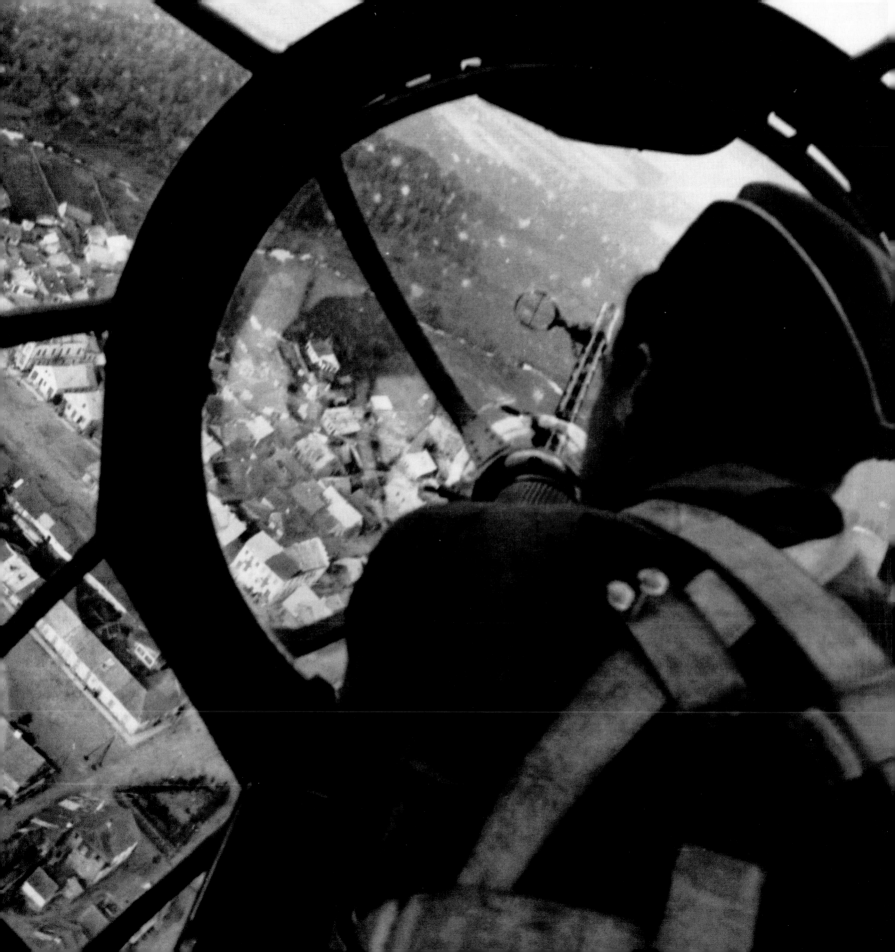

"Germany has occupied Danish and Norwegian soil in order to protect those countries from the Allies."

JOACHIM VON RIBBENTROP,
German Foreign Minister

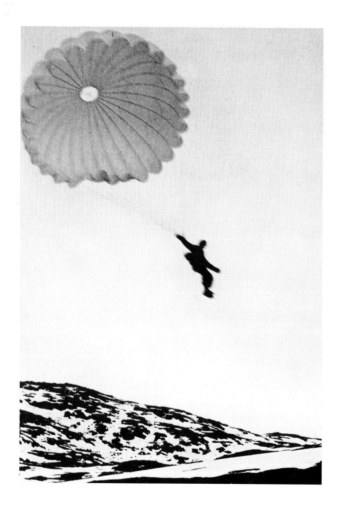

DESCENDING ON NARVIK

A German parachutist descends near the strategic port of Narvik in 1940. This was the first use of paratroops to surprise and capture key points behind enemy lines.

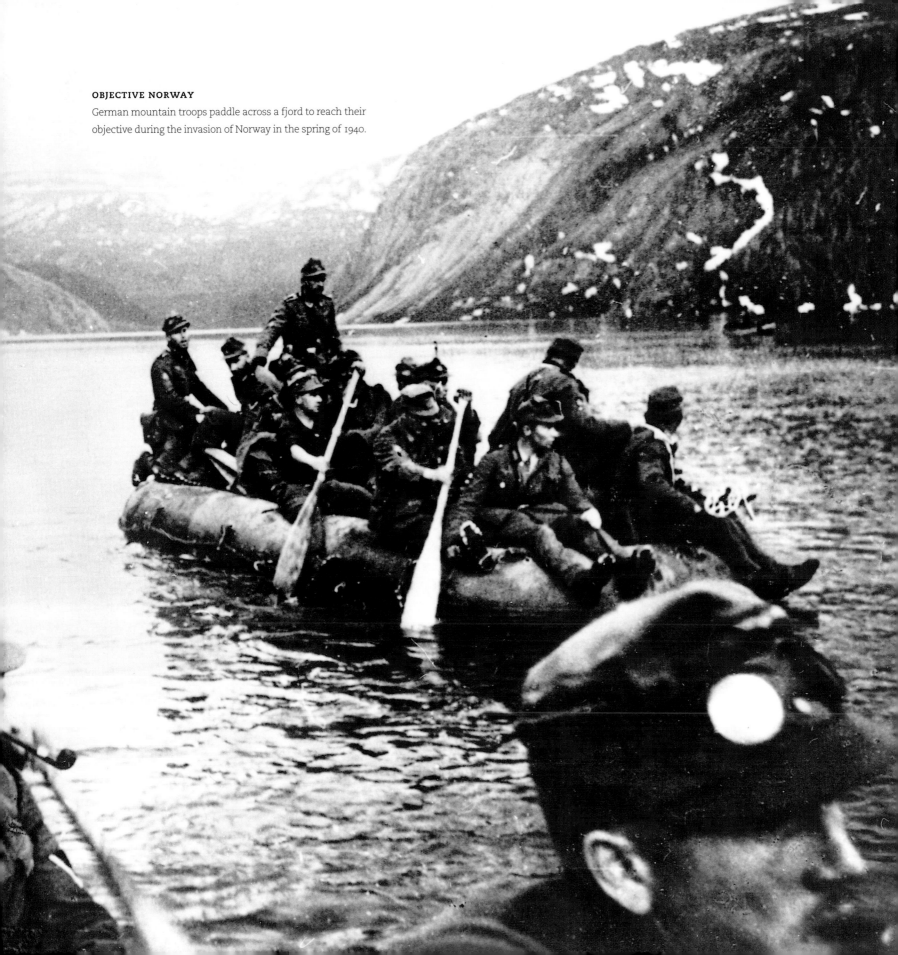

OBJECTIVE NORWAY

German mountain troops paddle across a fjord to reach their
objective during the invasion of Norway in the spring of 1940.

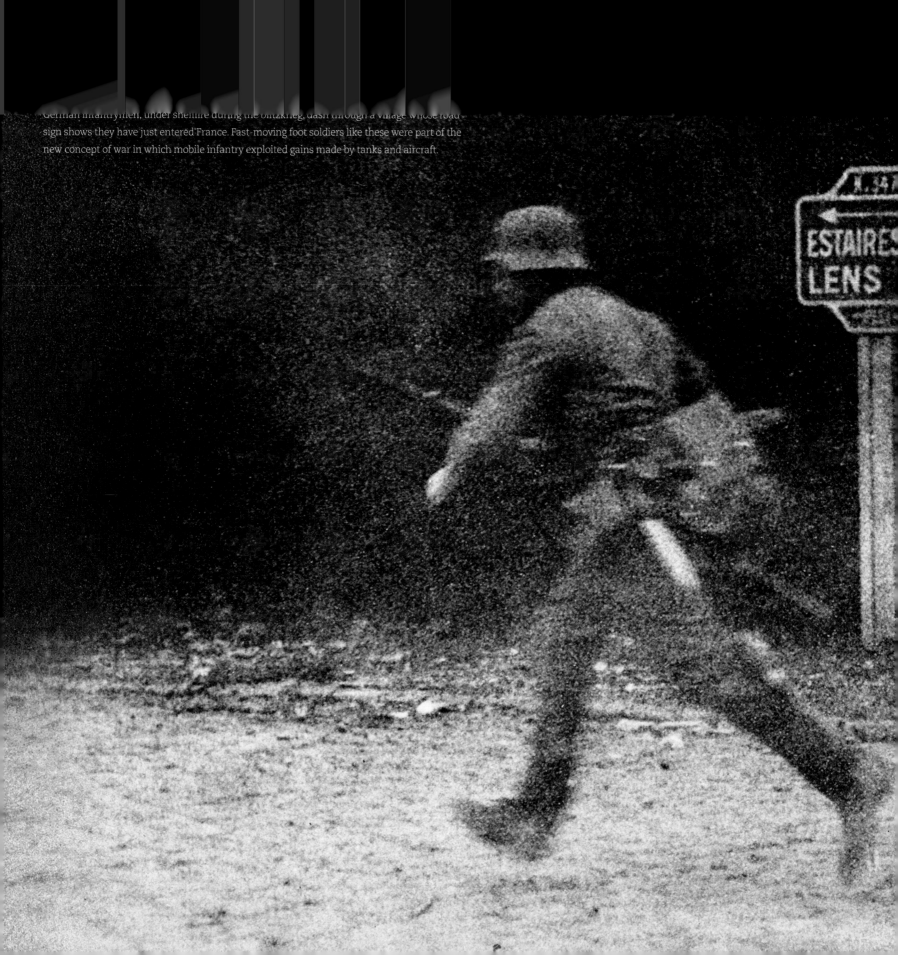

German infantrymen, under shellfire during the blitzkrieg, dash through a village whose road sign shows they have just entered France. Fast-moving foot soldiers like these were part of the new concept of war in which mobile infantry exploited gains made by tanks and aircraft.

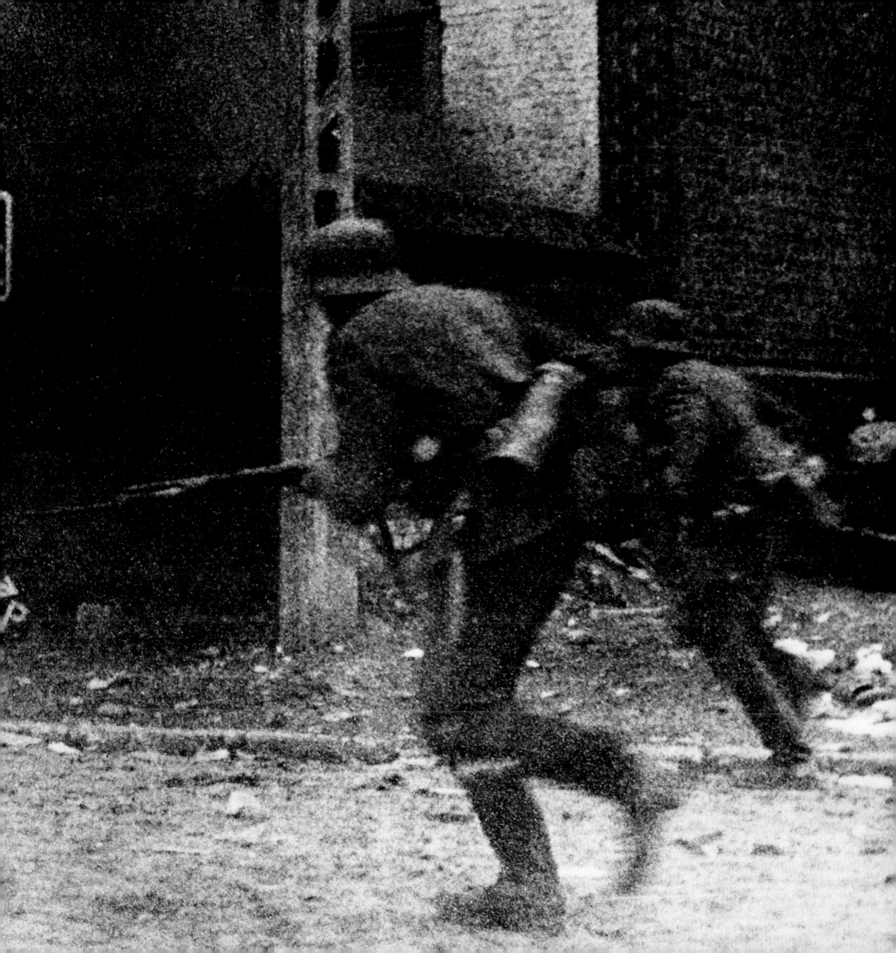

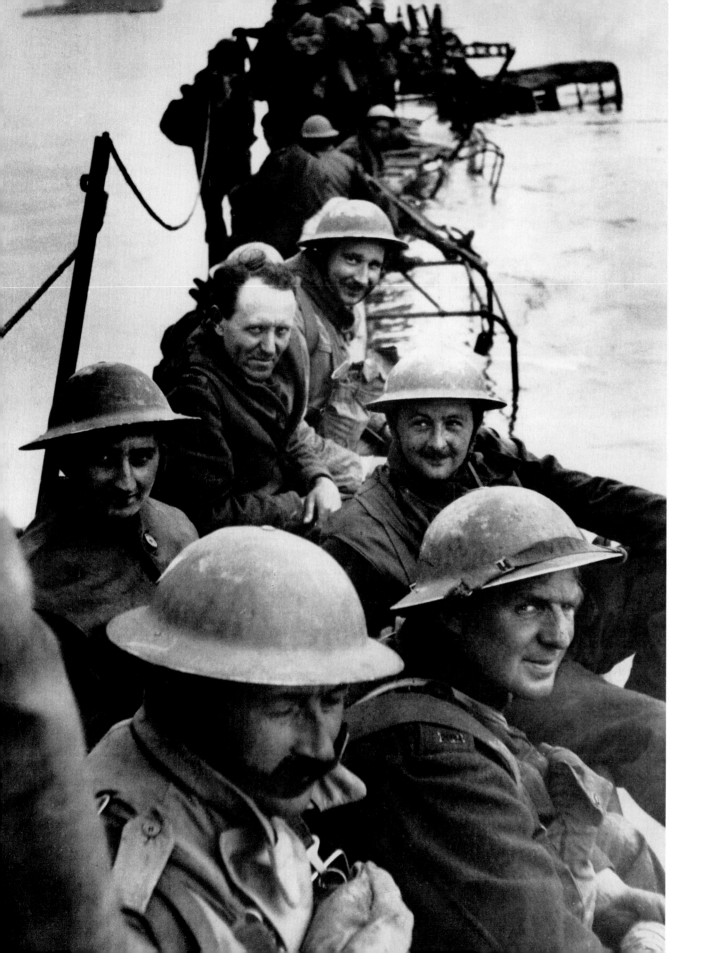

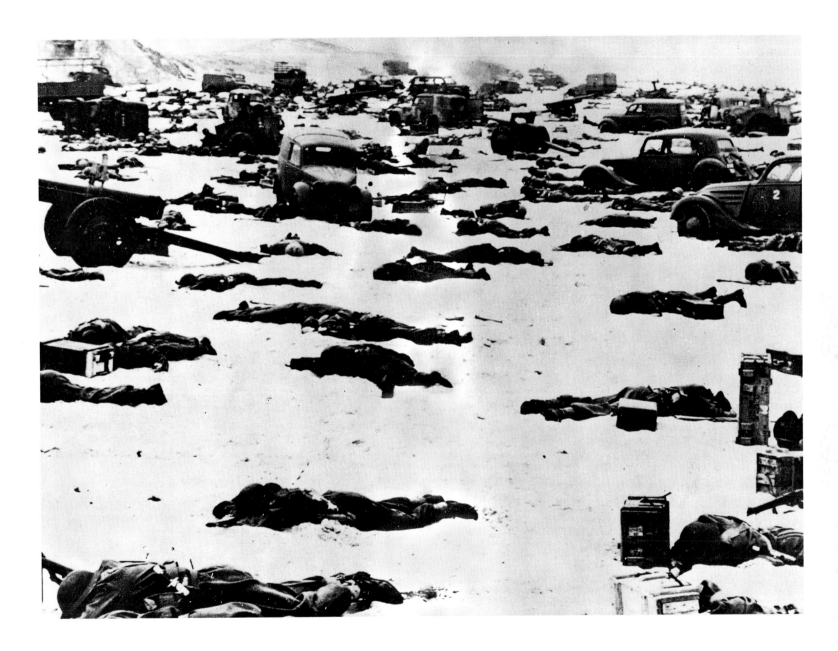

HEADING HOME

British soldiers (*left*) maintain a confident air as they await evacuation from besieged Dunkirk.

AFTERMATH AT DUNKIRK

A German soldier snapped this grim tableau of a Dunkirk beach littered with dead soldiers, wrecked vehicles, artillery pieces, and ammunition boxes shortly after panzer units finally succeeded in smashing through Allied lines. German commanders were dismayed to discover that while most of the British and French forces' equipment had been captured, the bulk of the troops had escaped by sea.

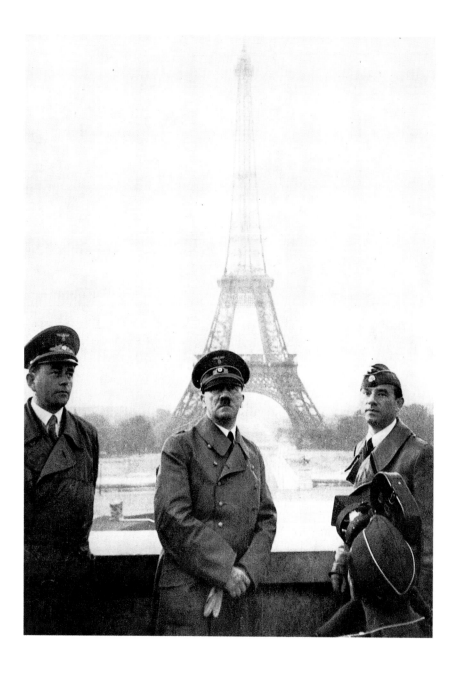

CONQUEROR OF FRANCE

Savoring his triumph, Hitler stands against the backdrop of the Eiffel Tower in occupied Paris on June 23, 1940, with architect Albert Speer *(left)* and sculptor Arno Breker.

MOURNING THE LOSS

A Frenchman mourns the departure of the nation's regimental flags, which were carried through the streets of Marseilles in February 1941 following the German occupation of northern France and shipped to Algeria for safekeeping.

Battle of Britain

"THE BATTLE OF FRANCE IS OVER," DECLARED WINSTON CHURCHILL after Paris fell in June 1940. "I expect that the Battle of Britain is about to begin." The stage had been set for that battle a month earlier when Churchill replaced Neville Chamberlain as prime minister and ruled out any deal with Hitler that would neutralize Britain and leave German troops free to dominate Europe. "We shall fight on the beaches," he vowed, "we shall fight on the landing grounds, we shall fight in the fields and in the streets, we shall fight in the hills; we shall never surrender."

After conquering France, Hitler considered launching an amphibious invasion and fighting the British on their beaches. But the risks would be great, and assembling an invasion

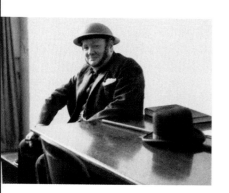

fleet would take months. So Hitler ordered his vaunted Luftwaffe to obliterate the smaller Royal Air Force. Once British air defenses had been knocked out, Luftwaffe bombers could rain destruction at will on industries and cities. Victory might be achieved without an invasion.

This plan failed to account for the accuracy of British radar, for the skill and dedication of RAF pilots who scrambled into action at a moment's notice, and for the defiant spirit that led Churchill and the public to withstand repeated bombings without buckling. The Battle of Britain began in July and peaked in late August with massive attacks on airfields and radar stations that left the RAF near collapse. Then British bombers struck Berlin, and Hitler lost patience, unleashing an aerial blitz on London that caused mayhem but allowed the RAF to rebuild defenses elsewhere and weather the storm. German bombers continued to pound British cities into the winter, prompting the evacuation of children from some areas. But the outcome was clear. There would be no surrender and no invasion. Hitler's aura of invincibility was gone.

PICTURE OF CONFIDENCE

His bowler momentarily set aside for a steel helmet, a confident, smiling Churchill relaxes in a shelter during an RAF-Luftwaffe air battle over Dover.

WITHSTANDING THE BLITZ

The great dome of St. Paul's Cathedral rises above the smoke and the flames of an incendiary raid in late 1940. Despite the intensity of this December 29 attack, in which 1,500 fires burst out on the East End alone, St. Paul's came through almost unscathed.

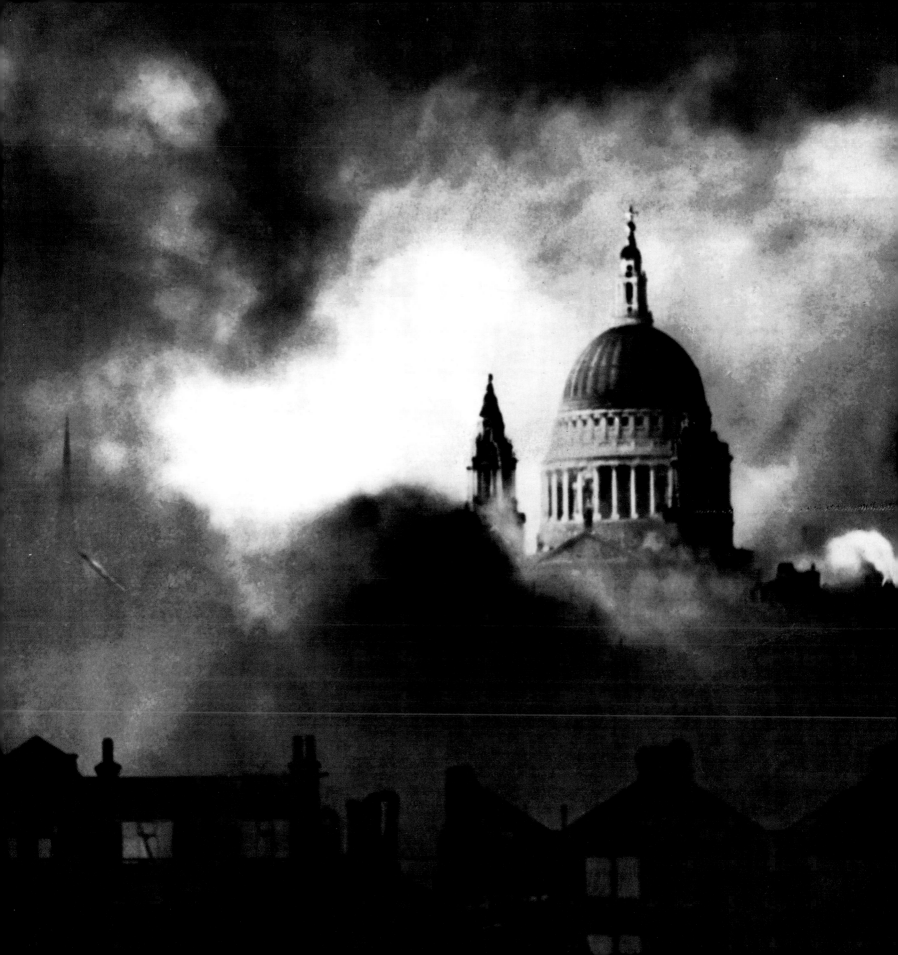

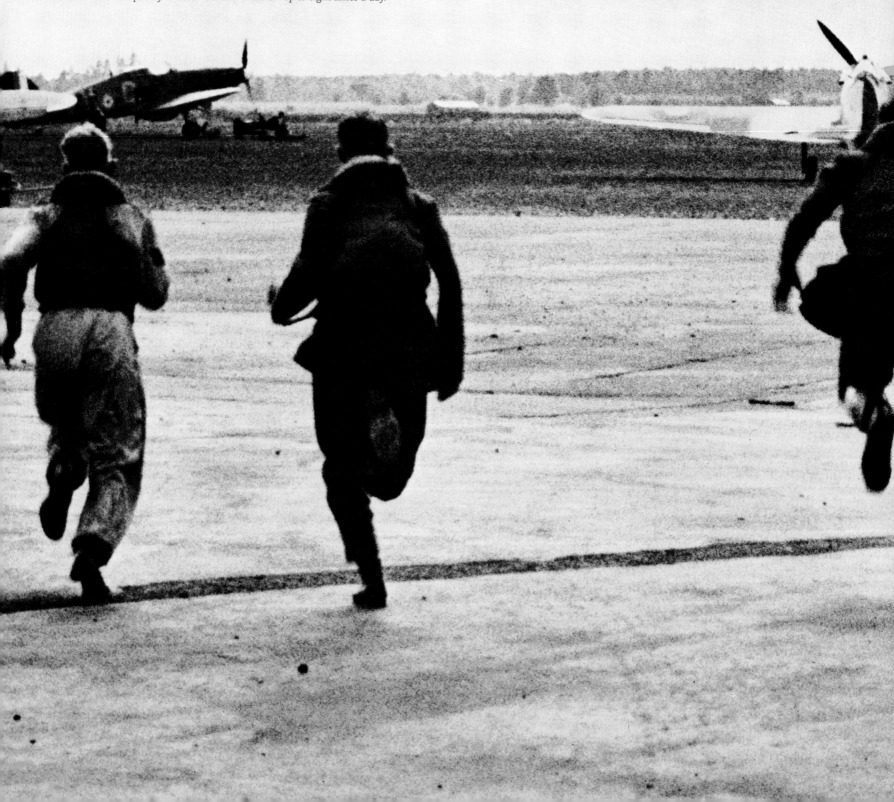

NO TIME TO LOSE
At an RAF base in southern England, pilots rush to their fighters on July 25, 1940. During the height of the Battle of Britain in late summer, overworked airmen had to scramble—take off quickly to meet German attacks—up to eight times a day.

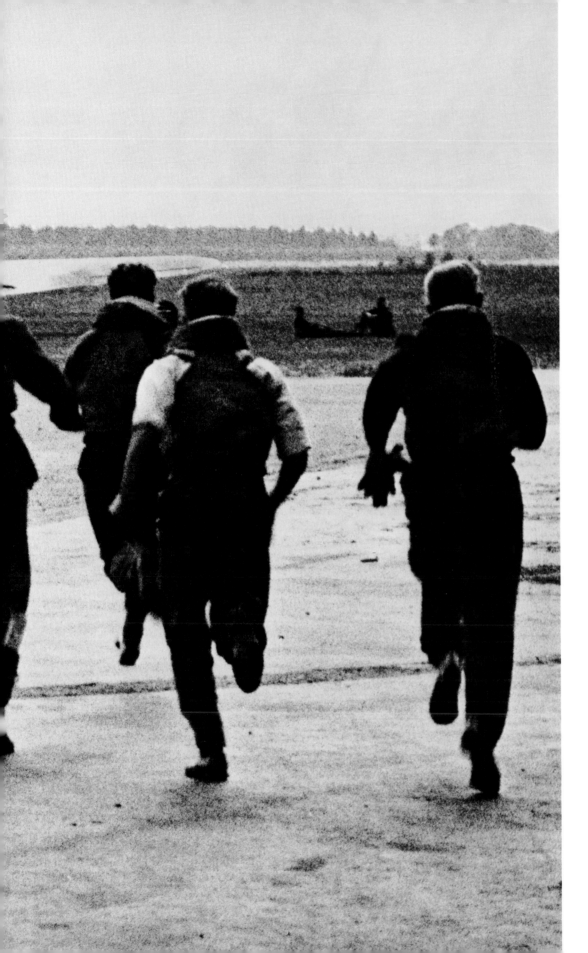

> *"Never in the field of human conflict was so much owed by so many to so few."*

WINSTON CHURCHILL,
August 20, 1940

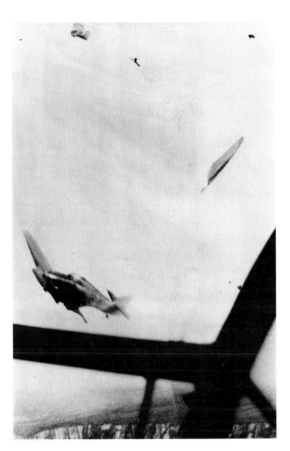

BAILING OUT

This midair photograph, made from the cockpit of a Luftwaffe fighter, shows a British Hurricane that has lost a wing *(spinning off at upper right)* after a burst of fire from the German plane. The Hurricane's pilot *(top)* has already bailed out and is parachuting to safety over the chalk cliffs of Dover.

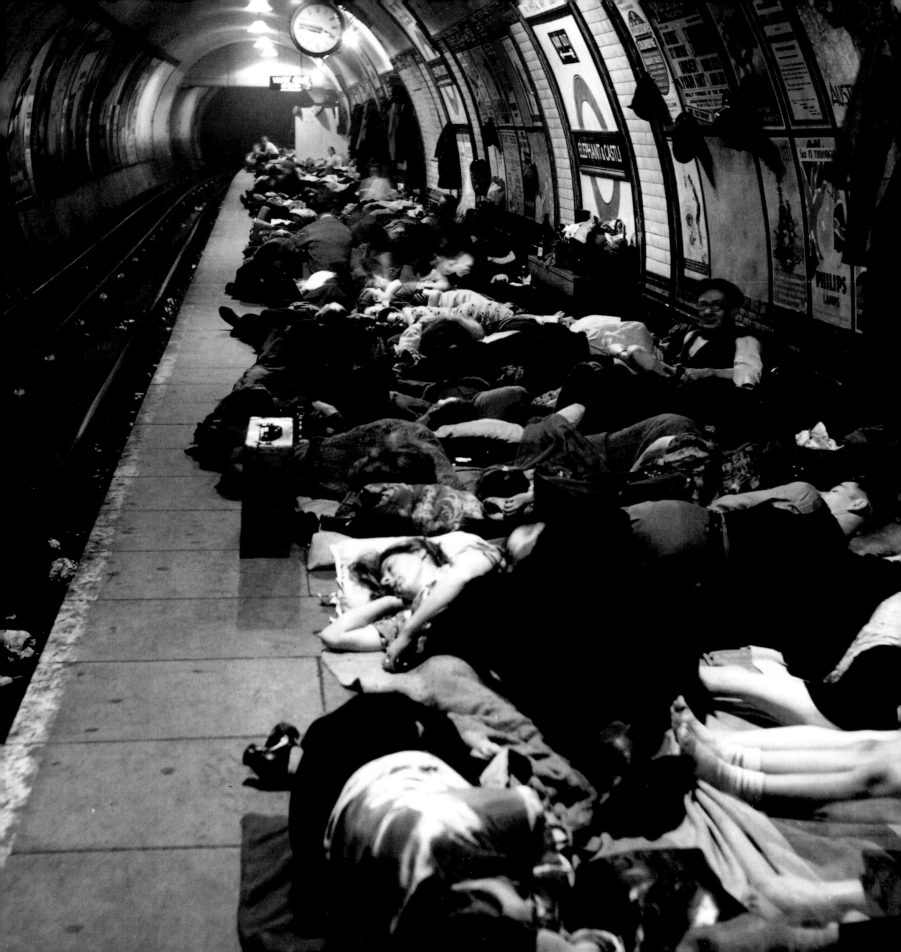

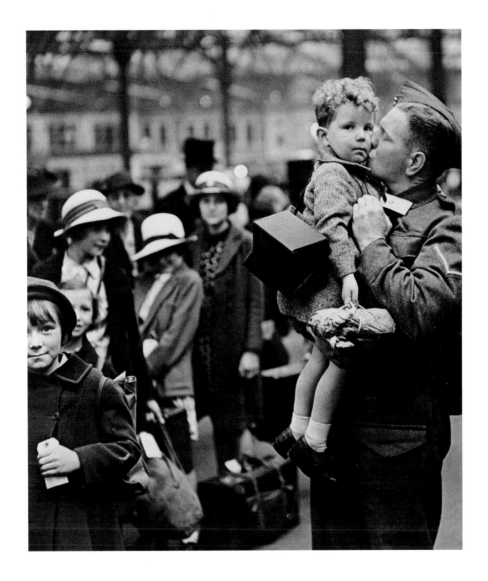

SHELTER FROM THE STORM

At a station underneath the Elephant and Castle section, just south of the Thames, Londoners attempt to catch some sleep on the subway platform.

FLEEING TO SAFETY

A British soldier gives a farewell kiss to his son as the boy prepares to leave town to escape the blitz, equipped with an identification tag, a parcel of belongings, and a gas mask in a box slung over his shoulder.

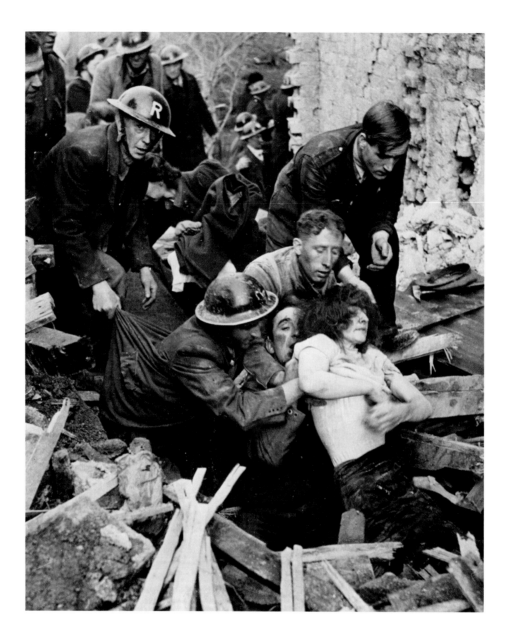

PLUCKED FROM THE RUINS

Rescue workers, some of them wearing steel helmets marked with an identifying R, drag an injured woman from the cellar of her demolished house after digging for 18 hours to find her. One 12-year-old girl was saved from the ruins of her house by a rescue squad after having been buried for 108 hours.

CARNAGE AT COVENTRY

The shell of the cathedral at Coventry, gutted by German bombs, stands wreathed in a smoky haze after a massive air raid on November 14, 1940. Lasting 10 hours, the attack was the heaviest yet suffered by a British city. German raiders dropped hundreds of tons of bombs, razing 100 acres of homes and factories and leaving 554 dead and 865 wounded.

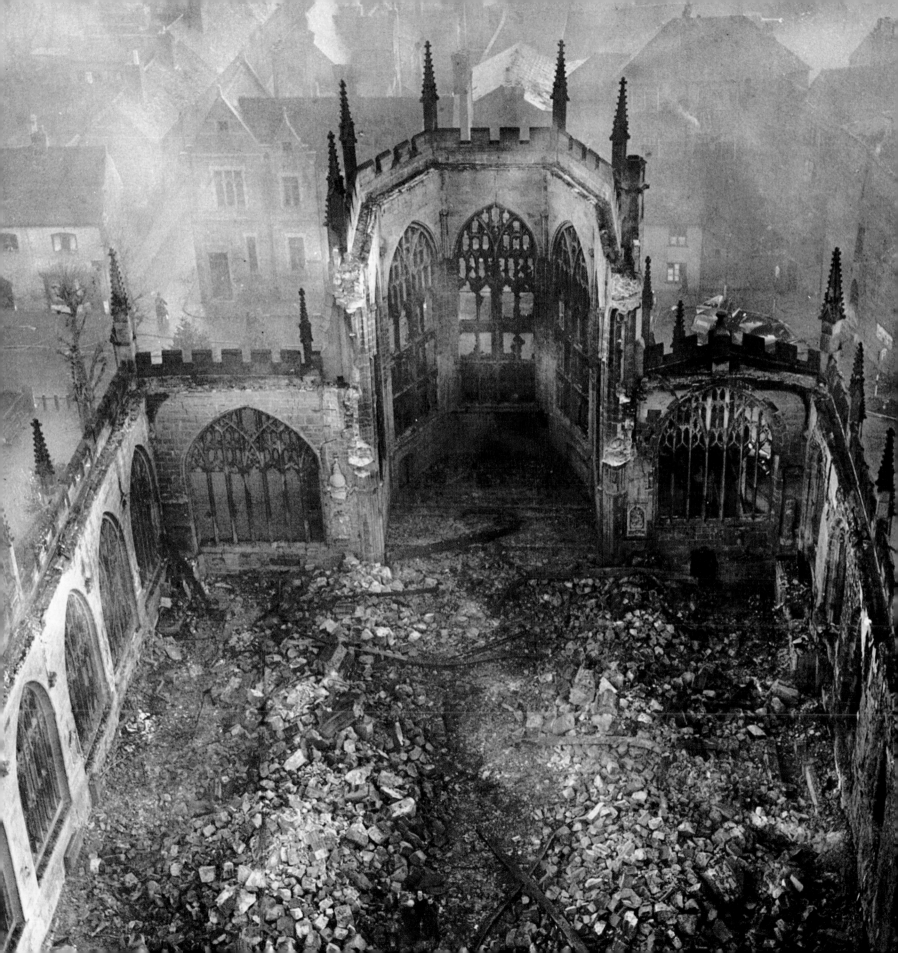

War in the Balkans

THWARTED BY CHURCHILL, HITLER TURNED EASTWARD IN EARLY 1941 and prepared for his long-awaited showdown with the Soviets. Before he could launch that offensive, he had to protect his southern flank by securing the Balkans. His chief worry there was Greece, where British troops arrived in March to bolster a government that had recently beaten back an invasion by Italian forces occupying Albania. Yugoslavia proved hostile to the Axis as well when Serbian officers ousted their pro-German regent, Prince Paul.

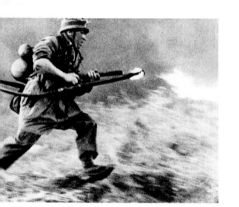

On April 6, Hitler launched a blitzkrieg against the defiant Balkan nations. German forces sliced through Yugoslavia and seized Belgrade in less than a week. By month's end, they had conquered Greece and forced British troops to withdraw to the island of Crete, which fell to a German airborne assault in early June.

If Hitler thought he could now invade Russia without worrying about the Balkans, he was mistaken. Fierce resistance was brewing in ethnically divided Yugoslavia, where Serbians blamed rival Croatians for conspiring with the Axis to carve up the country. Two guerrilla groups arose—one consisting of Serbian monarchists and the other of Communist partisans led by Tito—and vied with each other even as they clashed with German troops and with Croatian fascists called the Ustashi. Tito's partisans emerged as the chief threat to Axis control of the Balkans and received aid from Britain as part of Churchill's covert campaign to subvert German occupation forces and "set Europe ablaze."

Despite terrible reprisals against partisans and their sympathizers—Hitler demanded that 100 Yugoslavs die for every German killed—Tito remained a thorn in Hitler's side. In early 1943, as German divisions were running short of men in Russia, 100,000 Axis troops waged war in the Balkans to wipe out the partisans. Tito's forces suffered heavy losses but regrouped with British support, and the fires of resistance continued to blaze.

SCORCHING THE BRITISH

A German soldier with a flamethrower rushes to attack a British tank on the island of Crete, where British troops evicted from Greece made the Germans pay dearly for their conquest.

SPECTERS OF DEFEAT

Troops of the 11th Panzer "Ghost" Division dash like phantoms through the smoldering city of Nis, Yugoslavia, on their way to Belgrade, which fell to the Germans on April 12, 1941.

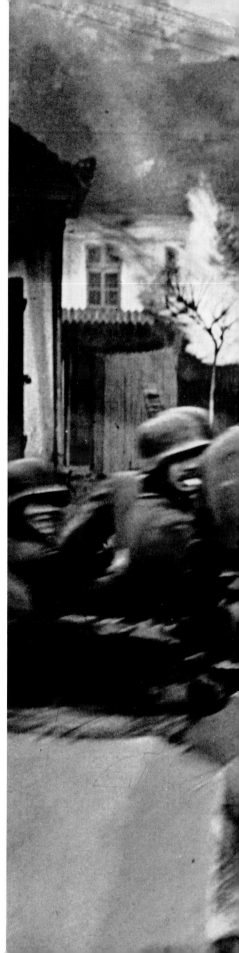

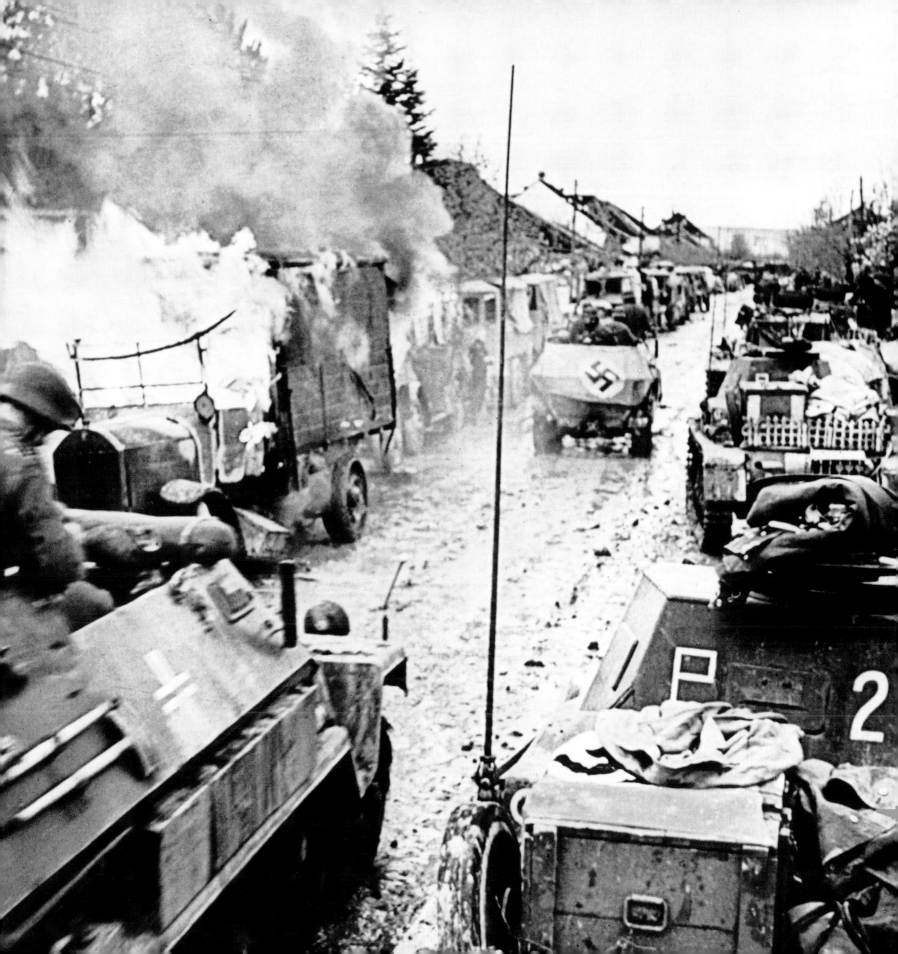

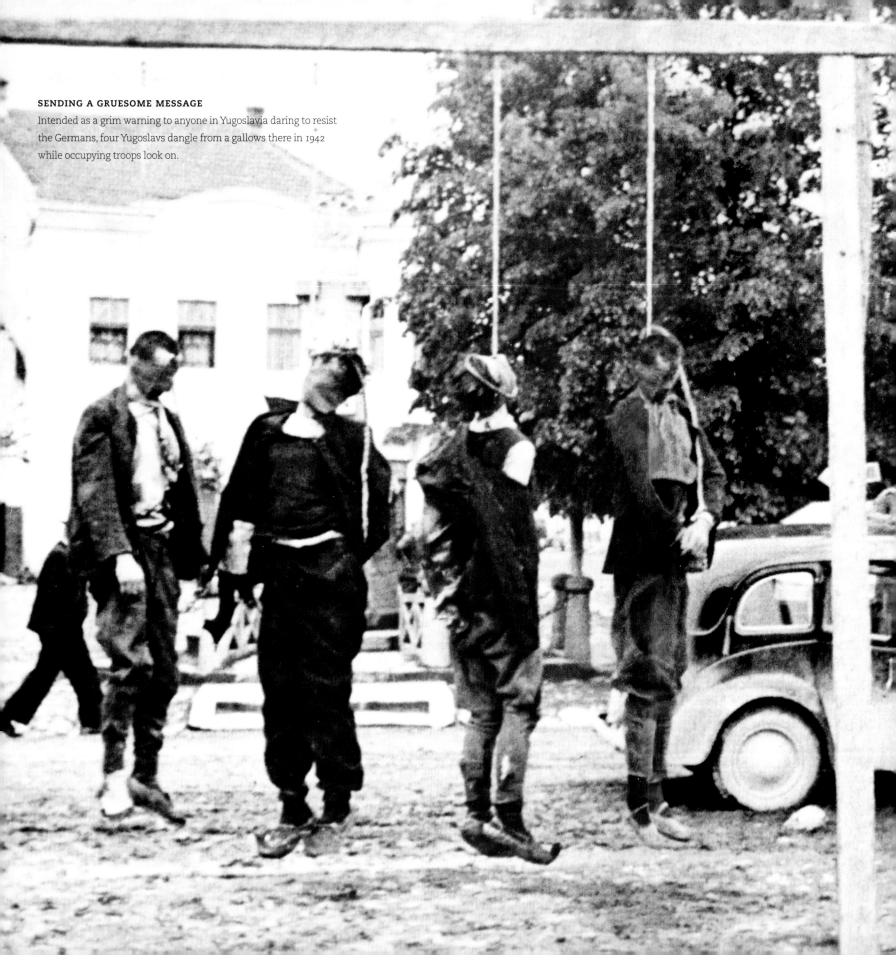

SENDING A GRUESOME MESSAGE
Intended as a grim warning to anyone in Yugoslavia daring to resist the Germans, four Yugoslavs dangle from a gallows there in 1942 while occupying troops look on.

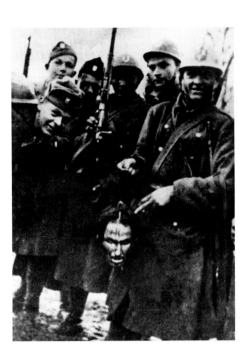

SAVAGE REPRISAL
Grinning Ustashi storm
troopers allied with the
Germans against Serbian
resistance fighters show
off the severed head of a
victim in 1942.

MURDEROUS RETRIBUTION
A German firing squad stands
ready while soldiers position
female hostages for execution.
The five women were among 100
Yugoslavs shot in relays in the
village of Celje in 1942 to discour-
age further partisan attacks.

FREE TO FIGHT AGAIN
Making good their escape from
encirclement by the Axis,
exhausted men and women of
the partisans trek through the
woods near Miljevina in June 1943
(overleaf), after one of the toughest
antiguerrilla campaigns of the
war in the Balkans. More than
6,000 partisans were killed in the
four weeks of the German-led
offensive, but Tito's forces kept
up their resistance.

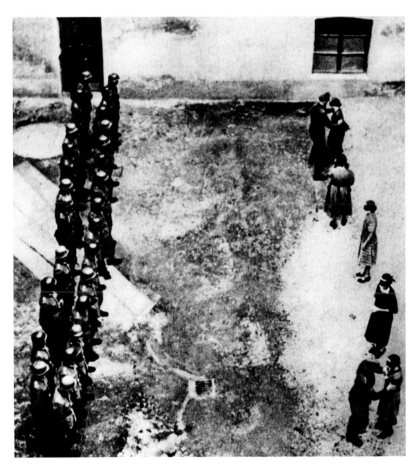

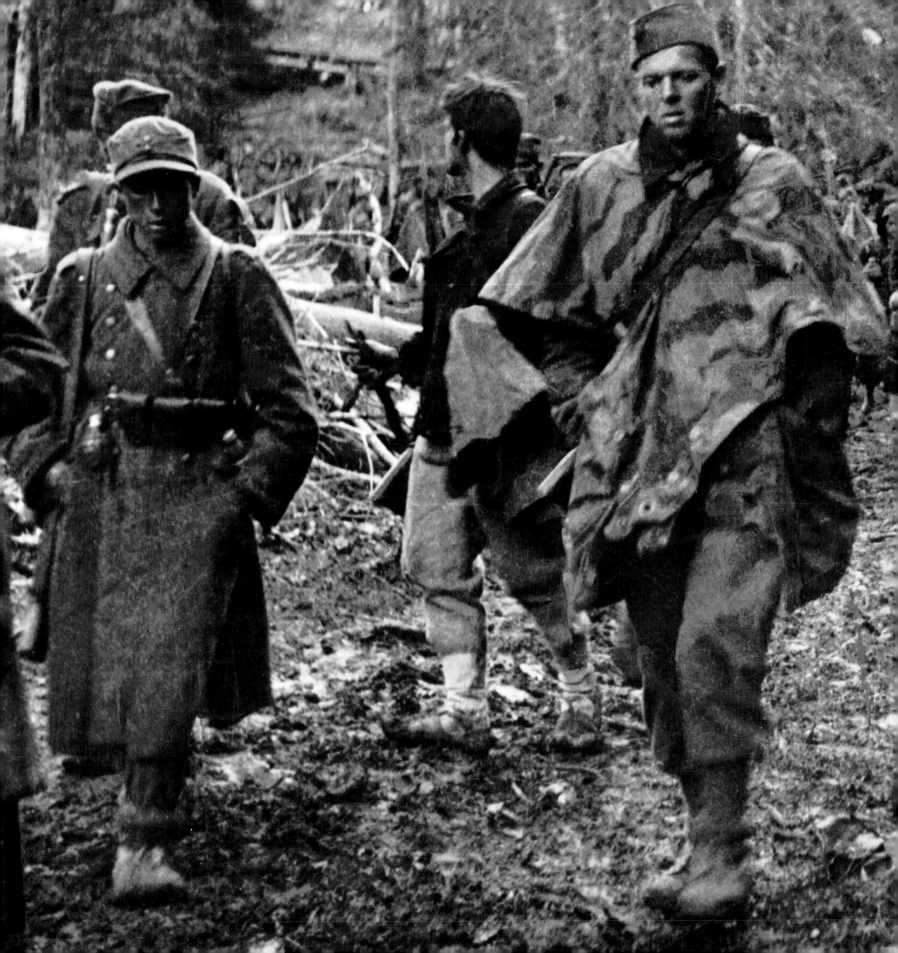

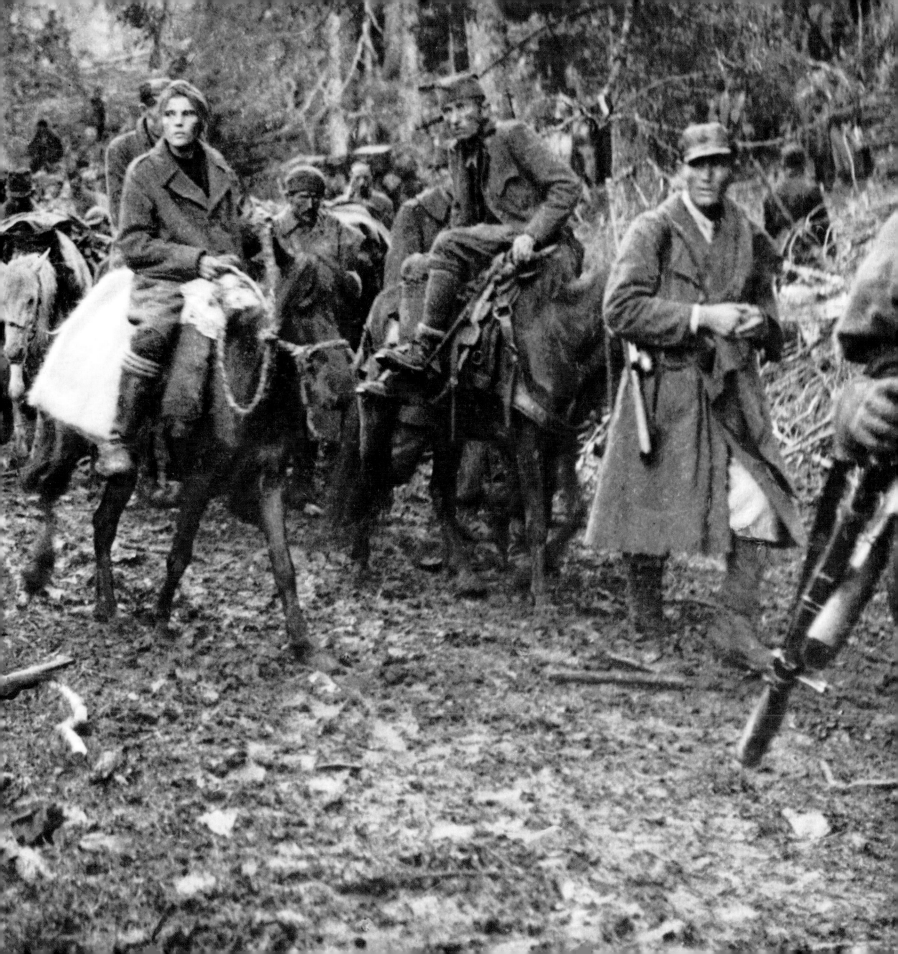

Russia Besieged

"JUST KICK IN THE DOOR," HITLER TOLD HIS GENERALS as they planned for the invasion of Russia, "and the whole rotten structure will collapse." Stalin had undermined that structure by purging many of his best officers, and his forces were demoralized and ill-equipped. The sorry state of the Red Army reinforced Hitler's belief that Russia, with its largely Slavic population, was racially inferior and ripe for conquest. He called for a "war of extermination" aimed at annihilating the Red Army and the Communist leadership, eliminating Russian Jews, and subjecting fertile areas like the Ukraine to ethnic cleansing to create "living space" for Aryans.

German commanders who did not share these racial obsessions regarded the coming invasion with foreboding. Some were repelled by directives from Hitler that sanctioned the killing of civilians. Many feared a prolonged war that would expose German troops to pun-

ishing winter weather and allow Stalin to replenish his army with men and equipment from the remote Russian interior. Few generals voiced their doubts, however, and Hitler pushed confidently ahead.

On June 22, 1941, over three million German troops swept across the frontier and cut through weak Soviet defenses in three prongs: Army Group North advanced toward Leningrad; Army Group South drove deep into the Ukraine; and Army Group Center sliced into the heart of Russia, aiming for Smolensk and the Russian capital beyond. By September, Germans had advanced to within 200 miles of Moscow, but trouble lay ahead. Welcomed as liberators by civilians hostile to Stalin's regime, they soon antagonized the populace and faced guer-

rilla warfare with Russian partisans. Meanwhile, autumn rains were followed by blizzards that froze the invaders in their tracks near Moscow. Then in early December, the resurgent Red Army struck back and forced them to give ground. In this war of extermination, Hitler's own forces were now struggling for survival.

THUNDER AT THE FRONT
Belching fire, a German 150-mm howitzer (*above*) lobs a high-explosive shell into nearby Russian positions.

CLEANING OUT THE SOVIETS
A group of panzer grenadiers, leaving the safety of their armored half-tracks, rush forward to clean out Soviet sharpshooters who had taken refuge in a farmhouse during the Germans' advance on Smolensk in July 1941.

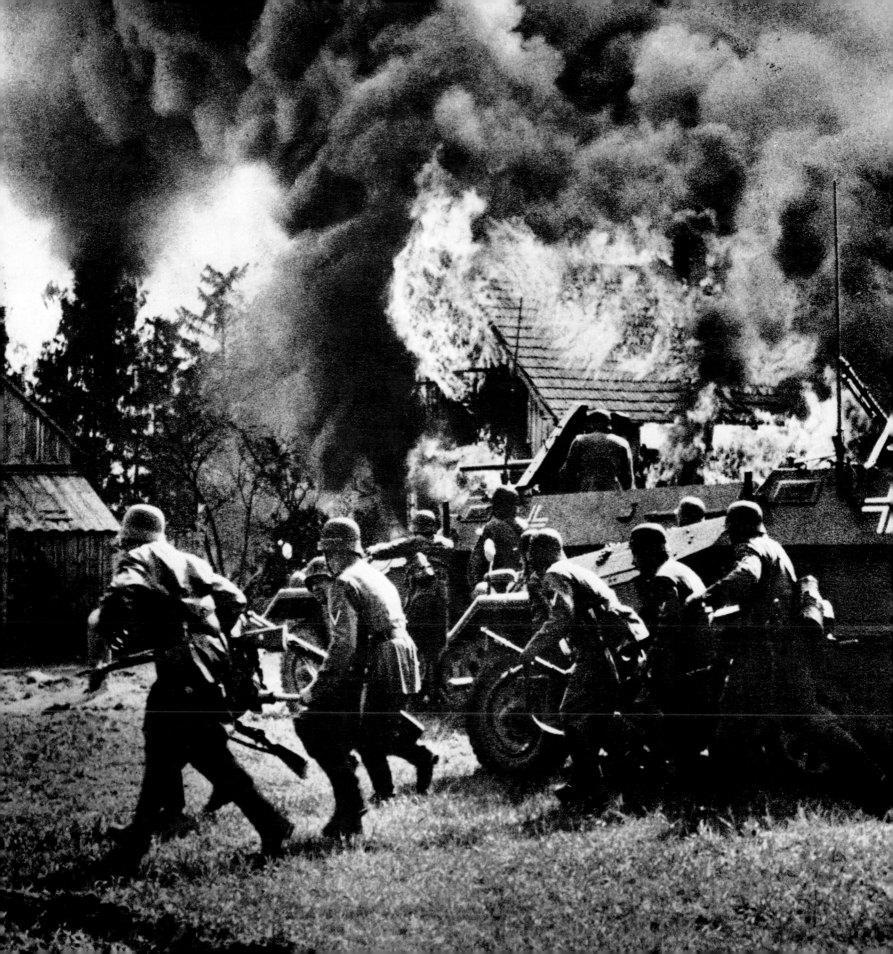

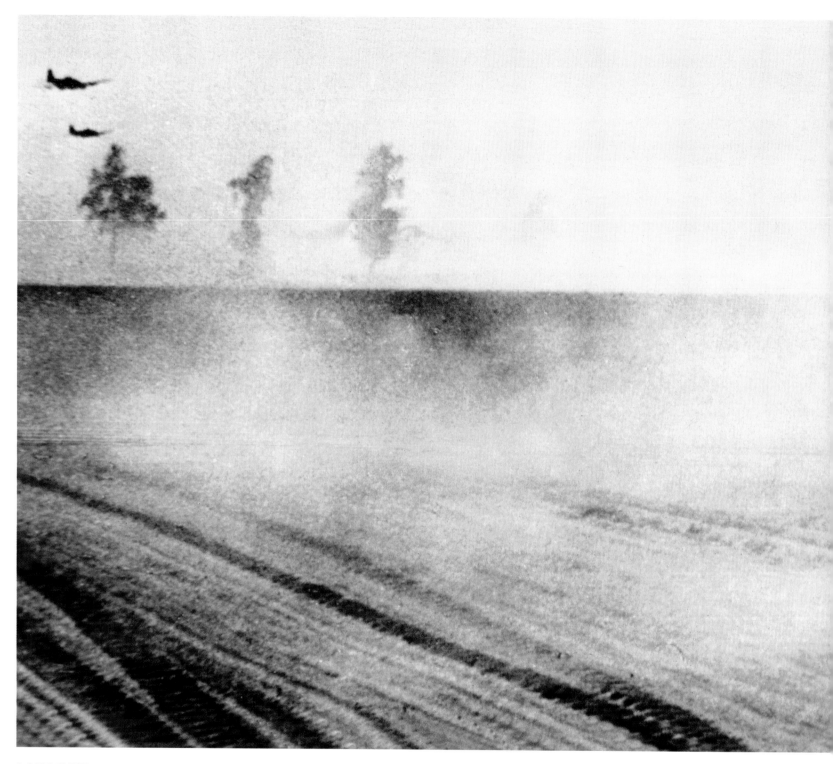

A RARE SIGHT

A German motorcyclist and his dispatch rider glance backward anxiously as two low-flying Soviet fighter planes race by during the push to Smolensk. Russian air attacks were too infrequent to slow the advance of the Germans.

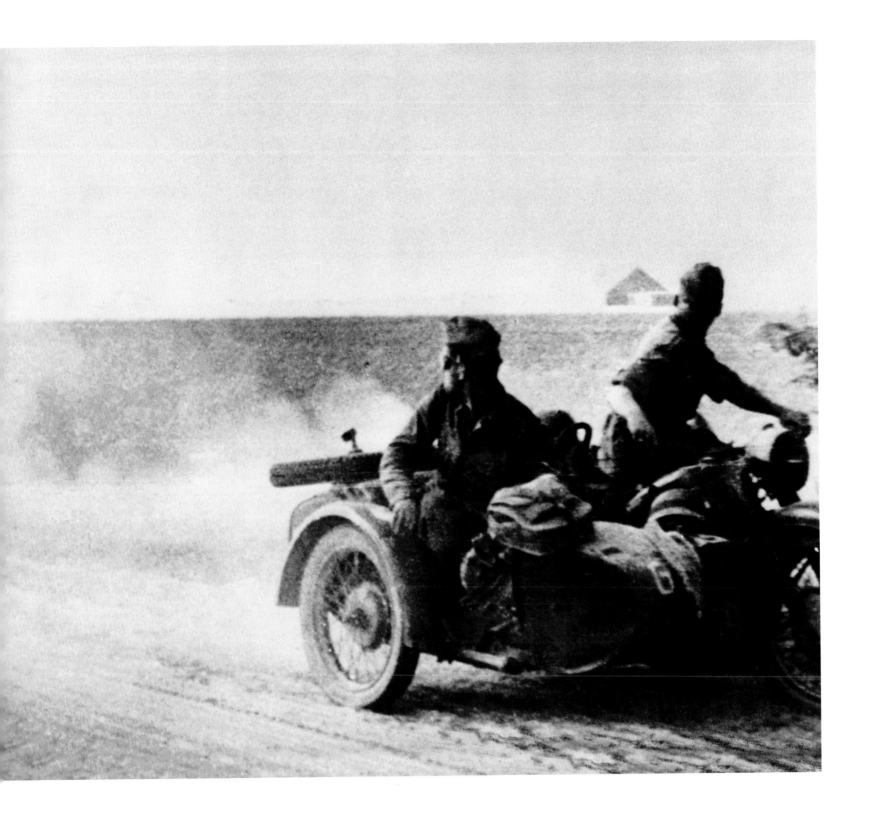

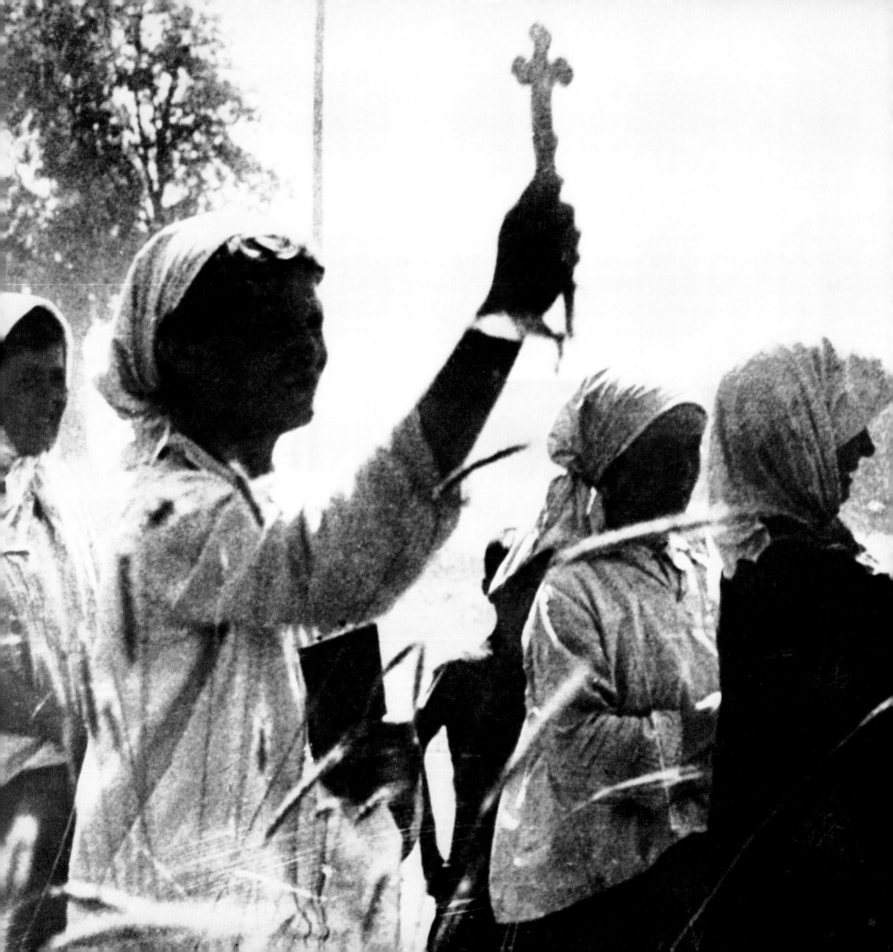

> *"In every village we're showered with bouquets of flowers, even more beautiful than the ones we got when we entered Vienna."*

GERMAN SOLDIER WITH THE INVASION FORCES IN UKRAINE

PRAYING FOR SAVIORS
Women in Ukraine, convinced that the German Army has come to free them from atheistic Communism, greet approaching soldiers with religious fervor.

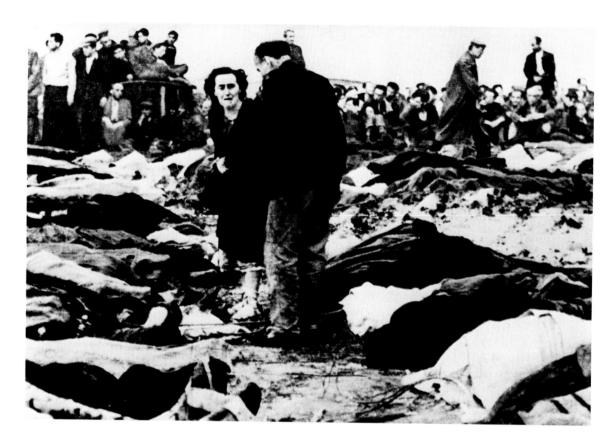

WIDOWED BY THE OCCUPIERS
A woman searches for her husband among the corpses of hostages slain by the Germans in retaliation for acts of resistance. In one instance, 400 men from Kiev were shot after a saboteur damaged a German transmitter.

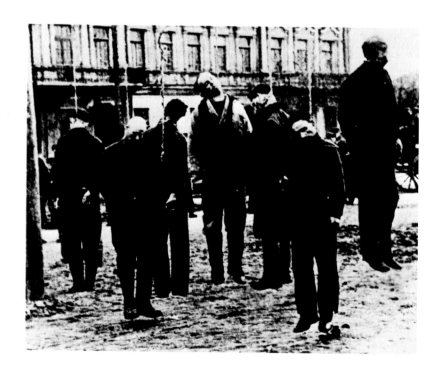

VICTIMS LEFT HANGING
Ukrainians dangle from a gallows in the city of Nikolayev, a center of underground activity.

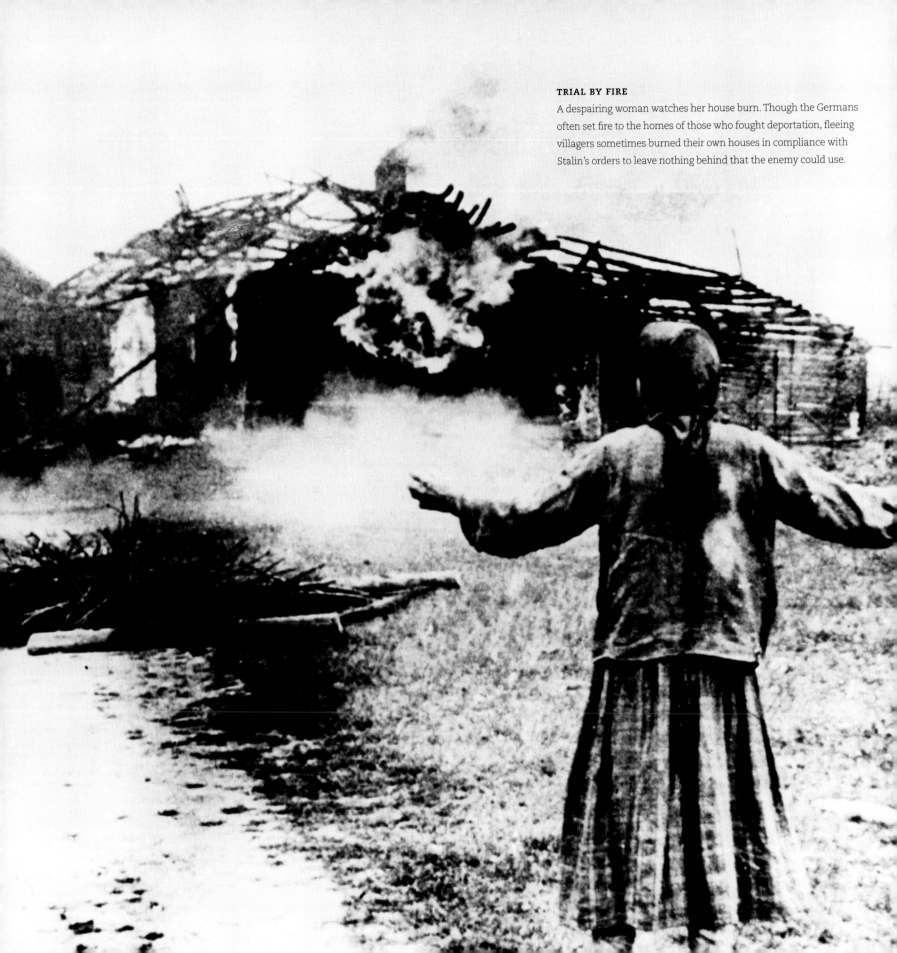

TRIAL BY FIRE
A despairing woman watches her house burn. Though the Germans often set fire to the homes of those who fought deportation, fleeing villagers sometimes burned their own houses in compliance with Stalin's orders to leave nothing behind that the enemy could use.

> "*All valuable property that cannot be withdrawn must be destroyed.*"

JOSEPH STALIN,
addressing the nation by radio in July 1941

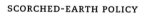

SCORCHED-EARTH POLICY

As the Russian city of Vitebsk burns around them, conquering German soldiers pause to rest and eat—and refresh their spirits with vodka. Before withdrawing from the town, Russian troops went from house to house setting fires as part of a scorched-earth policy, shooting any owners who resisted.

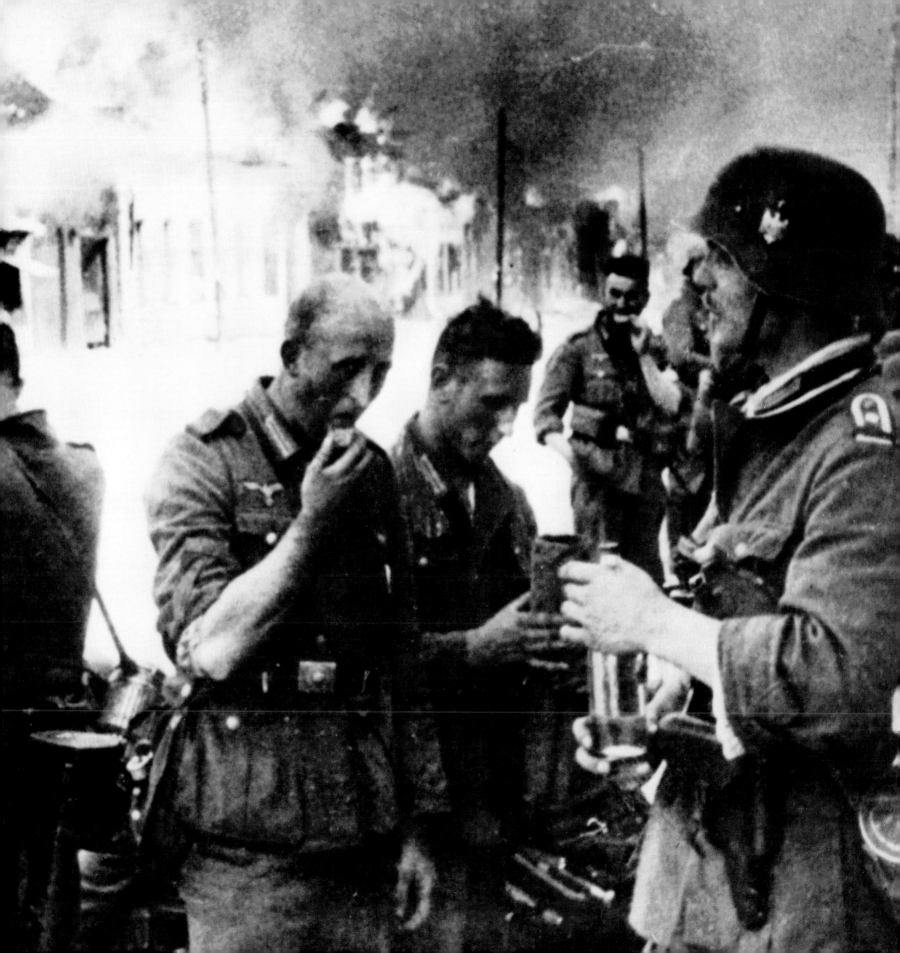

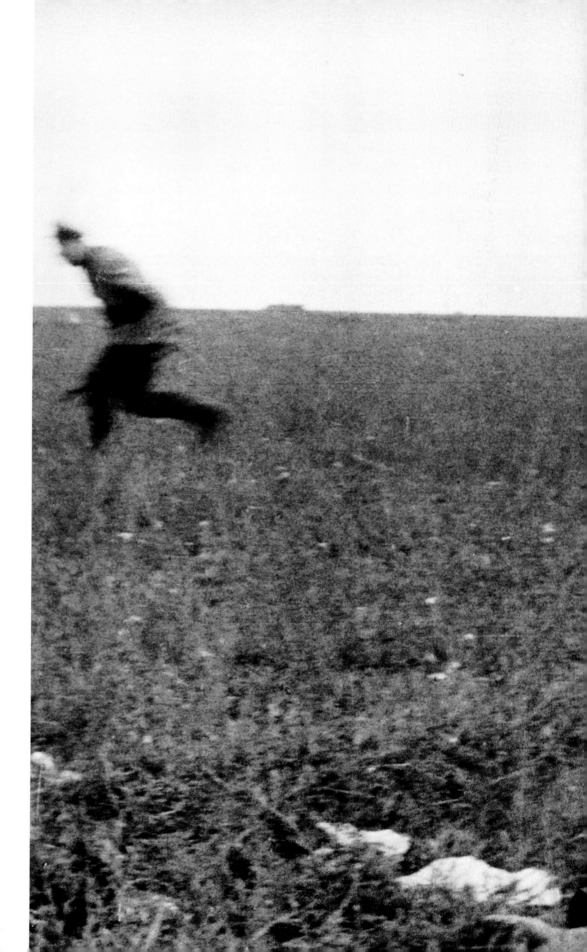

SCAVENGING FOR WEAPONS

Always on the lookout for weapons, a partisan on the attack grabs a machine gun from a dead German while advancing with other members of his detachment.

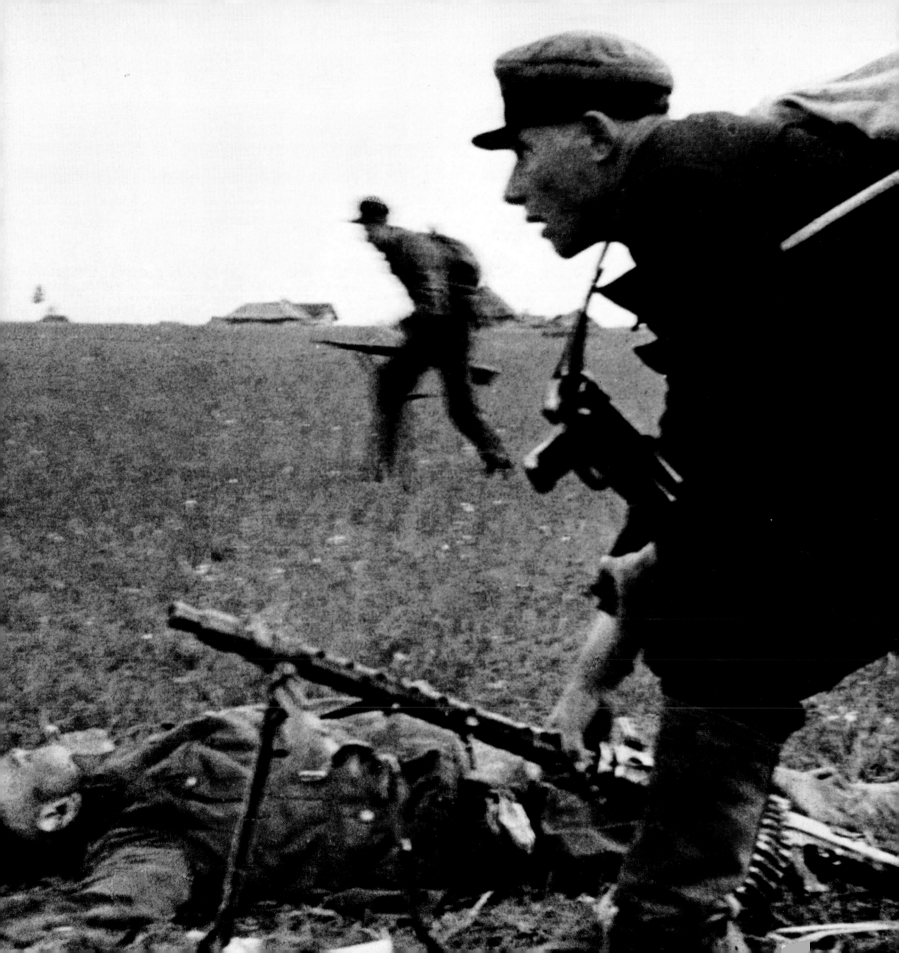

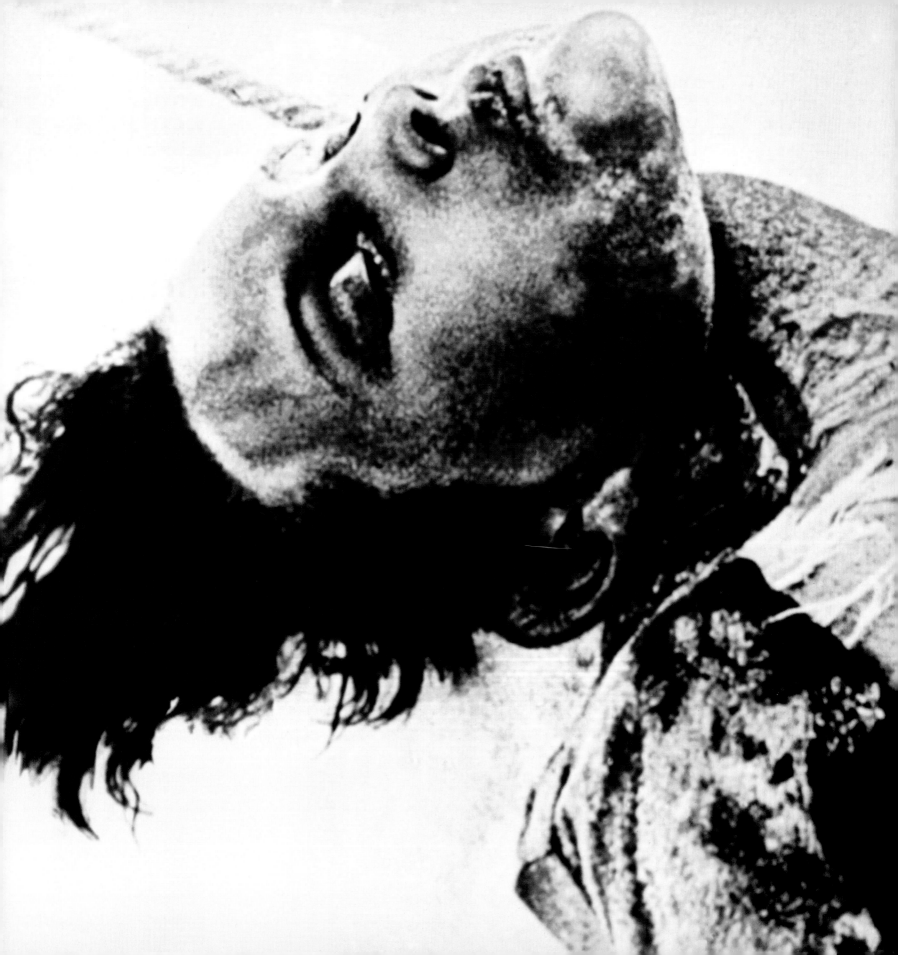

HEROINE OF THE SOVIET UNION
Zoya Kosmodemyanskaya, posthumously named Heroine
of the Soviet Union, was an 18-year-old member of the
Young Communist League who joined the partisans. To
divert attention from a major partisan operation, Zoya
set fire to a German stable. She was captured and brutally
executed in November 1941.

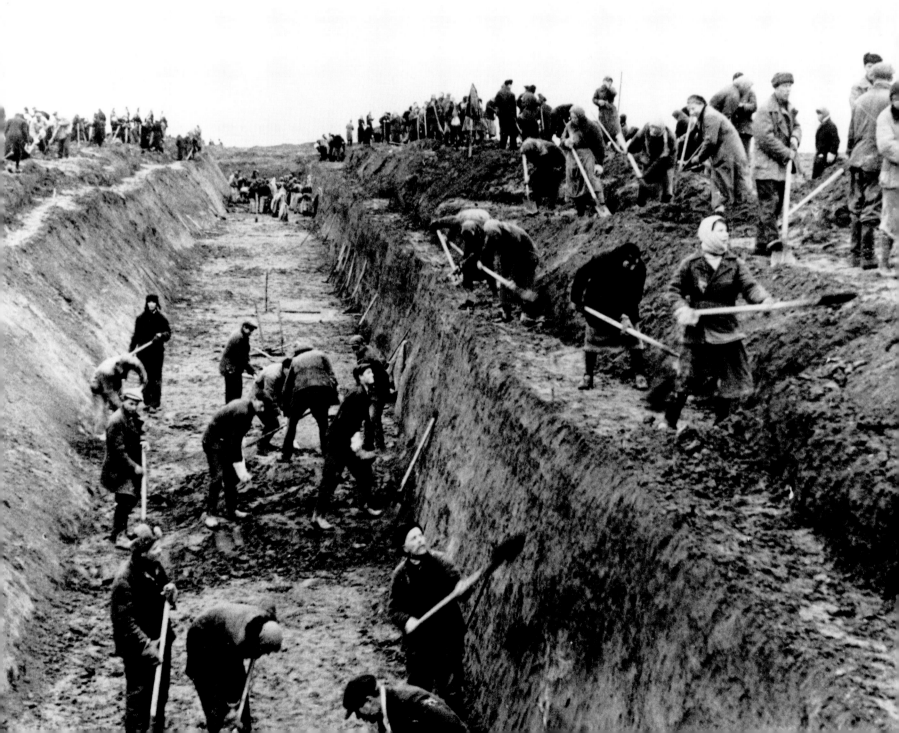

PREPARING FOR THE ONSLAUGHT
Civilians from Moscow prepare an antitank trench outside Moscow in the fall
of 1941. By the time German troops approached the capital in late November,
snow and subzero cold had descended on the region.

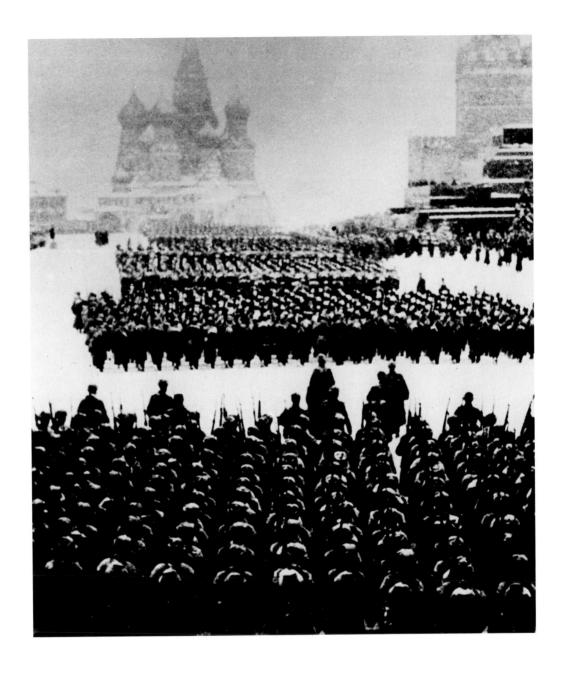

DEFENDERS OF MOSCOW

Red Army units parade through Red Square in the November 7 anniversary review, just minutes before marching to the front to defend Moscow.

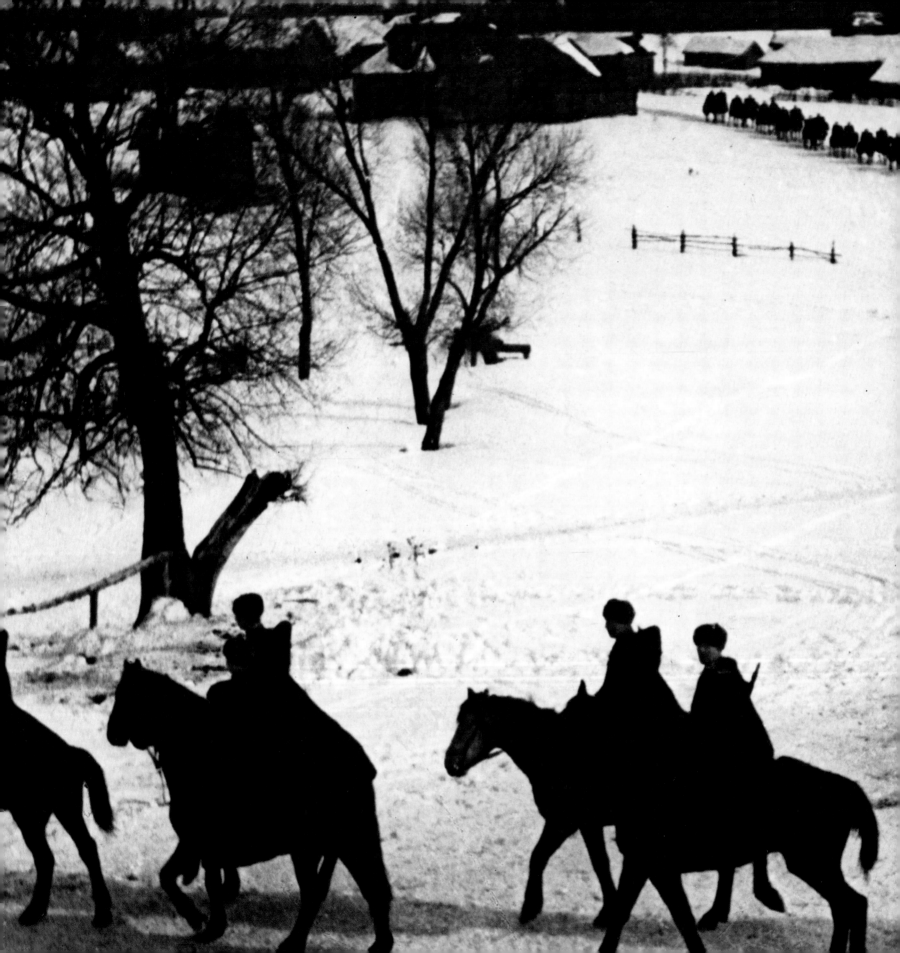

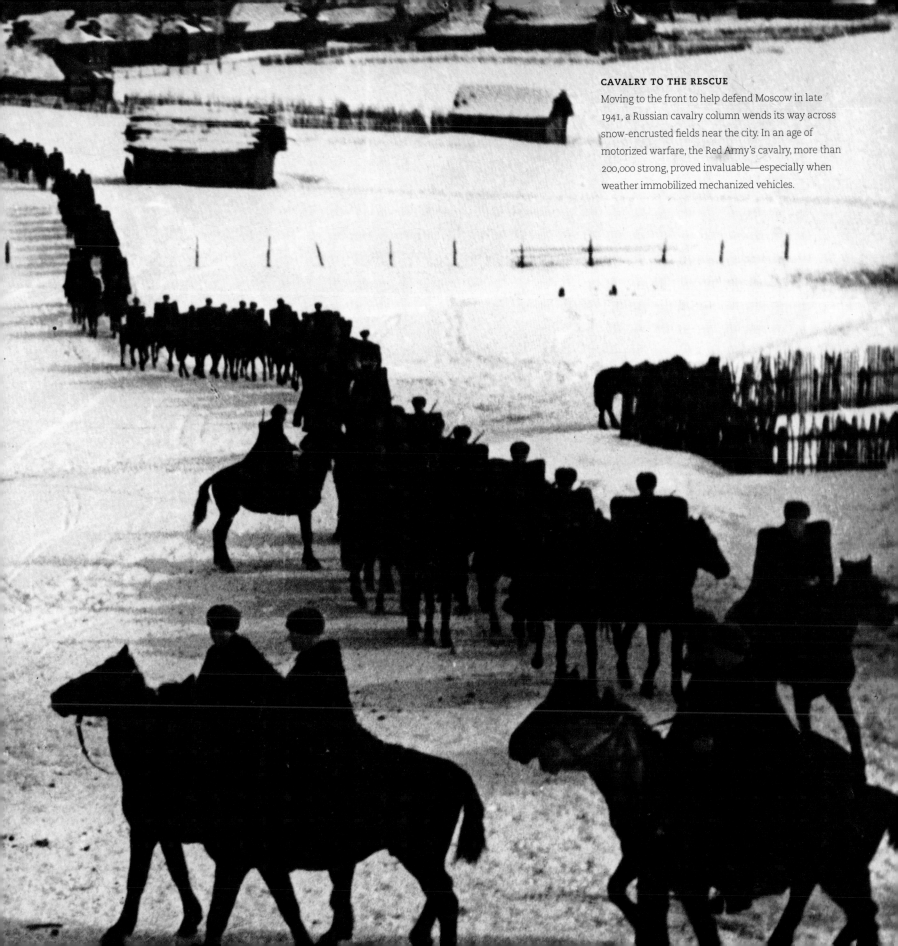

CAVALRY TO THE RESCUE
Moving to the front to help defend Moscow in late 1941, a Russian cavalry column wends its way across snow-encrusted fields near the city. In an age of motorized warfare, the Red Army's cavalry, more than 200,000 strong, proved invaluable—especially when weather immobilized mechanized vehicles.

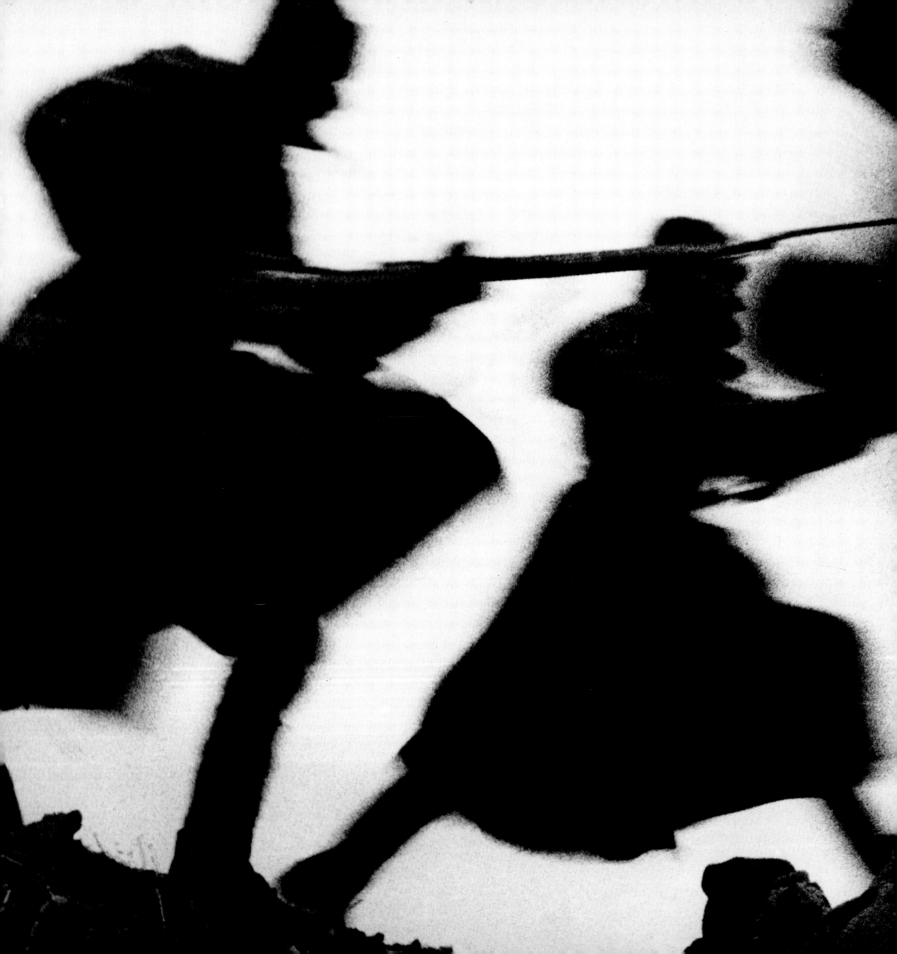

LEAPING INTO ACTION
Silhouetted Russian troops, warmly clad for winter warfare, hurdle their frontline trenches and charge German lines southeast of Moscow in December 1941.

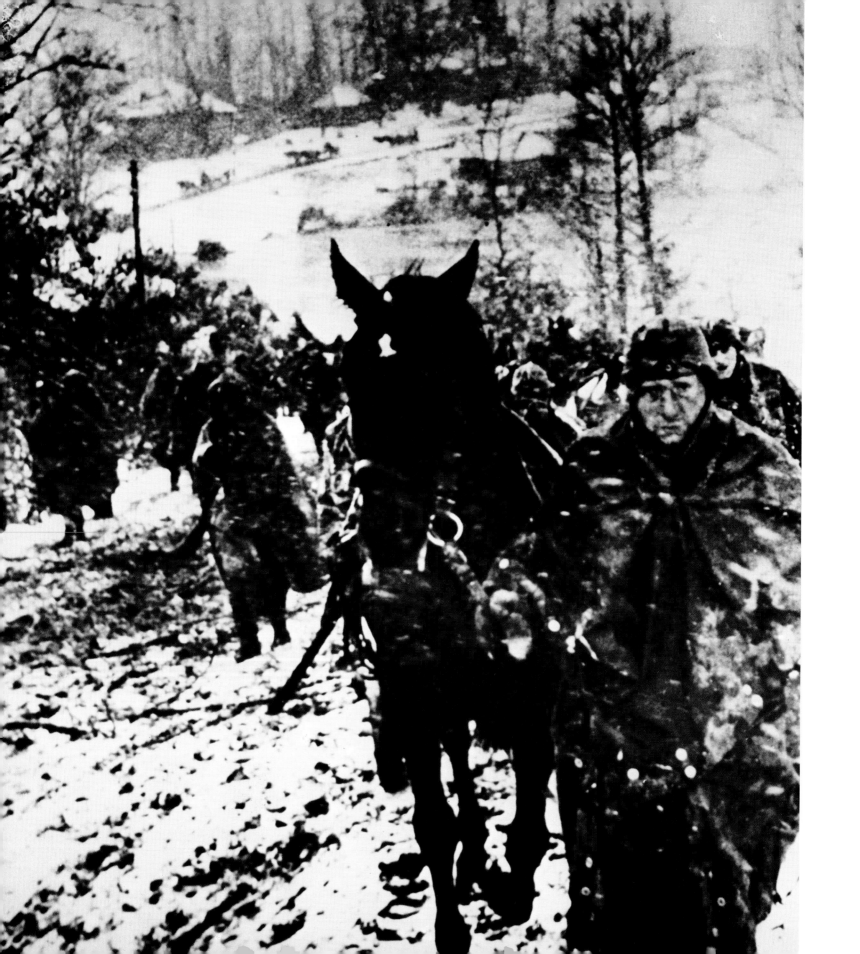

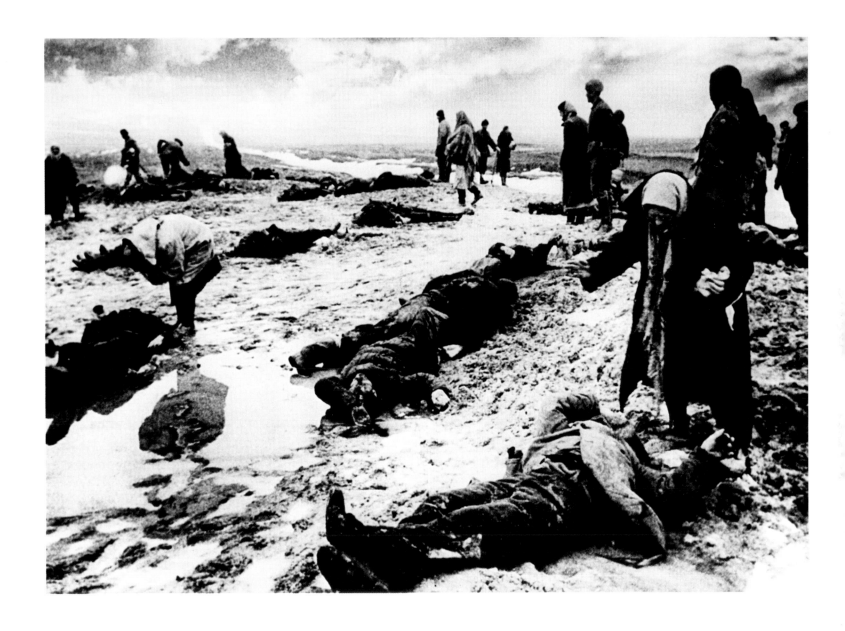

A BITTER RETREAT

German troops and horses retreat past a Russian village. Wilhelm Pruller, one of the officers who managed to survive the awful winter with the German Army, wrote on December 7, 1941: "Yesterday we had 32 degrees below zero. It will get worse. The villages lying in front of us are burned down now, so that the Russians can't use them against us."

GUNNED DOWN BY DEATH SQUADS

Searching for missing relatives, grieving Jewish survivors on the outskirts of Kerch peer at corpses left behind by roving SS death squads, who gunned down victims in the open.

The Rising Sun

IN OCTOBER OF 1941, A SOVIET SPY IN TOKYO NAMED RICHARD SORGE sent a message to Moscow disclosing a momentous secret: The Japanese had decided not to wage war on their old enemies the Russians and would instead attack U.S. bases in the Pacific. The revelation came as a godsend to Stalin, who could now deploy all his forces against the Germans and look forward to the day when Japanese aggression forced America into the war against the Axis.

Japan's fateful decision grew out of its imperial ambitions in Asia, where British, French, and Dutch colonies rich in oil and other resources were ripe for the taking. Only the Americans stood in the way. Roosevelt, alarmed by the occupation of China and intent on keeping Japan's rising sun from eclipsing American interests in Asia, slapped an oil embargo on that nation after it seized French Indochina in 1940. Tokyo responded by laying plans for a sweeping offensive against U.S. bases as well as British and Dutch possessions.

At dawn on December 7, 1941, over 350 Japanese warplanes took off from six aircraft carriers near Hawaii, homed in on radio signals from Honolulu, and blasted the Pacific Fleet in Pearl Harbor and adjacent airfields. The surprise attack claimed some 2,400 American lives, wrecked or damaged 18 warships, and drove Congress to declare war on Japan.

The Pacific Fleet soon regrouped, bolstered by aircraft carriers that were safely at sea when the attack occurred. But there would be no reprieve for U.S. forces in the Philippines, where Japanese air raids on December 7 were followed by an invasion. After holding out for months, some 80,000 starving American and Filipino troops were captured at Bataan by the Japanese and herded off to prison in a death march that served as a grim prelude to the savage Pacific conflict to come.

HOMING IN ON PEARL HARBOR
In a frame from a captured Japanese propaganda film, pilots aboard a carrier ship en route to Pearl Harbor pick up radio broadcasts from unsuspecting Honolulu.

BREAKING THE PEACE
On the flight deck of a Japanese carrier off Hawaii, crewmen prepare to release fighters revving up for takeoff in the early morning of December 7, 1941.

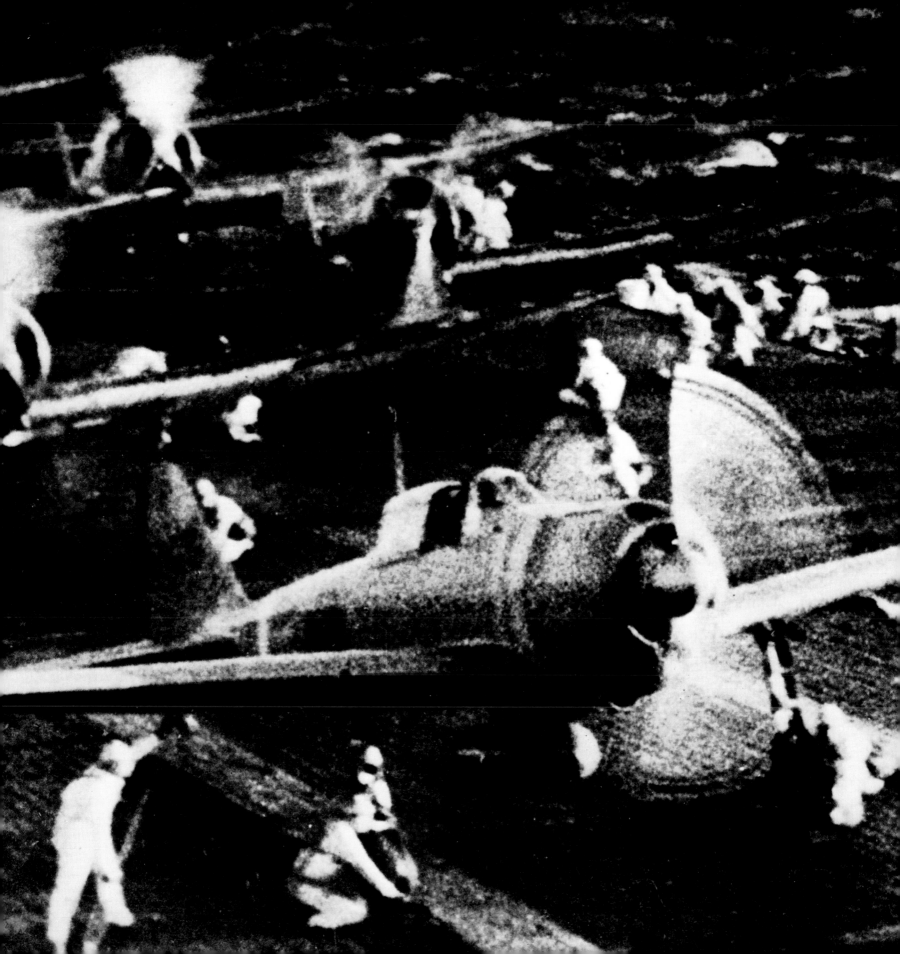

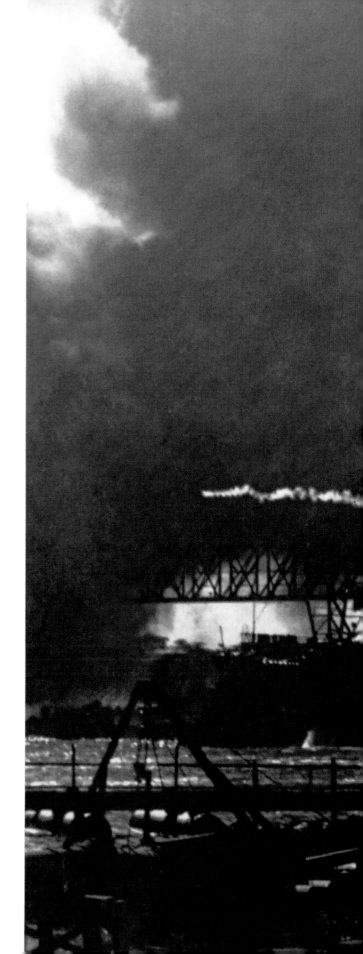

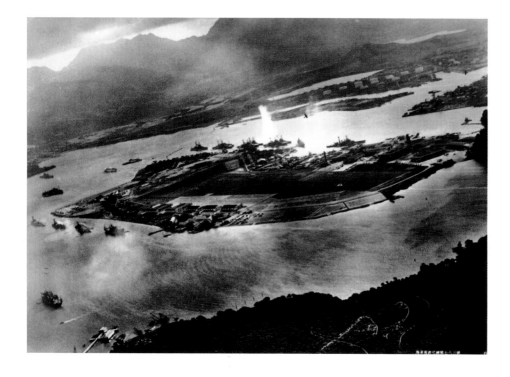

TARGETING THE FLEET
Japanese warplanes swoop over Ford Island in Pearl Harbor (*above*), targeting both the airfield there and the ships at anchor.

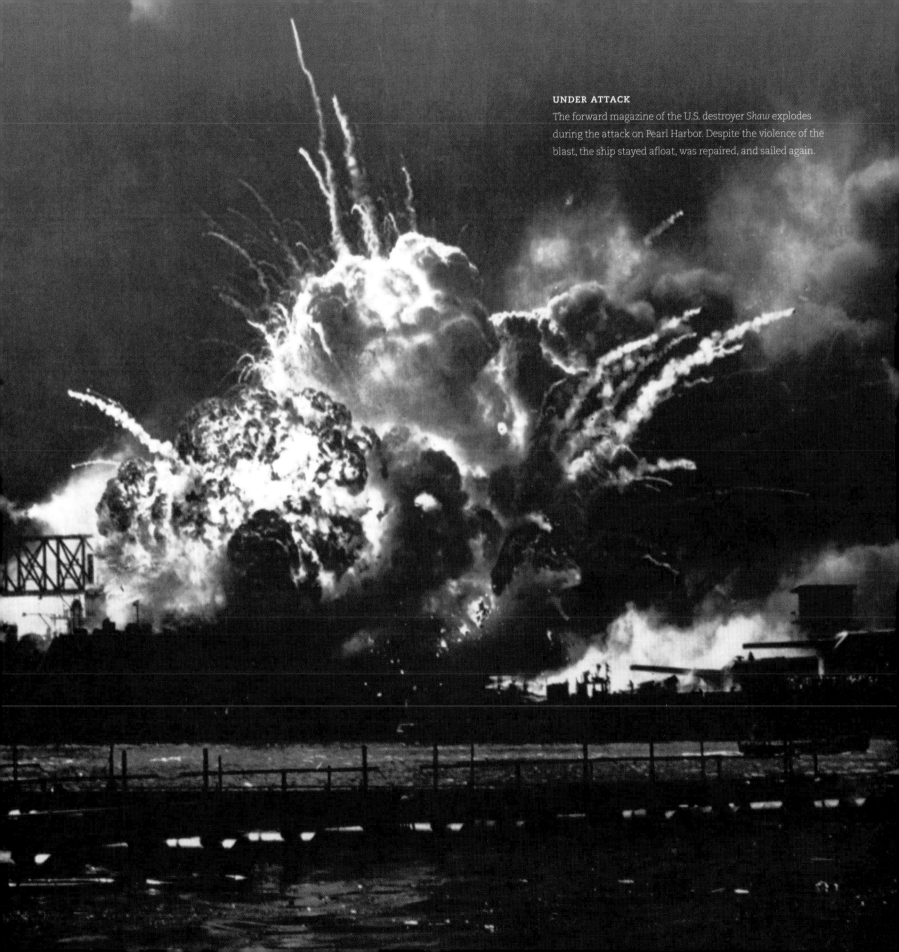

UNDER ATTACK
The forward magazine of the U.S. destroyer *Shaw* explodes during the attack on Pearl Harbor. Despite the violence of the blast, the ship stayed afloat, was repaired, and sailed again.

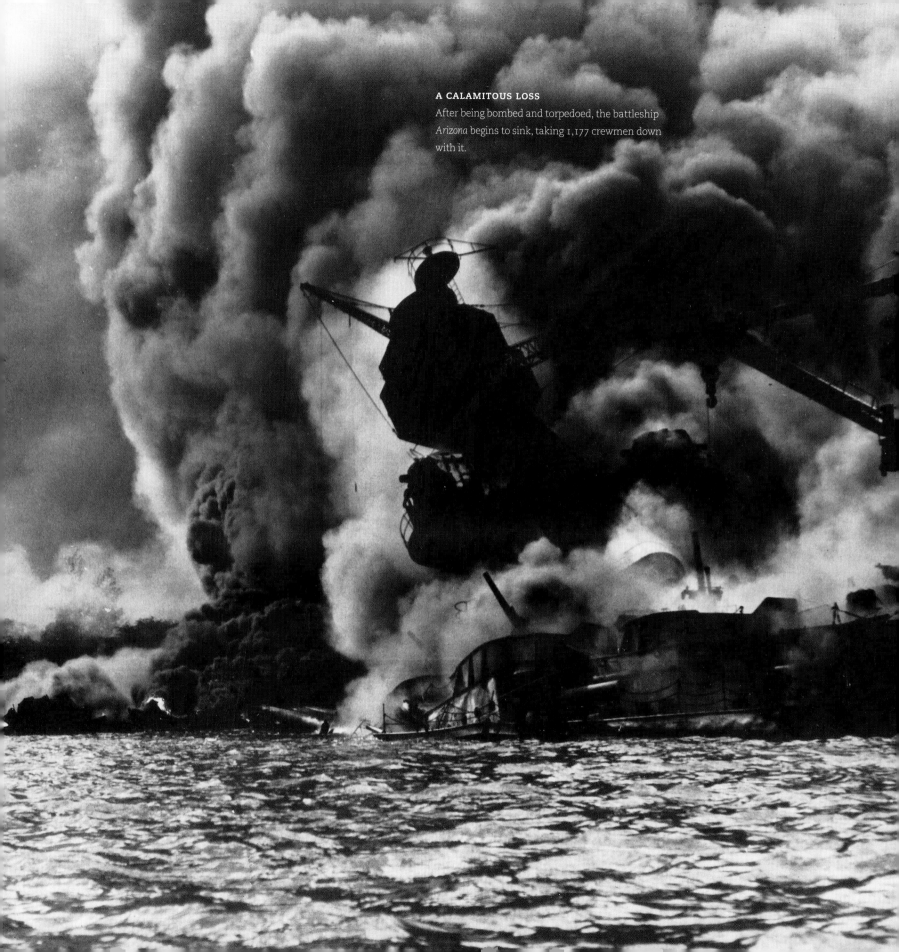

A CALAMITOUS LOSS
After being bombed and torpedoed, the battleship
Arizona begins to sink, taking 1,177 crewmen down
with it.

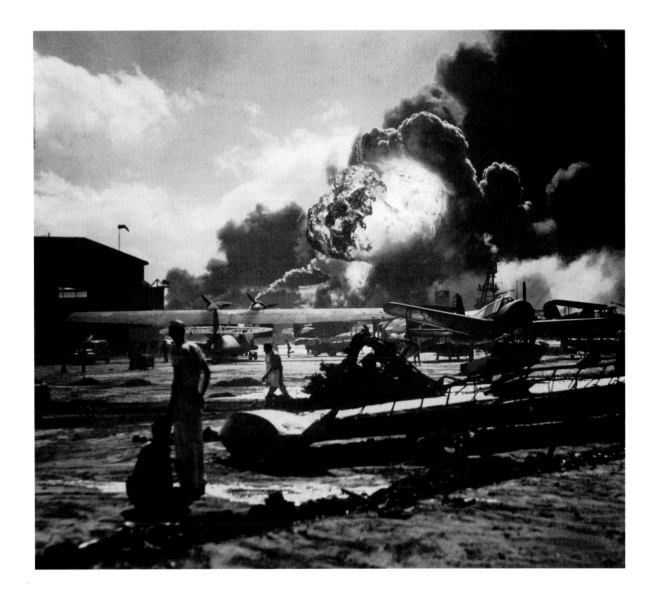

IMAGE OF DEFEAT

In a searing image emblematic of the shocking attack at Pearl Harbor, dazed servicemen watch planes and hangars at the Ford Island Naval Station engulfed in flame and smoke.

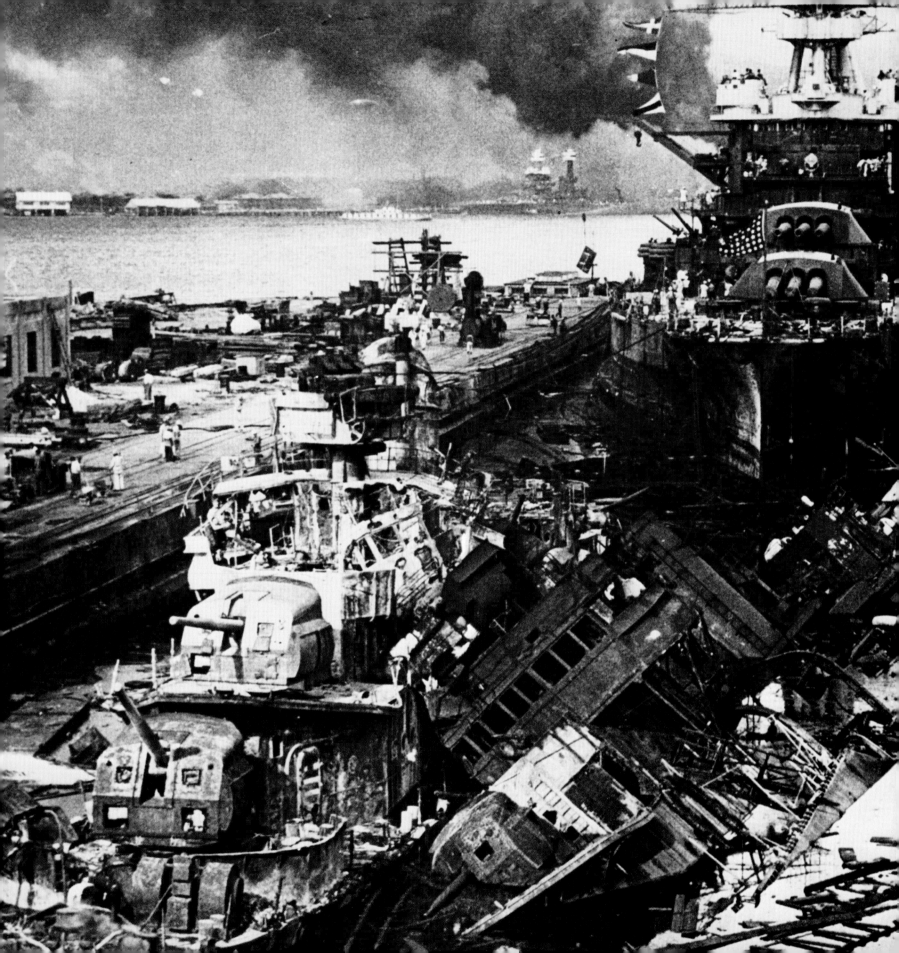

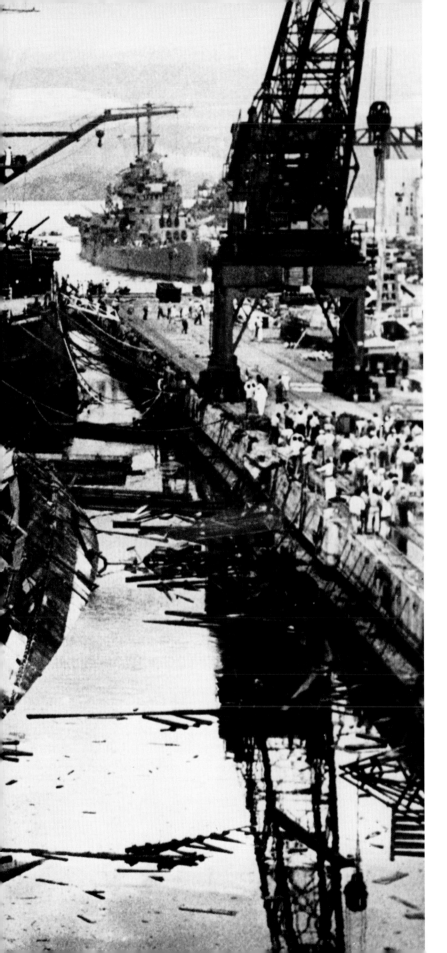

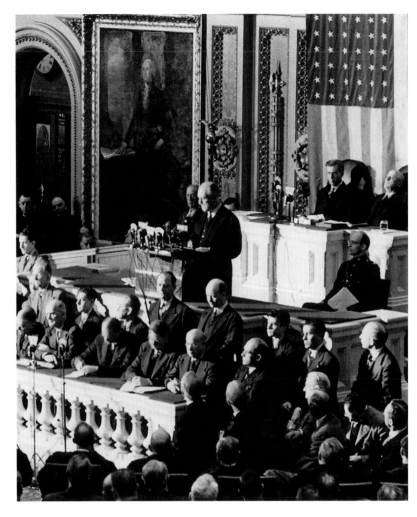

CALL TO ACTION

Speaking to a joint session of Congress on the day after Pearl Harbor, Roosevelt asks for a declaration of war against Japan. Roosevelt waited for a provocation to enter the conflict against Germany, and Hitler obliged him on December 11 by declaring war on the United States.

DESTROYERS LAID LOW

The destroyers *Cassin (right)* and *Downes* lie partially submerged in Drydock No.1, while smoke billows from Battleship Row and Ford Island in the distance. Three bombs passed through the *Cassin* and exploded in the bottom of the drydock, starting intense fires and damaging the hulls of both destroyers.

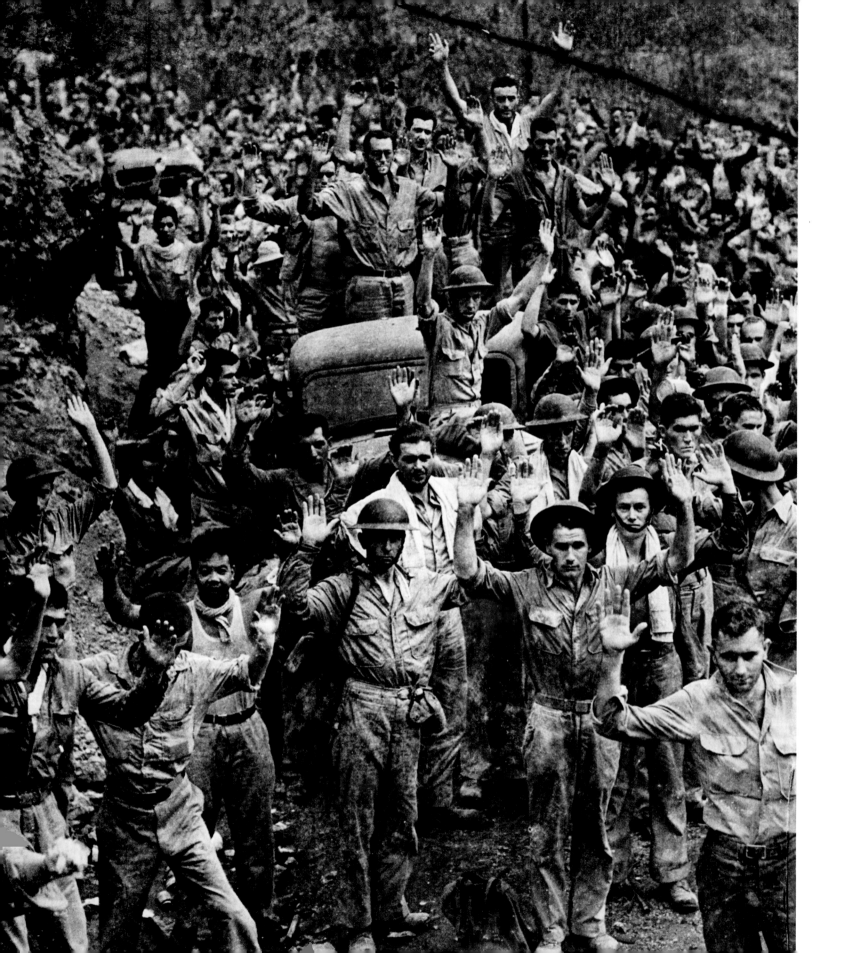

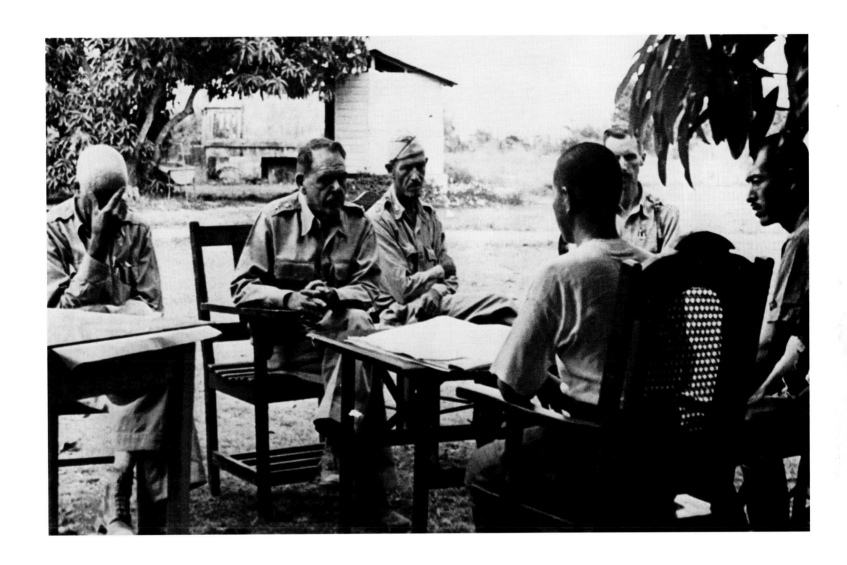

SURRENDERING THE PHILIPPINES

Filipino and American troops on Corregidor—an island off the Bataan peninsula that served as a last refuge for the defenders—give up outside the 1,400-foot Malinta Tunnel, in which their garrison withstood 27 days of artillery bombardment.

CONCESSION AT BATAAN

To spare his exhausted, defeated men, Major General Edward King (*center*) arranges with a Japanese colonel the surrender of the Philippine bastion of Bataan in April 1942.

A DISMAL DESTINATION
Shouldering improvised litters bearing their disabled comrades,
Bataan marchers approach the end of their arduous journey—
the prison enclosure at Camp O'Donnell, on a dusty plain in Luzon.
Since the invasion began, 25,000 American and Filipino troops
had perished, and as many as 400 a day would die in prison from
disease, malnutrition, and brutality.

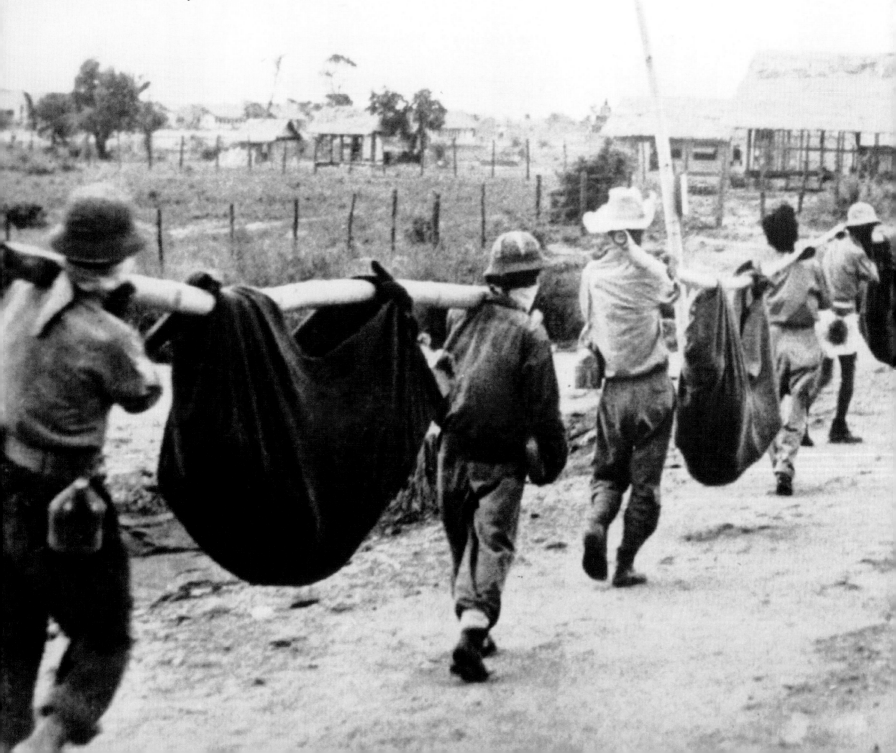

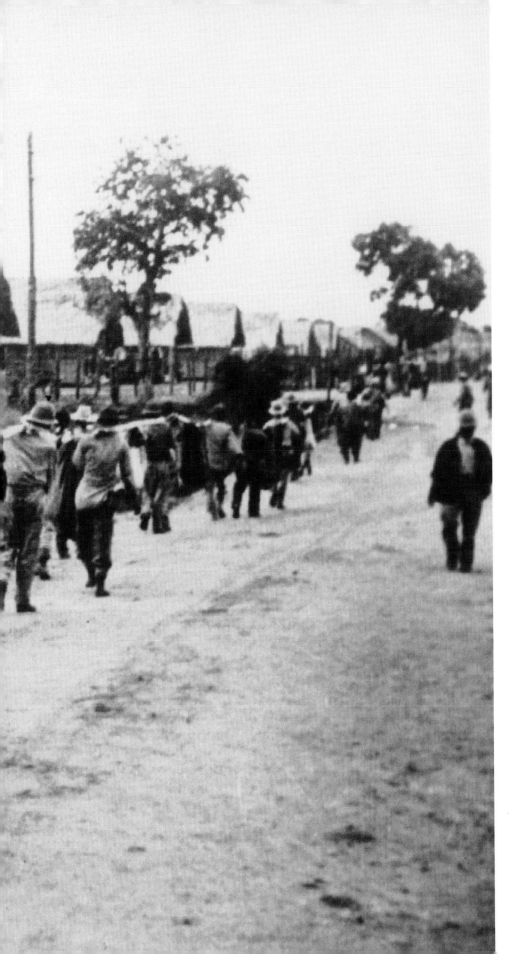

"*We all knew that falling out of line meant certain death.*"

LESTER TENNEY,
survivor of Bataan Death March

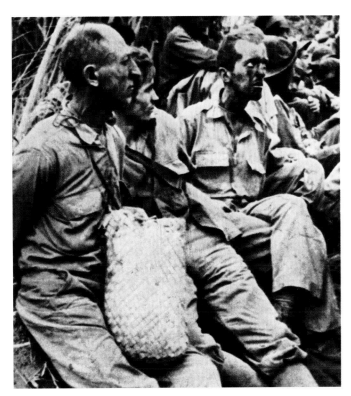

ENDURING THE DEATH MARCH
Hands tied behind their backs, captives Samuel Stenzler, Frank Spear, and James Gallagher rest briefly during a halt on the murderous trip to prison camp, made worse by harsh treatment from Japanese soldiers who considered surrender dishonorable.

Carrier Warfare

IN EARLY 1942, THE BATTERED U.S. NAVY STRUGGLED TO REGAIN CONTROL of the Pacific and strike back at the Japanese. No one witnessing the devastation at Pearl Harbor could doubt that aircraft carriers were now key to naval supremacy. Admiral Chester Nimitz, commanding the Pacific Fleet, had just 4 carriers to the enemy's 10, including 6 big flattops organized for offensives. Until American shipyards could narrow that gap, the navy faced long odds.

Despite the loss of the Philippines, the United States retained control of Pearl Harbor and a vital air base on the island of Midway 1,300 miles to the northwest that protected Pearl Harbor

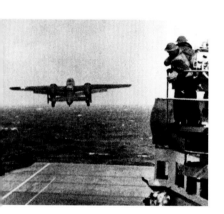

and menaced the defensive perimeter shielding Japan. In April 1942, a U.S. carrier task force slipped through that screen and steamed to within 650 miles of Tokyo before releasing 16 B-25 bombers for a daring raid on Tokyo and environs. Led by Colonel James Doolittle, the raid inflicted little damage and many of the crewmen had to bail out over China because the bombers were not built to land on carriers. But the specter of warplanes over Tokyo shocked the Japanese high command into backing a high-stakes gamble by Admiral Yamamoto, who set out to attack Midway and then crush the Pacific Fleet when it rushed to defend that base.

Yamamoto might have succeeded had not his plans been deciphered by navy code breakers. Armed with that intelligence, Nimitz hurriedly repaired the carrier *Yorktown*, damaged recently off New Guinea in the Battle of the Coral Sea, which had cost Nimitz the *Lexington* and Yamamoto one of his own carriers. Nimitz then sent all three surviving flattops —*Yorktown, Enterprise,* and *Hornet*—to surprise Yamamoto's strike force in early June. In furious fighting off Midway, the *Yorktown* was fatally damaged, but four big Japanese carriers went down in flames. Yamamoto's hopes were shattered, and he was forced onto the defensive.

TARGET TOKYO
A B-25 lifts off from the deck of the aircraft carrier *Hornet* in April 1942 as part of the Doolittle raid, designed to strike Tokyo and bring the war home to the Japanese.

CAPTURED IN A DARING RAID
Lieutenant Robert Hite, one of eight flyers involved in the Doolittle raid who were captured by the Japanese in occupied China, is led blindfolded from a transport plane in Tokyo. Hite survived, but three of the eight were executed and another died in prison.

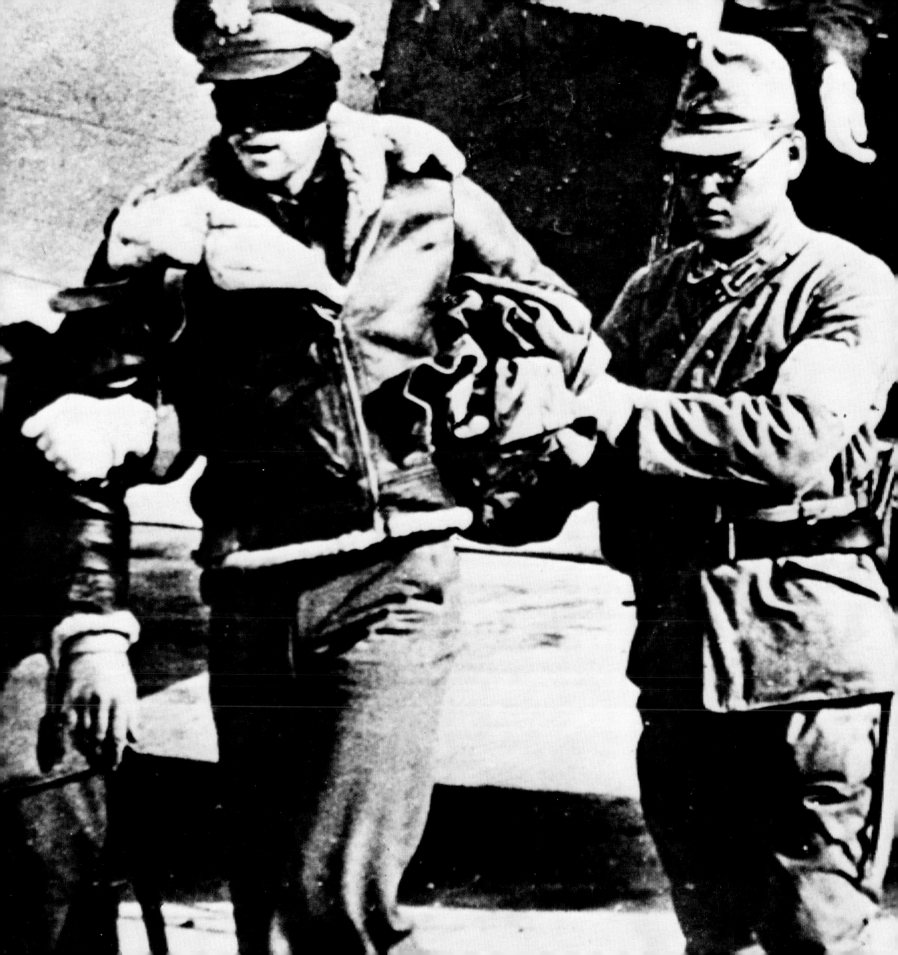

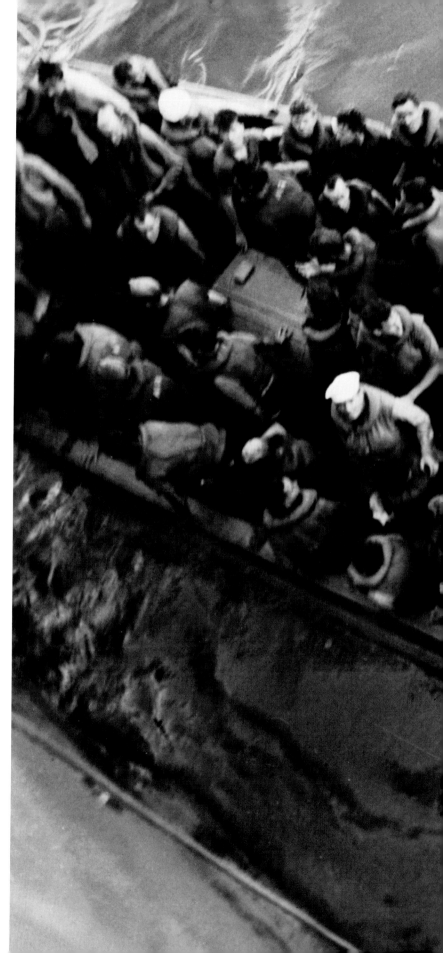

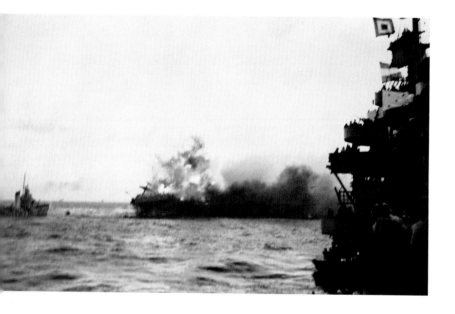

A FATAL BLOW

The *Lexington* erupts in flames after being targeted by warplanes from a Japanese carrier during the Battle of the Coral Sea on May 8, 1942.

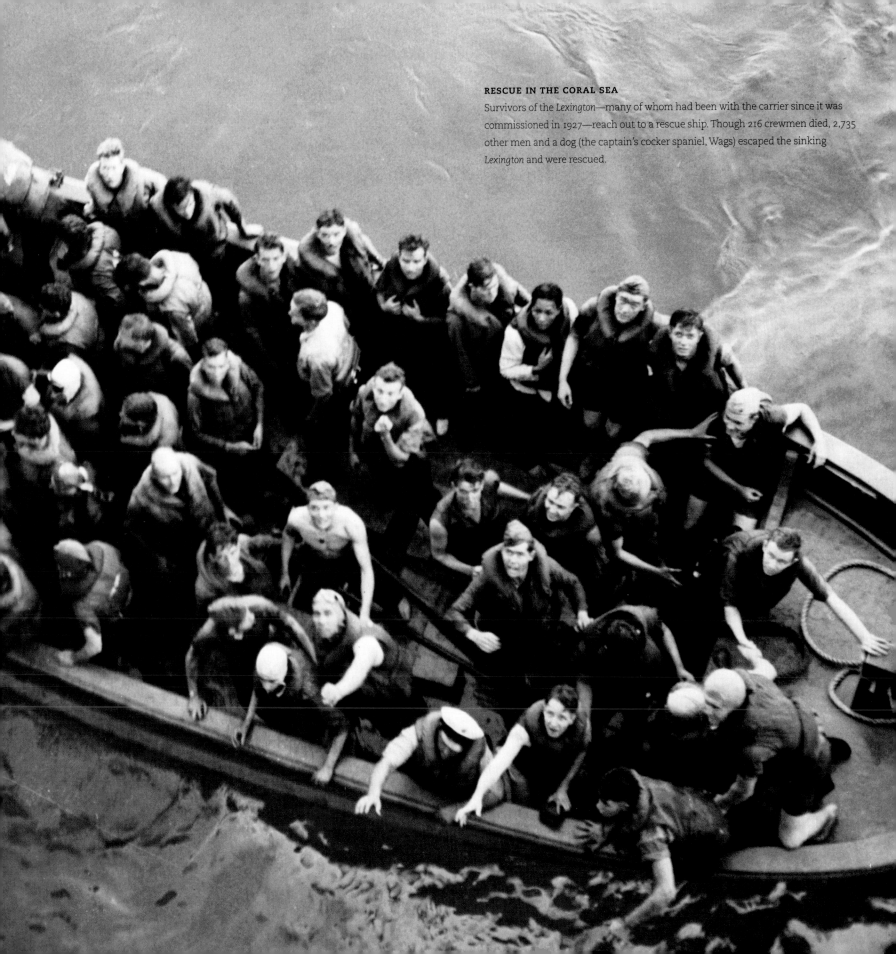

RESCUE IN THE CORAL SEA
Survivors of the *Lexington*—many of whom had been with the carrier since it was commissioned in 1927—reach out to a rescue ship. Though 216 crewmen died, 2,735 other men and a dog (the captain's cocker spaniel, Wags) escaped the sinking *Lexington* and were rescued.

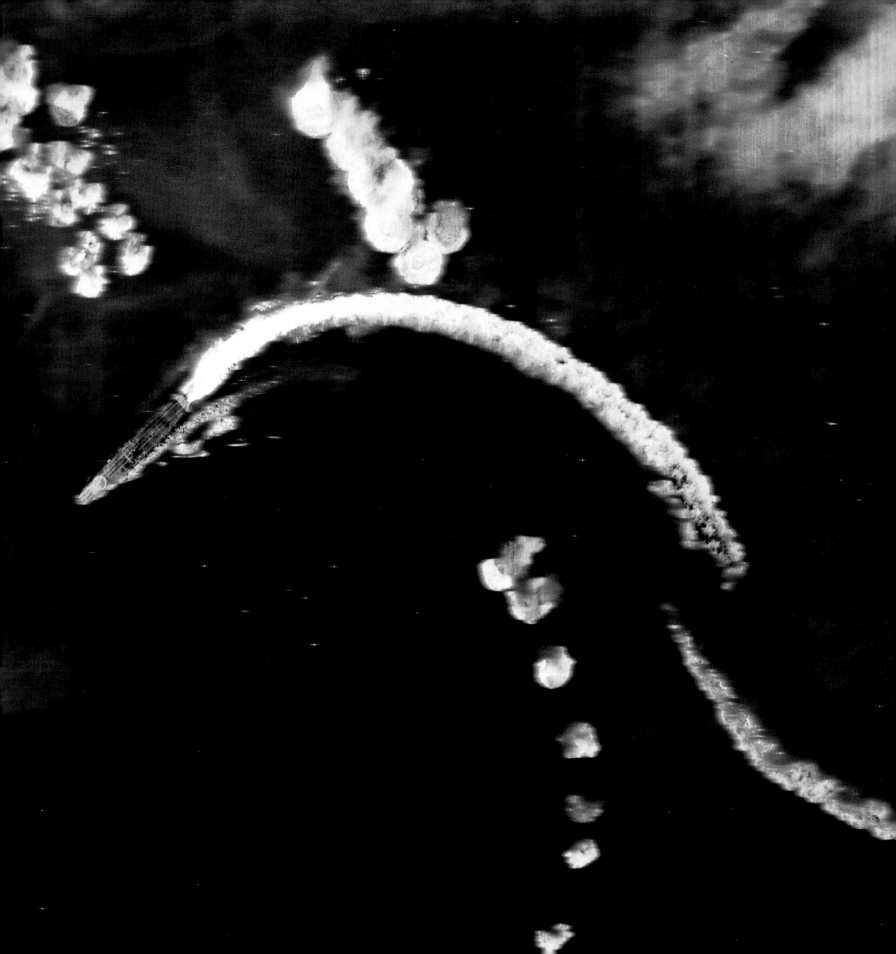

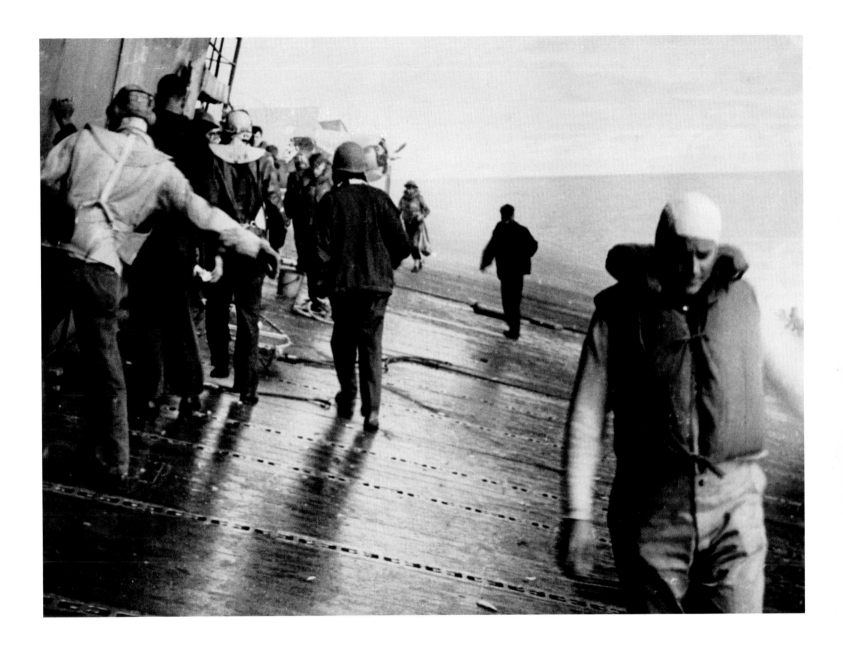

EVASIVE ACTION AT MIDWAY

The doomed carrier *Akagi* veers off course to avoid U.S. bombers, which succeeded in destroying the ship and three other Japanese carriers during the pivotal Battle of Midway on June 4.

SINKING OF THE YORKTOWN

Sailors and pilots grimly maintain their balance aboard the listing *Yorktown* after two Japanese torpedoes plowed into the carrier. The men abandoned ship in orderly fashion before it sank the next day.

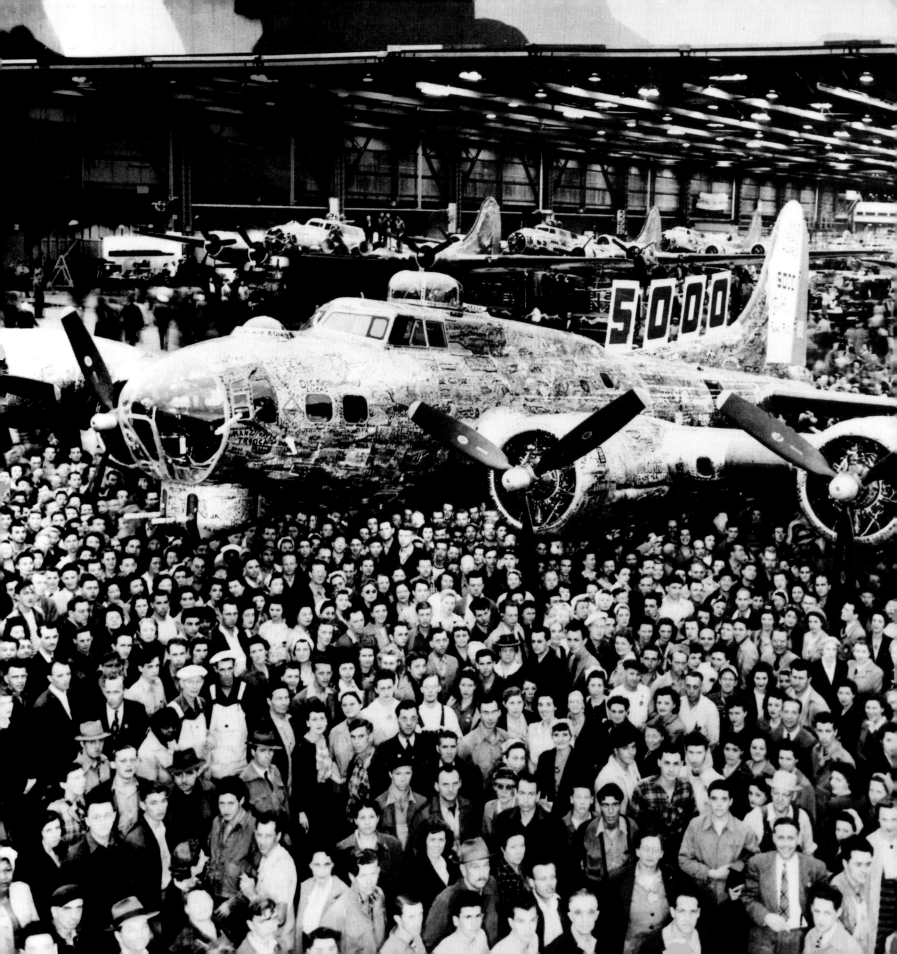

Home Front: USA

BEFORE ATTACKING PEARL HARBOR, Admiral Yamamoto warned his superiors in Tokyo of the risks of waging war on the world's greatest industrial power. "If I am told to fight regardless of the consequences," he declared, "I shall run wild for the first six months or a year, but I have utterly no confidence for the second or third year." He feared that unless Japan won a quick victory, the Americans would soon bring to bear their superior economic resources, which he had witnessed while serving as a naval attache in the United States. "Anyone who has seen the auto factories in Detroit and the oil fields in Texas," he remarked, "knows that Japan lacks the national power for a naval race with America."

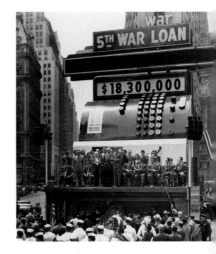

Others shared Yamamoto's assessment, including Winston Churchill, who hailed America's entry into the war on Britain's side as ensuring an Allied victory. Before Americans could fulfill that promise, however, they had to mobilize on the home front, where the economy remained mired in depression. Huge government defense contracts gave ailing industries a big boost. But fighting a war on two fronts meant inducting some 10 million men into the army, greatly reducing the labor force. Industry responded by hiring women and African Americans, who had been largely excluded from heavy industry in the past.

Not all changes on the home front were to the nation's credit. The attack on Pearl Harbor produced a tidal wave of fear and intolerance that swept nearly 130,000 Japanese Americans into internment camps, where they languished for years. But overall, the war did far more to unite the country than to divide it, and Americans worked wonders. Confounding predictions that it would take years to gear up fully for war, the United States outproduced the Axis in 1942, turning out 13,000 more tanks and 20,000 more aircraft than Japan, Germany, and Italy combined.

RINGING UP CONTRIBUTIONS
A swing band onstage and a navy brass band in the street below help ring up contributions to a 1944 War Bond drive, displayed on a giant cash register in New York's Times Square.

HOT OFF THE ASSEMBLY LINE
Workers at a Boeing plant in Seattle pose in front of the 5,000th Flying Fortress to come off their assembly line. Virtually everyone who worked on the B-17 signed it somewhere, and in a last loving send-off, they pushed it out onto the tarmac by hand.

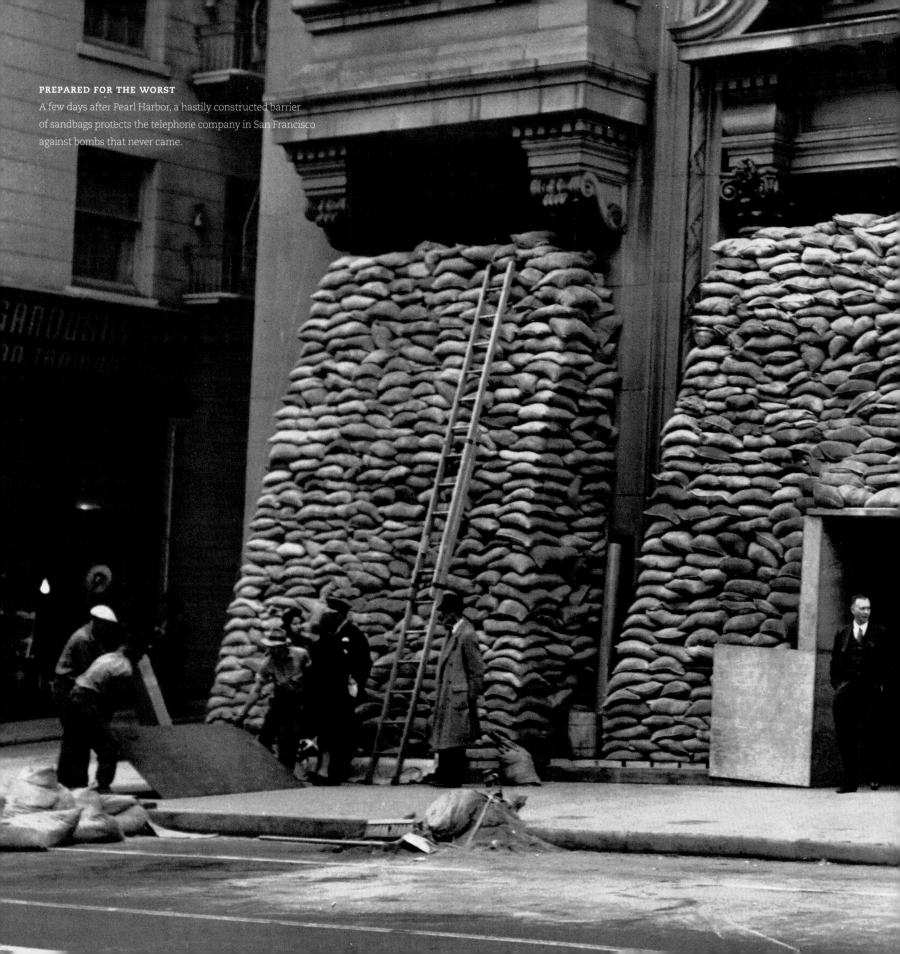

PREPARED FOR THE WORST
A few days after Pearl Harbor, a hastily constructed barrier of sandbags protects the telephone company in San Francisco against bombs that never came.

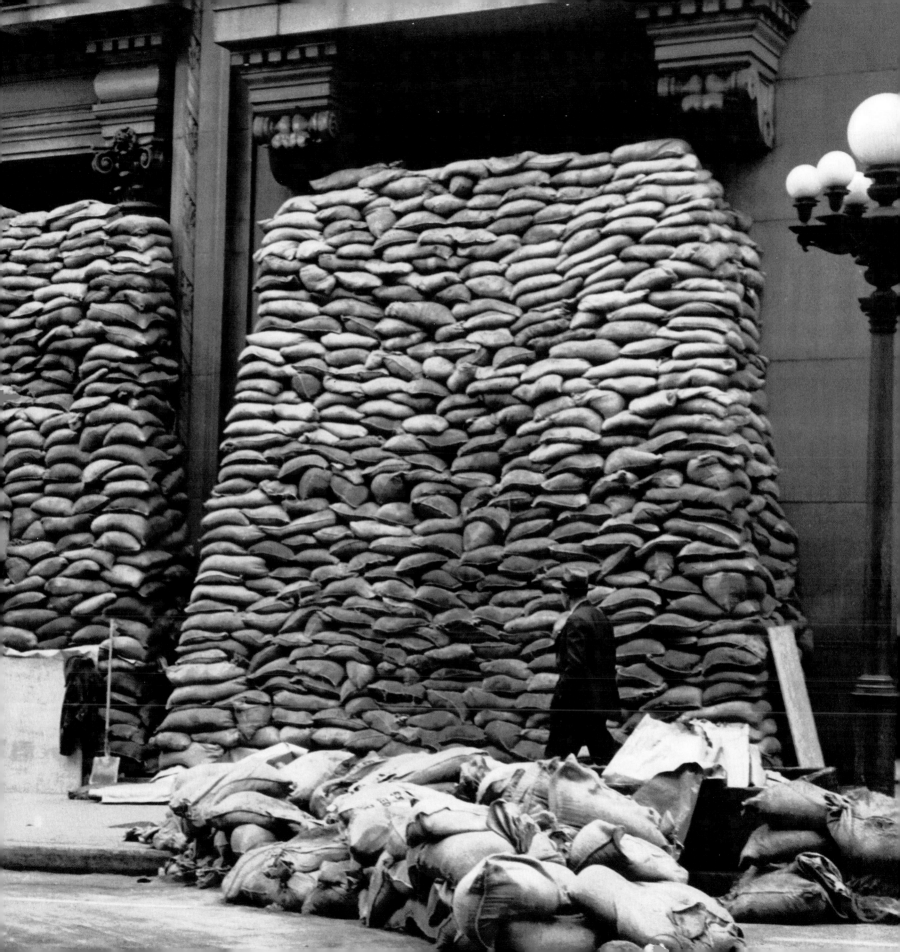

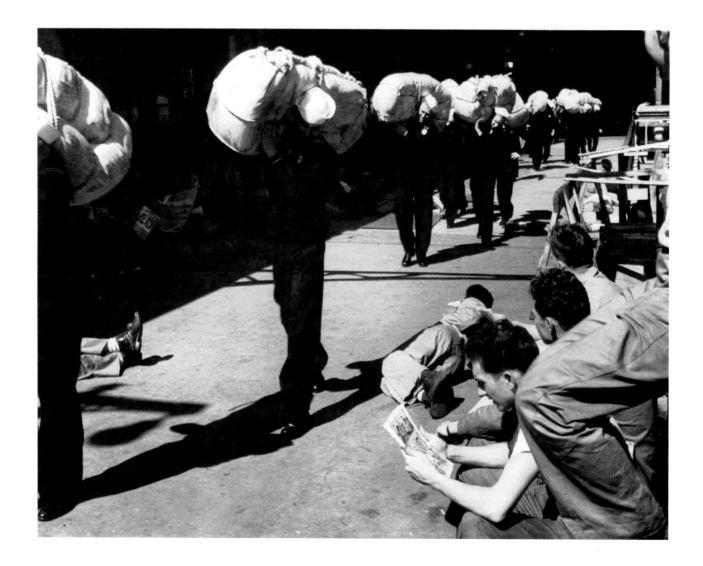

SHIPPING OUT

Through an isle of comrades idly waiting their turn, sailors shouldering heavy duffel bags prepare to ship out from the big naval base in San Diego.

ANSWERING THE CALL

During processing, a draftee at Fort Dix, New Jersey, whose hat is now his sole claim to dignity, is inoculated from both sides for smallpox and typhoid.

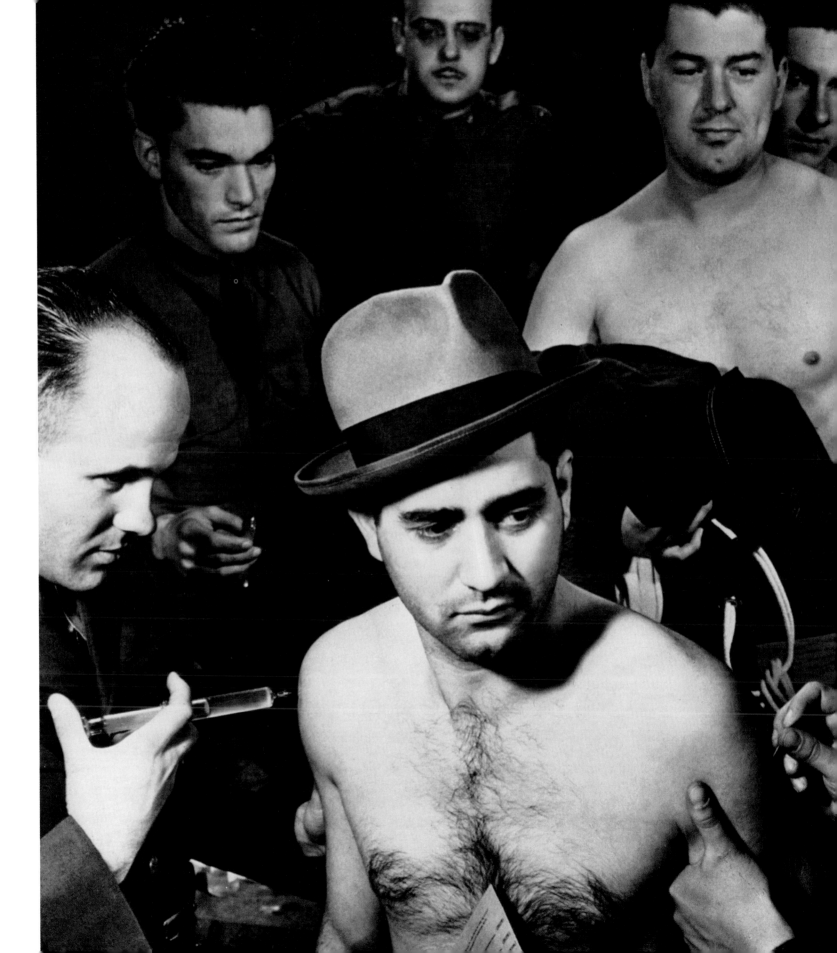

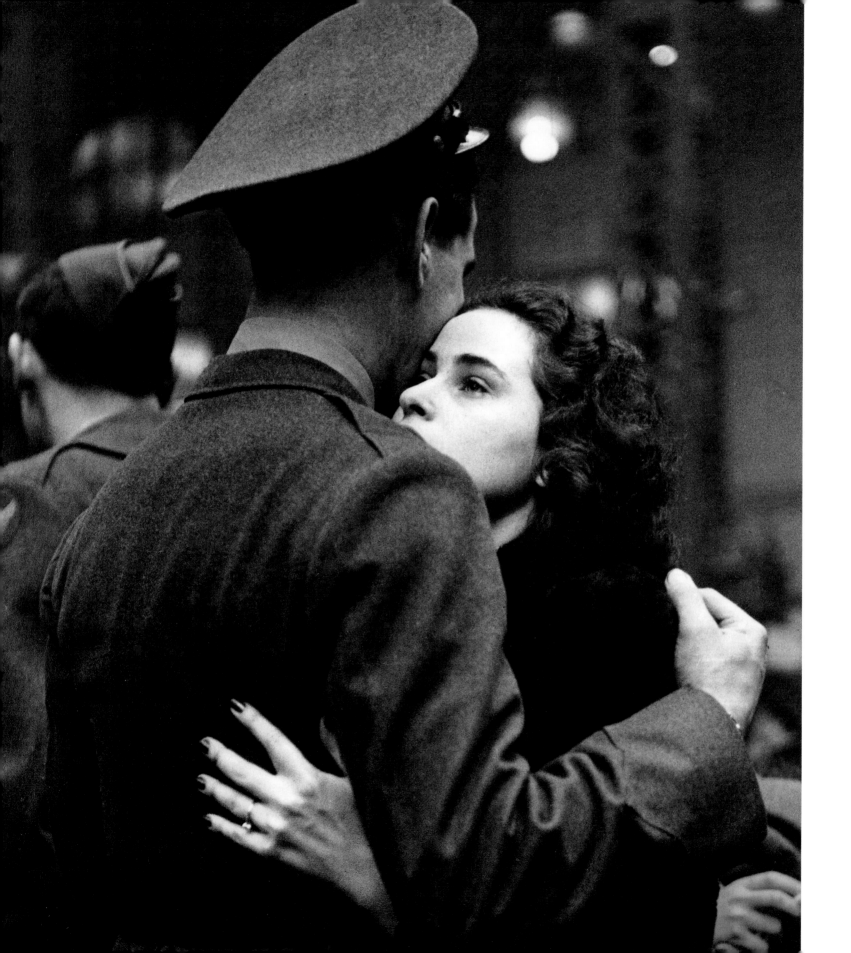

THE LONG GOOD-BYE

Emotional scenes like these were commonplace on the home front as soldiers bid farewell to sweethearts, wives, and children, leaving loved ones bereft.

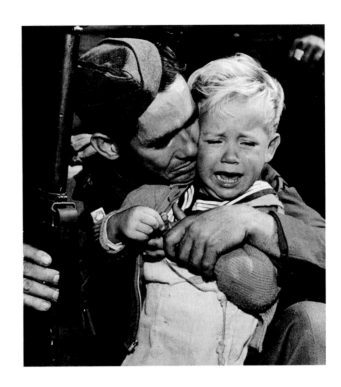

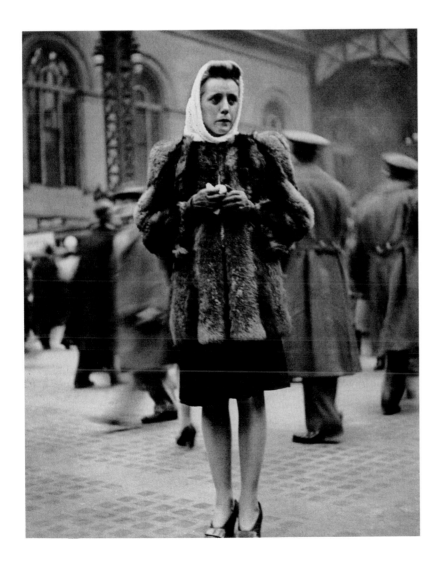

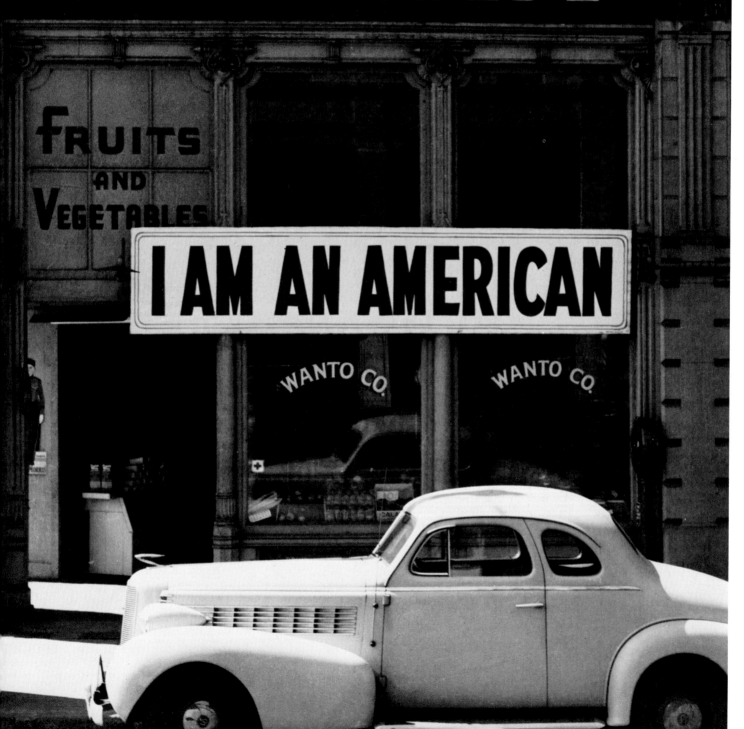

FORCED OUT

The Japanese American grocer who
ran this store proclaimed his loyalty
for everyone to see, but as the sign
at top indicates, he still had to leave.

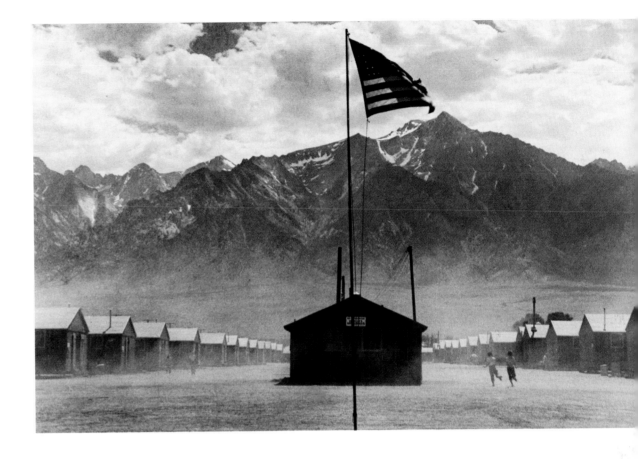

NO LONGER AT LIBERTY

Wind billows the Stars and Stripes
as a dust storm swirls around
barracks at a desolate Japanese
American relocation camp in the
desert at Manzanar, California.

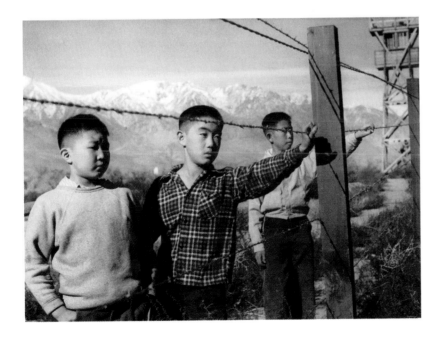

FENCED IN

In plain sight of a guard tower, three Japanese
American boys gaze beyond the barbed-wire
enclosure of their camp.

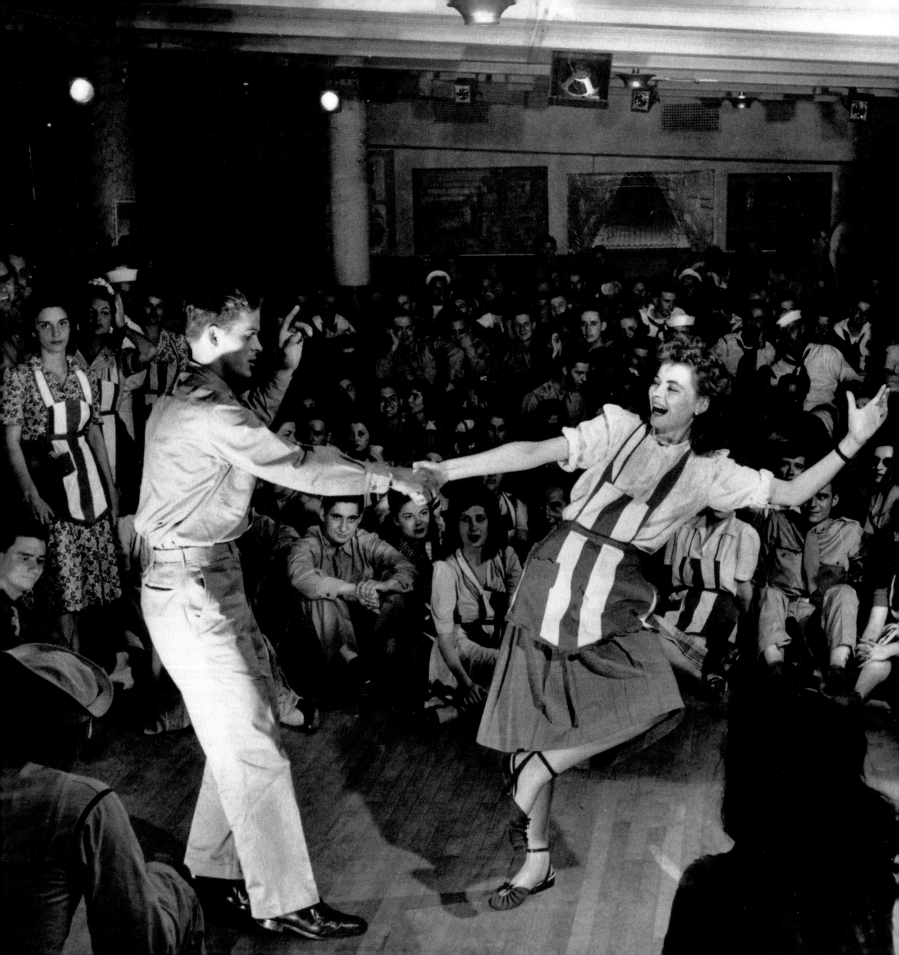

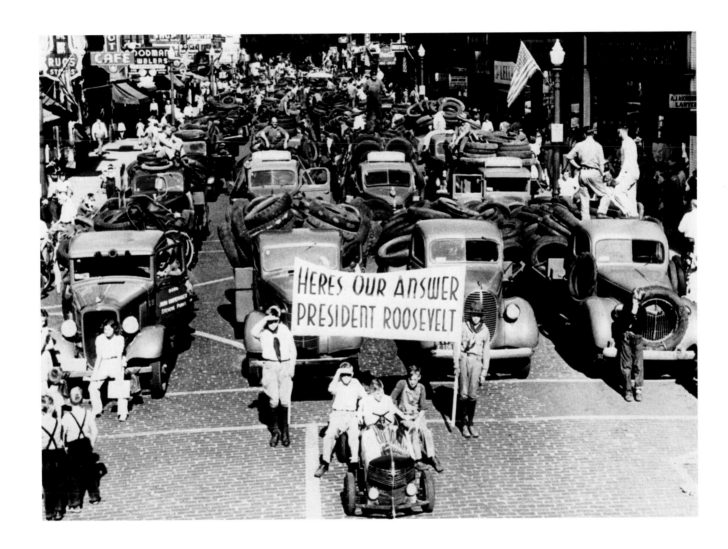

ENTERTAINING THE TROOPS

Actress Dorothy McGuire and her proud dance partner entertain other servicemen and their guests during a United Service Organizations, or USO, event at Broadway's Stage Door Canteen.

MOBILIZING MAIN STREET

Boy Scouts lead a parade of trucks filled with more than 80 tons of old automobile and bicycle tires through Stevens Point, Wisconsin, in June 1942. When Japanese conquests in the Far East deprived the United States of most of its sources of natural rubber, President Roosevelt called for a nationwide scrap drive.

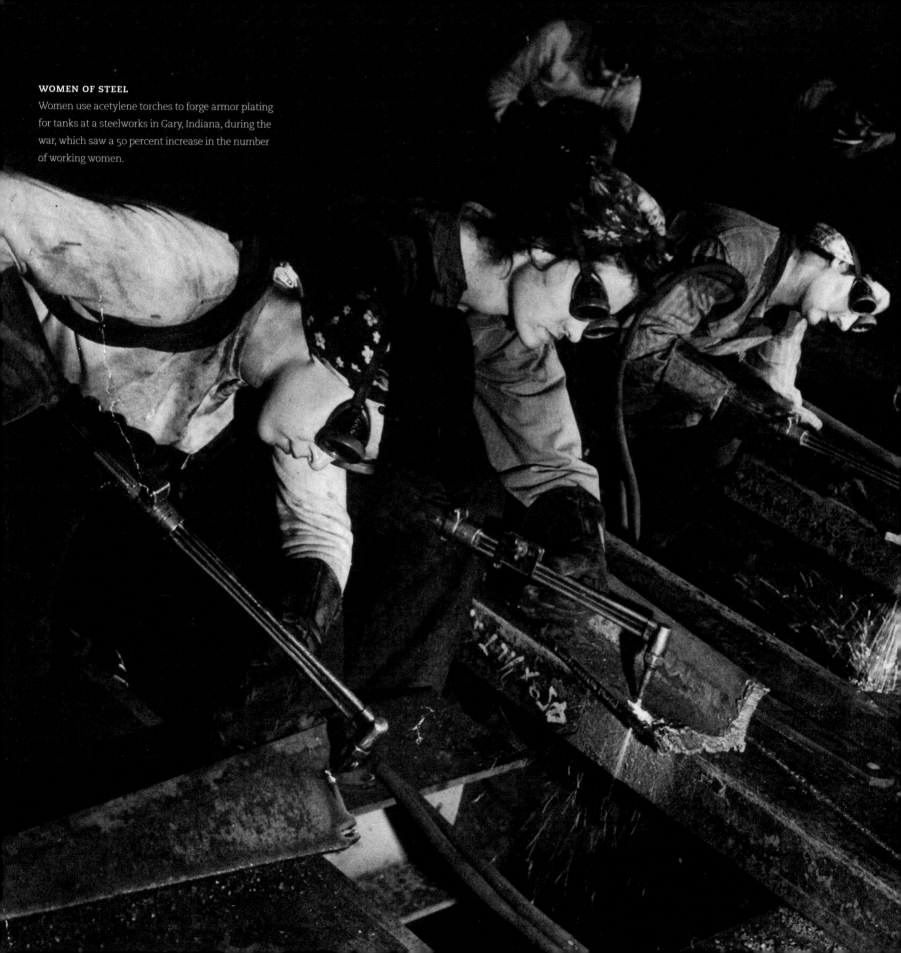

WOMEN OF STEEL
Women use acetylene torches to forge armor plating for tanks at a steelworks in Gary, Indiana, during the war, which saw a 50 percent increase in the number of working women.

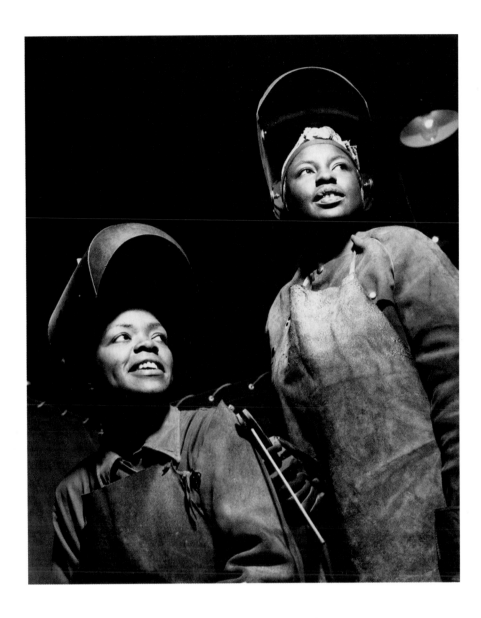

ENHANCING THE WORK FORCE

African Americans like these female welders in Connecticut made the most of an executive order by President Roosevelt forbidding racial discrimination in defense industries.

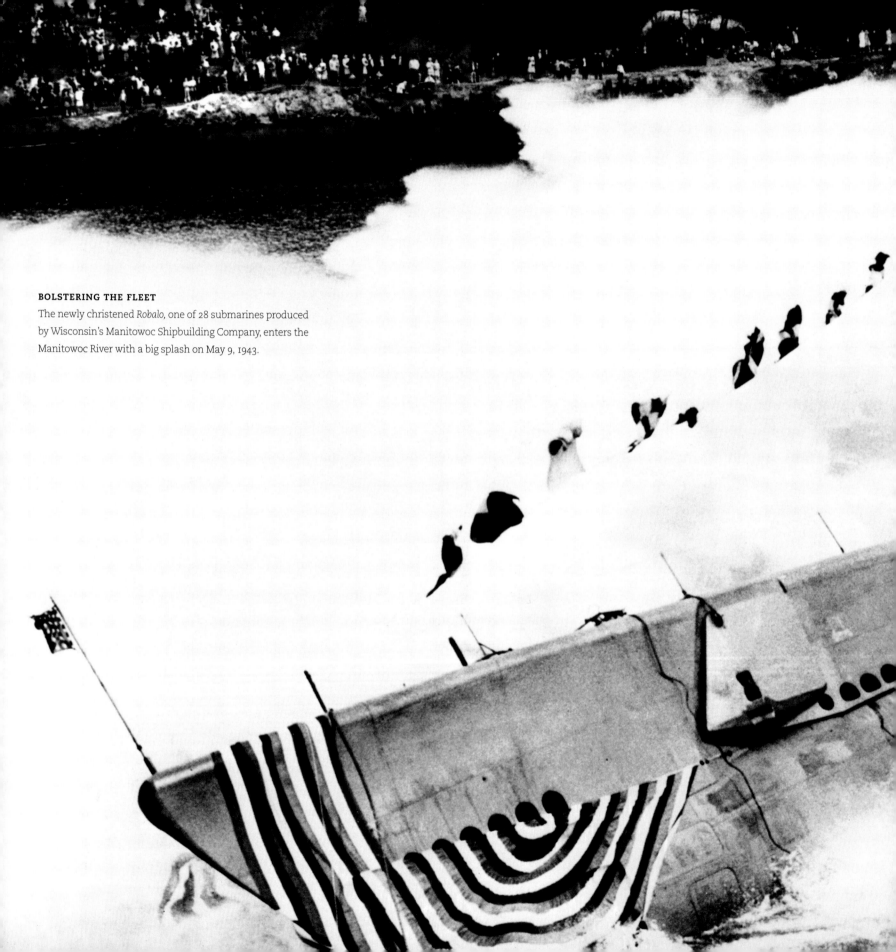

BOLSTERING THE FLEET
The newly christened *Robalo,* one of 28 submarines produced by Wisconsin's Manitowoc Shipbuilding Company, enters the Manitowoc River with a big splash on May 9, 1943.

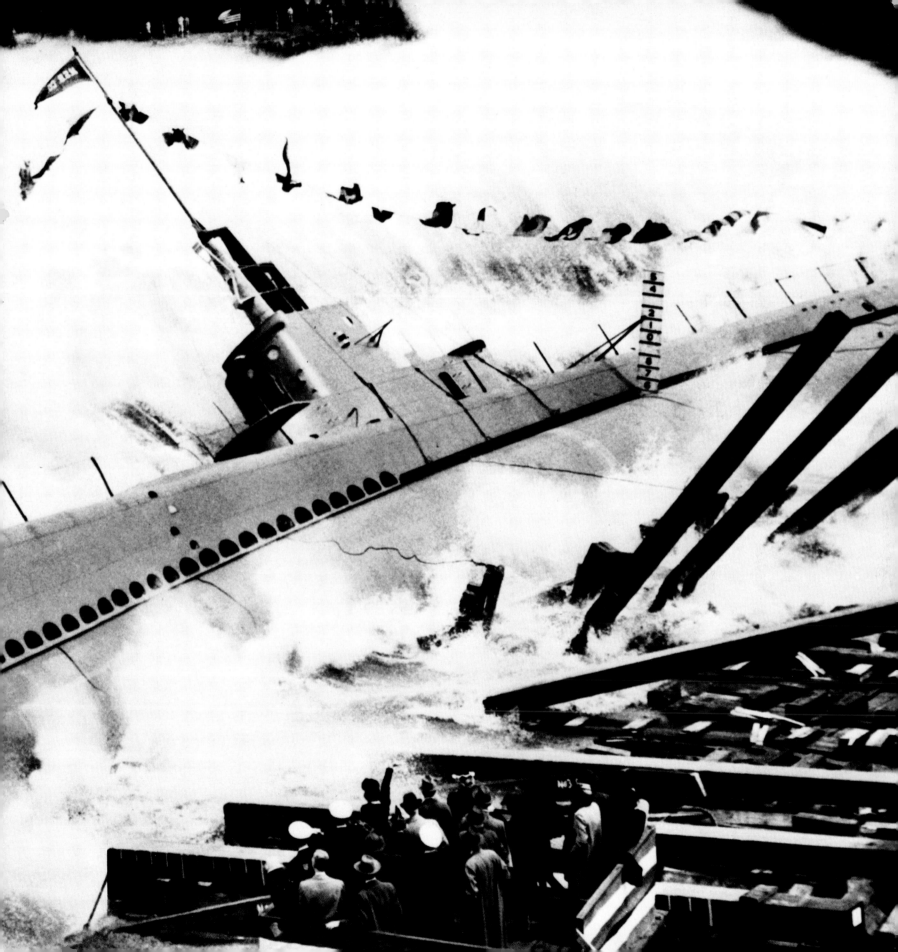

Battle of the Atlantic

OFFICIALLY, AMERICA AND GERMANY BECAME ENEMIES ON DECEMBER 11, 1941, when Hitler declared war on the United States. In truth, hostilities began earlier that year when Roosevelt ordered the navy to protect British merchant ships in the Atlantic, and German U-boats responded by targeting American vessels. On October 17, the destroyer *Kearny* was torpedoed while escorting ships off Iceland and lost 11 men before limping into port. "America has been attacked," Roosevelt declared. Later that month, another U-boat assault sent the destroyer *Reuben James* down with 115 men. The desperate struggle known as the Battle of the Atlantic was under way. Much depended on the outcome. Britain relied mightily on shipments of food, fuel, and weaponry from America. If that lifeline was severed, the triumphant transatlantic partnership Churchill envisioned would be reduced to a lonely struggle for survival. "The only thing that really frightened me during the war was the U-boat peril," he wrote afterward.

For Americans, that peril hit home in early 1942 when U-boats began sinking ships within sight of the East Coast. Between January and May, 87 ships went down in American waters, many of them oil tankers. The navy responded by organizing merchant vessels into convoys escorted by warships, but even then U-boats prowling in wolf packs found openings in convoy defenses and took a fearful toll.

Hitler might have won this battle had he been less enamored with surface ships—which did little to advance Germany's cause—and invested more in U-boats. Not until mid-1942 did Admiral Karl Dönitz have the 300 subs he had hoped for at the start of the war. By then, the Allies were greatly improving their techniques for detecting and destroying U-boats. In May 1943, after losing 43 subs in a single month, Dönitz ordered his wolf packs to disperse, ending any concerted threat to the British-American lifeline.

SCANNING FOR TARGETS

With his cap reversed to keep the peak from obstructing his view, German U-boat commander Kurt Diggins surveys an Allied convoy in the Atlantic through the periscope.

THE BATTLE'S FIRST VICTIMS

The British aircraft carrier *Courageous*, the first major casualty of a U-boat attack during the war, goes down off Ireland on September 17, 1939, with a loss of 518 lives.

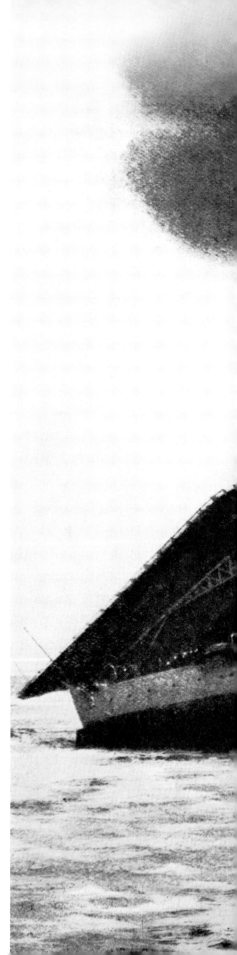

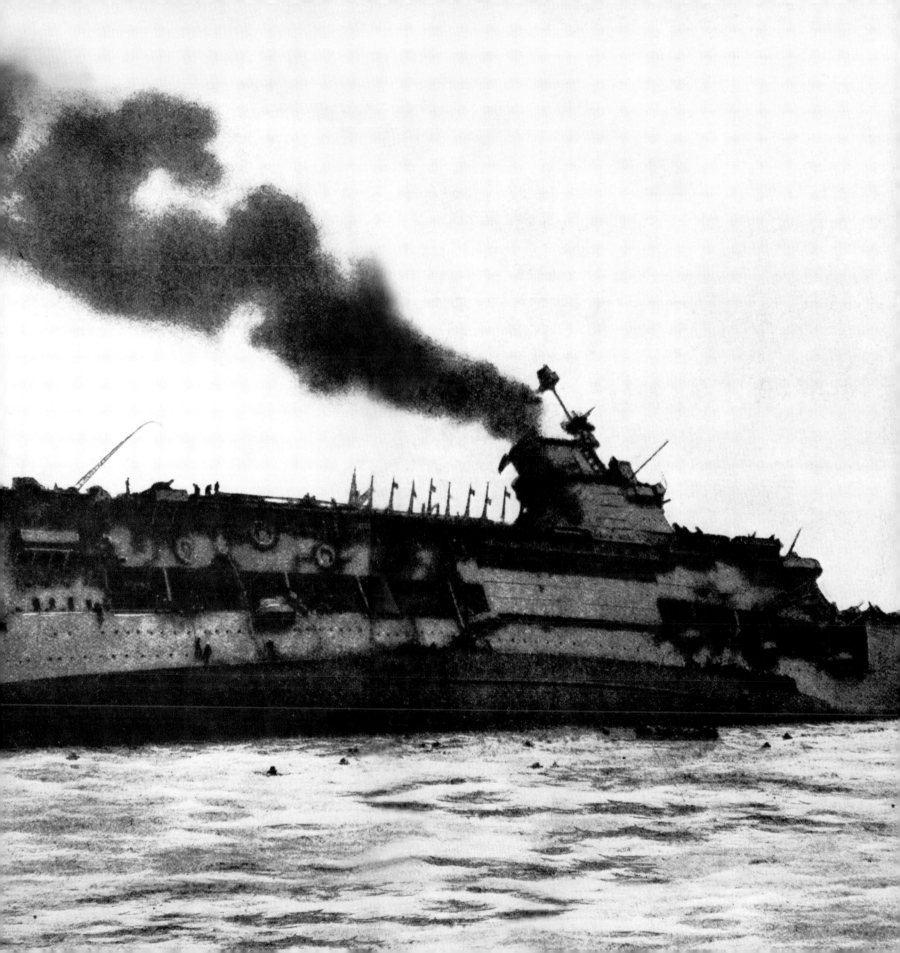

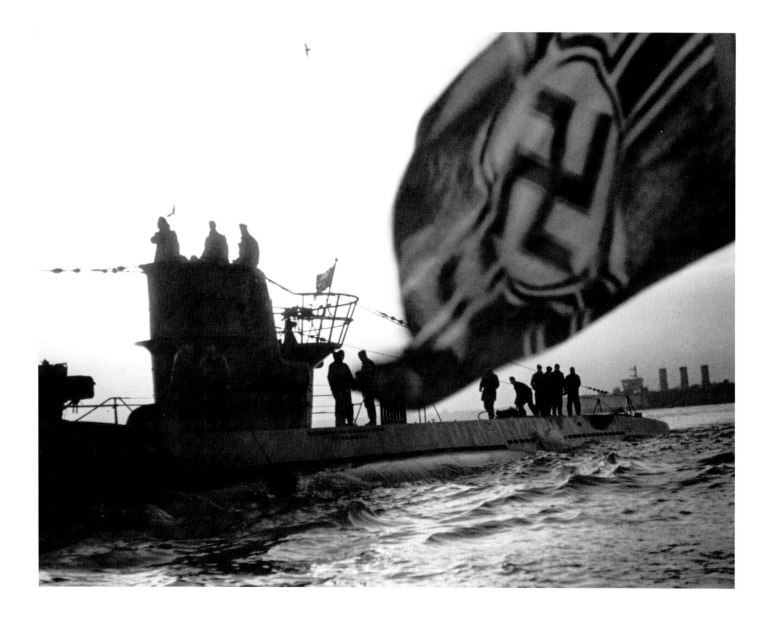

BACK FROM THE HUNT

A German U-boat returns in 1940 to its base at Lorient, where the Nazi flag flew until Allied forces liberated France four years later.

SAFETY IN NUMBERS

Merchant ships steaming across the Atlantic in Allied convoys like the one above sought safety in numbers, relying on destroyer escorts to supplement their limited firepower.

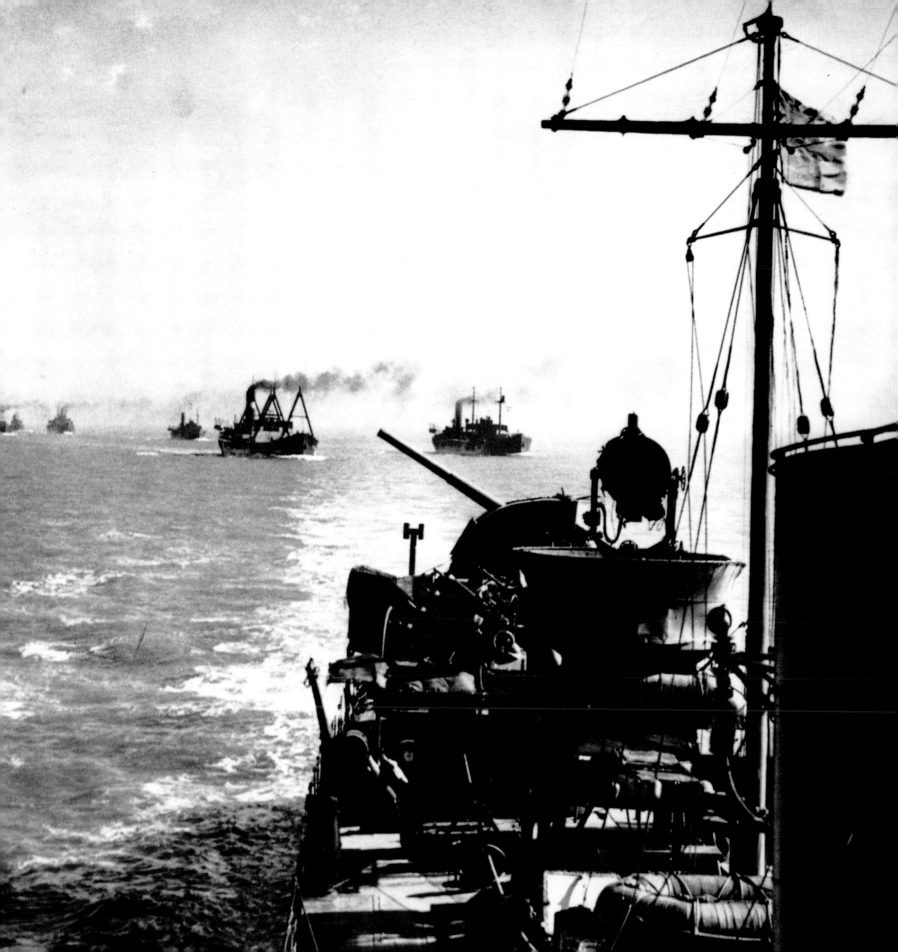

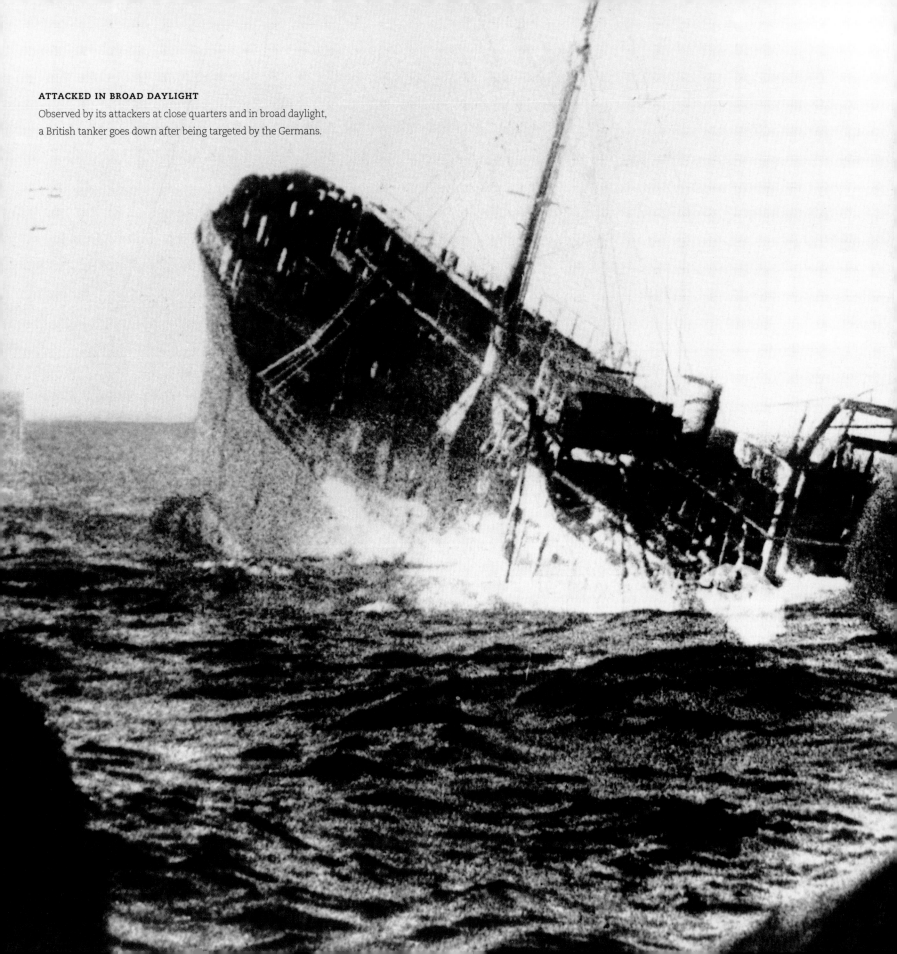

ATTACKED IN BROAD DAYLIGHT
Observed by its attackers at close quarters and in broad daylight,
a British tanker goes down after being targeted by the Germans.

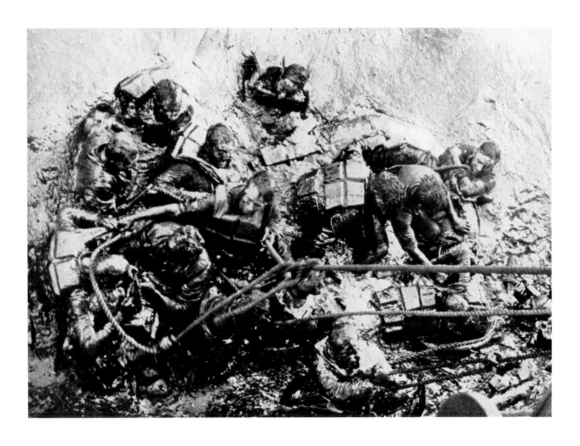

OIL-SOAKED SURVIVORS

Oil-soaked crew members of the British destroyer *Glowworm*, sunk by the German heavy cruiser *Admiral Hipper* off the Norwegian coast on April 8, 1940, wallow on a nearly swamped lifeboat while being hoisted aboard by the raider's crew.

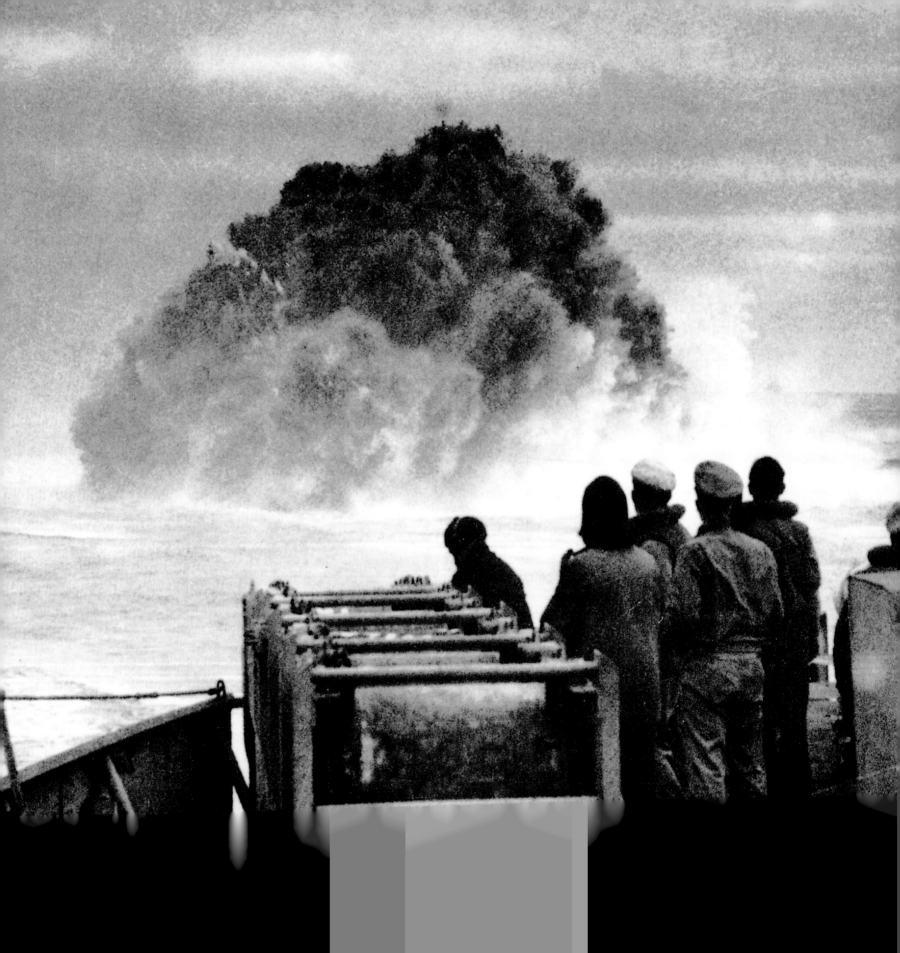

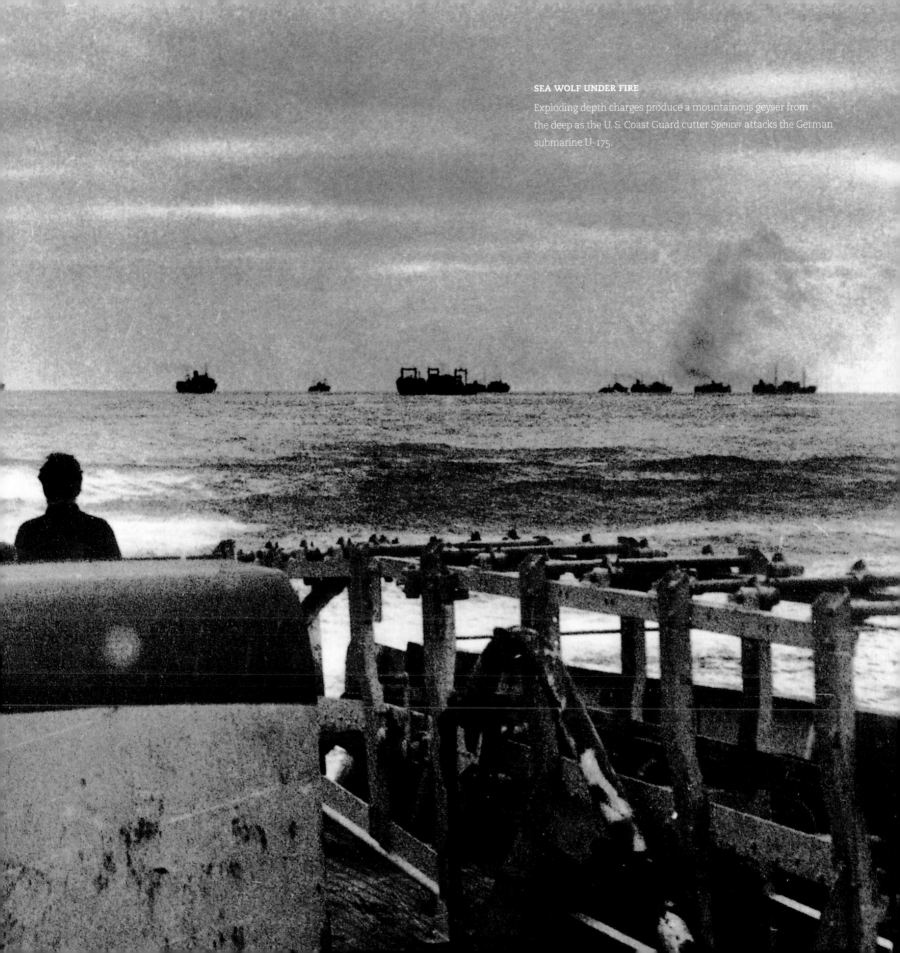

SEA WOLF UNDER FIRE
Exploding depth charges produce a mountainous geyser from
the deep as the U. S. Coast Guard cutter *Spencer* attacks the German
submarine U-175.

War in the Desert

IN EARLY 1942, WINSTON CHURCHILL WENT BEFORE PARLIAMENT and offered a remarkable tribute to the enemy commander who was bedeviling British forces in North Africa: "We have a very daring and skillful opponent against us," Churchill acknowledged, "and, may I say across the havoc of war, a great general." That general was Erwin Rommel, known as the Desert Fox for slyly outmaneuvering his opponents. Admiration for his abilities was one of the few things Churchill and Hitler had in common.

Like the fighting in the Balkans, the war in the desert began with a disastrous attempt by Mussolini to match Hilter's aggressive exploits with conquests of his own. In late 1940, he ordered his forces in the Italian colony of Libya to invade British-occupied Egypt. Although numerically superior, the Italians were ill-equipped and ended up surrendering in droves. In February 1941, as British forces advanced deep into Libya, Hitler sent Rommel and his Afrika Korps to the rescue. By mid-1942, the Desert Fox had chased the British back into Egypt and was threatening Cairo. But attacks on Rommel's overextended supply lines left him short of fuel and materiel, allowing the British to regroup near El Alamein under the sure hand of General Bernard Montgomery, known to his men as Monty. "We will finish with Rommel once and for all," he promised them.

In September, illness forced Rommel to seek treatment in Germany. Before he returned in late October, Monty launched his assault—a systematic bludgeoning that nearly finished the Desert Fox. Although Hitler ordered him to stand fast, Rommel succeeded in salvaging the battered remnants of his Afrika Korps and retreating to Tunisia. He remained a troublesome opponent there for months to come, but the tide had turned. Fresh Anglo-American forces were landing in Morocco and Algeria, and all of North Africa would soon be in Allied hands.

UP PERISCOPE
Partially concealed behind a hastily improvised rock shelter, a German forward observer peers through a periscopic instrument used to direct artillery fire.

DESERT FOX ON THE PROWL
General Erwin Rommel, sporting a jaunty plaid scarf and a pair of captured British sun goggles, leads his panzer troops across the North African desert.

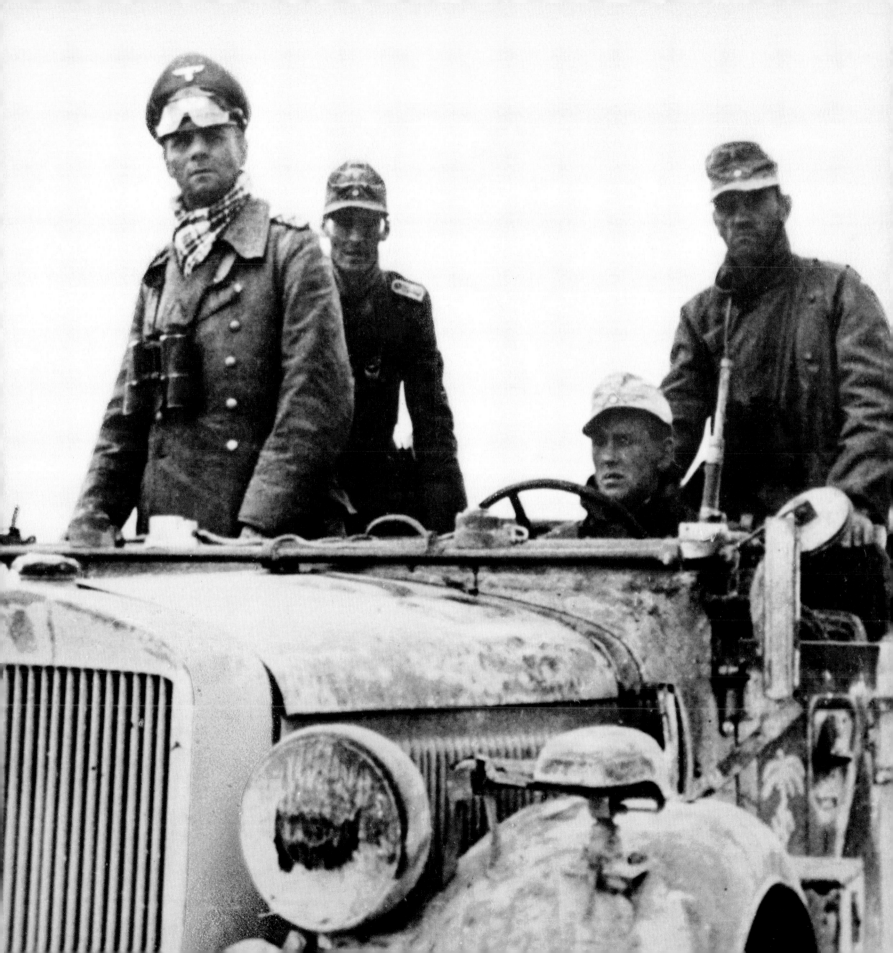

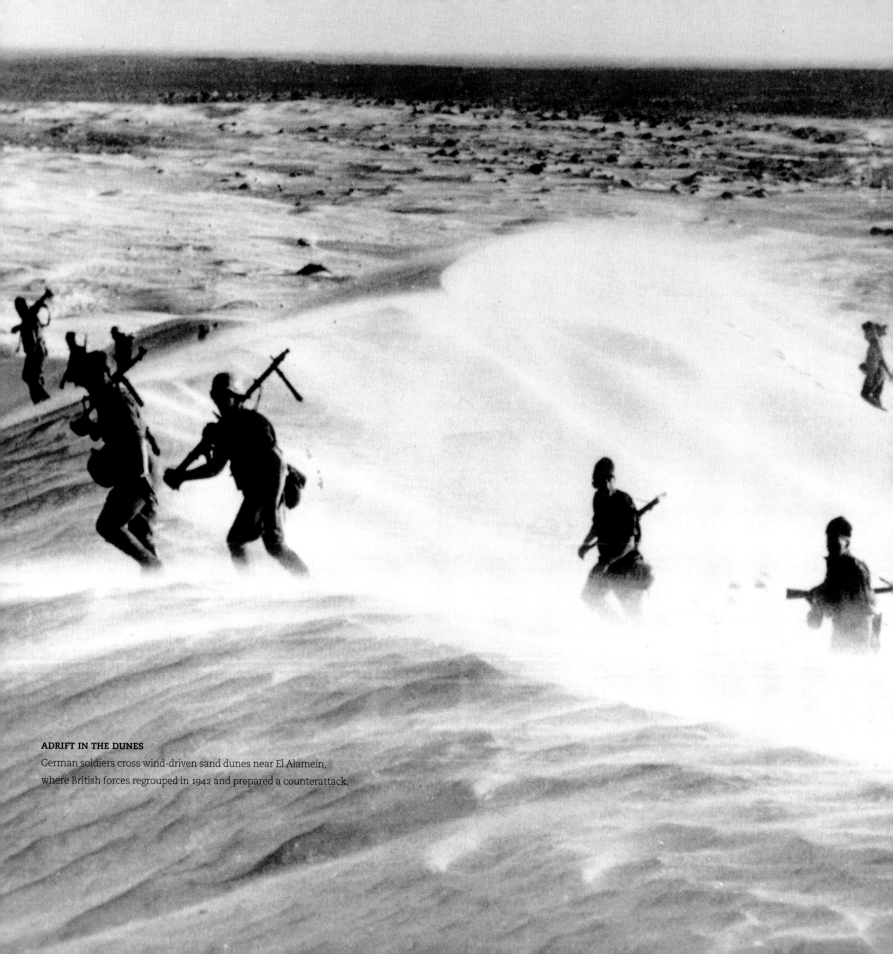

ADRIFT IN THE DUNES
German soldiers cross wind-driven sand dunes near El Alamein,
where British forces regrouped in 1942 and prepared a counterattack.

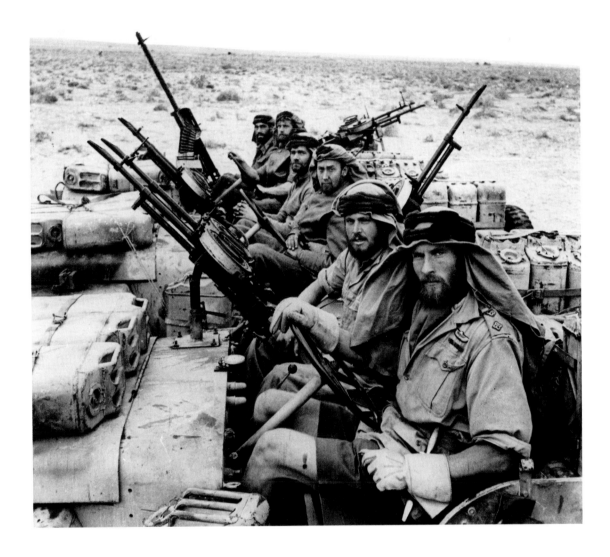

RETURN OF THE RAIDERS

Seasoned British commandos return in September 1942 from a three-month sortie into enemy territory, during which they destroyed depots and airfields behind Axis lines.

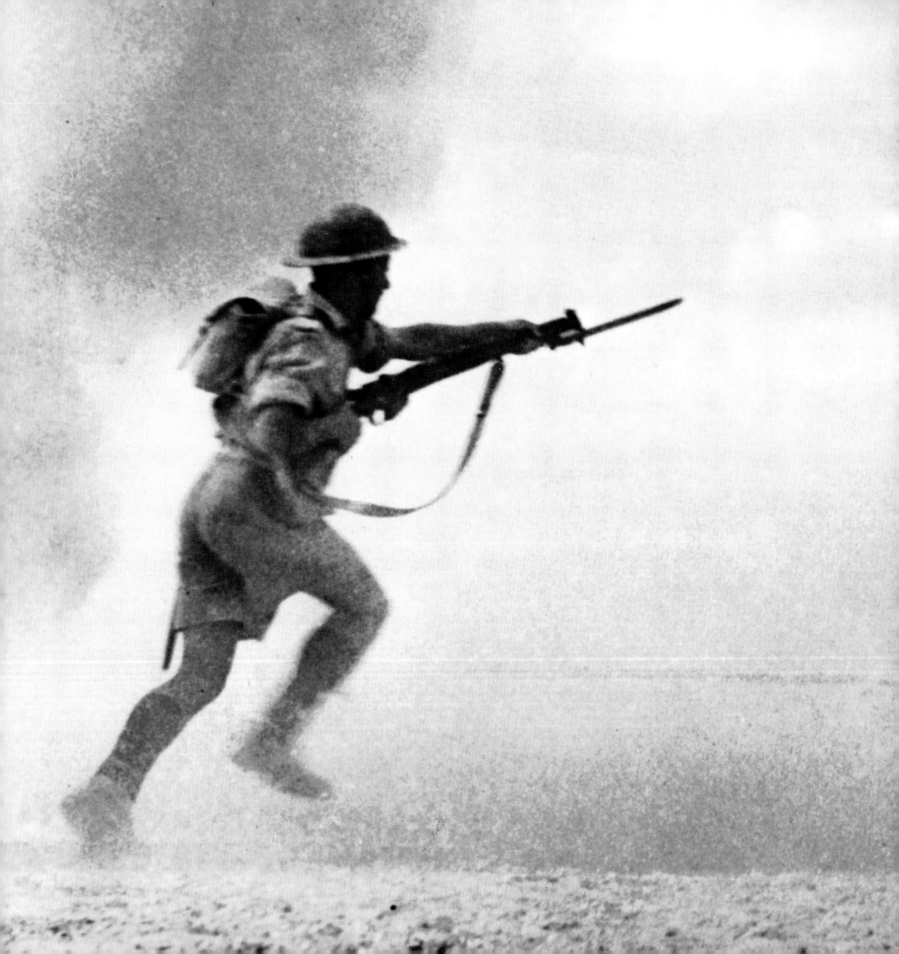

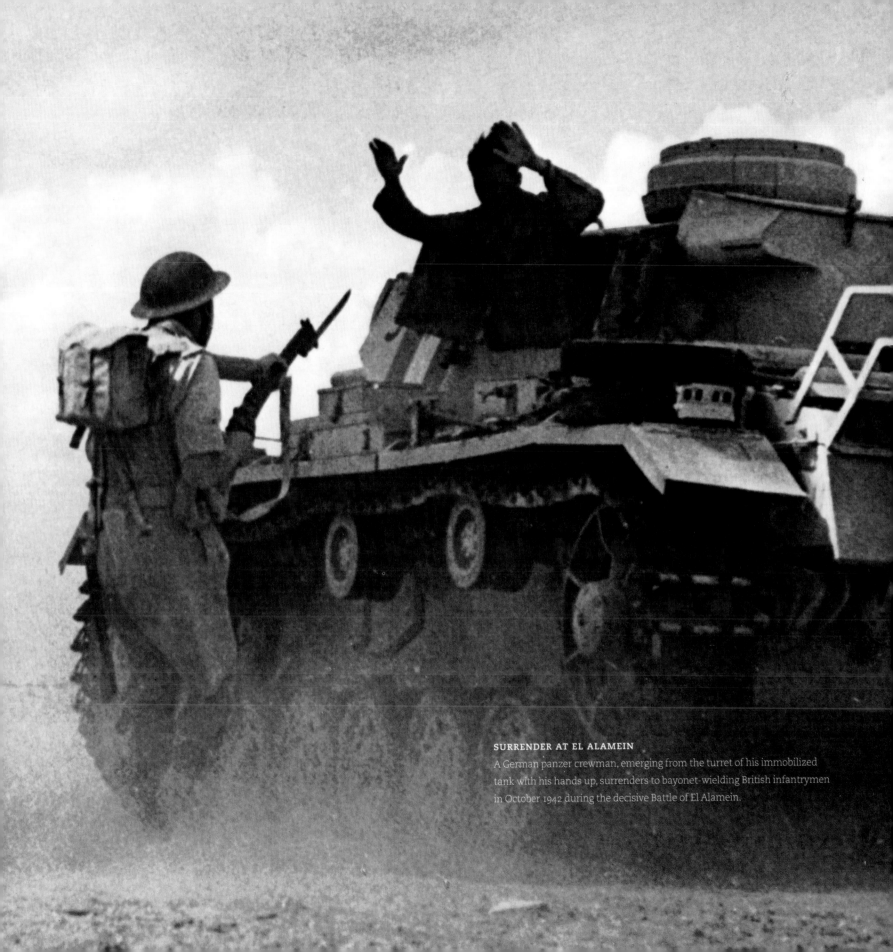

SURRENDER AT EL ALAMEIN

A German panzer crewman, emerging from the turret of his immobilized tank with his hands up, surrenders to bayonet-wielding British infantrymen in October 1942 during the decisive Battle of El Alamein.

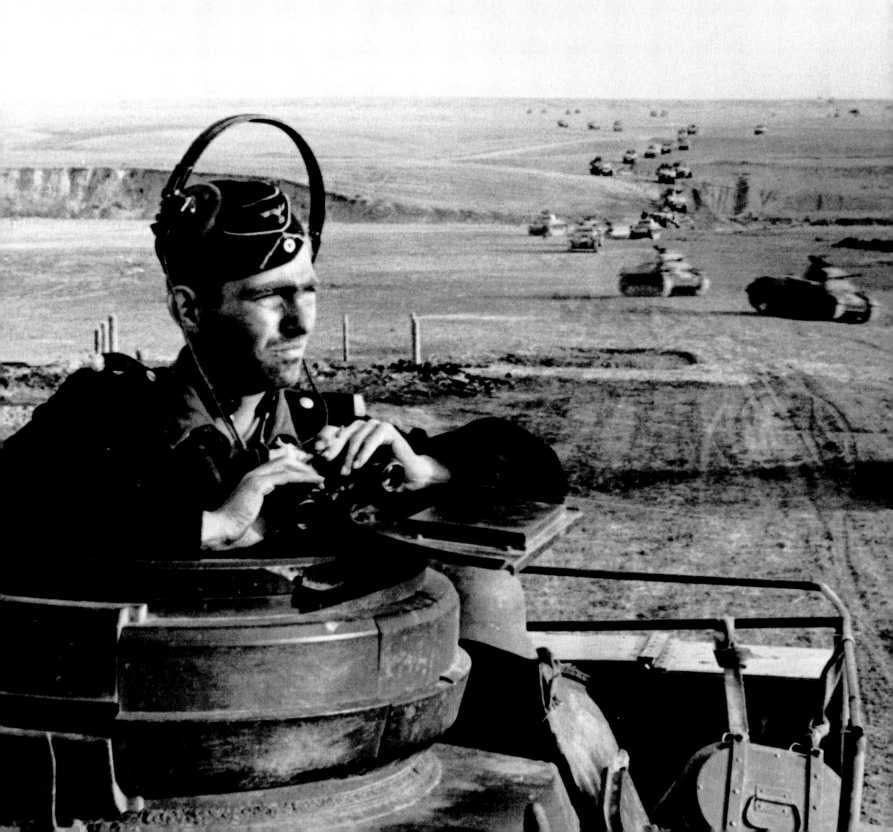

Road to Stalingrad

IN THE SPRING OF 1942, JOSEPH GOEBBELS TRIED TO PUT THE BEST FACE on Germany's bitter setback in Russia over the winter by claiming that "the Führer alone saved the Eastern Front." That, of course, was Hitler's view as well. After the Soviets counterattacked outside Moscow in December 1941 and drove the Germans back, he had issued an order forbidding any further withdrawals. Commanders who gave ground to save their units were removed from command.

By winter's end, the Germans had regrouped. Hitler came away convinced that he could still conquer Russia if he forced his generals to fight to the death and never yield ground. His plans for the summer—hatched while Rommel was advancing across North Africa toward Cairo—were typically grandiose. German forces in Russia would capture Sevastapol on the Black Sea and drive south through the oil-rich Caucasus to a hoped-for rendezvous with Rommel, whose forces would smash through Egypt and conquer the Middle East, giving Hitler a stranglehold on the region's oil supplies. Almost as an afterthought, Hitler mentioned that the heavily defended city of Stalingrad on the Volga River might have to be captured or bombarded to guard against a Soviet counterattack.

German forces succeeded in taking Sevastapol in the face of stiff resistance, but panzer divisions entering the Caucasus were plagued by rough terrain and fuel shortages and slowed to a crawl. Frustrated, Hitler shifted his attention to Stalingrad and threw his Sixth Army into the battle. Luftwaffe bombers devastated the city in August, but Germans faced fierce opposition there from defenders holed up in bunkers and blasted tenements. Then the Soviets counterattacked in November and encircled over 250,000 German troops in Stalingrad. Hitler ordered them to hold their ground and rejected any attempt to break out. In January, the desperate survivors surrendered. Hitler had sacrificed an entire army and handed Stalin a momentous victory.

ONE DEATH AMONG MANY

Above, a Russian bullet claims the life of a German soldier on the Eastern Front, where Hitler's attempt to regain the offensive in 1942 ended in disaster at Stalingrad.

OBJECTIVE STALINGRAD

A German officer keeps a sharp lookout as the 24th Panzer Division advances over barren terrain toward Stalingrad.

*"We were poor, but to the front—
we gave what we had."*

A SOVIET WORKER

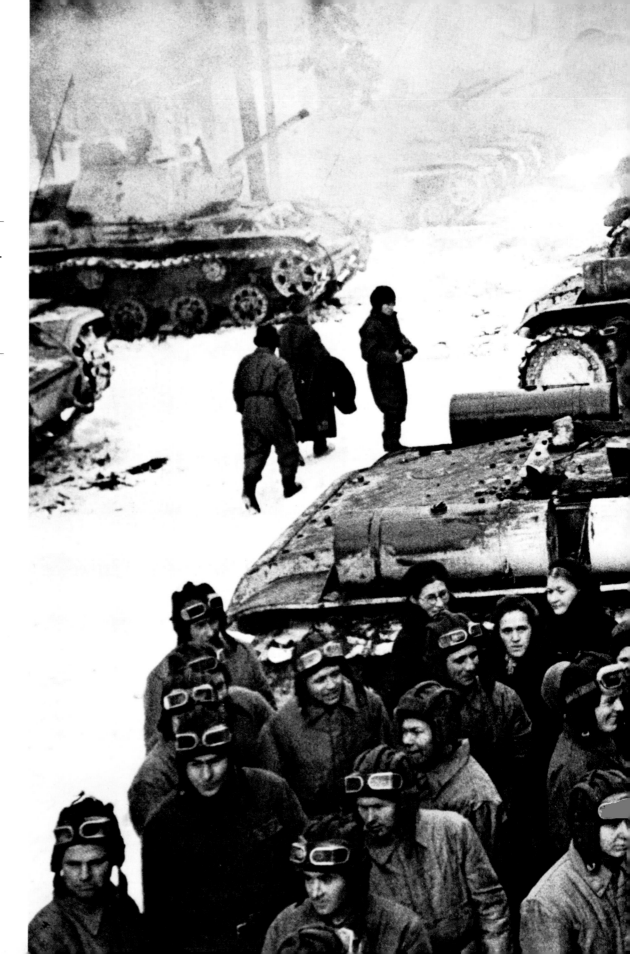

HEFTY CONTRIBUTIONS
Red Army crews gratefully accept a line of tanks
from farm workers who pooled their savings to help
pay for the weapons. Soviet citizens contributed to
the war effort nearly 10 billion rubles—the equiva-
lent of $800 million.

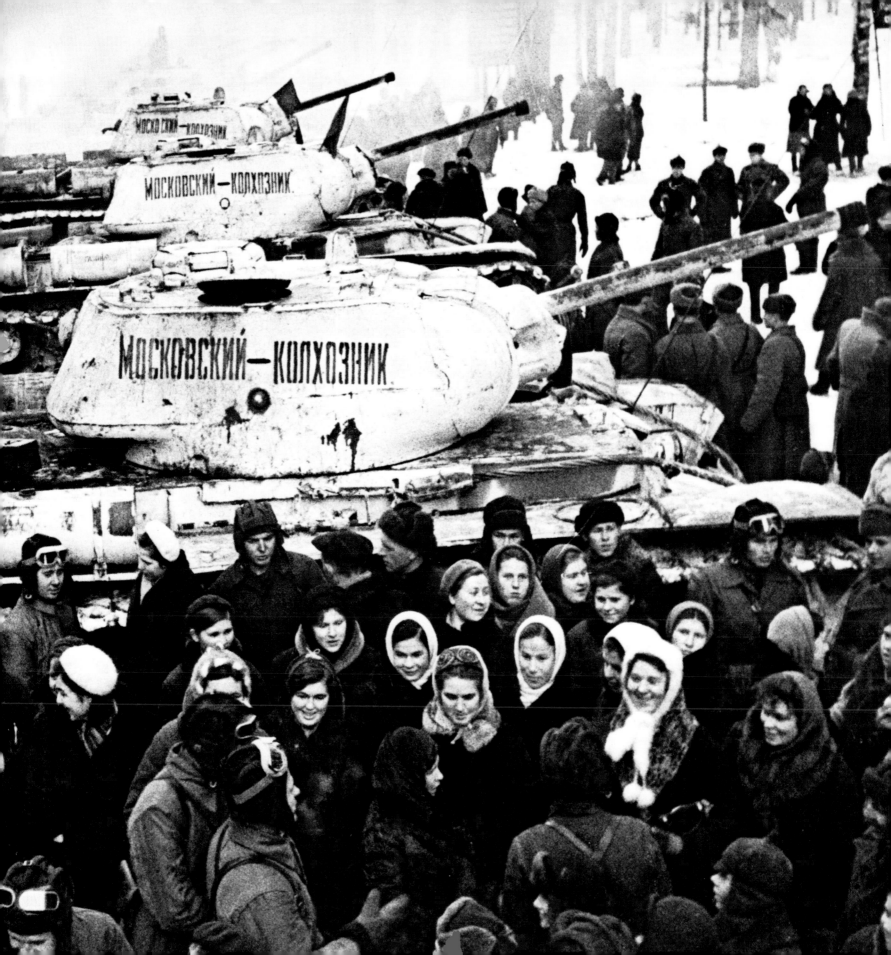

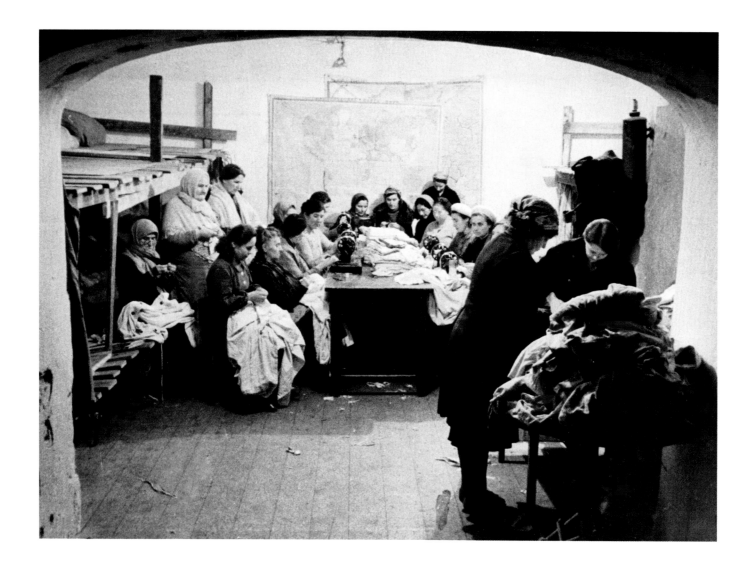

UNDER SIEGE

Members of a sewing brigade mend torn clothing for the troops defending besieged Sevastapol. The brigade repaired more than 100,000 garments before the city fell to the Germans in July.

POUNDING SEVASTAPOL

Wreathed in smoke, a hulking mortar fires one-ton shells at Sevastapol, bombarded by one of the heaviest concentrations of artillery the Germans ever assembled.

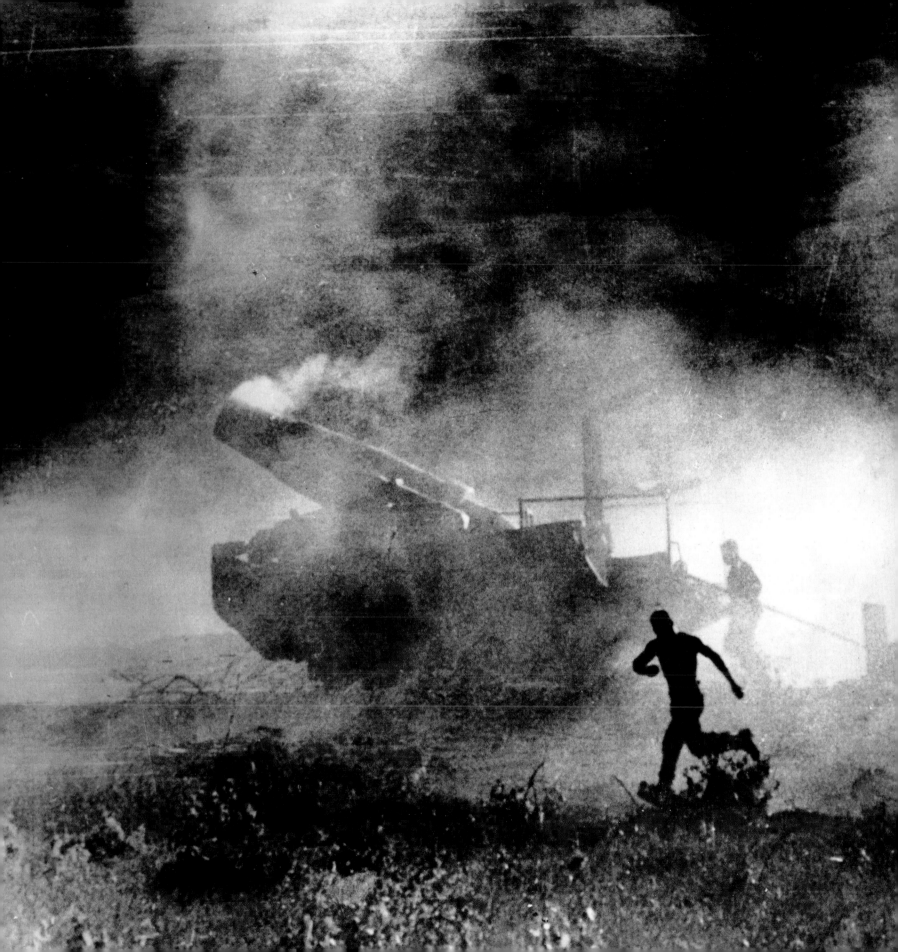

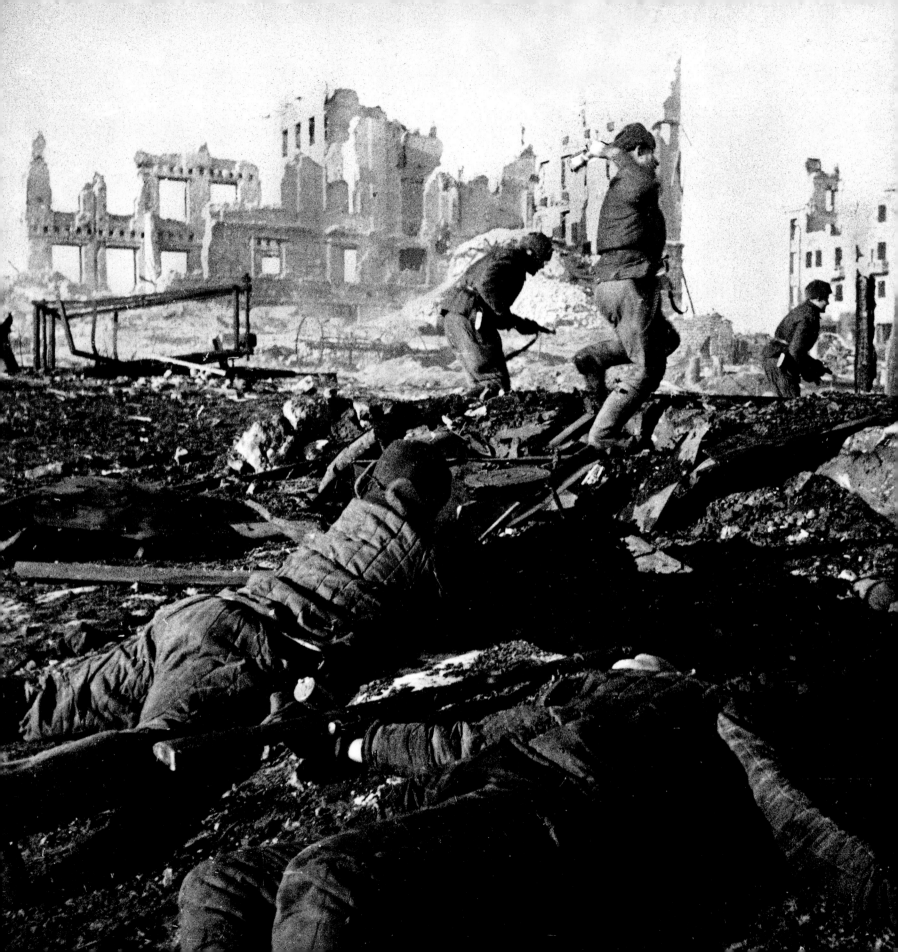

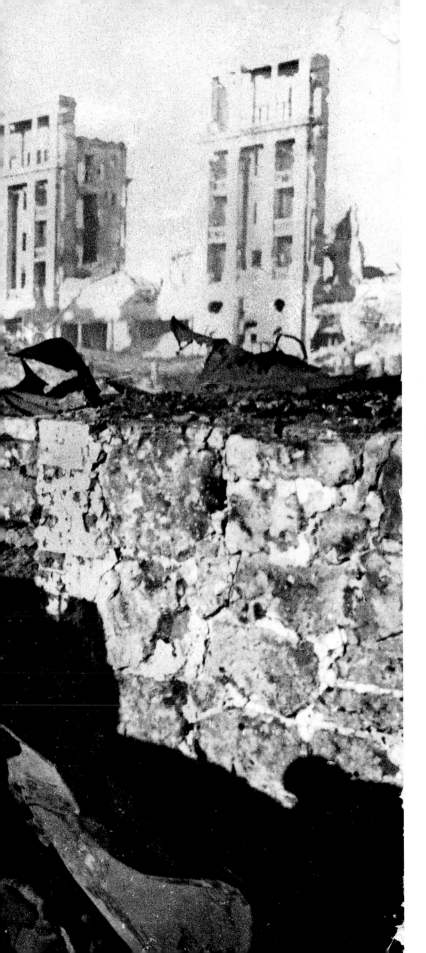

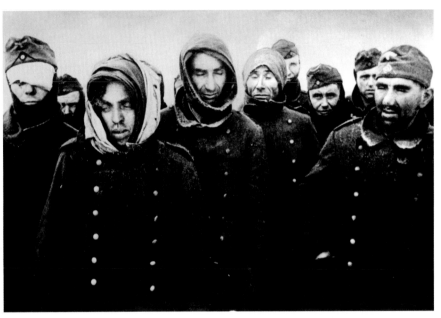

SHOWDOWN AT STALINGRAD

A Soviet victim of the fierce battle for Stalingrad sprawls in the foreground at left as his comrades advance through the rubble toward German positions in November 1942. German soldiers who were surrounded and taken captive here, like the downcast prisoners above, faced a grim future amid severe cold and Soviet neglect. Of 91,000 troops who surrendered at Stalingrad, only 5,000 would return to Germany alive.

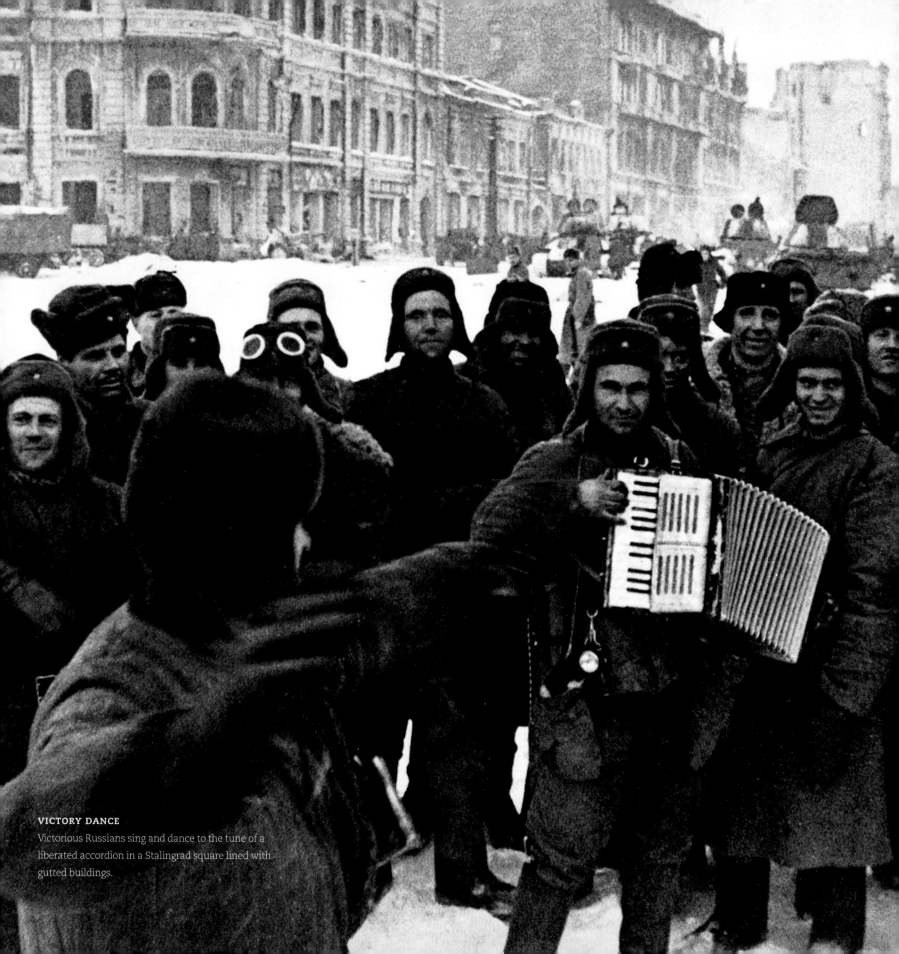

VICTORY DANCE
Victorious Russians sing and dance to the tune of a
liberated accordion in a Stalingrad square lined with
gutted buildings.

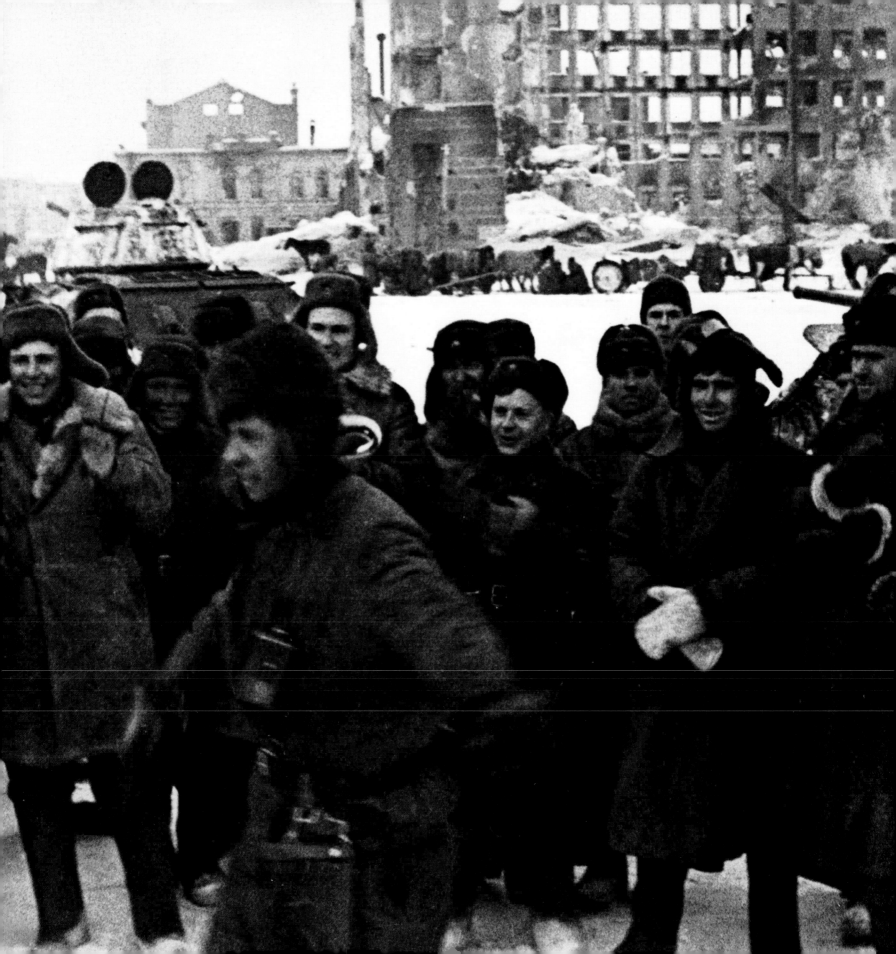

Holocaust

IN JANUARY 1942, SS SECURITY CHIEF REINHARD HEYDRICH hosted a meeting of Nazi officials in the Berlin suburb of Wannsee to implement the Final Solution: the extermination of European Jews. That fearful process was already under way. Since 1939, over a million Jews in occupied Russia and Poland had been executed by SS death squads. But such massacres were too costly and chaotic to be repeated all across occupied Europe. Heydrich proposed deporting Jews to camps to serve as slave laborers. Those who did not "fall away through natural reduction," he told the officials at Wannsee, "would have to be dealt with appropriately." His meaning was clear—Jews who did not die of disease or abuse would be put to death—and no one

objected. Hitler had imbued Nazis with a murderous contempt not just for Jews but for all those deemed "subhuman," including Gypsies, Slavs, and the mentally ill. Many in those groups would die at the hands of this ruinous Nazi regime as well. Indeed, the cyanide gas used to kill inmates in SS camps was first tested with deadly effect on mental patients.

Jews were not blind to the peril. In Warsaw, they rebelled against deportation in 1943. Those who surrendered after the Germans torched their ghetto were sent to the worst of the SS killing grounds—death camps where inmates judged fit for labor usually survived for only a few months before being herded into gas chambers like the others. Many of the six million Jews executed during the war perished at death camps like Auschwitz, but large numbers were killed as well in concentration camps like Buchenwald or Mauthausen after slaving for years amid conditions so degrading that death was almost preferable. In the words of one survivor, the aim was "to destroy our human dignity, to fill us with horror and contempt for ourselves and our fellows."

INSTRUMENT OF DEATH

The systematic brutality of the SS—symbolized by the human skull ornamenting the SS vehicle above—made the organization the perfect instrument to carry out the Nazis' horrendous Final Solution.

EVICTED FROM WARSAW

Jews evicted from the smoldering Warsaw ghetto after the uprising there in 1943 face deportation to death camps. Avraham Neyer, wearing a dark coat at right, was the only member of his family to survive.

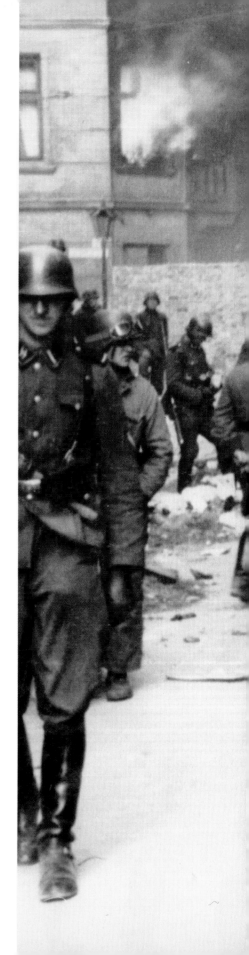

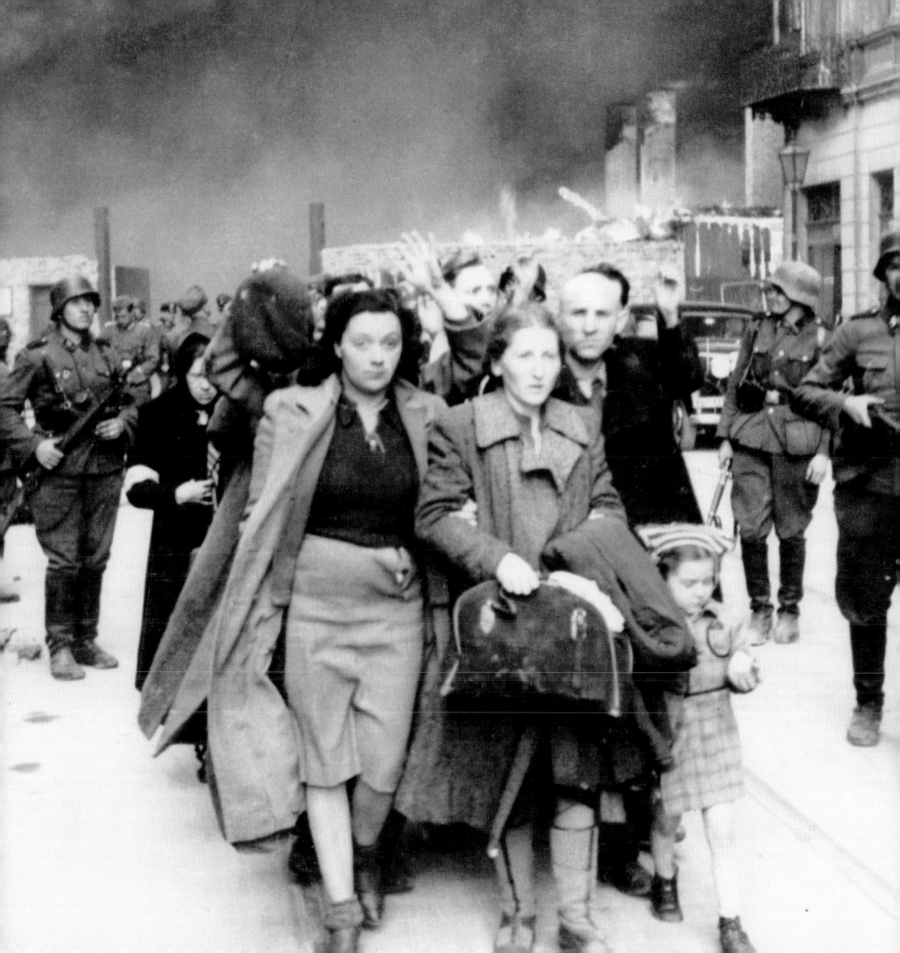

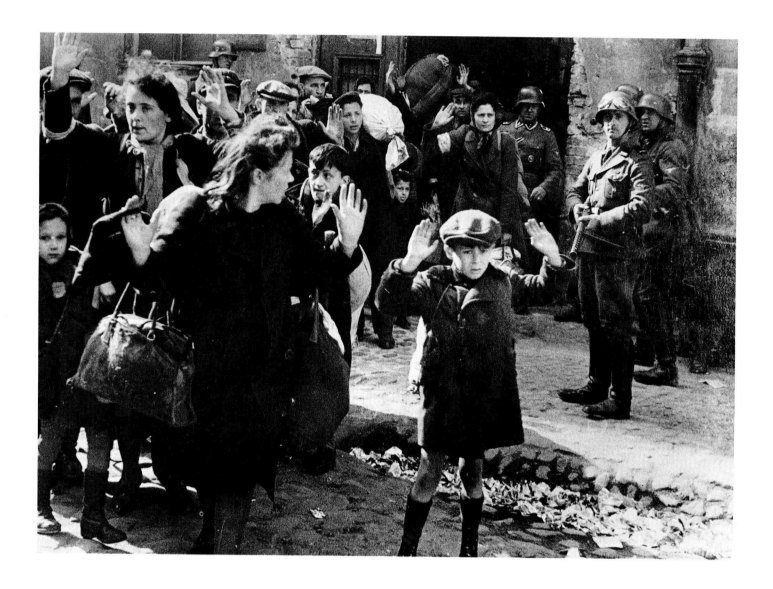

SURRENDER OF THE INNOCENT

Women and children signal their surrender after the uprising in Warsaw by holding their hands aloft. Deportees were transported to death camps in locked boxcars carrying up to 100 people each and stripped of their belongings when they reached their destinations.

ORGANIZED VIOLENCE

A rape victim in the Ukrainian city of Lvov cries out in rage and anguish as an older woman comforts her. SS officers encouraged such atrocities by local anti-Semites, who rounded up 1,000 Jews in the area and turned them over to the Germans.

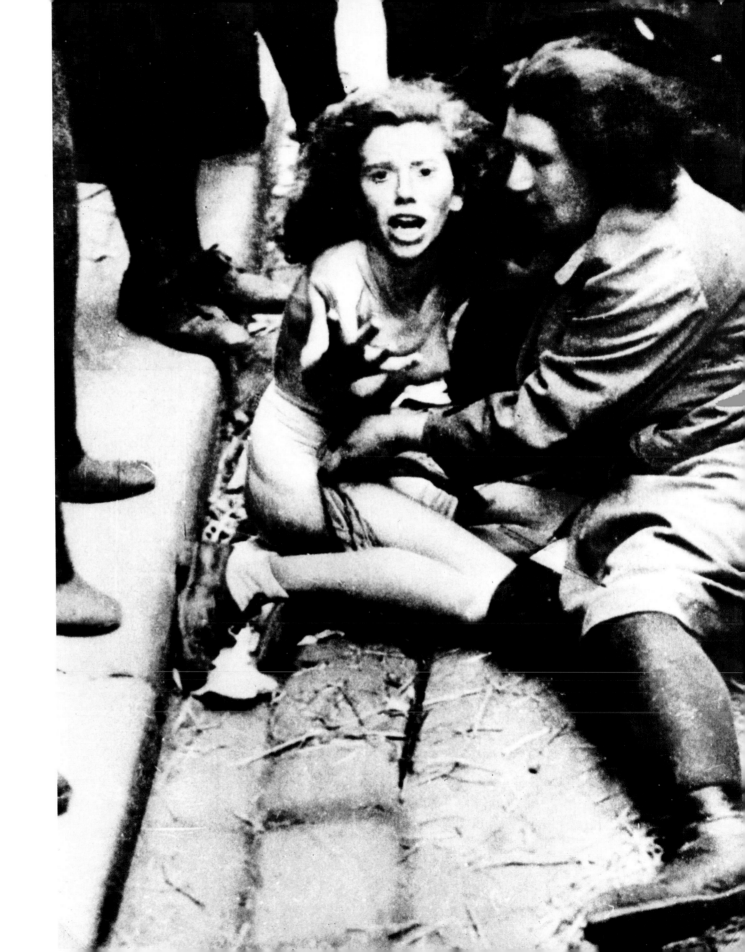

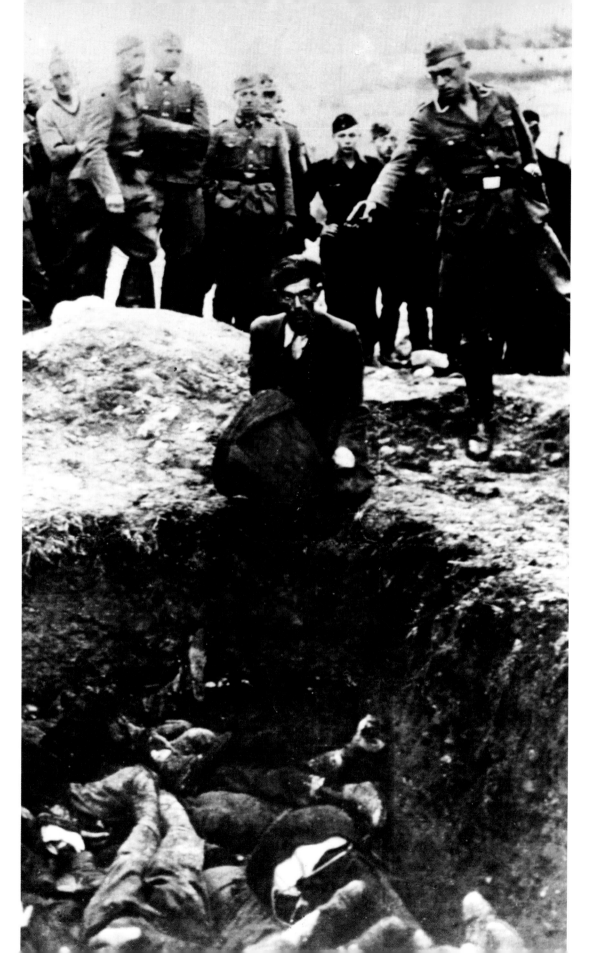

MASSACRE IN POLAND
A Polish Jew kneels before his SS executioner at the edge of a common grave filled with the bodies of earlier victims.

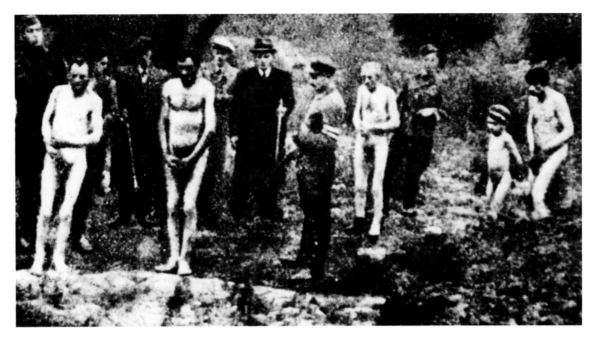

DEATH WITHOUT DIGNITY

After being forced to strip, four Jewish men and a boy from a town in Poland are brought forward for execution by a death squad.

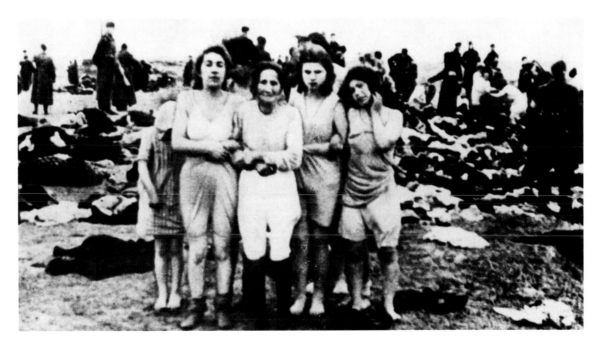

HUDDLED VICTIMS

Near the Latvian town of Lijepaja, women and girls link arms, waiting in fear. Their clothes are scattered about on the ground.

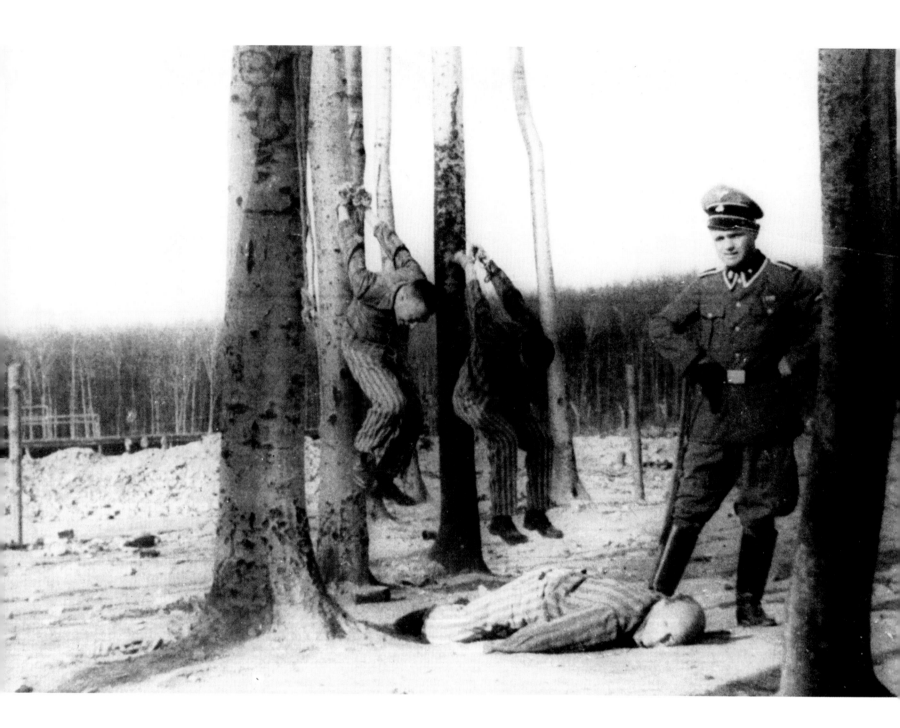

TORTURE AT BUCHENWALD

An SS guard at Buchenwald stands over a torture victim while two other inmates hang suspended by their wrists.

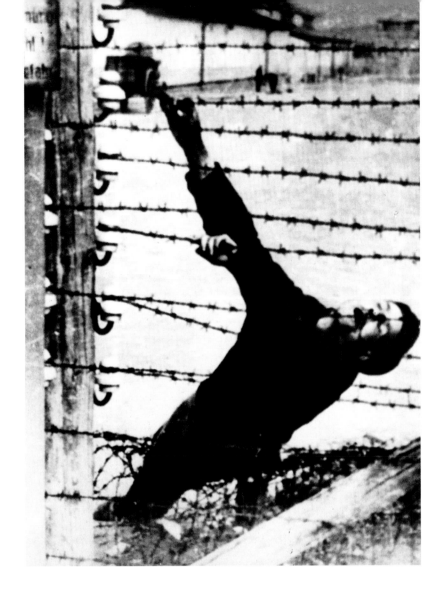

ESCAPE BY SUICIDE
An inmate who escaped the horrors of life at Mauthausen by committing suicide clasps an electrified barbed-wire fence in a death grip.

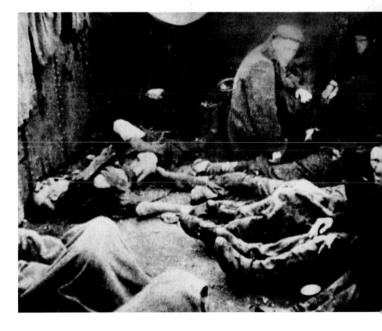

LIVING IN DEGRADATION
Weakened by hunger and illness, prisoners at the concentration camp at Sachsenhausen sprawl in their filthy quarters among the bodies of fellow inmates.

HAND OF DEATH

A lifeless hand rests on the sill of a cremation oven door in an unknown Nazi death camp. The photograph may have been taken by an SS officer recording the operation of the camp or by an Allied soldier documenting the horrors he found there.

Island Fighting

TO THE MARINES WHO LANDED ON GUADALCANAL IN AUGUST 1942, the place hardly seemed worth fighting for. "She was a mass of slops and stinks and pestilence," recalled Robert Leckie of the 1st Marine Division. Yet this forlorn Pacific island was crucial to Allied hopes of beating back the Japanese, who had occupied a vast area extending from Burma to the Gilbert Islands, midway between Australia and Hawaii. A Japanese air base under construction on Guadalcanal menaced troops and supplies bound for Australia, where General MacArthur was planning to retake the major islands of the Pacific rim—including Papua, New Guinea, and the Philippines—while the navy launched amphibious assaults on remote island chains.

Landing on August 7, marines took the air base at Guadalcanal with ease but then faced repeated assaults by the Japanese, who sent in reinforcements by sea, triggering furious naval battles. Fighting dragged on for months, with tropical diseases adding to the toll on both sides. In February 1943, the marines finally prevailed. Meanwhile, on Papua, the Japanese had beaten back an assault on their stronghold at Buna, prompting MacArthur to dispatch General Robert Eichelberger with a stern order. "I want you to take Buna, or not come back alive." Buna fell, and MacArthur's forces went on to secure New Guinea at great effort, setting the stage for an invasion of the Philippines.

Late in 1943, marines began tightening the noose on the Japanese in the central Pacific by capturing Tarawa Atoll on the Gilbert Islands in a chaotic battle that left over 1,000 Americans dead. In 1944, island-hopping invasion forces would seize Guam and Saipan in the Marianas. From there, long-range bombers would begin pounding Japan—even as U.S. submarines preyed on the remnants of Japan's navy and devastated its merchant fleet. After 1943, American subs sank so many tankers that only one-tenth of Japan's oil reached port.

SEVERED IN A SAVAGE CONFLICT

The charred head of a Japanese soldier propped on a burned-out tank offers grim testimony to the brutal island fighting that began with the American assault on Guadalcanal in 1942.

TAKING TARAWA

Marines storm a well-camouflaged blockhouse and drop grenades and dynamite charges through air vents to rout Japanese defenders on Betio Island in the Tarawa Atoll in November 1943.

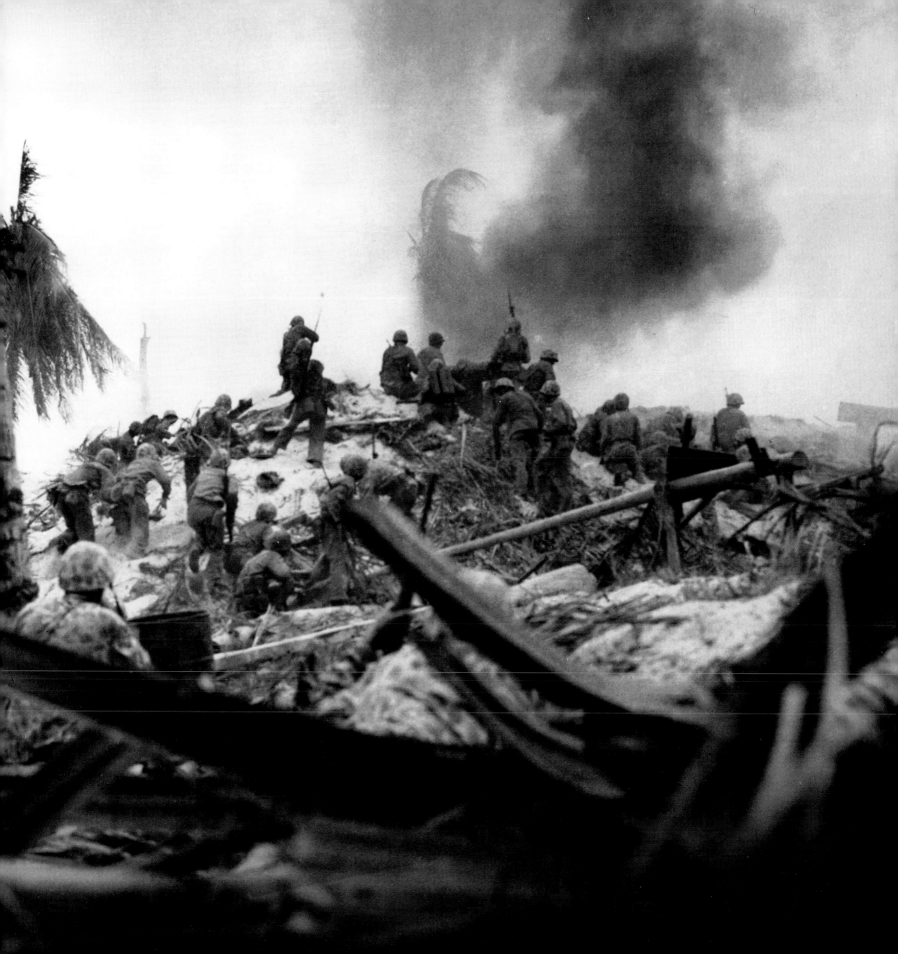

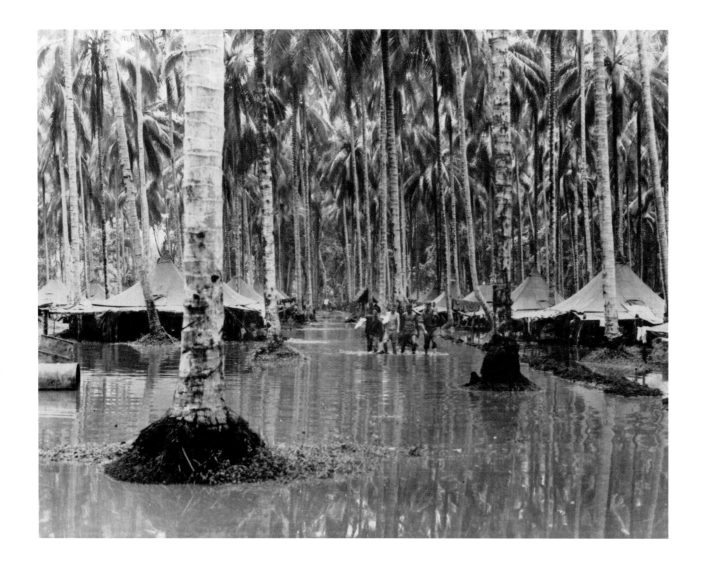

PESTILENTIAL HEADQUARTERS

Marines slog through their waterlogged headquarters on Guadalcanal, where
malaria claimed more American casualties than the Japanese did.

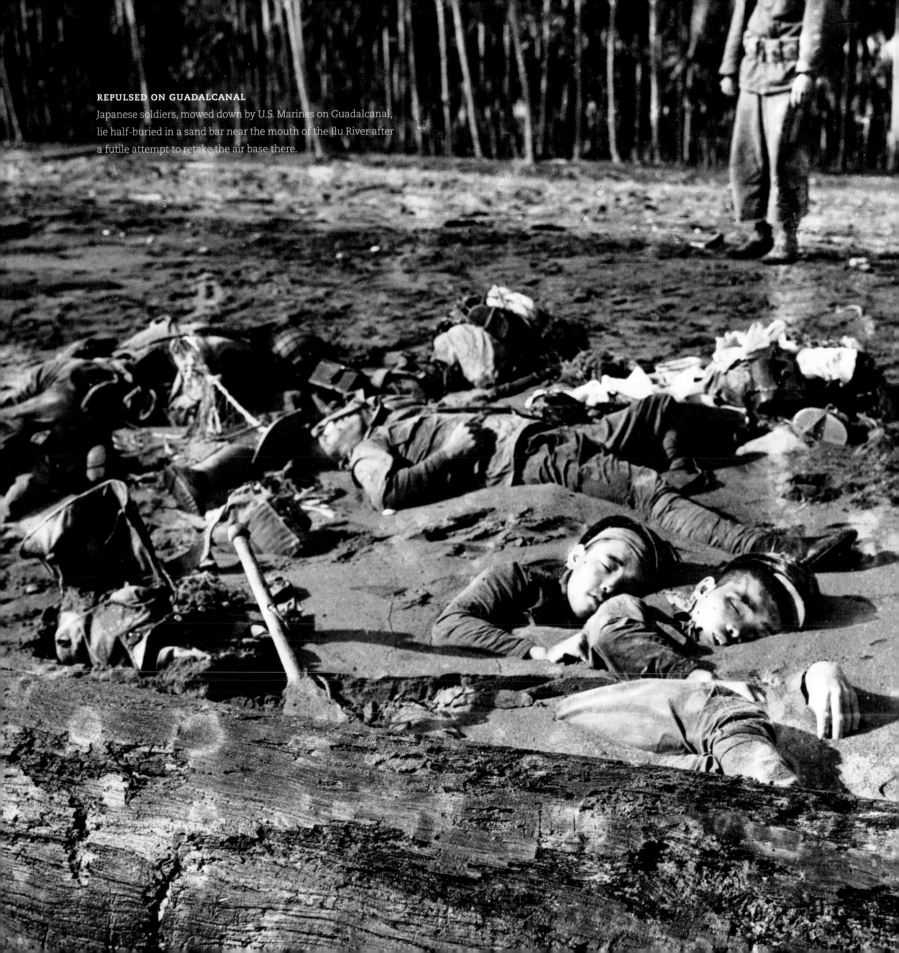

REPULSED ON GUADALCANAL
Japanese soldiers, mowed down by U.S. Marines on Guadalcanal, lie half-buried in a sand bar near the mouth of the Ilu River after a futile attempt to retake the air base there.

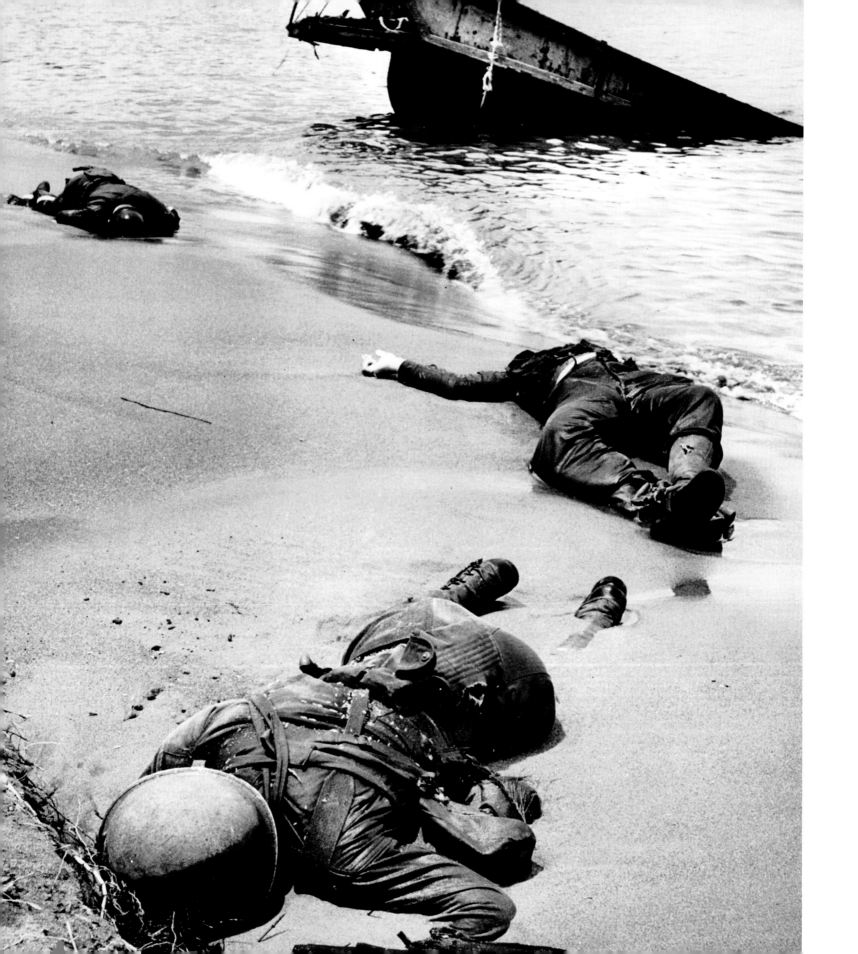

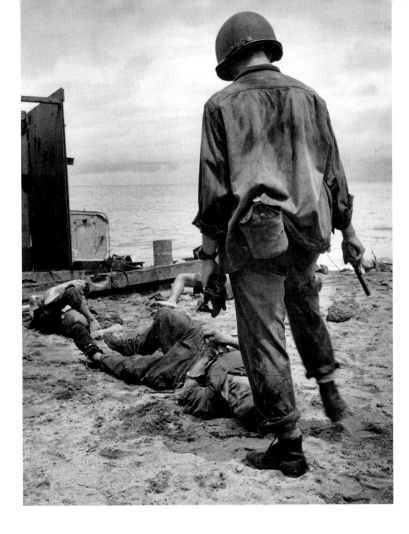

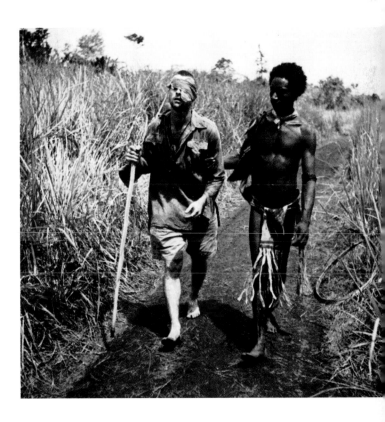

CONFRONTING THE ENEMY
Pistol in hand, an American soldier warily approaches fallen enemy snipers near Buna in Papua, where some Japanese stubbornly held out long after Buna fell in January 1943.

ACT OF MERCY
An Australian soldier wounded in the fighting near Buna is guided to safety by a Papuan (*right*) who found him—partially blind and left for dead—in a thicket. The Papuan led him through jungles and over rivers for two days and nights before reaching an Allied camp.

THE PRICE OF VICTORY
Crawling with maggots, the corpses of three American soldiers killed by fire from a hidden machine-gun nest lie sprawled on the wet sand of Buna Beach.

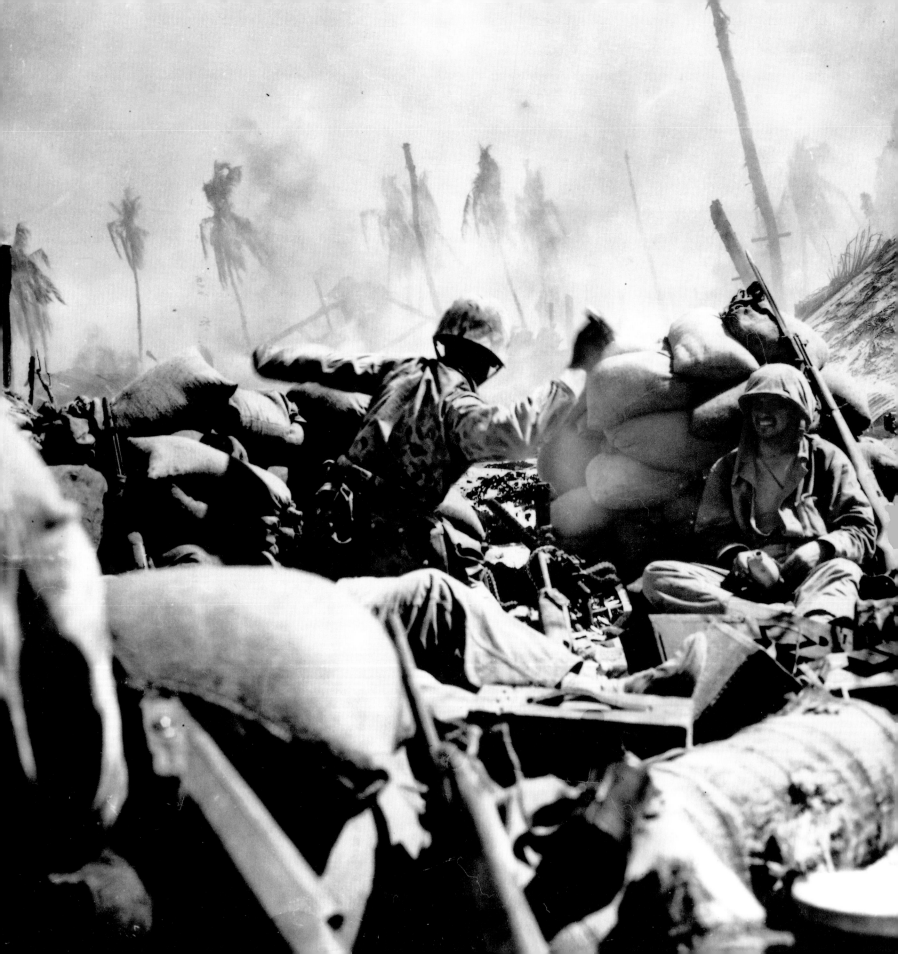

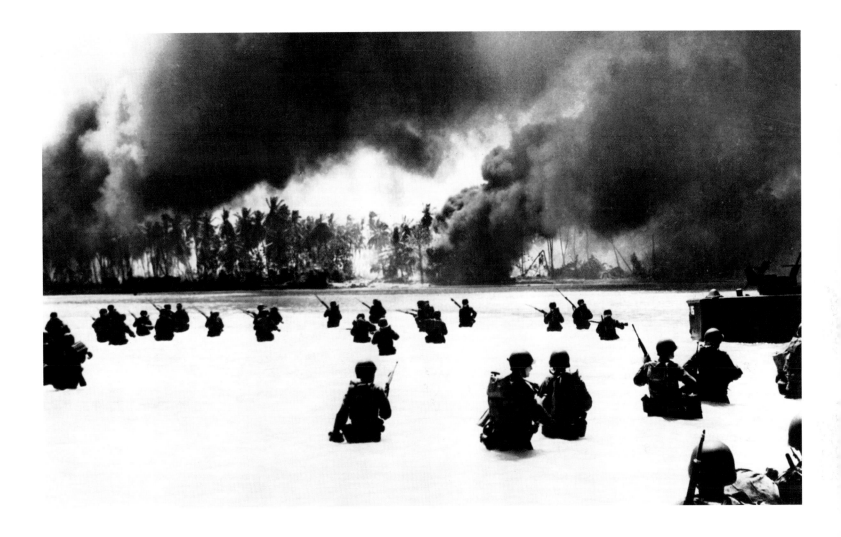

ORDEAL AT TARAWA

Protected by sandbags, a marine hurls a grenade as an exhausted buddy takes a breather during the ferocious fighting at Tarawa in late 1943.

AN INAUSPICIOUS LANDING

Smoke billows menacingly from flaming Japanese oil dumps as men of the U.S. 27th Infantry Division wade ashore at Butaritari Island on Makin Atoll, neighboring Tarawa. Although they outnumbered the Japanese troops by more than 20 to 1, the untested Americans took four days to capture Makin and suffered 218 casualties.

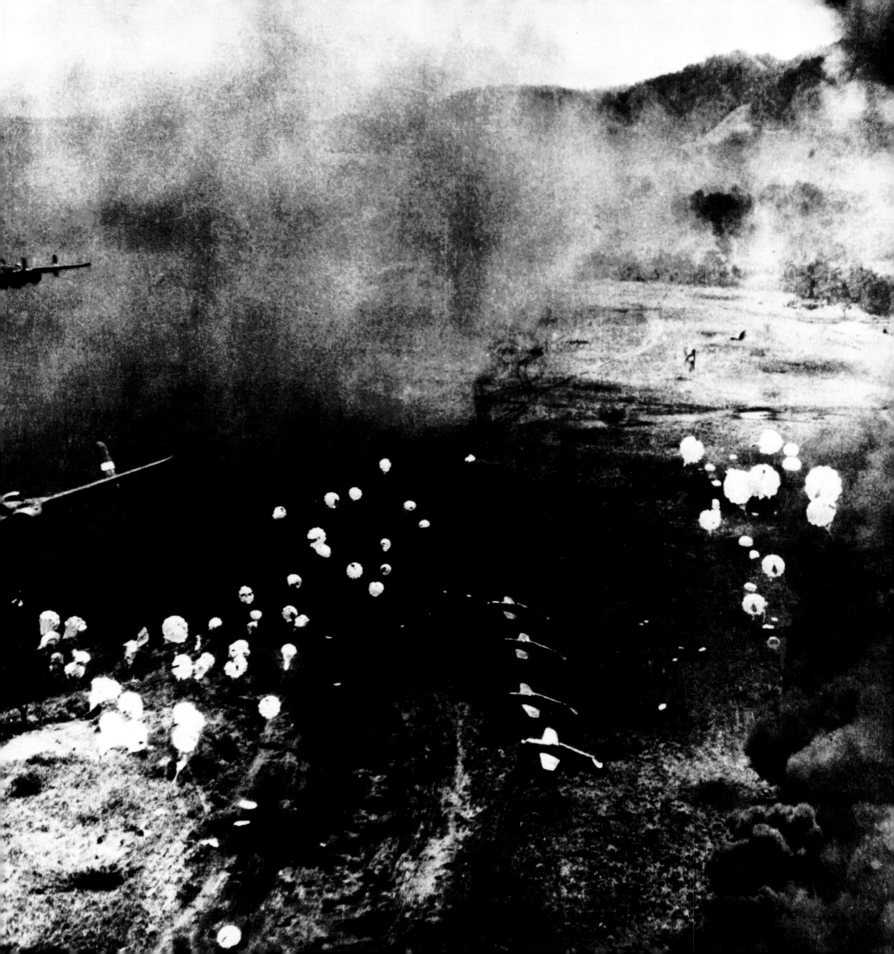

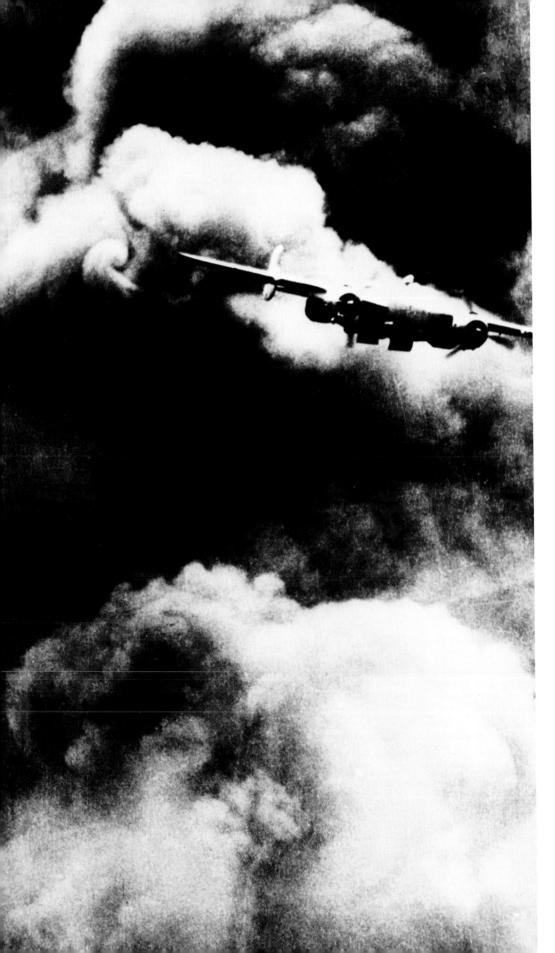

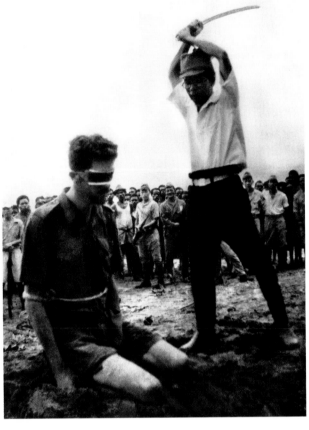

MILITARY INJUSTICE

A Japanese executioner prepares to behead an Australian pilot downed and captured in New Guinea. Japanese regulations governing prisoners of war prescribed "immediate death" for such offenses as speaking or moving about without first obtaining permission.

TARGETING A STUBBORN FOE

Low-flying U.S. Fifth Air Force B-25s plaster the Japanese airstrip at Dagua, New Guinea, in 1944 with "parafrags," fragmentation bombs attached to parachutes to give bombers time to escape the blast. Japanese resistance remained intense on New Guinea until August 1944.

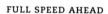

"There's no better morale booster than the sound of your own torpedo exploding against an enemy ship."

U.S. SUBMARINE SKIPPER
IN THE PACIFIC

FULL SPEED AHEAD
On war patrol in the western Pacific, the American submarine *Batfish* slices ahead at high speed while an officer scans the horizon for enemy ships. As the war progressed, the Japanese navy dwindled and U.S. subs found other targets, seeking out the tankers that fueled enemy resistance.

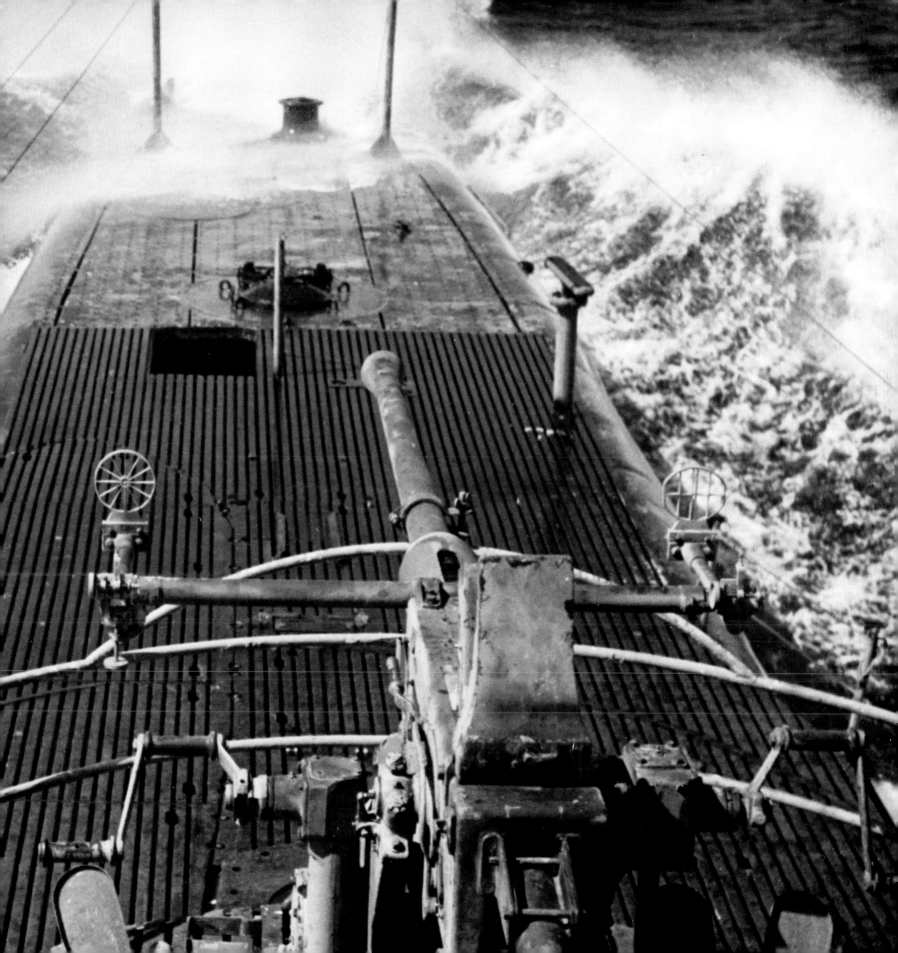

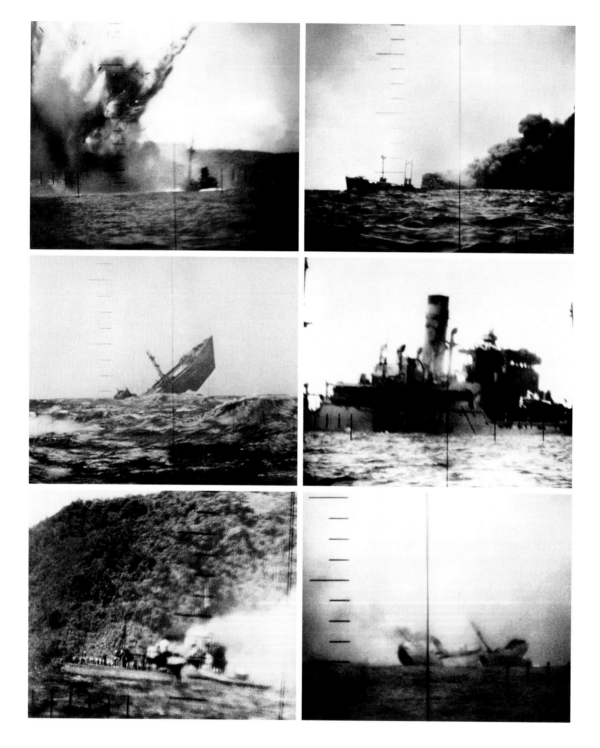

CAUGHT IN THE PERISCOPE

Periscope photographs taken from U.S. submarines record the violent deaths of torpedoed Japanese vessels, including warships, freighters, troop transports, and tankers. In one shot, sailors in distress line the deck of a destroyer (*bottom, far left*) burning off an island north of New Guinea.

China, Burma, India

THE FATE OF THE THREE COUNTRIES WAS SO CLOSELY LINKED that the Allies saw them as one operation: CBI, or China-Burma-India. China had been at war since 1937, when Japanese troops brutally occupied its populous eastern region. Chiang Kai-shek, China's Nationalist leader, had moved his capital to Chungking in the west, but that city too came under attack in orchestrated air raids that reached a bloody crescendo in 1941. Supplies for Chiang's army came from the British colony of Burma along the 680-mile-long Burma Road. When Japan invaded Burma in December 1941 and severed that supply route, British India became the Allies' last bastion in Asia—a staging ground for efforts to recapture Burma and sustain opposition in China.

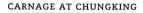

The senior American officer in CBI was General Joseph Stilwell, in command of Chinese forces sent to keep the supply line open. Stilwell reached Burma as Japanese were overrunning the country in early 1942 and eluded capture by leading soldiers and civilians on a harrowing 200-mile trek to India. He refused to celebrate their escape. "We got run out of Burma," he declared, vowing to "go back and retake it." Among the assets he had to work with were daring American fighter pilots called the Flying Tigers and two outfits trained to operate behind enemy lines—the British-led Chindits and Americans known as Merrill's Marauders.

In early 1944, Stilwell and company reclaimed northern Burma from the Japanese, enabling the Allies to increase the flow of supplies from India to China, which were moving by air over the towering Himalayas. Now aid could be funneled to the Nationalists by a road from Ledo in India that linked up with the Burma Road near the Chinese border. Those supplies helped Chiang Kai-shek avoid utter defeat and kept 25 Japanese divisions tied down in China while Americans forces in the Pacific were closing in on Japan.

CARNAGE AT CHUNGKING

Dead bodies are heaped outside a shelter in Chungking, the Chinese wartime capital, after civilians there panicked during a Japanese air raid in June 1941. Four thousand people suffocated or were trampled to death.

REDUCED TO RUBBLE

Smoke from firebombs fills the sky over Chungking after a blistering Japanese attack on June 15, 1941. By 1942, a third of the city had been leveled and much of the rest was damaged.

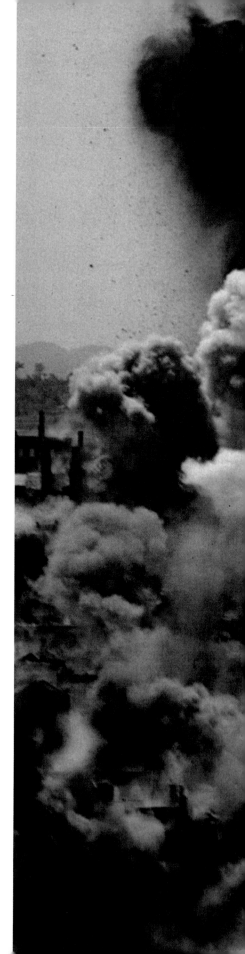

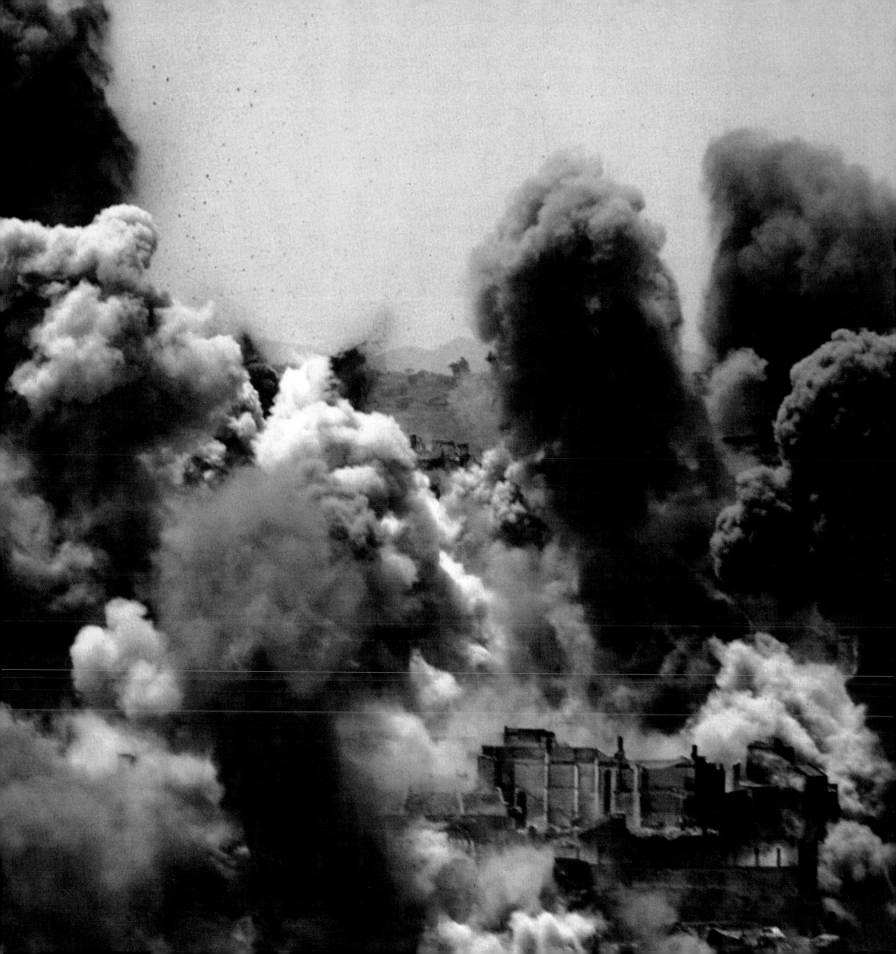

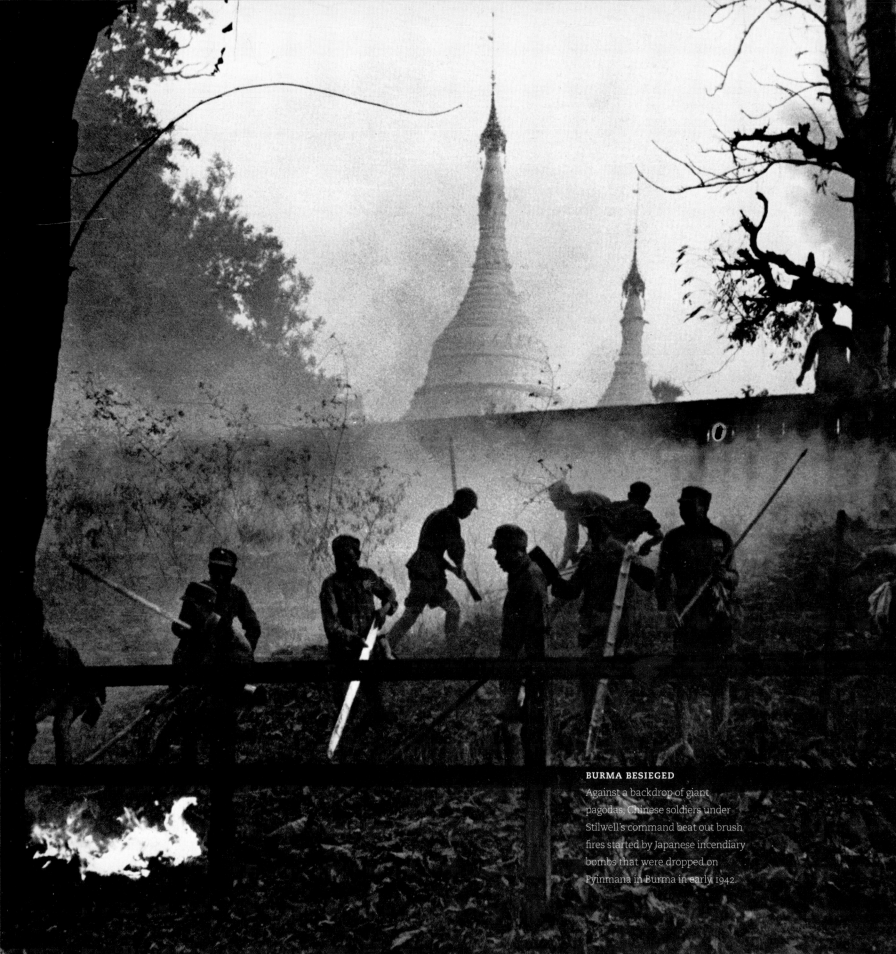

BURMA BESIEGED
Against a backdrop of giant pagodas, Chinese soldiers under Stilwell's command beat out brush fires started by Japanese incendiary bombs that were dropped on Pyinmana in Burma in early 1942.

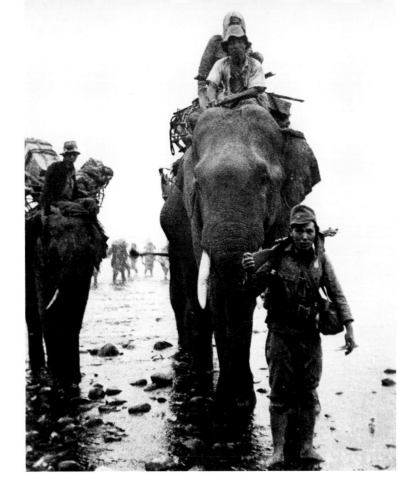

LUMBERING TRANSPORTS
Japanese soldiers in Burma ford a shallow, boulder-strewn stream on elephants, which were commandeered to transport the troops across the rugged terrain.

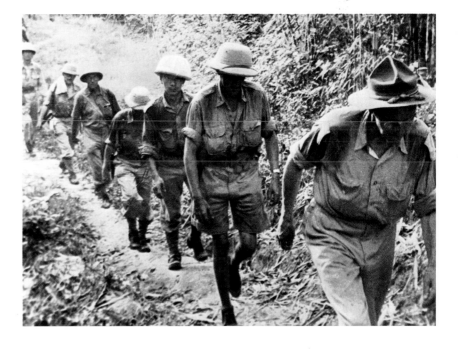

STILWELL'S EXODUS
"Vinegar Joe" Stilwell leads his exiles along a jungle trail in Burma to safety in India. The thought of what might happen to them if captured, he said, made his "guts turn to water."

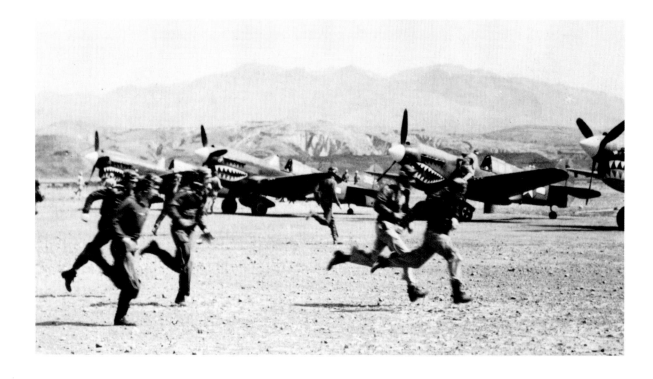

SCRAMBLING TIGERS

Flying Tigers at a base in western China scramble for their P-40 fighters, emblazoned with shark's teeth.

OVER THE HUMP

A C-46 transport carrying supplies to the Nationalists in China descends over rooftops to the Kunming airstrip there. At the peak of the airlift operation, pilots made 650 flights a day from India to China over the Hump, as they referred to the Himalayas.

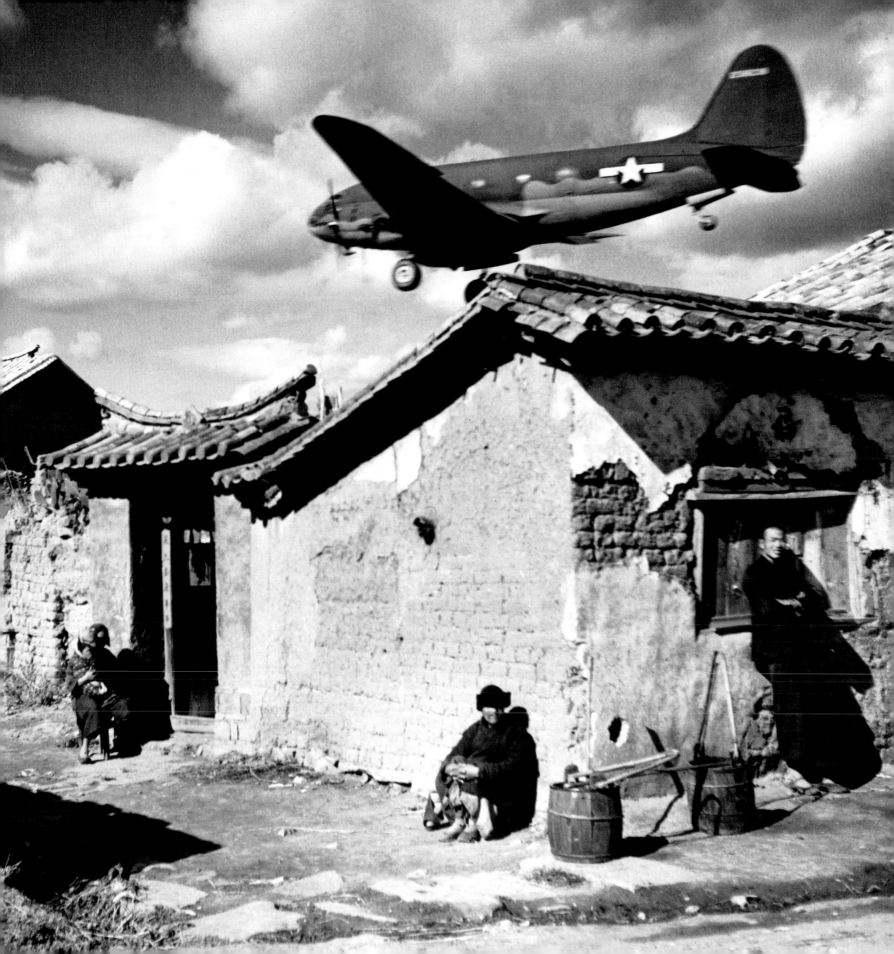

A SINUOUS SUPPLY ROUTE

A U.S. Army convoy destined for supply-starved Chungking snakes its way up a hillside in China late in the war after engineers rebuilt the Ledo-Burma Road.

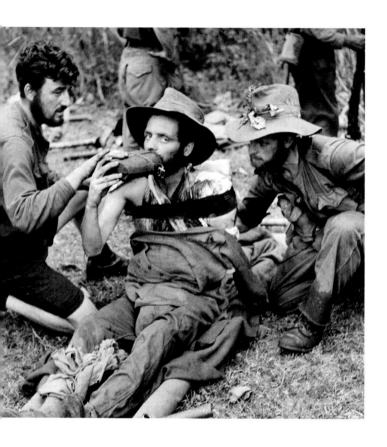

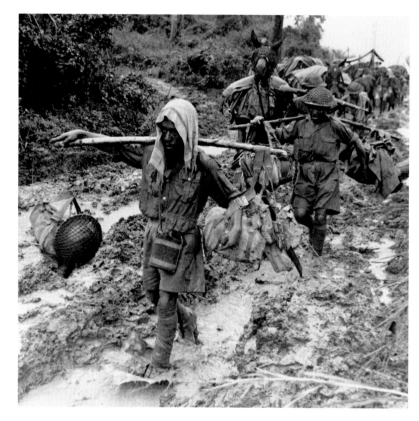

CARING FOR THEIR OWN

Chindits of the 77th Indian Infantry Brigade, organized by the British in 1942 for operations behind Japanese lines, look after a wounded comrade during a foray.

MUDDY ROAD TO CHINA

Reinforcements from India bound for China follow the Ledo Road to the Burma Road, carrying their worldly goods on poles as they slog along the monsoon-drenched path in October 1944. Up to 300 inches of rain fell here between May and September, transforming the road into a river.

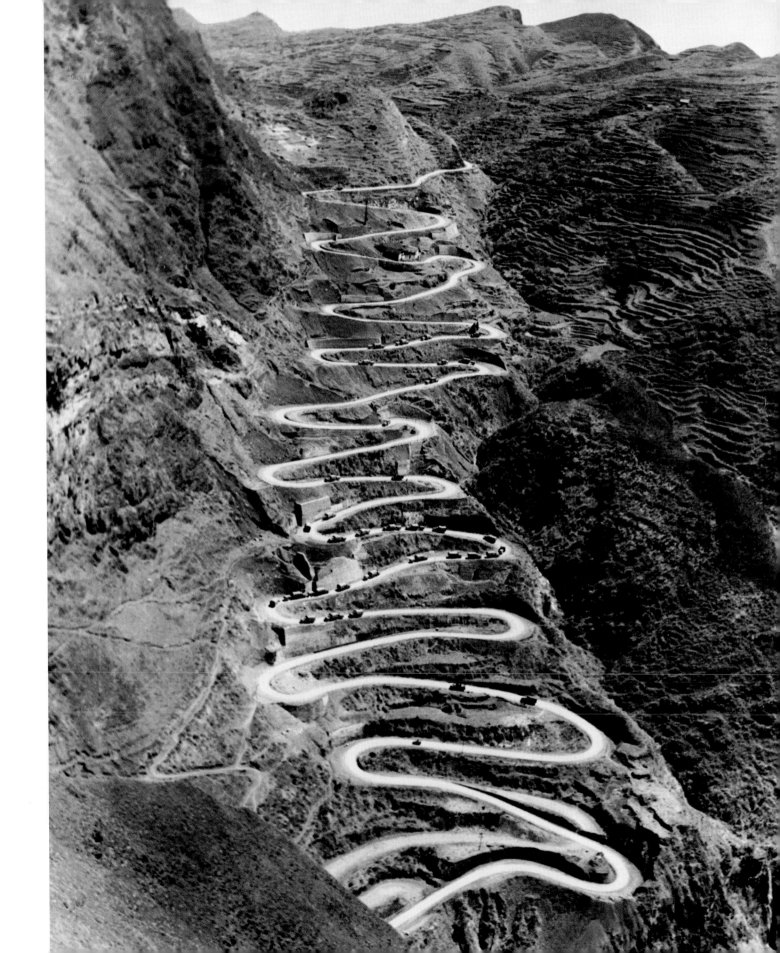

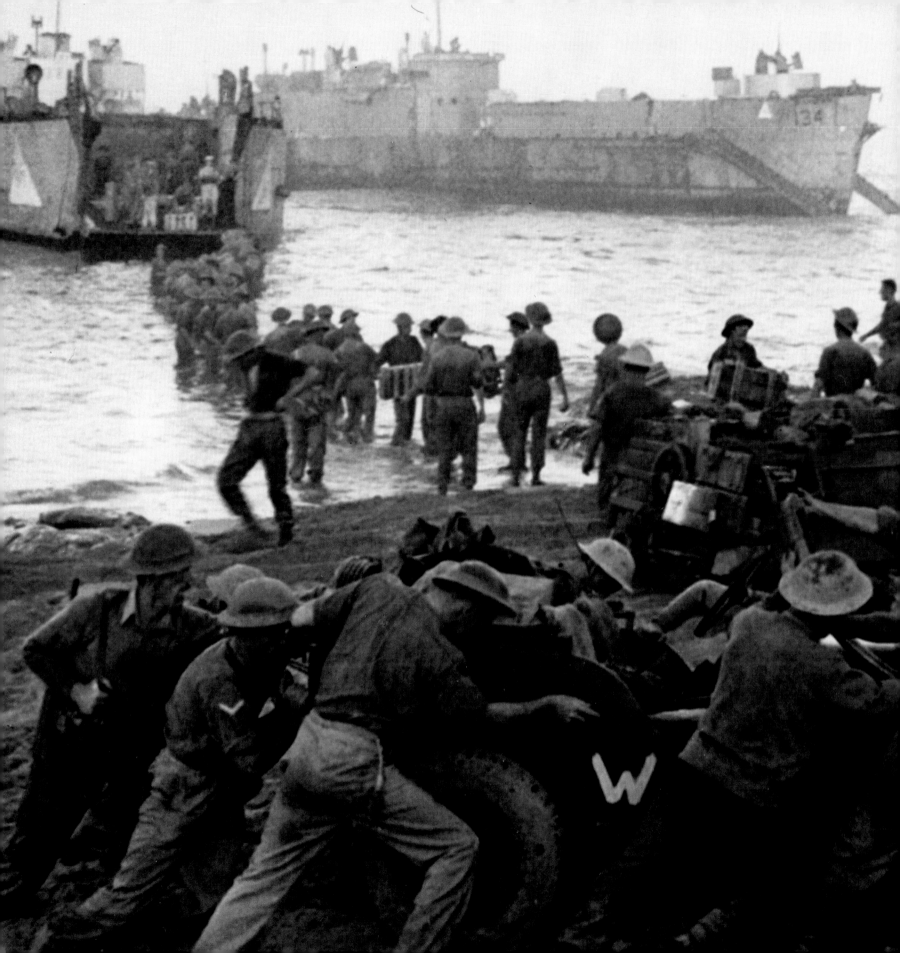

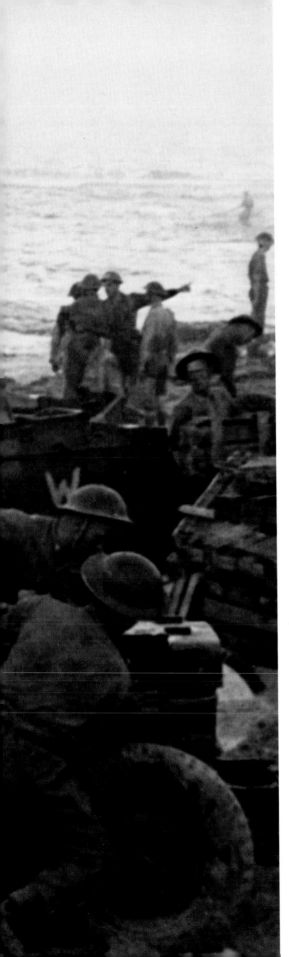

Italian Campaign

IN JULY 1943, AN INVASION FLEET OF OVER 3,000 SHIPS carrying 80,000 Allied troops and 7,000 vehicles from North Africa approached the shores of Sicily. It was a huge commitment that some considered a mistake. At a meeting of Anglo-American leaders in Casablanca earlier in the year, U.S. Army chief George Marshall had urged the Allies to ignore Italy and seek the shortest route to Germany by invading France in 1943. But Churchill had persuaded Roosevelt that more time was needed to prepare for that invasion. Meanwhile, Allied troops in North Africa would take Sicily and, if all went well, cross to the Italian mainland. Several divisions would then be pulled out to bolster the invasion of France. From start to finish, this grueling Italian campaign was a massive diversion, aimed at toppling Mussolini's regime and forcing Hitler to defend Italy in depth with German forces who might otherwise oppose the main Allied thrust through France.

Mussolini's weak grip on his war-weary populace soon became obvious. German forces in Sicily fought harder against the invasion than their Italian allies, and many civilians hailed the Allies as liberators. Shortly after American tanks rolled through Palermo on July 23, Mussolini was deposed. Hitler would later rescue him from prison and set him up as a puppet in northern Italy, but he would die at the hands of his own people at war's end. Mussolini's successor in 1943 surrendered to the Allies, prompting Hitler to seize control of Italy in September. Allied forces who crossed from Sicily that month faced stiff opposition from German troops who grudgingly abandoned Naples but barred the way to Rome by fiercely defending the mountain stronghold of Cassino. Not until 1944 did Allied forces enter the Italian capital—just days before what Marshall called the war's "main plot," the invasion of France, unfolded on the beaches of Normandy.

A LABORIOUS LANDING

Safely ashore on Sicily in July 1943, British troops push a stalled, driverless jeep as comrades form a chain to unload a supply craft.

BOYS IN BATTLE

A trio of Italian snipers—the youngest only nine years old—stands ready for action in Naples, where hundreds of youths took up arms against the Germans before the Allies entered the city on October 1, 1943. One school lost 20 boys between the ages of 14 and 20.

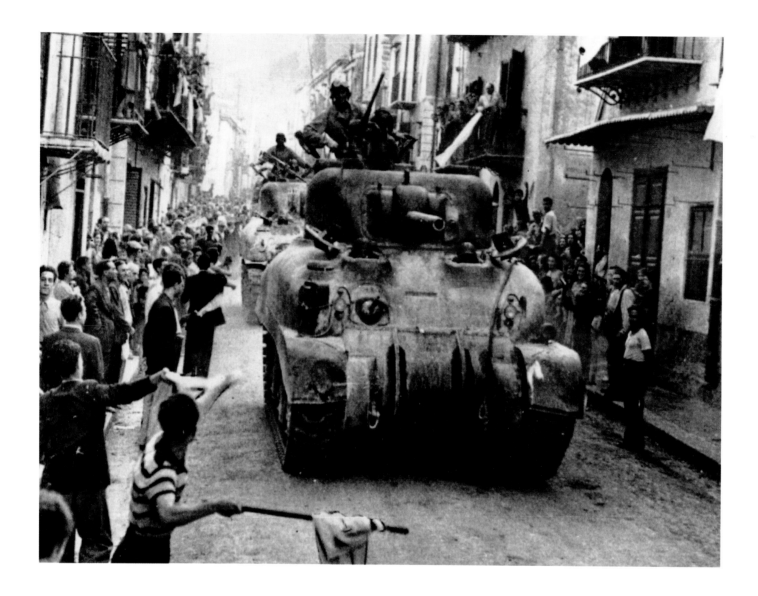

JUBILANT WELCOME

A festive crowd greets tank crews of General George Patton's Seventh Army as they enter Palermo, Sicily's largest city, on July 23.

GARLANDS FOR THE TROOPS

An Allied soldier accepts a rose from a solemn Italian child in exchange for a piece of candy.

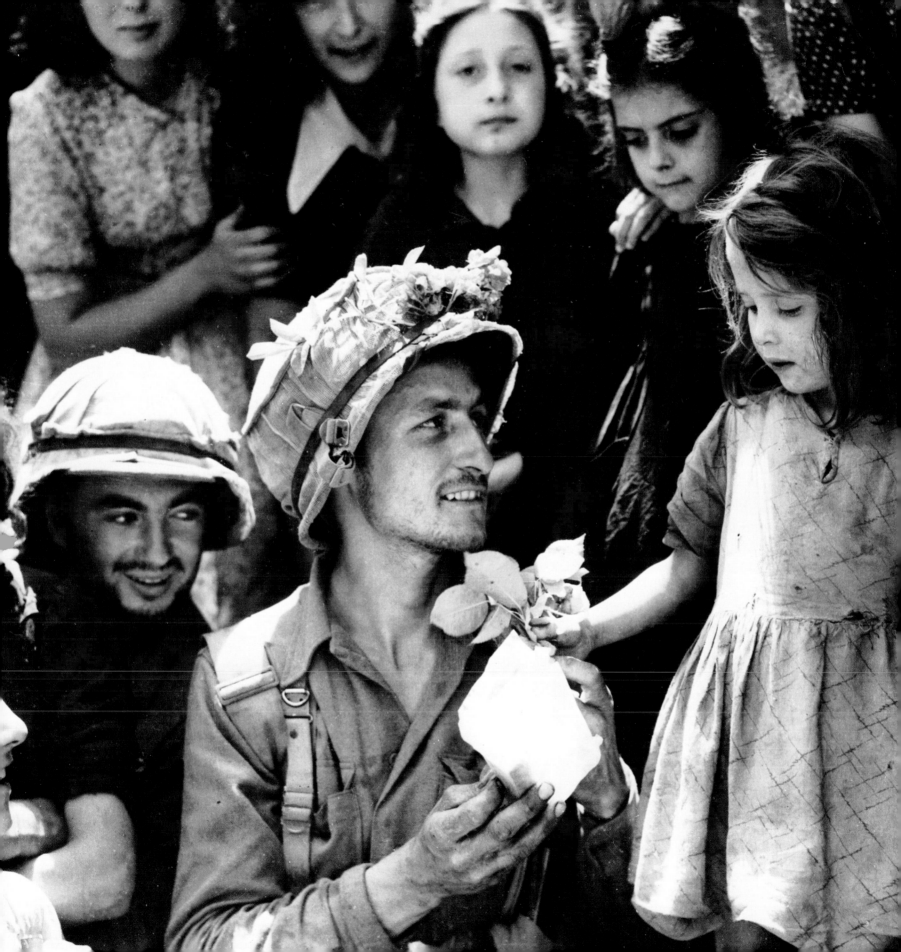

"We went clear over there and fought them and when we had won they looked upon us as their friends."

CORRESPONDENT ERNIE PYLE,
with the Allies in Sicily

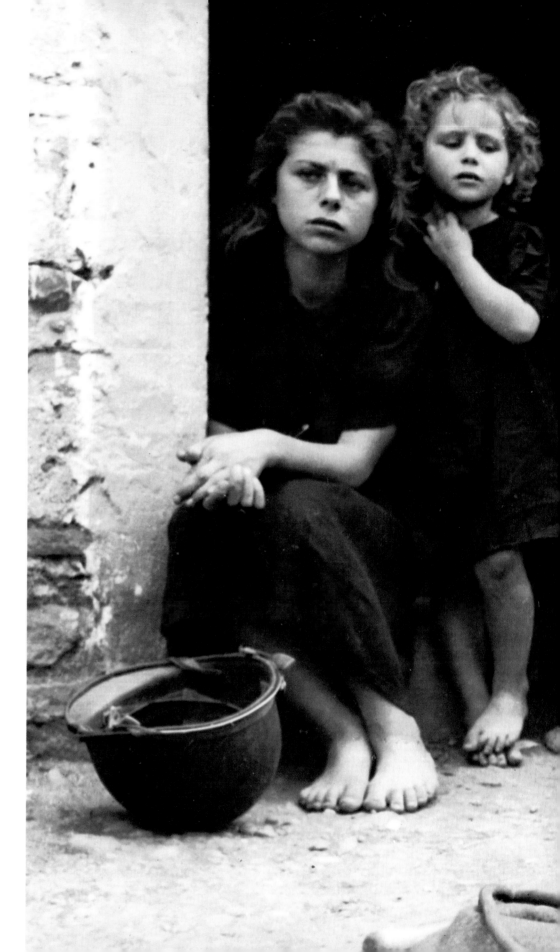

WAR AT THEIR DOORSTEP
As villagers look on with concern, a U.S. Army medical corpsman administers a bottle of blood plasma to a soldier wounded in action on Sicily.

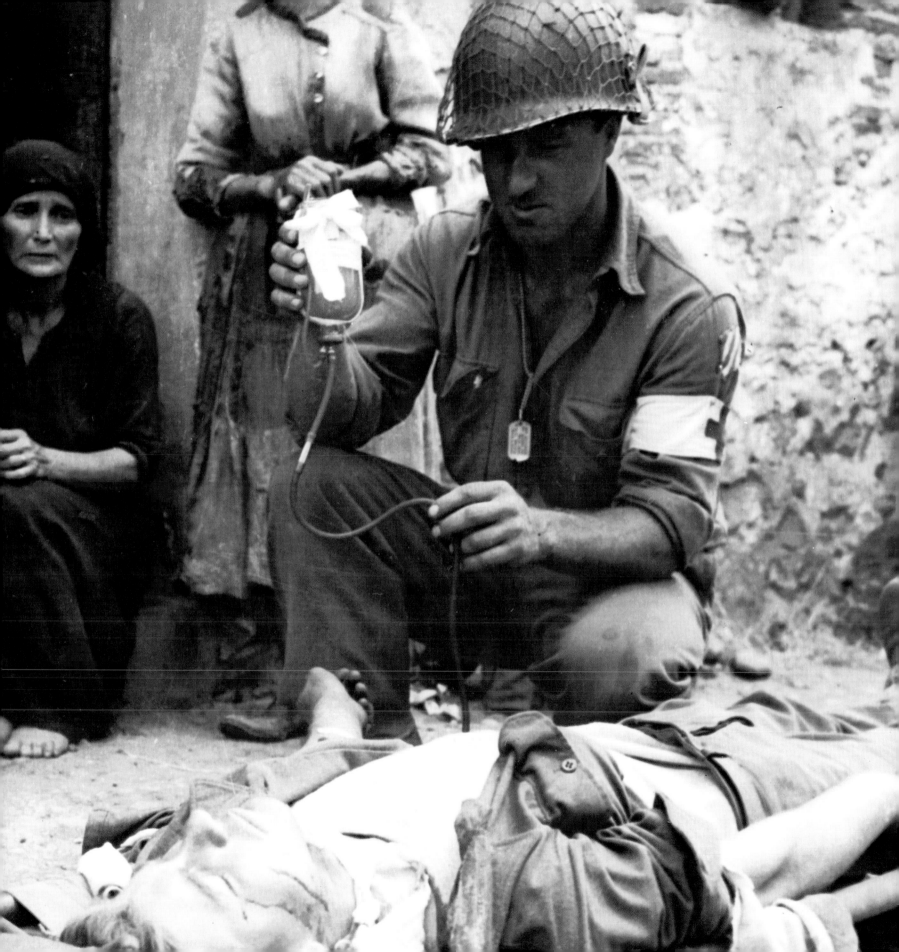

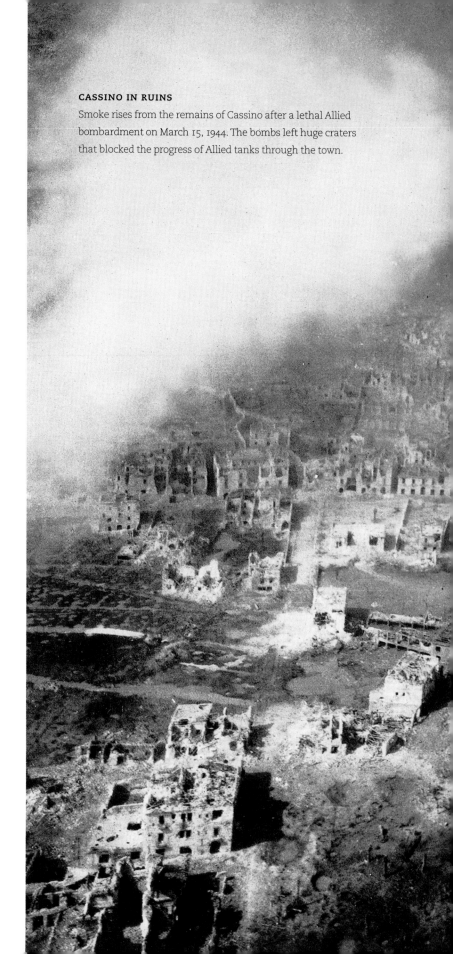

CASSINO IN RUINS
Smoke rises from the remains of Cassino after a lethal Allied bombardment on March 15, 1944. The bombs left huge craters that blocked the progress of Allied tanks through the town.

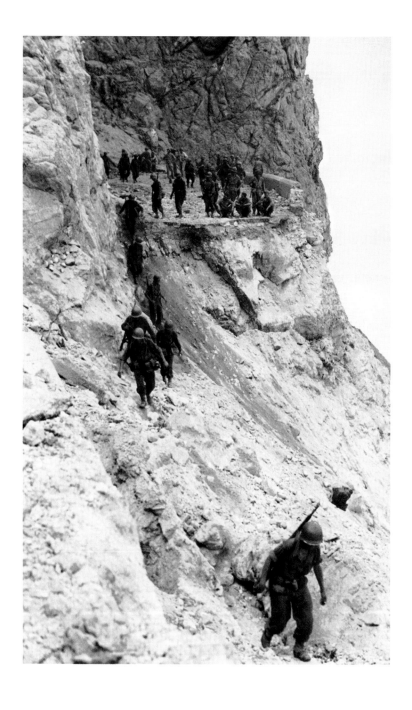

A PERILOUS DESCENT
En route to Messina, American infantrymen negotiate the rocky remains of the blasted cliffside road at Cape Calava in Sicily. The retreating Germans blew up a 150-foot section of the highway to bottleneck the advancing U.S. 3rd Division.

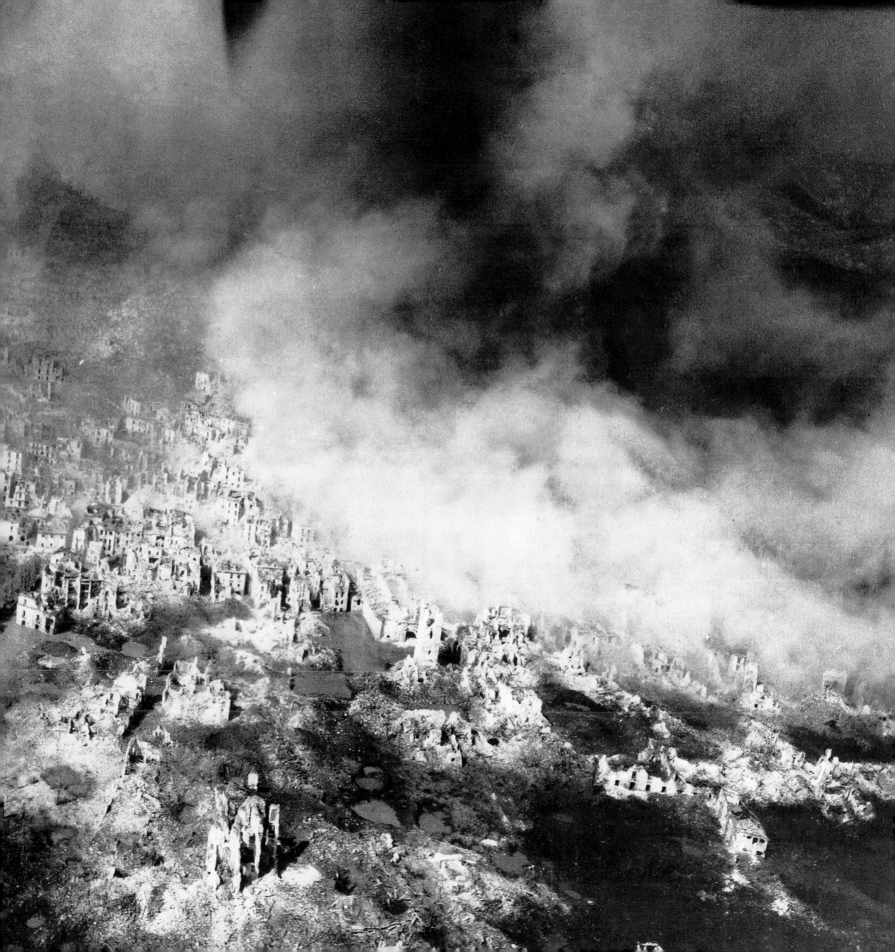

RESCUING IL DUCE

A photographer's hurried snapshot shows the ailing Mussolini in September 1943 being escorted to a rescue plane by Germans who have just freed him from imprisonment. Mussolini returned a short while later to German-controlled northern Italy as a figurehead.

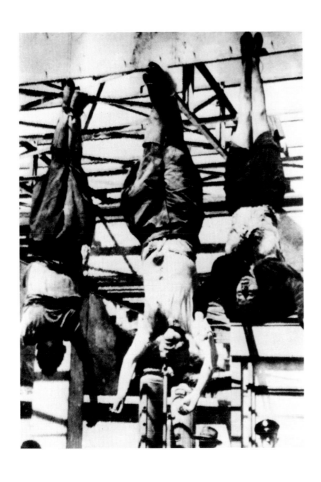

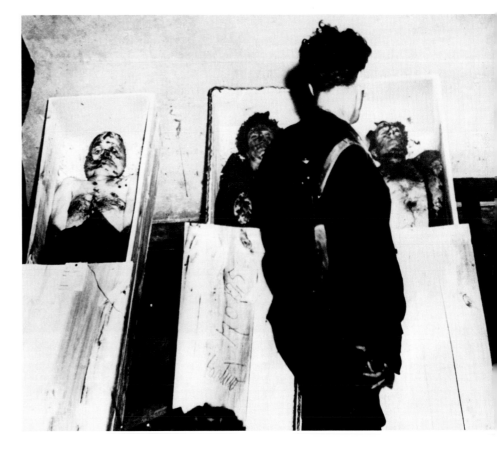

IGNOMINIOUS END

Like butchered animals, Mussolini, his mistress Claretta Petacci, and a cohort hang in Milan at war's end after being shot to death.

BATTERED REMAINS

A partisan inspects the battered corpses of Mussolini, Claretta Petacci, and another Fascist. Jammed into plain wood coffins, the bodies were displayed inside the Milan city morgue for the benefit of civilians, who came to stare and spit at them.

Air War in Europe

"BOMB THE DEVILS ROUND THE CLOCK." With those words borrowed from General Ira Eaker, commander of the Eighth U.S. Air Force, Winston Churchill summed up Allied strategy against Germany in the crucial period leading up to the invasion of France. Churchill and his aides were initially skeptical of Eaker's claim that American pilots could carry out precision daylight raids on German targets while British bombers pounded the enemy at night. After all, the British had abandoned daylight raids because their bombers were too easily spotted and suffered prohibitive losses. Eaker believed his pilots would fare better because American bombers like the B-17 Flying Fortress were more heavily armed. Despite misgivings, Churchill relished the idea of bombing the devils day and night and agreed to let the Yanks have a try.

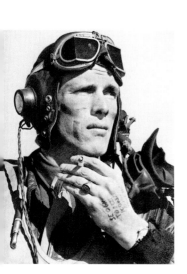

Both British and American pilots faced severe trials as this combined bomber offensive progressed in 1943. Flying at night offered the British no protection against radar-directed antiaircraft batteries or fighters, and squadrons attacking heavily defended targets suffered steep losses. The introduction of radar-confusing chaff by the RAF in July helped reduce casualties, but crewmen who had to fly 30 missions before completing their tours still faced long odds. Prospects were even worse for American pilots striking targets deep inside Germany in daylight. During one attack, 60 bombers were shot down, prompting the air force to suspend raids on Germany until it had long-range fighters to escort bombers to the target and back. The arrival that fall of fighters like the P-51 Mustang with auxiliary fuel tanks transformed the air war. By early 1944, the overmatched Luftwaffe was wearing thin. "We shall be forced to our knees before the coming year is out," predicted Field Marshal Erhard Milch. Indeed, Allied air supremacy all but doomed German forces in France—and exposed German cities like Dresden to annihilation.

PILOT'S SHORTHAND
Enjoying a smoke after seven hours of escort duty, an American P-51 fighter pilot displays the briefing-session instructions he wrote on the back of his hand for ready reference aloft—including the times for starting engines, taking off, and setting course.

BLAZING TRAILS
Speeding toward a target in occupied France, U.S. Eighth Air Force bombers and their faraway fighter escorts lace the sky with snow-white vapor trails.

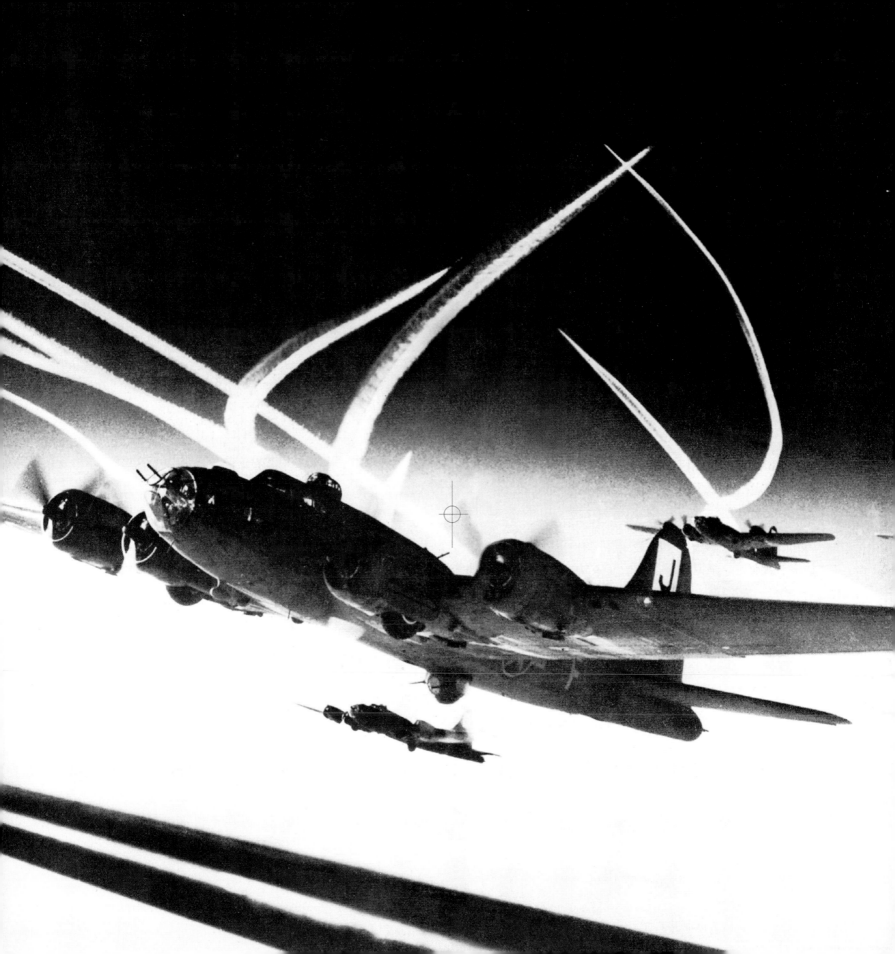

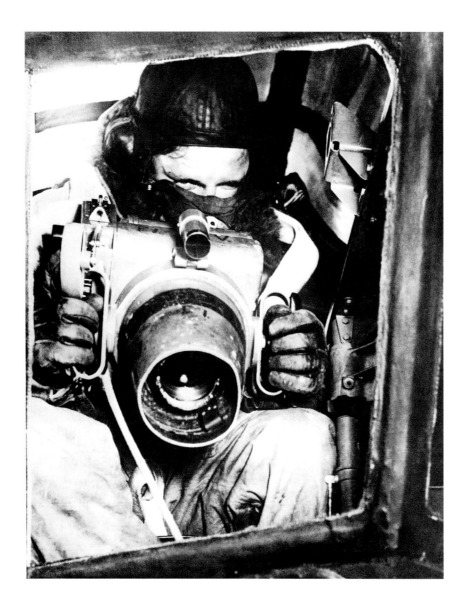

AERIAL RECONNAISSANCE

An RAF photographer, seated at the open observation port of a Blenheim bomber in 1940, focuses his cumbersome F-24 camera on a ground target.

FLYING FORTRESS OVER GERMANY

An American B-17 Flying Fortress takes part in a perilous daylight raid on an aircraft factory in Germany in January 1943.

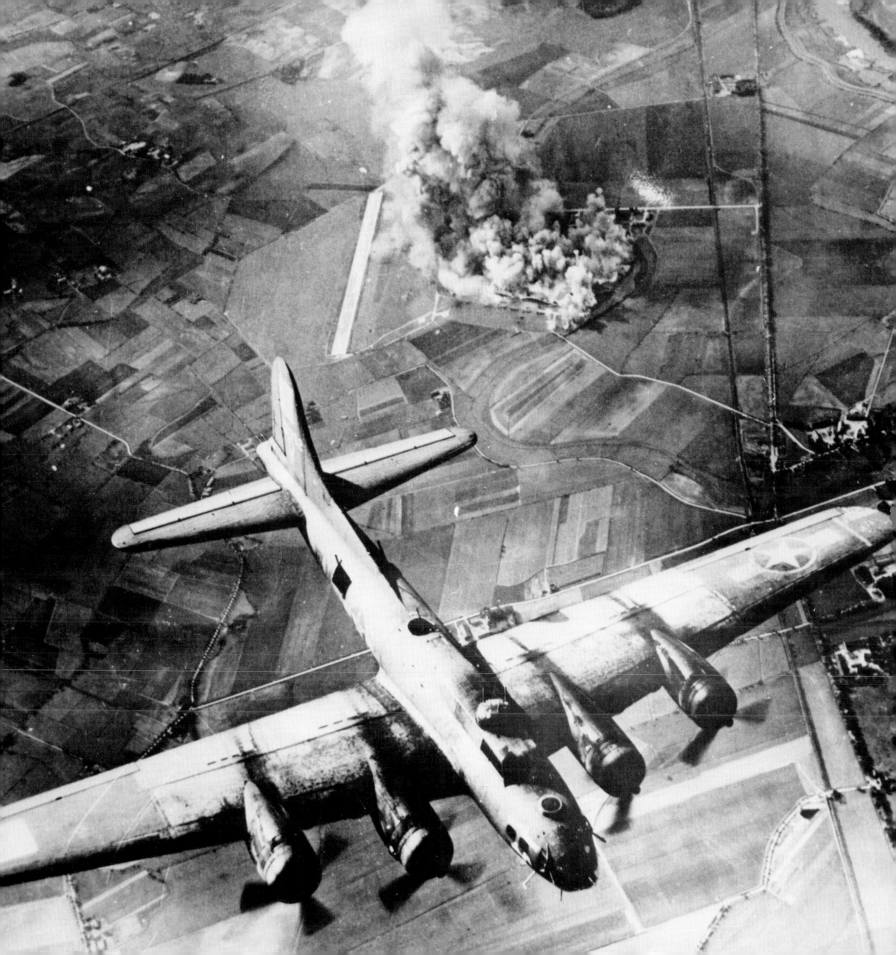

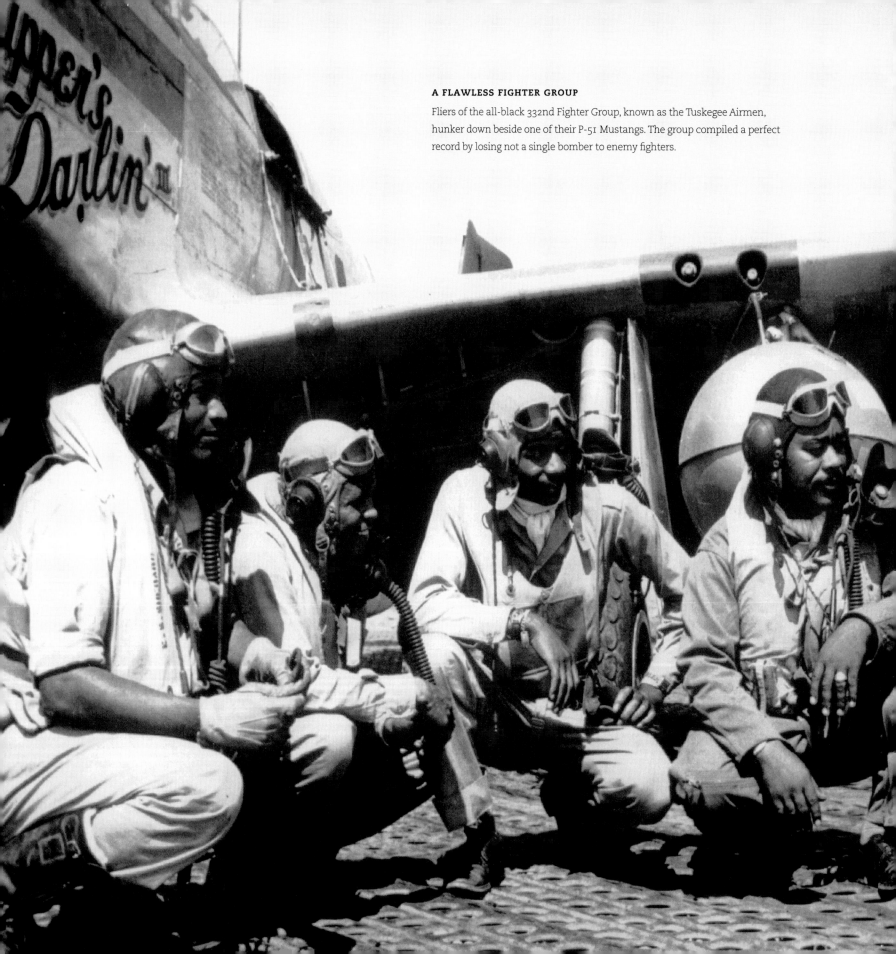

A FLAWLESS FIGHTER GROUP
Fliers of the all-black 332nd Fighter Group, known as the Tuskegee Airmen, hunker down beside one of their P-51 Mustangs. The group compiled a perfect record by losing not a single bomber to enemy fighters.

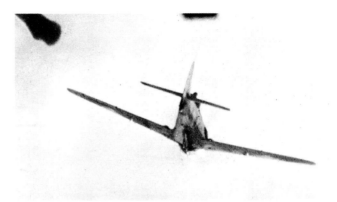

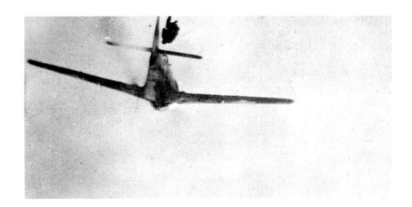

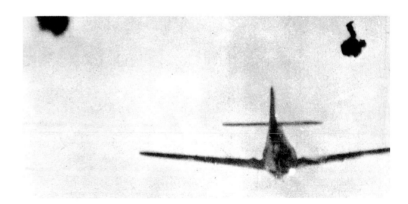

NARROW ESCAPE

A German fighter pilot tumbles from the cockpit of his Focke-Wulf 190 and begins his parachute descent to earth as the plane catches fire.

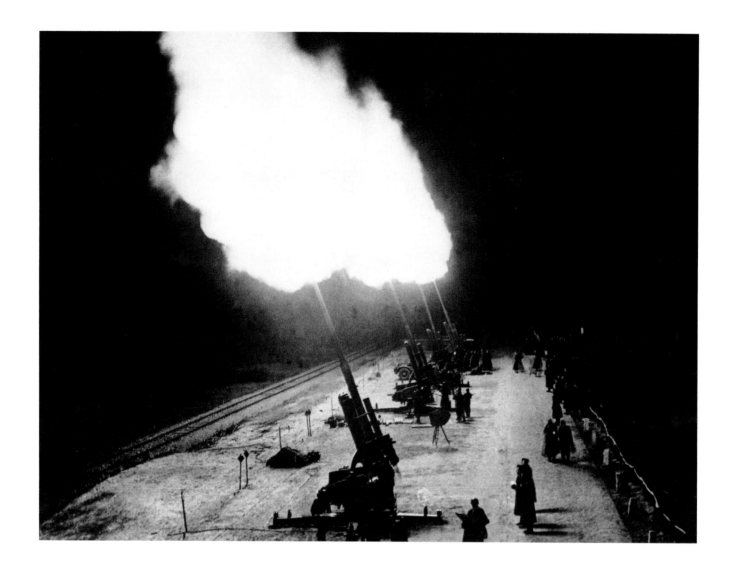

BLASTING THE NIGHT BOMBERS

A German 88 mm battery erupts in fire during a British bombing raid. With radar guidance, these big guns were effective against bombers, but they were even deadlier when leveled against tanks, and some German officers thought they would be better employed against Russian armor.

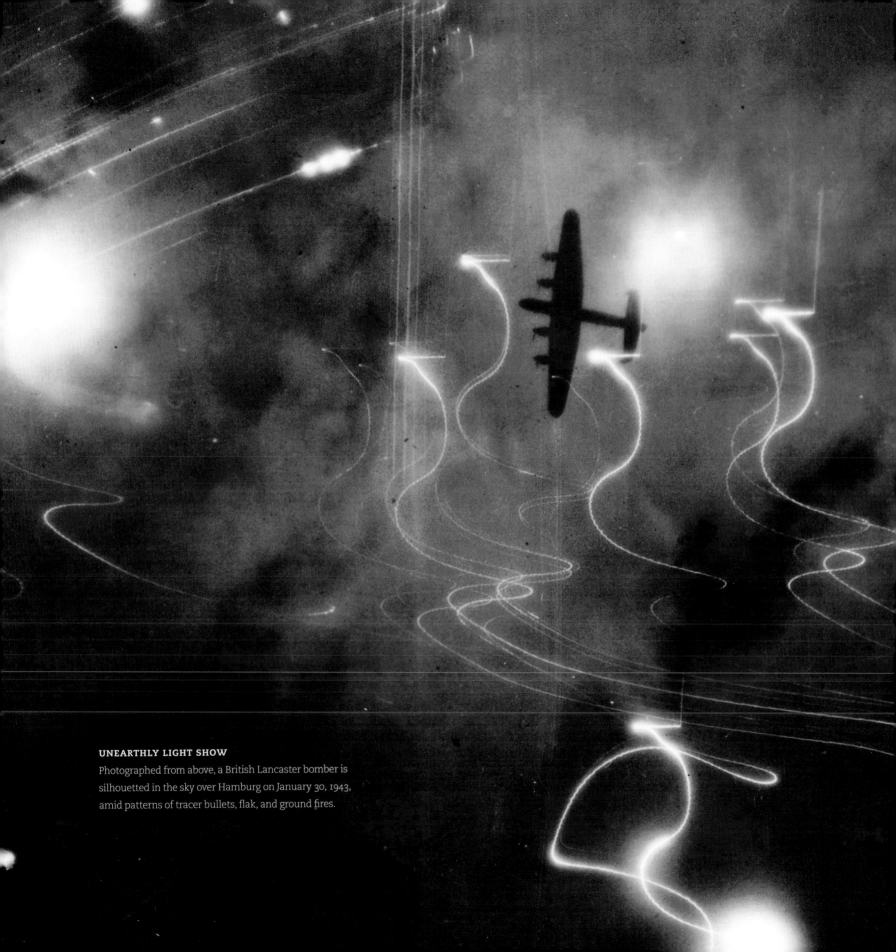

UNEARTHLY LIGHT SHOW
Photographed from above, a British Lancaster bomber is silhouetted in the sky over Hamburg on January 30, 1943, amid patterns of tracer bullets, flak, and ground fires.

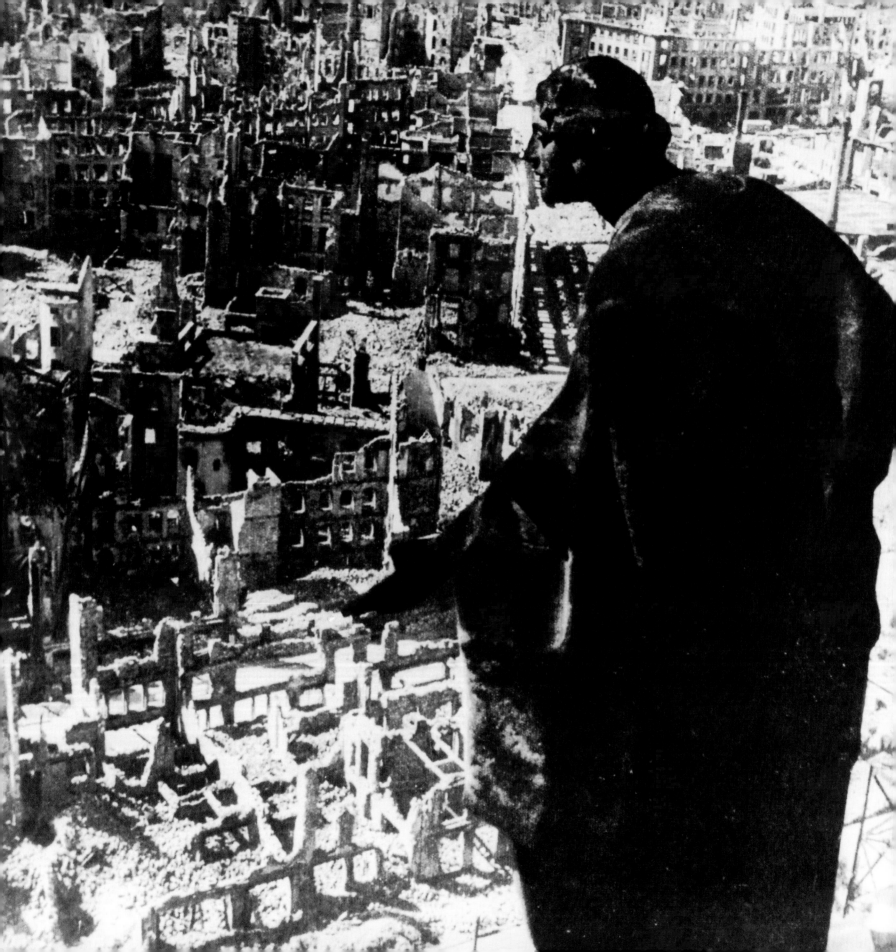

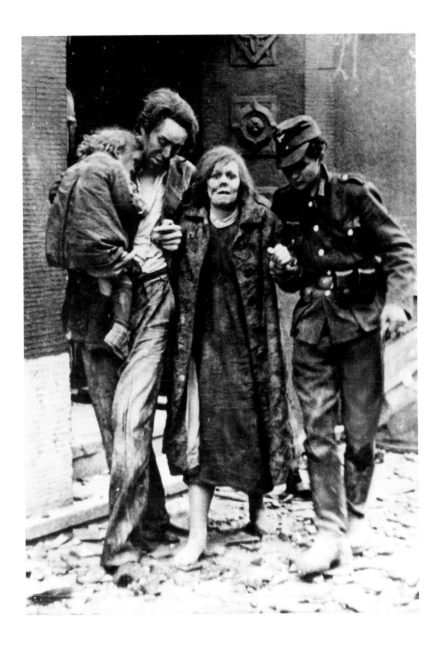

DEVASTATION AT DRESDEN

A statue atop Dresden's town hall overlooks the ruins of the city's old quarter, ravaged in February 1945 by a fire storm set off by Allied bombing that killed some 35,000 people. A British pilot wrote: "For the first time in many operations I felt sorry for the population below."

SURVIVORS IN SHOCK

Desolate survivors of an Allied bombing raid, coated with debris and grimacing with shock, are helped through rubble-strewn Mannheim by a German in uniform.

D-Day

BEFORE INVADING FRANCE, THEY INVADED BRITAIN. By 1944, there were one and a half million American soldiers on British soil. Locals complained that the Yanks were "overpaid, oversexed, and over here," but beneath the rivalry lay a common purpose. British and American invasion forces were united under Allied Supreme Commander Dwight Eisenhower. Ike inherited a sound plan from the British—one that bypassed the shortest route to Germany through strongly defended Calais in favor of a longer haul through Normandy, the weakest link in the enemy's Atlantic Wall. While British agents fed Germans false leads suggesting a landing at Calais, 5,000 ships gathered in ports on England's south coast to ferry 175,000 troops to Normandy in early June and a million men by month's end. Allied forces were coiled like a "great human spring," Ike wrote, and the time had come to release that energy "in the greatest amphibious assault ever attempted."

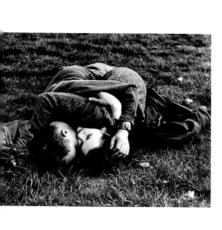

At dawn on D-Day, June 6, troops came ashore at Normandy in five sectors between Cherbourg and Caen. The fiercest reception awaited the Americans landing at Omaha Beach, who suffered over 2,000 casualties before securing their beachhead. Hitler initially refused the request of his commander in France, Erwin Rommel, to rush reinforcements from Calais to Normandy, believing that the landing there was a diversion. Soon the Allies were too heavily reinforced to be driven back into the sea, but dogged German resistance and difficult terrain rendered their progress painfully slow. The German stronghold of Caen, slated for capture on the first day, held out until July. Finally, the Allies squeezed their stubborn opponents into a pocket at Falaise, killing many before the remnant escaped. The road to Paris lay open, and liberators arrived there in late August to a jubilant welcome from French patriots eager to salute their champions—and scourge Nazi collaborators in their midst.

ANGLO-AMERICAN ALLIANCE
A GI and his date embrace in London's Hyde Park, one of many public places where American soldiers and their British girlfriends tried to find a little privacy before the invasion of France.

OBJECTIVE NORMANDY
At an English port, a motorized artillery unit bound for Normandy rolls up ramps into cavernous landing ships. The first vessels embarked on June 3, 1944.

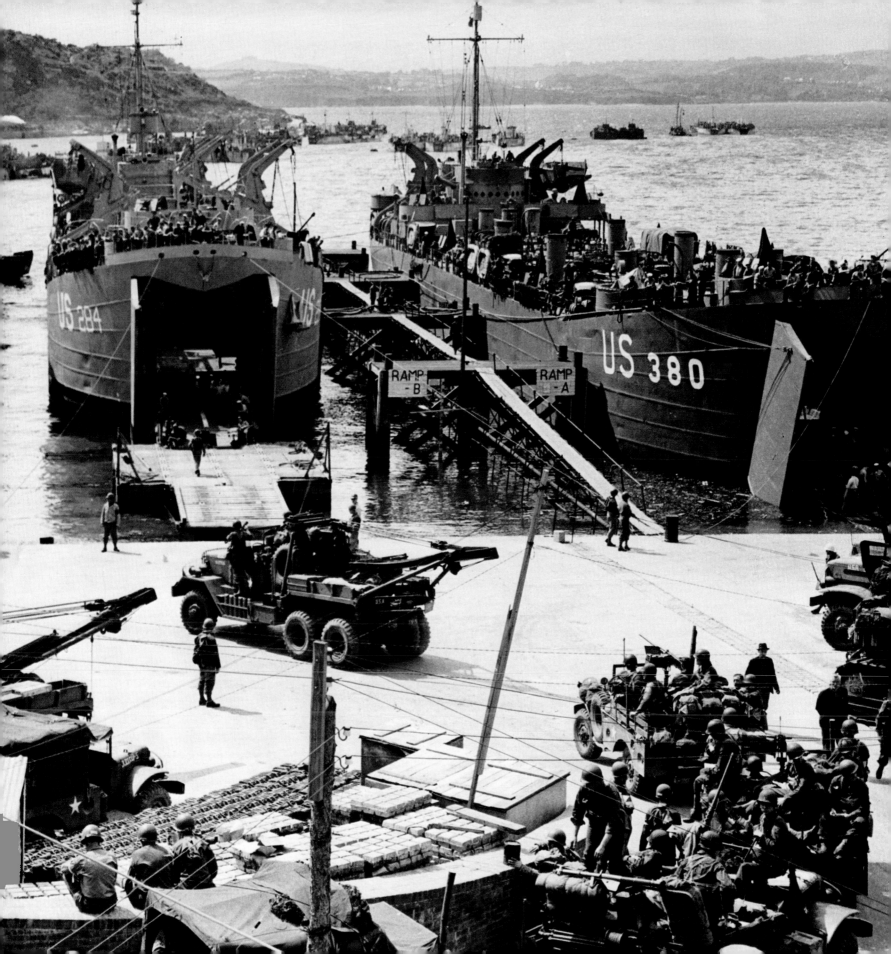

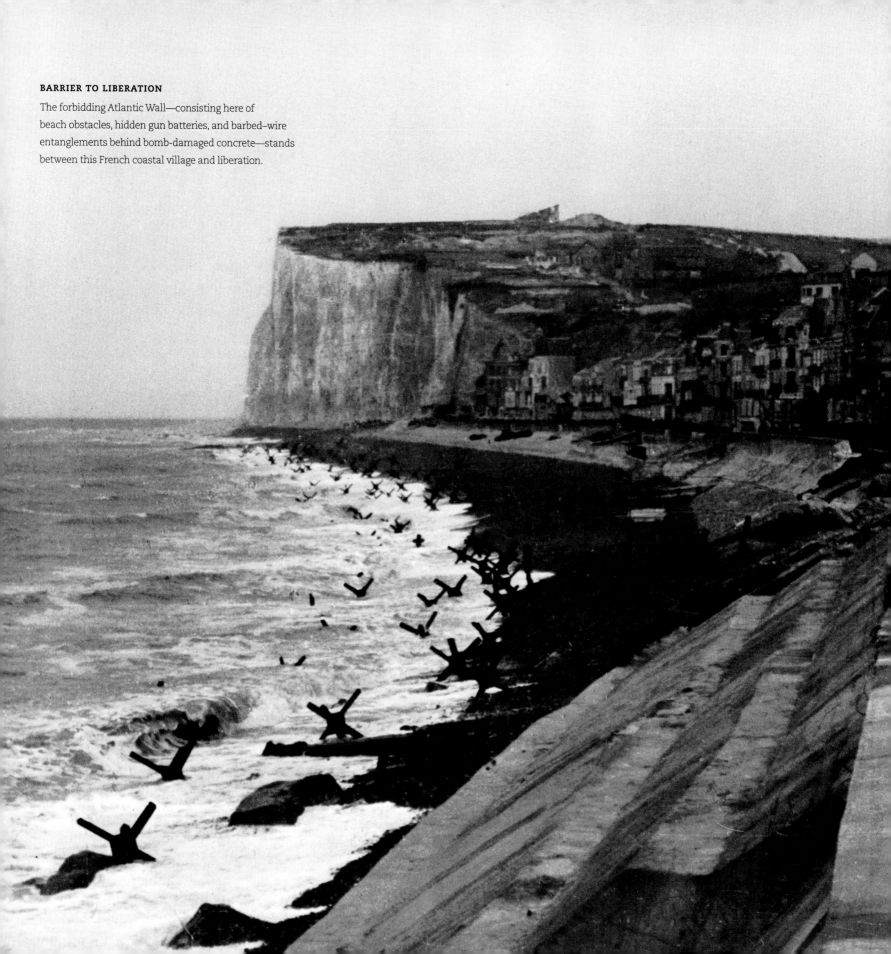

BARRIER TO LIBERATION

The forbidding Atlantic Wall—consisting here of
beach obstacles, hidden gun batteries, and barbed-wire
entanglements behind bomb-damaged concrete—stands
between this French coastal village and liberation.

MANNING A MONSTER

A massive coastal gun dwarfs the German soldier servicing it in a concrete blockhouse along the Atlantic Wall.

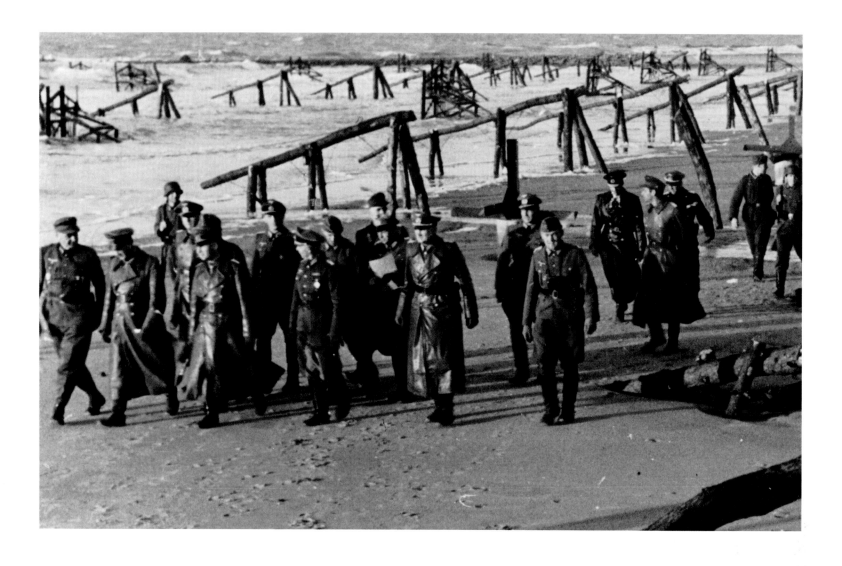

ROMMEL'S LAST STAND

Field Marshal Rommel (*front row, third from left*) and other high-ranking German officers inspect obstacles designed to block tanks and landing craft on the beach near Calais in April 1944. Rommel expressed satisfaction with the defenses in this sector of the Atlantic Wall, but he was disappointed with those along the Normandy coast.

ENCOURAGEMENT FROM IKE

Paratroopers of the U.S. 101st Airborne Division, their faces camouflaged with night paint, chat with Eisenhower before departing from their base near Newbury to attack heavily fortified positions in Normandy. Ike, worried about the paratroopers' perilous assignments, spent part of the evening encouraging them.

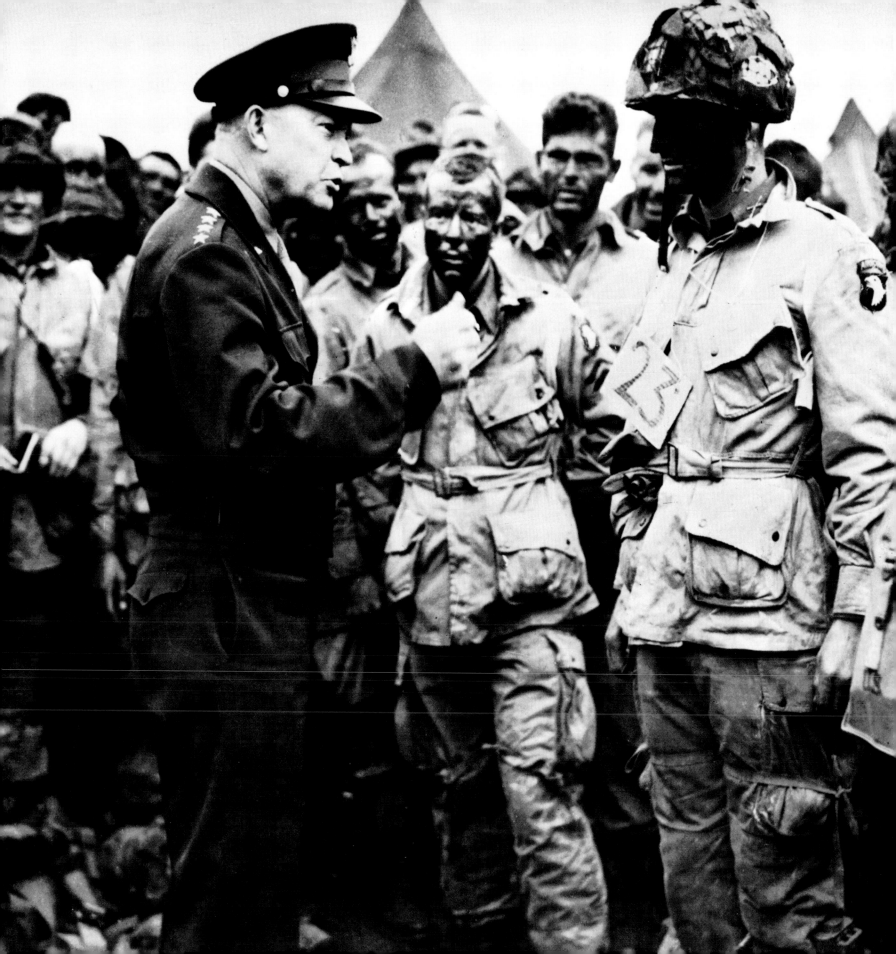

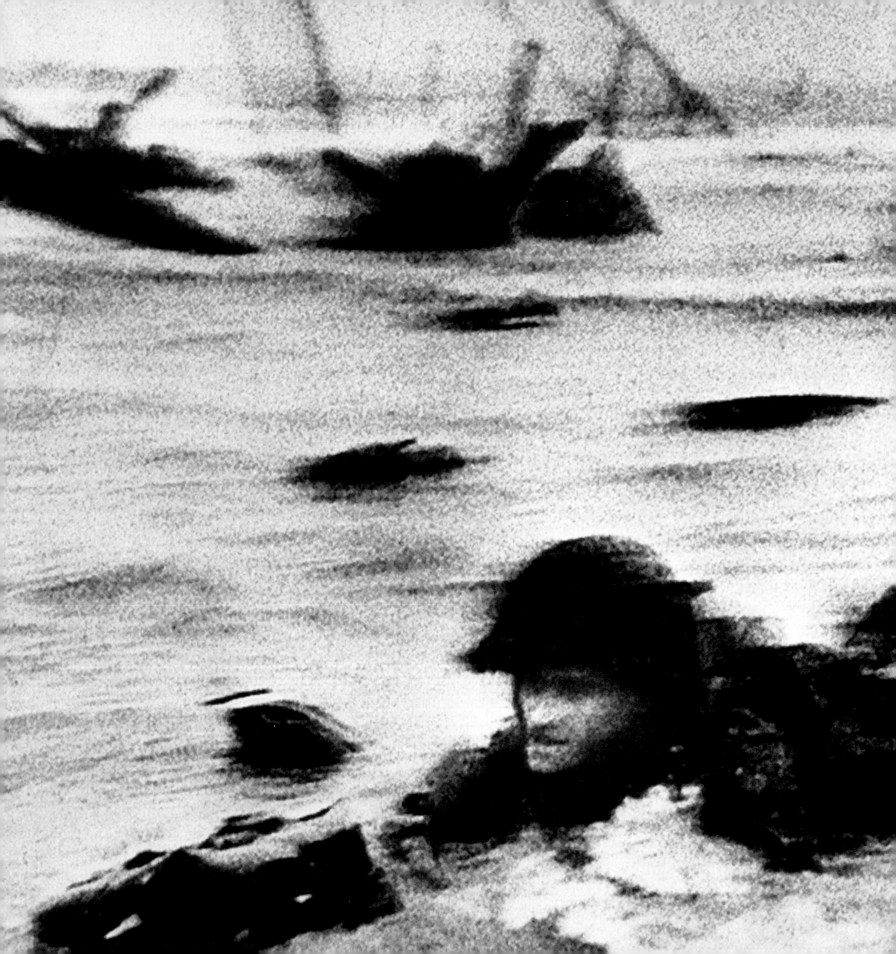

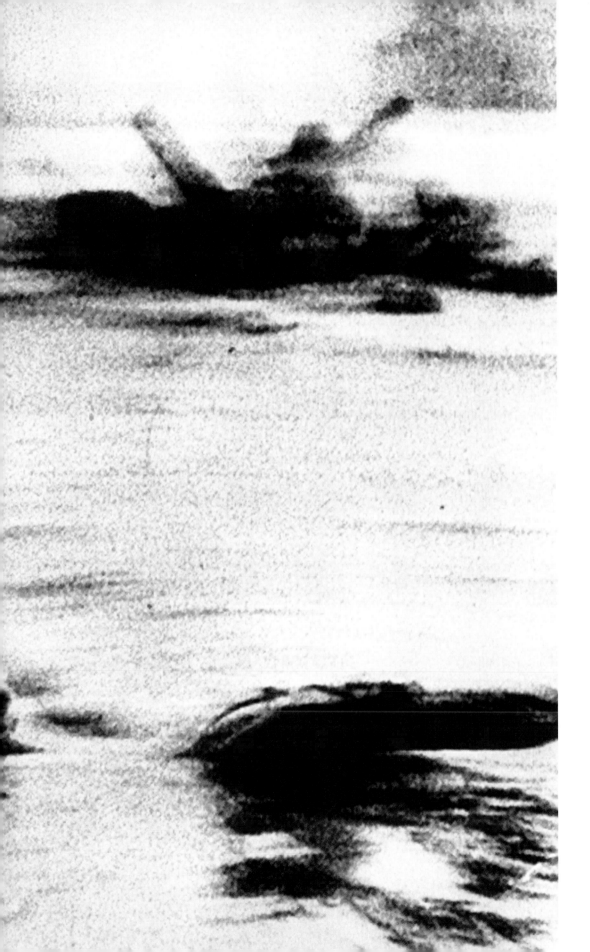

> *"Some were hit in the water and wounded. Some drowned then and there. . . . Those who survived kept moving forward with the tide."*

OFFICIAL REPORT OF COMPANY A,
116th Regiment, at Omaha Beach

D-DAY AT OMAHA

A GI crawls toward Omaha Beach on D-Day in this photograph by Robert Capa. The soldier—identified as Edward Regan of the 116th Regiment—survived the landing, but his regiment was devastated, with one company suffering a catastrophic casualty rate of 96 percent.

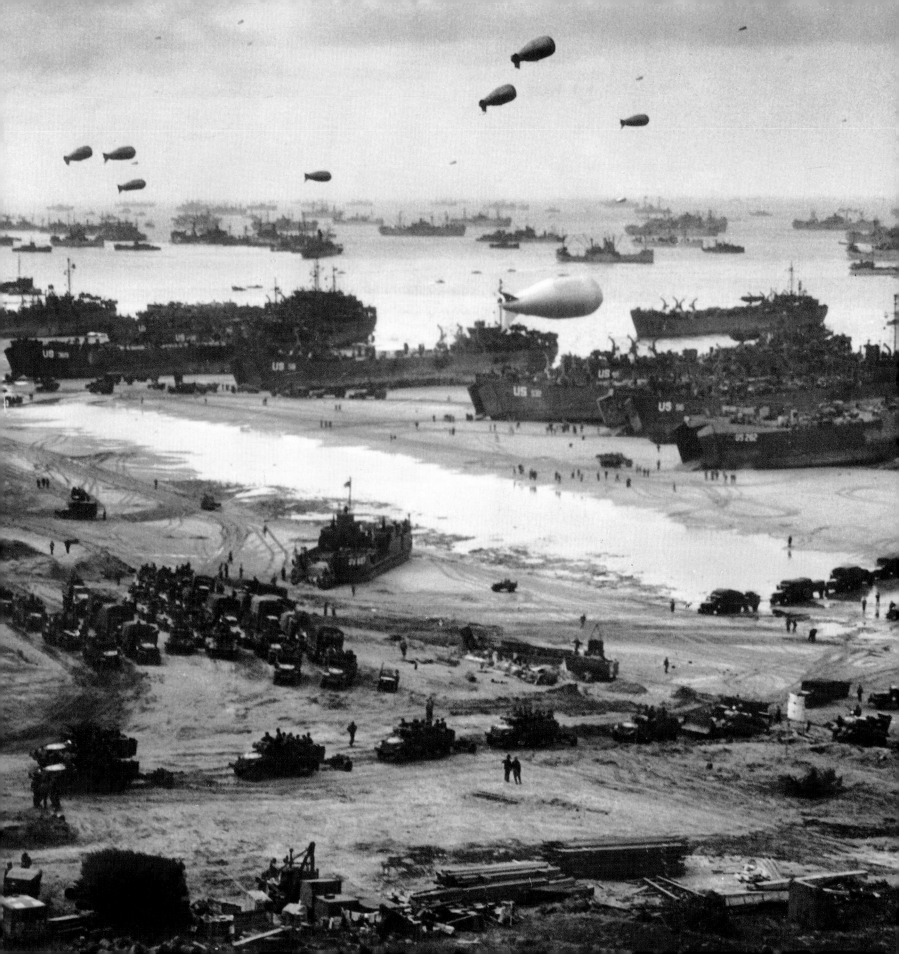

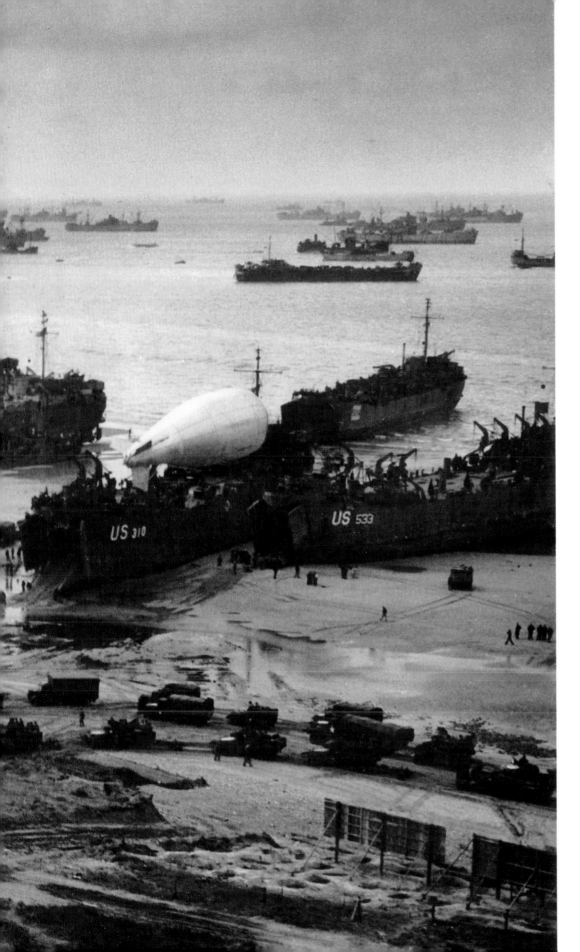

"If we can't capture a port we must take one with us."

CAPTAIN JOHN HUGHES-HALLETT,
D-Day planner

REINFORCING THE BEACHHEAD

Protected by barrage balloons, Omaha Beach
swarms with ships and trucks funneling supplies
inland to support the advancing troops. Allied
engineers created an artificial harbor offshore to
accommodate supply ships until troops captured
the nearby port of Cherbourg. By the end of June,
almost 180,000 tons of supplies and 50,000 vehicles
had landed at Omaha.

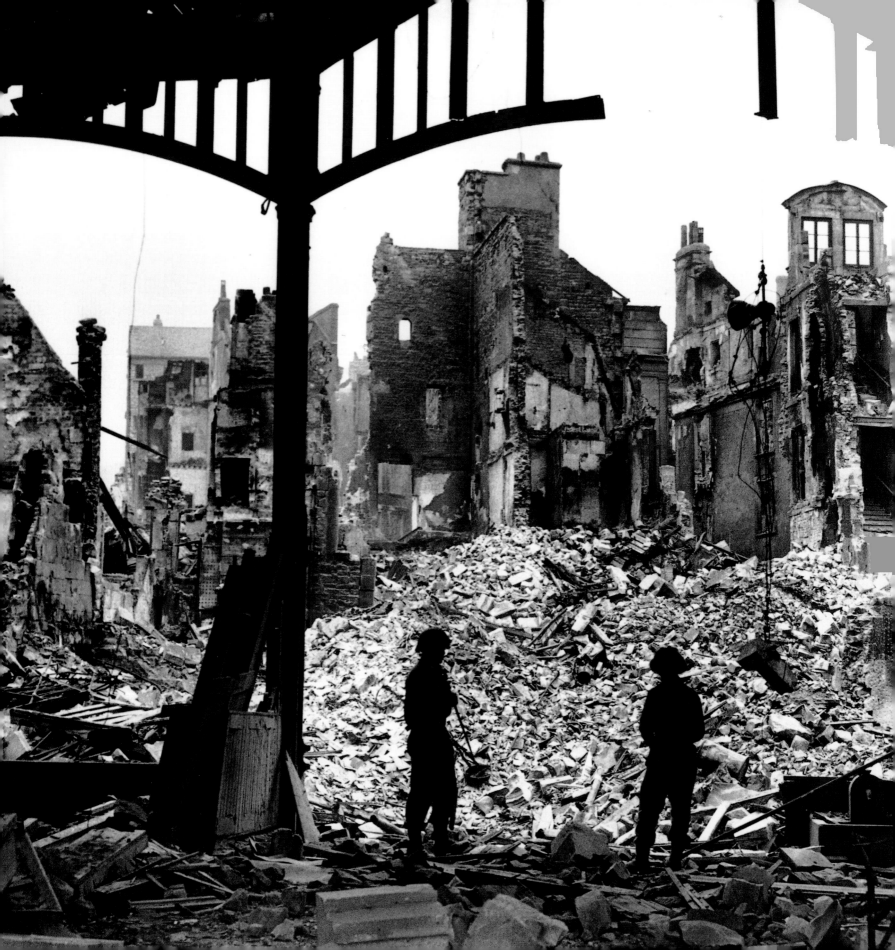

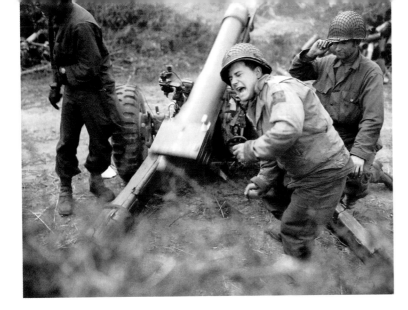

FEELING THE SHOCK

An American gun crew recoils from the blast of their howitzer, fired at retreating Germans near the town of Carentan, a vital crossroads whose capture on June 12 allowed the linkup of U.S. troops from the Utah and Omaha beachheads.

COSTLY ADVANCE TO FALAISE

Along the bomb-ravaged road between Caen and Falaise, a Canadian casualty is tended by a medic while a German tank burns nearby. In August, the Canadian First Army battered its way through to Falaise at a cost of more than 2,000 casualties. "Ten feet gained on the Caen sector," Eisenhower said, "was equivalent to a mile elsewhere."

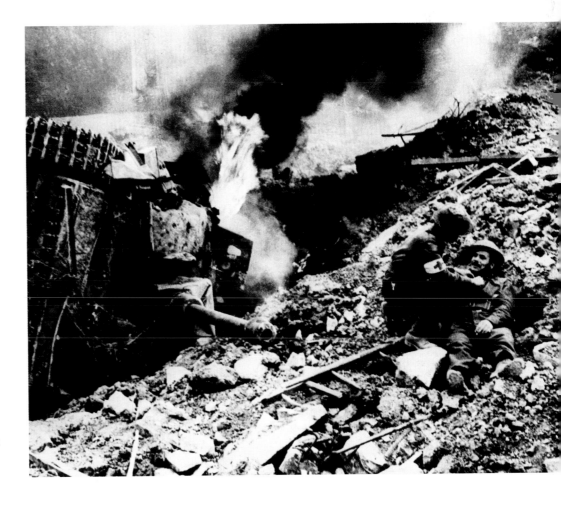

CAEN IN SHAMBLES

At left, British soldiers stand amid the rubble of Caen after Allied forces captured the city on July 8 in an armored assault complicated by the devastation caused by bombing.

> *"I have never seen in any face such joy as radiated from the faces of the people of Paris this morning."*

CORRESPONDENT CHARLES C. WERTENBAKER,
in liberated Paris

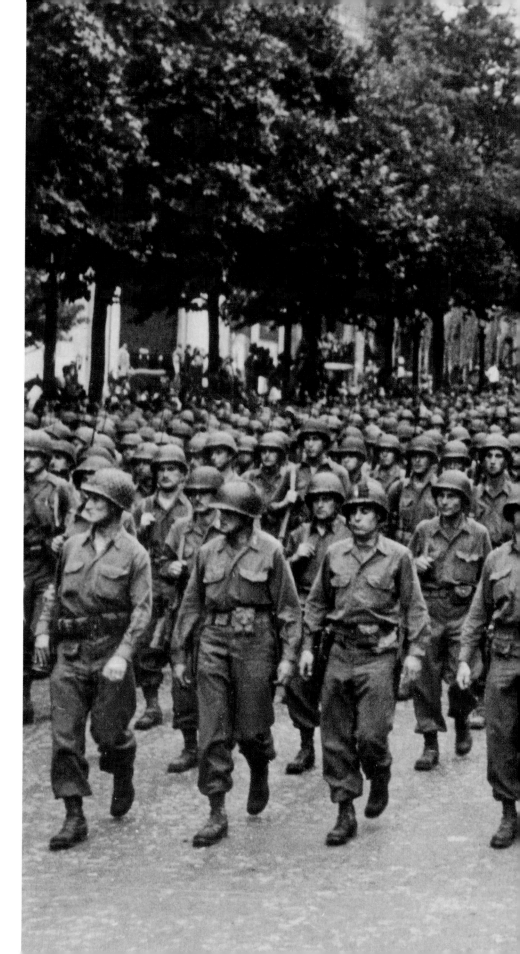

MARCH OF TRIUMPH

Troops of the U.S. 28th Infantry Division march through the Arc
de Triomphe and down the Champs Élysées in a victory parade
on August 29, four days after the liberation of Paris.

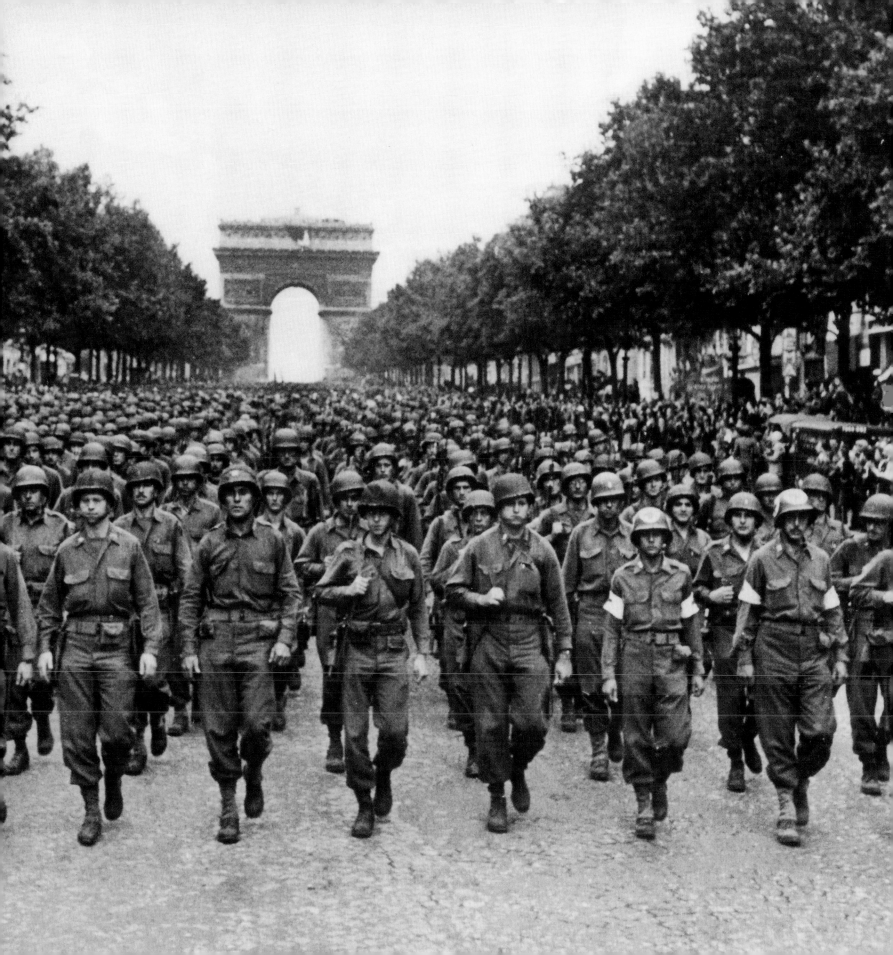

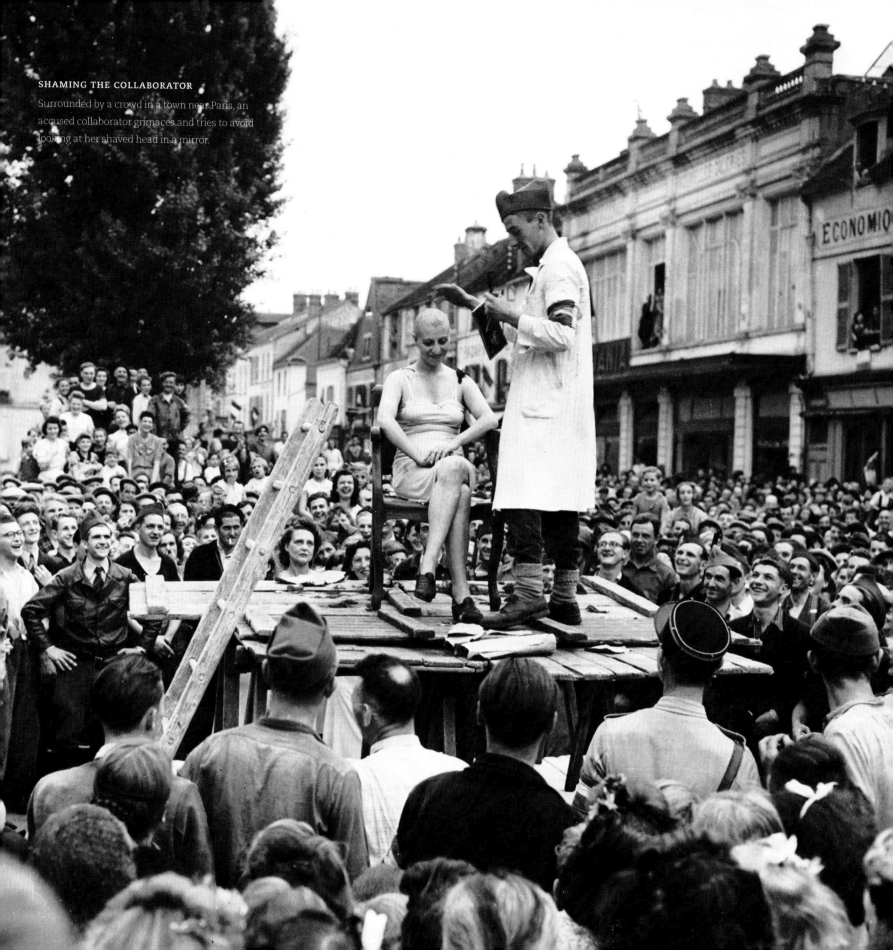

SHAMING THE COLLABORATOR
Surrounded by a crowd in a town near Paris, an accused collaborator grimaces and tries to avoid looking at her shaved head in a mirror.

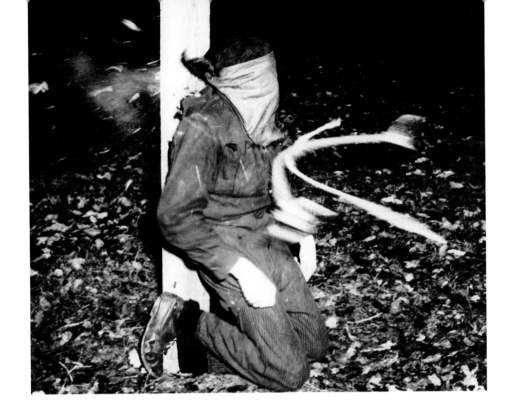

HOUR OF RECKONING

Ripped by the volley of a resistance firing squad in the city of Rennes, a blindfolded Frenchman condemned for collaborating with the Gestapo and SS collapses in death, his body freed by bullets that cut through his ropes and splintered the execution stake.

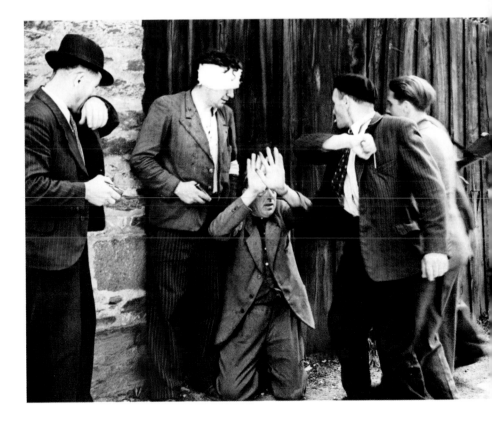

PATRIOTIC FURY

Holding up his hands in self-defense, a kneeling collaborator tries to shield his face from the backhand blow of an accuser in Rennes. His assailants compelled him to shout, "Vive de Gaulle!" and "Vive la France!"

Return to the Philippines

FOR DOUGLAS MACARTHUR, RECLAIMING THE PHILIPPINES FROM THE JAPANESE was a personal crusade. "I shall return," he had pledged after leaving his besieged post there in 1942 to take charge of U.S. forces in Australia. His ultimate objective was to occupy Japan, and the only way to get there, he insisted, was through the Philippines. Not everyone agreed. Operations against the Japanese were divided between General MacArthur and Admiral Nimitz, who argued that that the surest road to Tokyo lay across the atolls of the central Pacific. The Joint Chiefs compromised by approving dual drives by Nimitz and MacArthur to keep the enemy off balance.

By September 1944, MacArthur's forces, with support from the navy and marines, had secured New Guinea and nearby New Britain and Bougainville and were preparing to storm the

Philippine island of Leyte. As the invasion fleet approached, the Japanese navy converged on Leyte, triggering an epic sea battle. Some Japanese warships served as decoys by luring U.S. carriers away from the landing zone, while others swept in to attack troop transports and their escorts. As one admiral put it, the plan required a "suicide spirit" among the Japanese sailors aboard the decoys and the kamikaze pilots who crashed their warplanes into American ships.

Their sacrifice was in vain, for the U.S. Pacific Fleet had been greatly enhanced since Pearl Harbor and the armada off Leyte was insuperable. The Japanese lost 26 warships and failed to prevent MacArthur's troops from taking Leyte and invading Luzon, where the Americans suffered 25,000 casualties capturing Manila. "People of the Philippines, I have returned," MacArthur declared. "The hour of your redemption is here." But that redemption came at a terrible price for civilians as well as soldiers. More than 100,000 Filipinos died in Manila, where some ill-fated inhabitants were killed by the Japanese and others were caught in the fighting.

MERCY IN THE CATHEDRAL
In an improvised hospital in the cathedral at Palo, a badly burned American soldier peers from a mask of bandages while a group of barefoot Filipino women pray in the background. When the fighting ended in the area, hundreds of civilians came out of hiding and volunteered to tend to the wounded.

FULFILLING THE PLEDGE
Repeating an earlier triumphant gesture, General Douglas MacArthur strides through shin-deep waters to the island of Luzon on January 9, 1945. MacArthur had labored for almost three years to fulfill his pledge to return to the Philippines. His first walk ashore had occurred on Leyte on October 20, 1944.

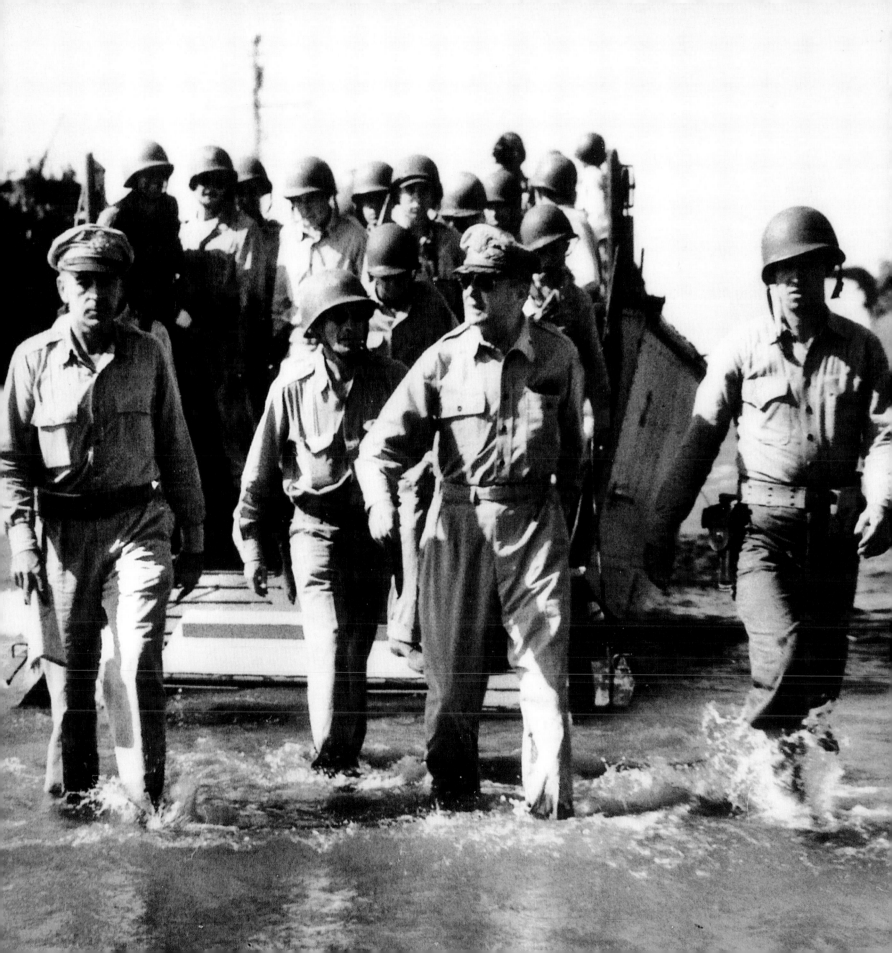

JUNGLE WARFARE
An eerie light suffuses the shattered jungle on Bougainville as an American tank and infantrymen press the attack. This largest of the Solomon Islands saw intense fighting—often hand to hand—for more than two weeks in March 1944.

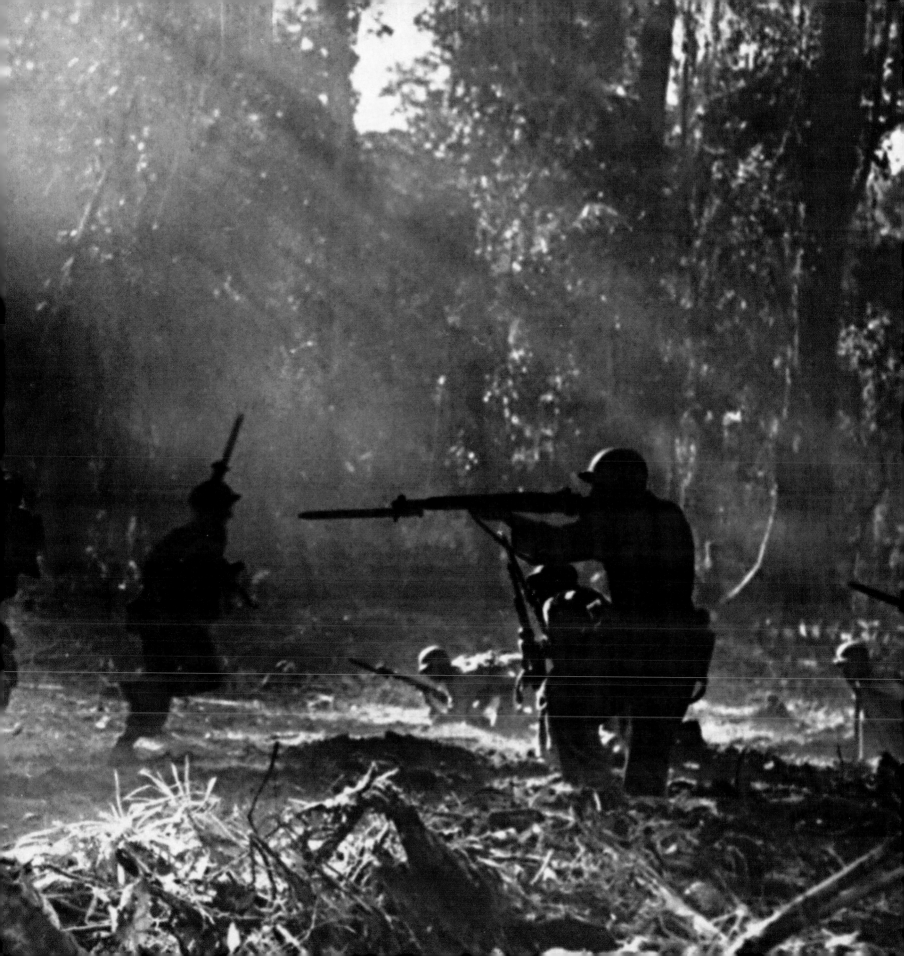

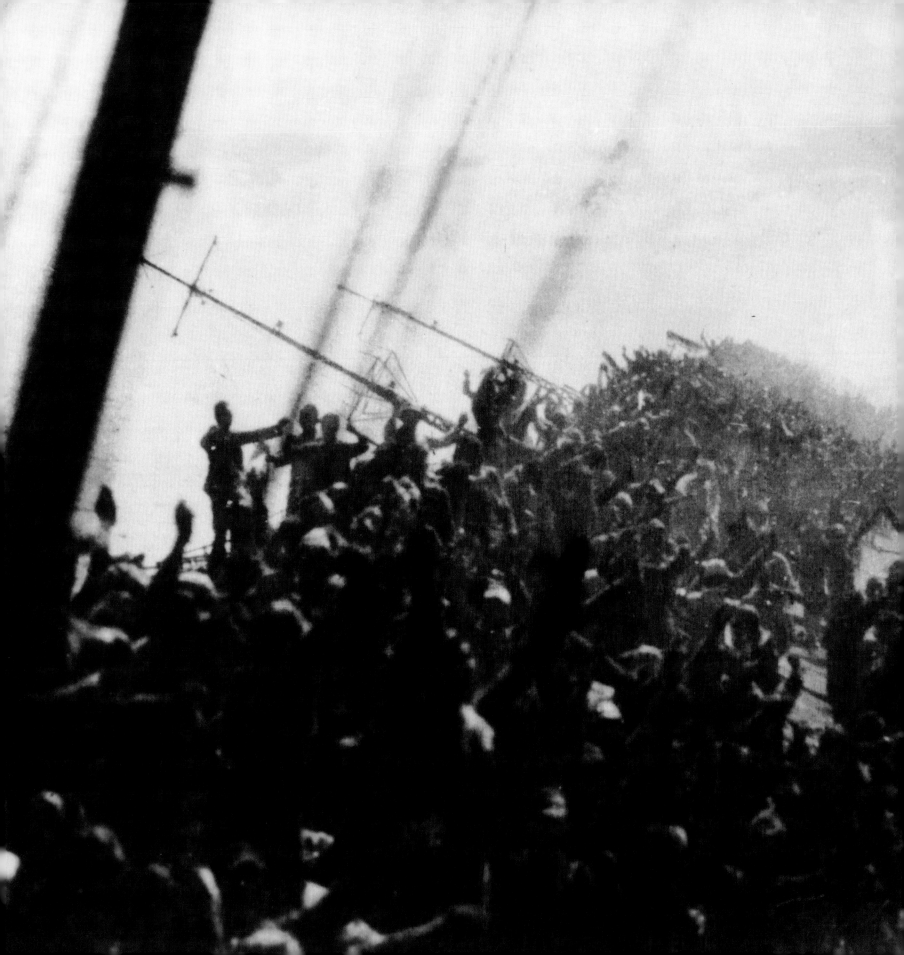

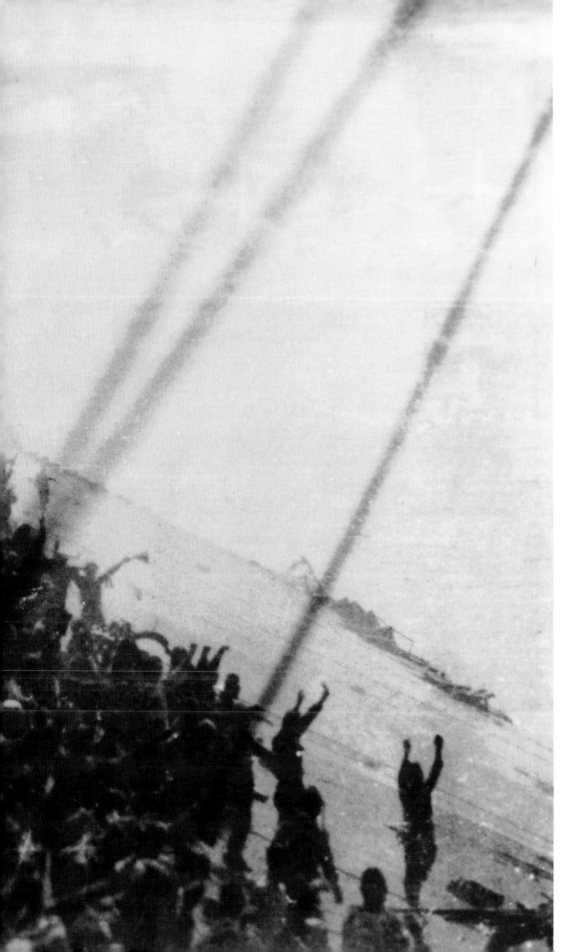

"*Thank you for your service.
Do your best to the end.*"

REAR ADMIRAL TOSHIHIRA INOGUCHI,
before going down with his ship

DEFIANT TO THE DEATH

Crewmen on the sinking carrier *Zuikaku* raise their
arms and voices in a farewell banzai cheer during
the Japanese navy's desperate campaign to block the
invasion of the Philippines in October 1944. Almost
half of the 1,700-man crew went down with the ship.

KILLED BY KAMIKAZES
Crewmen of the USS *Intrepid* crowd the rail for a mass burial at sea of comrades killed during kamikaze attacks. Bodies were rarely, if ever, returned home.

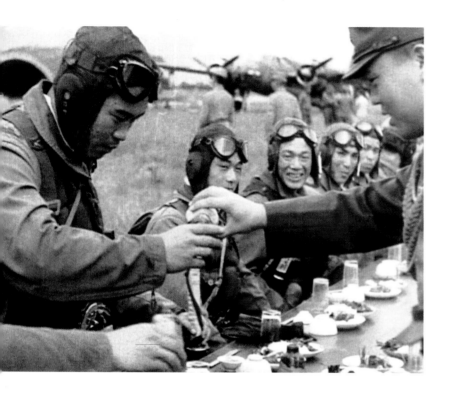

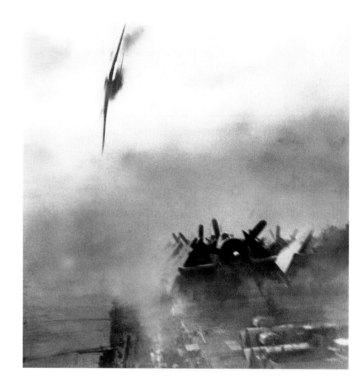

A PARTING CEREMONY
During a farewell party in October 1944, held in the middle of an airfield, smiling kamikaze pilots are regaled with sake, rice, and special rations. "Please congratulate me," one recruit wrote home to his parents, "I have been given a splendid opportunity to die."

PERILOUSLY CLOSE
A plummeting kamikaze plane barely misses the crowded deck of the escort carrier *Sangamon* in May 1945. Similar attacks destroyed 16 ships and damaged 80 others before American forces secured the Philippines that summer.

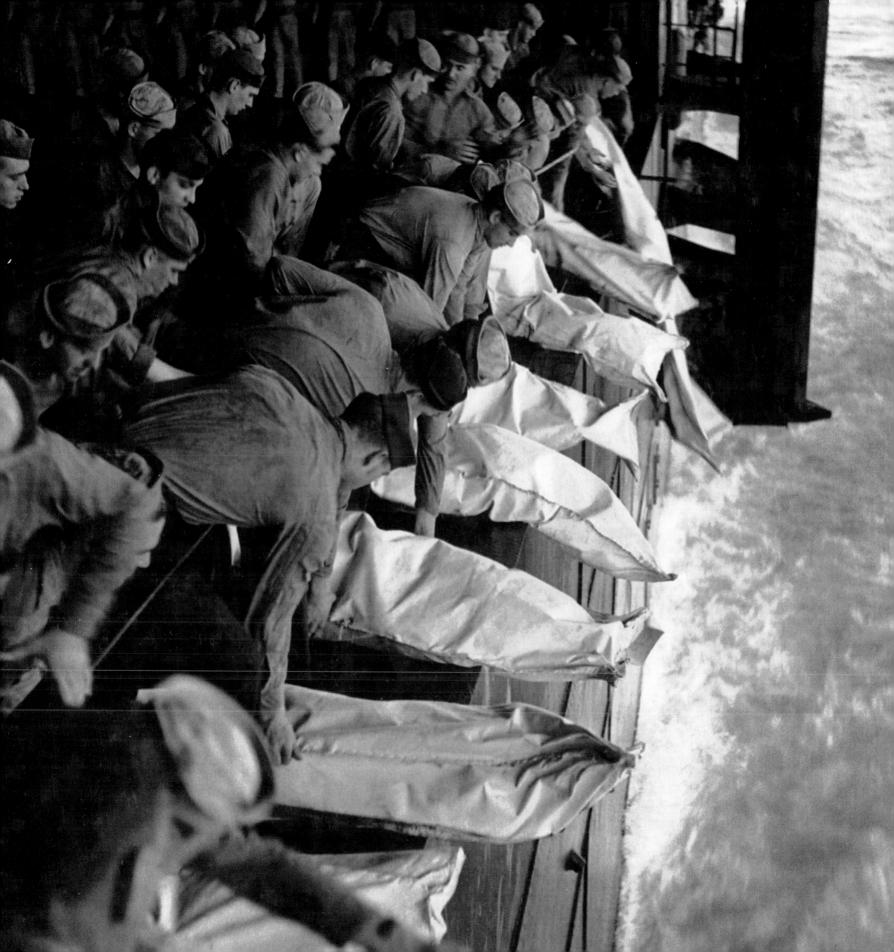

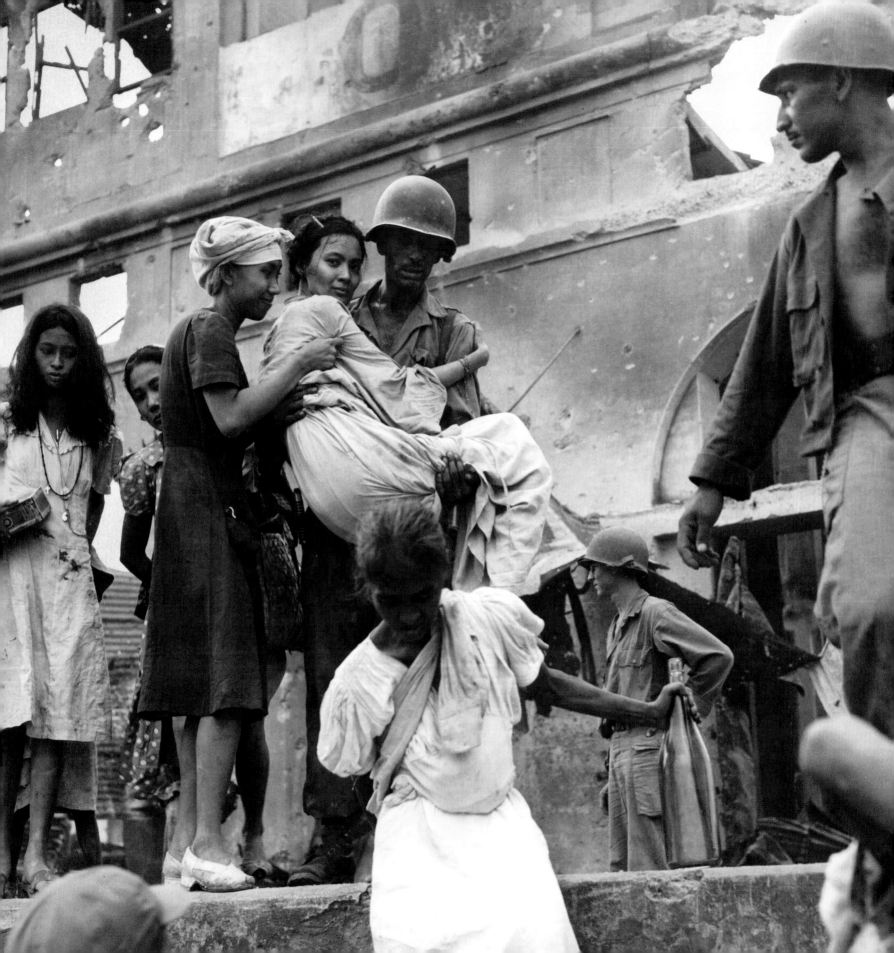

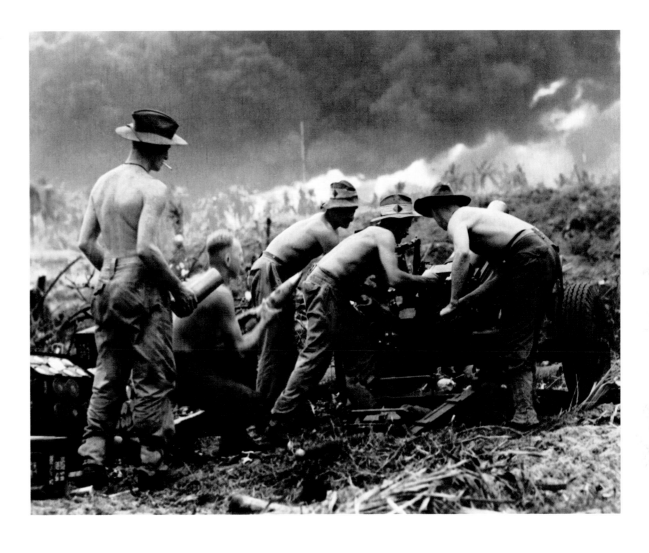

BOMBARDING BORNEO

Shirtless Australian artillerymen fire their 25-pounder at Japanese targets shrouded in smoke from burning fuel tanks during the assault on oil-rich Borneo, neighboring the Philippines, in the summer of 1945.

LIBERATED IN MANILA

Shell-shocked and wounded Filipinos receive a helping hand from GIs after being released in February 1945 from a church in Intramuros—the historic core of Manila—by Japanese troops who had taken them hostage. Many women and children were freed as American forces closed in, but others were slain by the Japanese or died in the fighting.

The Road to Tokyo

"EVERY MAN WILL RESIST UNTIL THE END, MAKING HIS POSITION HIS TOMB," vowed the commander of Japanese forces on Iwo Jima. Capturing that tiny island 660 miles south of Tokyo was the first step in an all-out American campaign in 1945 to crush enemy resistance and end the war. The assault on Iwo Jima in February—designed to capture its airfields and clear the way for the bombing of Tokyo and other targets—would be followed by a massive attack on Okinawa, a steppingstone for an invasion of Japan if its leaders refused to surrender. The defenders of both islands prepared to fight to the death.

Heavy air raids preceded the landing on Iwo Jima. But Japanese soldiers lurking in tunnels on the slopes of Mount Suribachi survived the bombardment and poured murderous fire on the marines as they huddled on the beach below, enduring what one witness called

"a nightmare in hell." Several days later, marines fought their way to the summit and raised the American flag. Even then, much of the island remained in control of the Japanese, who held out in bunkers until they were burned or blasted to death. Of the 20,000 troops defending the island, barely a thousand surrendered. The marines fought with equal tenacity and suffered over 25,000 casualties before securing Iwo Jima.

Twice as many Americans were later killed or wounded in the savage struggle for Okinawa, where Japanese soldiers holding the rugged interior offered fierce resistance while kamikaze pilots sacrificed themselves in blistering attacks on U.S. warships offshore. Among the targets was the aircraft carrier *Bunker Hill*, hit by two kamikazes on May 11 and knocked out of action, with the loss of 396 crewmen. Victory on Okinawa came at such a steep price that commanders feared an invasion of the Japanese home islands might cost a million American casualties.

NO PLACE TO HIDE
An American soldier crouches in the grass to avoid enemy shellfire on Okinawa in May 1945.

AN EXPLOSIVE STRUGGLE
Marine demolition experts on Iwo Jima take cover as their king-sized charge of TNT seals the entrance to a cave held by Japanese troops, sending rubble hurtling hundreds of yards in every direction. Demolition teams paved the way for the marines' slow advance by blasting scores of enemy caves and burying their occupants, who refused to surrender.

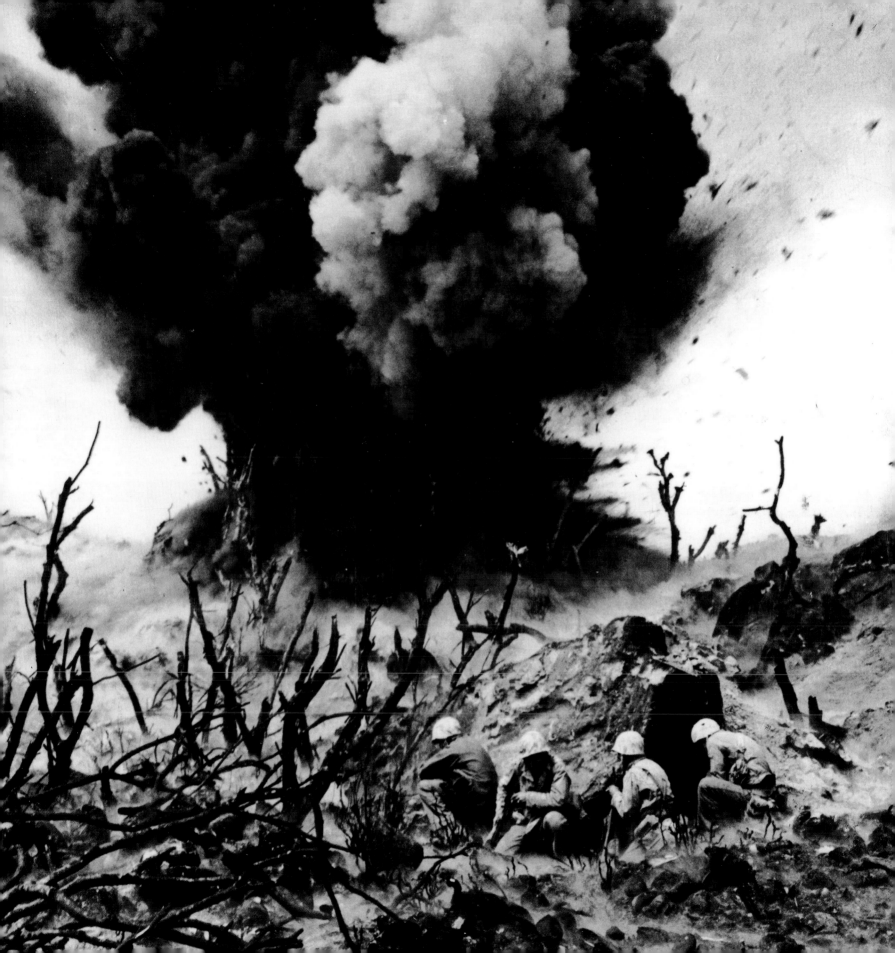

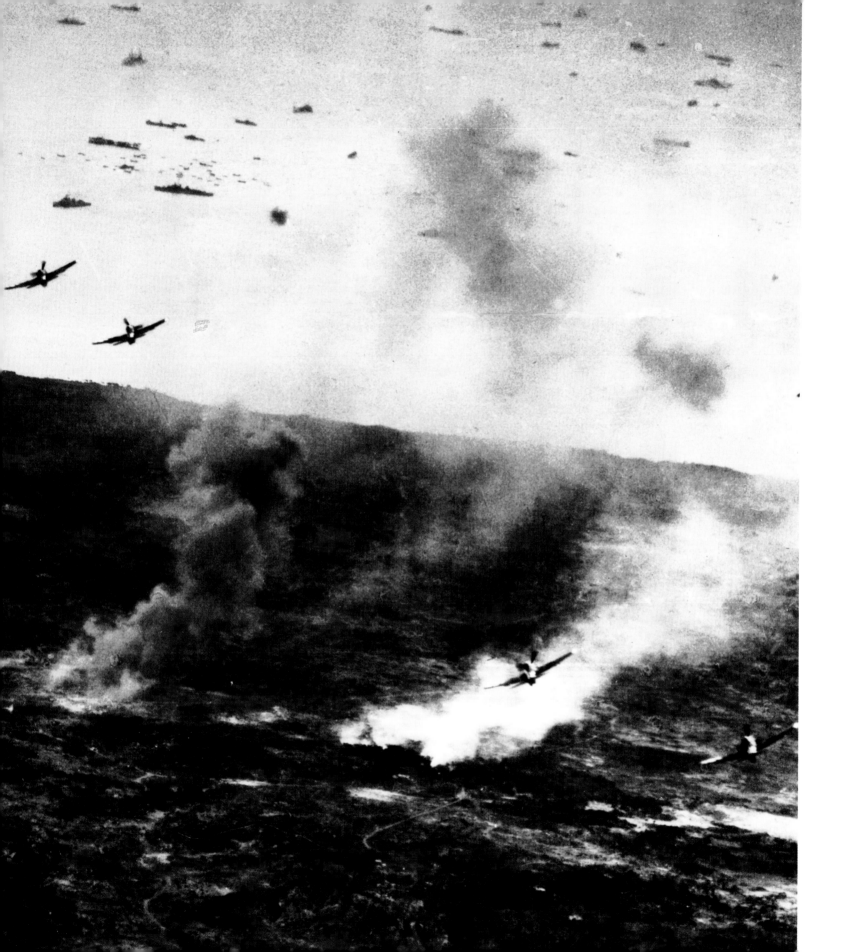

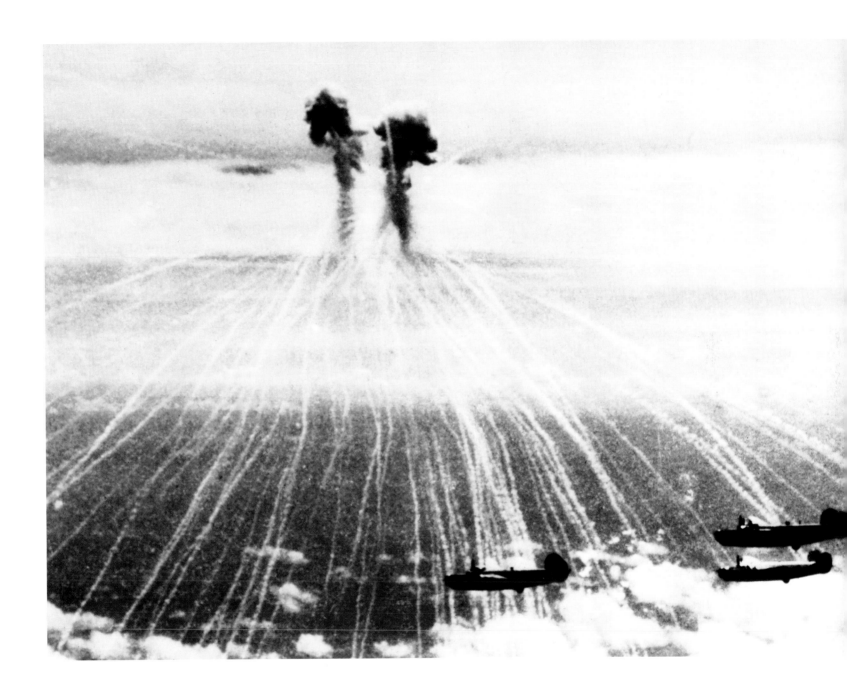

HELLCATS ON THE PROWL

F6F Hellcat fighter-bombers, swooping in over Iwo from Fifth Fleet carriers *(background)*, place their bombs on Japanese positions just ahead of the advancing 4th Marine Division. By the battle's end, American bombardiers had pounded the island with more than 1,000 tons of bombs, 12,000 rockets, and 400 tanks of napalm.

DODGING THE FLAK

Heading home from a raid on Iwo Jima, B-24 Liberators pass through a shower of incendiary fragments from two phosphorus bombs dropped by Japanese fighters flying high above. Though this spectacular weapon damaged many planes, it failed to knock down a single Liberator.

> *"Secure this lousy piece of real
> estate so we can get the hell off it."*

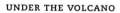

LIEUT. COLONEL CHARLES R. SHEPARD,
28th Regiment, on Iwo Jima

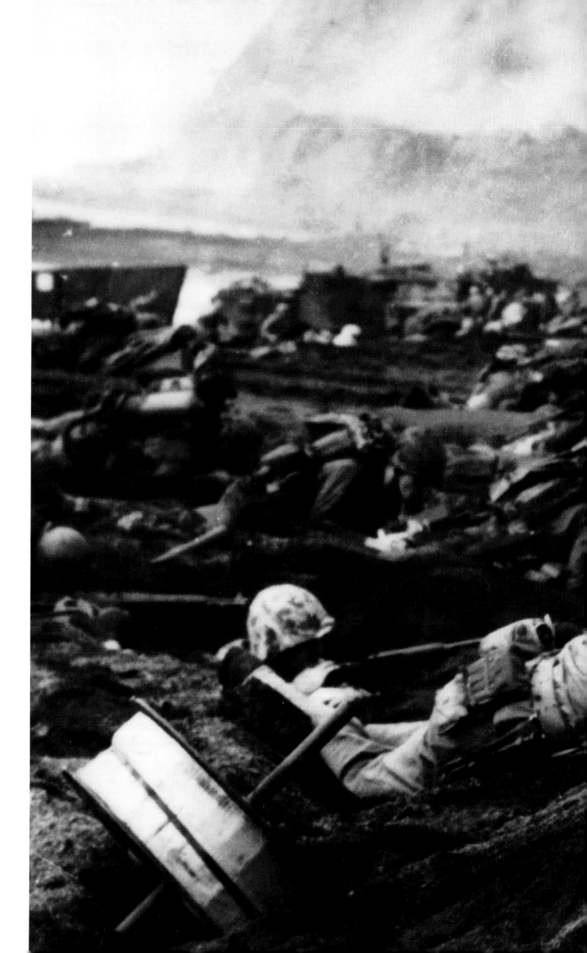

UNDER THE VOLCANO
While U.S. naval shelling raises clouds of smoke and dust
on Mount Suribachi, marine riflemen of the 28th Regiment
struggle to advance up a steep terrace of soft volcanic
sand on the beach. Two of the regiment's battalions later
attacked Japanese troops entrenched on the slopes of
the volcano.

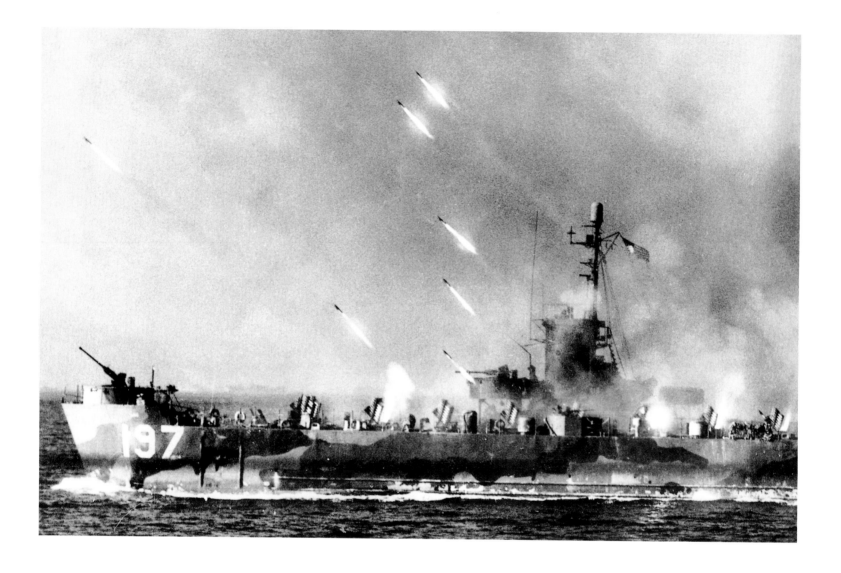

OVERTURE ON OKINAWA

Rockets unleashed by a U.S. warship streak toward Japanese positions on Okinawa in advance of the American assault there on April 1.

PRAYING FOR RELIEF

At the foot of Rocky Crags on Okinawa, a GI wounded in the head and foot is tended by a medic while awaiting evacuation. "Although he was in great pain, they did not give him morphine because of the head wound," wrote photographer W. Eugene Smith. "He lay there with his hands clenching and unclenching. Finally he brought his hands together in a position of prayer."

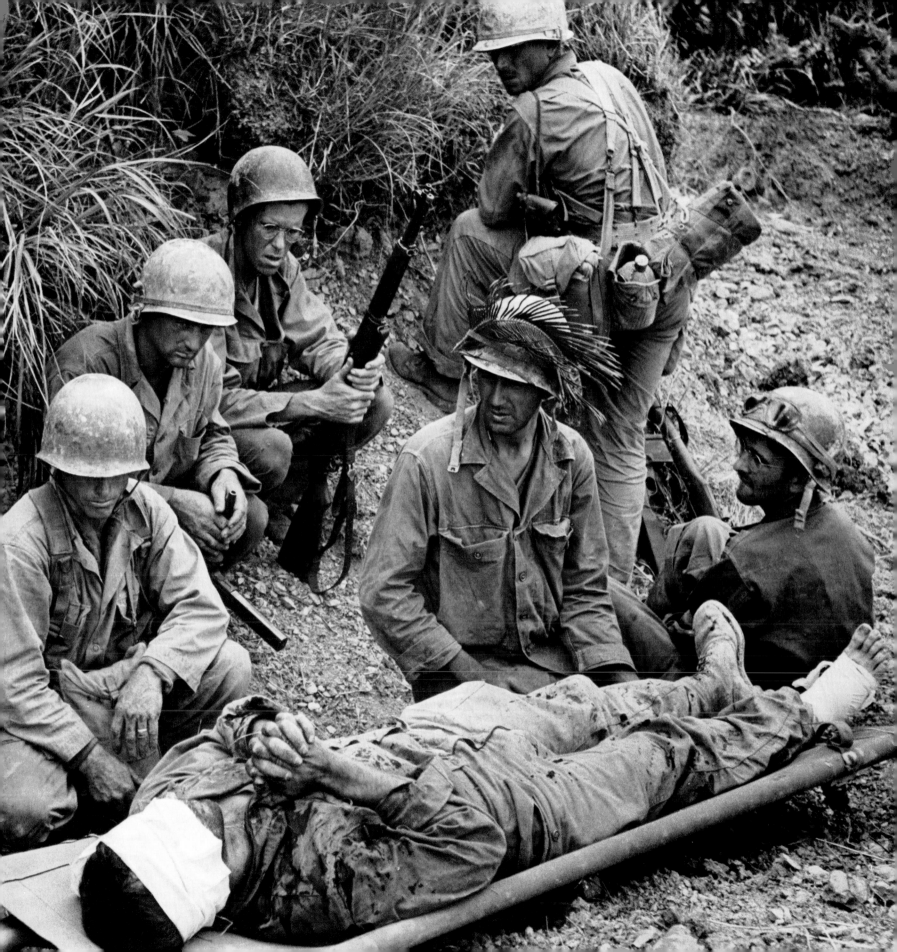

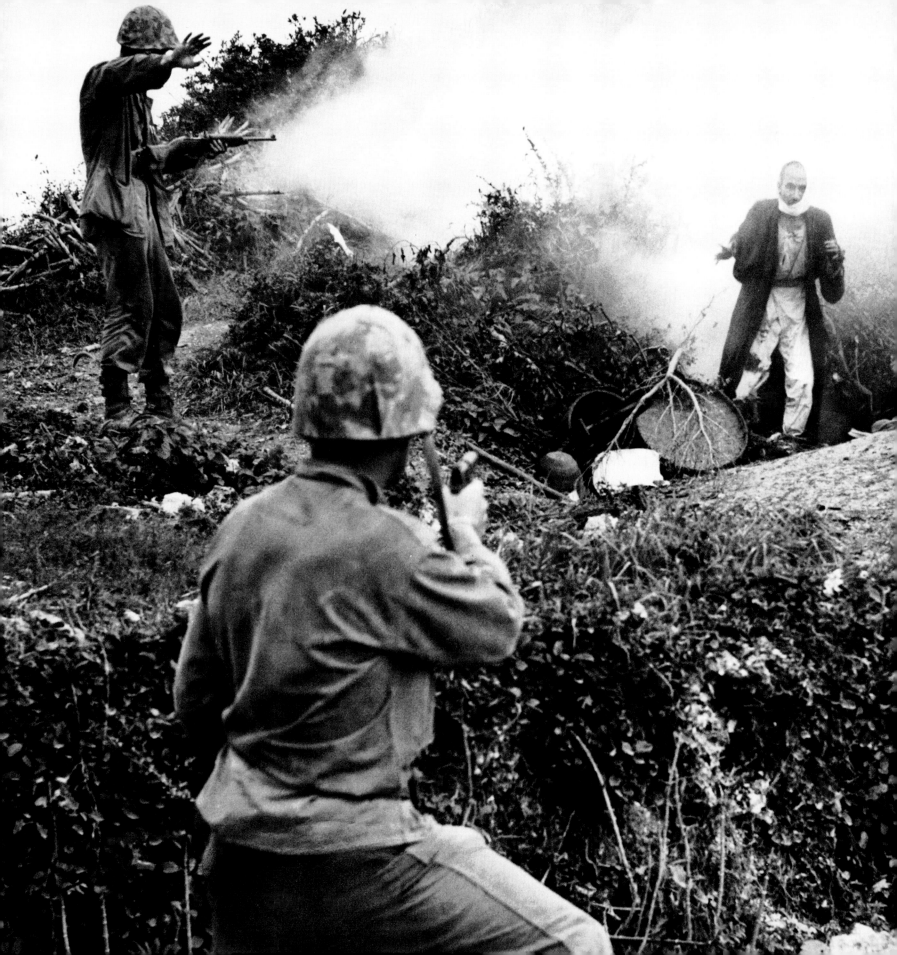

"Our people were shooting human beings who weren't necessarily military. But after I saw what their people— including civilians—did with their hands up, I worried about us, not them. I wanted to leave Okinawa alive!"

A U.S. MARINE ON OKINAWA

NO PLACE FOR CIVILIANS
A frightened Okinawan, his head swathed in a towel to protect him from the heat, is flushed out of his underground hiding place by cautious marines, who spared this man but feared violent resistance by civilians. Warned that Americans would brutalize them, many civilians on Okinawa held out with Japanese troops and over 50,000 died.

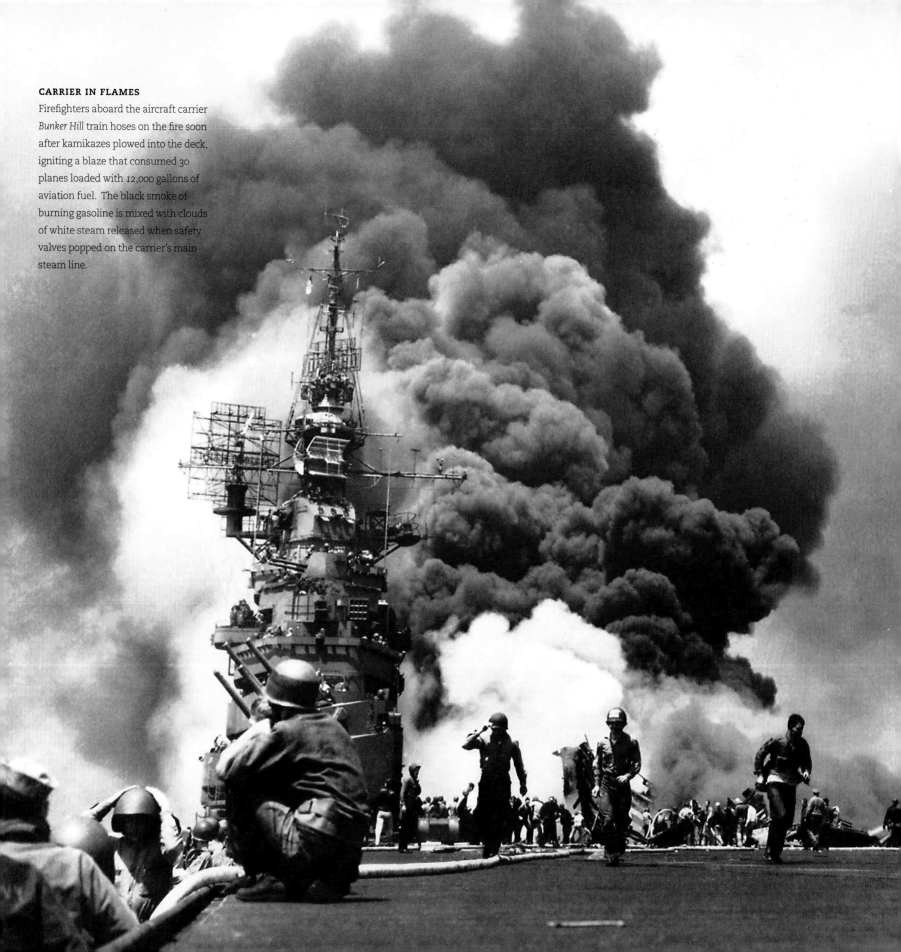

CARRIER IN FLAMES

Firefighters aboard the aircraft carrier *Bunker Hill* train hoses on the fire soon after kamikazes plowed into the deck, igniting a blaze that consumed 30 planes loaded with 12,000 gallons of aviation fuel. The black smoke of burning gasoline is mixed with clouds of white steam released when safety valves popped on the carrier's main steam line.

SUICIDE RUN

A kamikaze, skimming the water amid antiaircraft bursts and splashing shrapnel, makes a run at the battleship *Texas* off the coast of Okinawa. The plane evaded fire for a few hundred yards, then was blown to bits by a direct hit from the *Texas*.

LIFELINE AT SEA

A badly injured sailor is evacuated from the *Bunker Hill* to the cruiser *Wilkes-Barre* by means of a pulley system known as a transfer whip. The *Bunker Hill's* sick bay was knocked out, and injured crewmen, many horribly burned, were placed under the wings of undamaged aircraft to shield them from the sun until they could be moved to other ships.

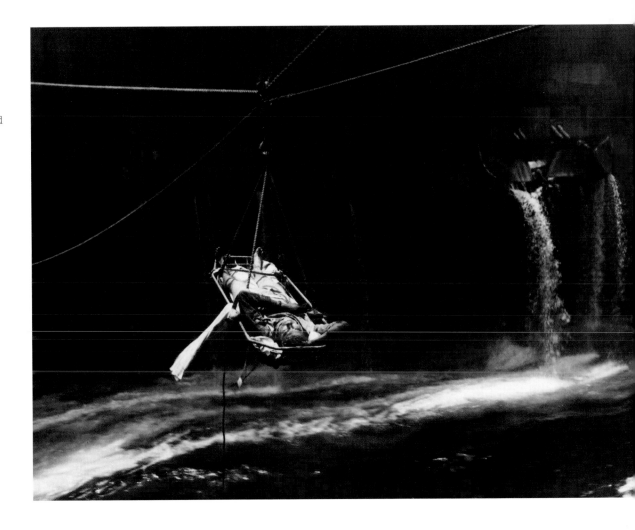

Across the Rhine

ALLIED HOPES WERE RUNNING HIGH. After liberating Paris in August 1944 and sweeping on toward Germany, many thought the war would be over by Christmas. Instead, December brought a jarring counteroffensive by enemy forces supposedly near collapse. The resulting struggle, known as the Battle of the Bulge, was a last-ditch effort by Hitler to dispel the growing conviction that he was leading Germany to ruin—even the dutiful Rommel had been implicated in a failed attempt to assassinate the Führer in July and been forced to commit suicide. Germany had lost over three million men in battle since 1939, but Hitler scraped together 250,000 troops for this big push by making all men between 16 and 60 eligible for service and diverting

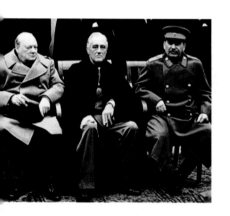

troops from the Eastern Front, where his forces were already vastly outnumbered by the Red Army. His plan was to smash the Allied forces to his west and then throw everything he had at the Soviets.

Beginning on December 16, German divisions swept through the Ardennes along the border of Belgium and Luxembourg and gouged a deep dent in the Allied front. Eisenhower, steady as ever, insisted to aides that this apparent disaster was an "opportunity for us." In bitter fighting over the next few weeks, his forces proved him right, preventing a breakthrough by holding the crucial junction of Bastogne and shattering Hitler's offensive by killing or wounding 125,000 Germans at a cost of 80,000 Allied casualties. Capitalizing on this hard-won victory, Eisenhower pushed into Germany before the winter was out, dropping paratroopers behind enemy lines while armor and infantry staged frontal assaults. By the spring of 1945, the Allies were across the Rhine in force and taking prisoners in droves. But they were not to seize Berlin. That prize—and the rest of eastern Germany—fell to the Soviets under an occupation agreement thrashed out by Allied leaders at Yalta in February.

THE BIG THREE AT YALTA

Churchill, Roosevelt, and Stalin pose grimly for photographers in February 1945 after the tense Yalta Conference, at which they drew up occupation zones in anticipation of Germany's defeat.

A FLOOD OF PRISONERS

Guarded by a few GIs, Germans march into captivity past an American mobile antiaircraft unit near Limburg, Germany. These prisoners, taken by the U.S. First Army in March 1945, joined the 500,000 who had already surrendered to Americans that year.

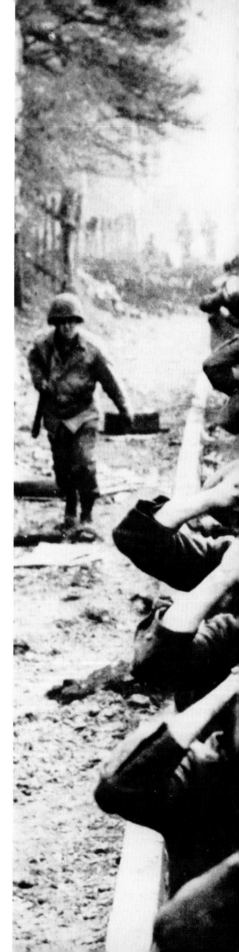

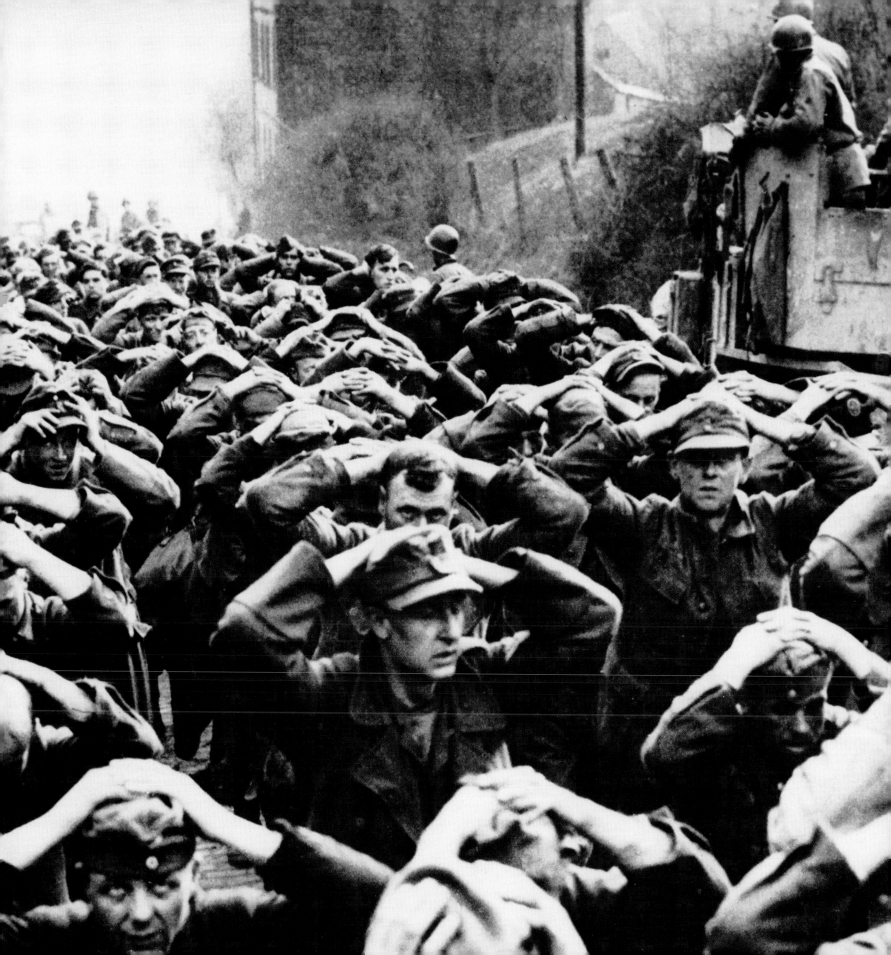

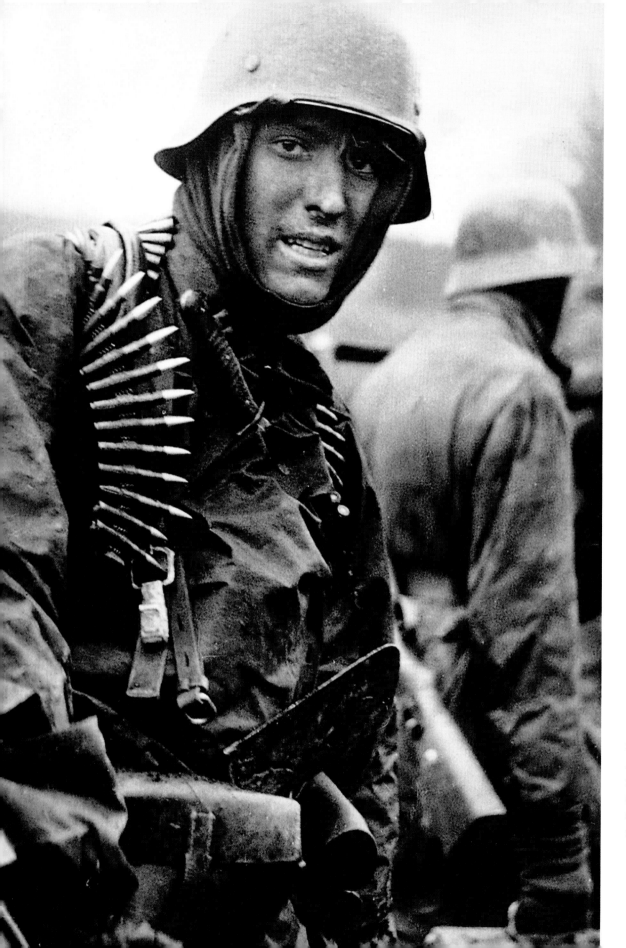

PANZER IN THE ARDENNES
A heavily armed SS panzer trooper radiates the confidence and excitement that pervaded the German armies after their early victories in the Ardennes in December 1944.

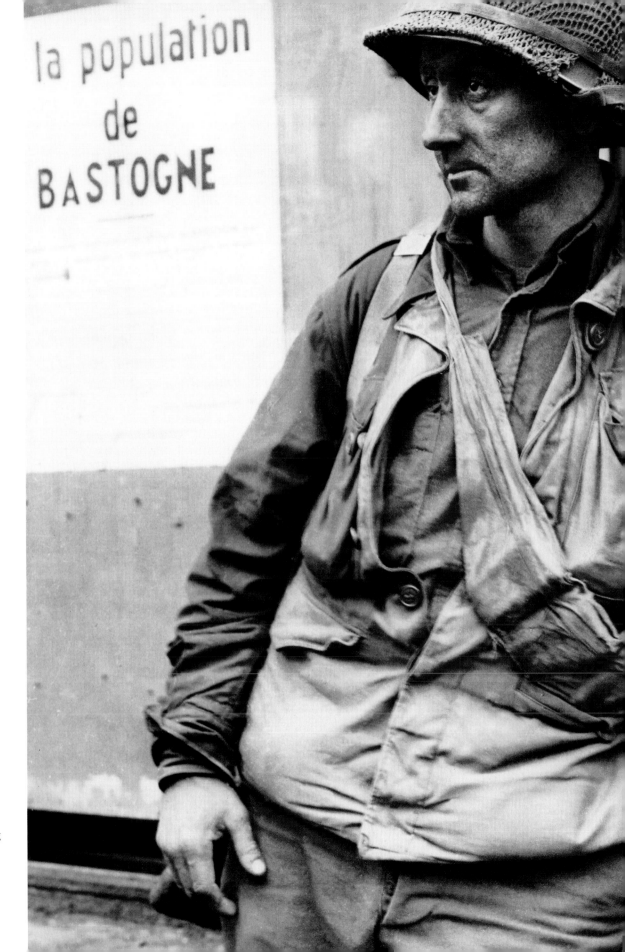

BESIEGED AT BASTOGNE

Exhaustion shows on the face of a GI defending Bastogne in late December. Besieged troops there called themselves the Battered Bastards of Bastogne, after the self-styled Battling Bastards of Bataan in the Philippines.

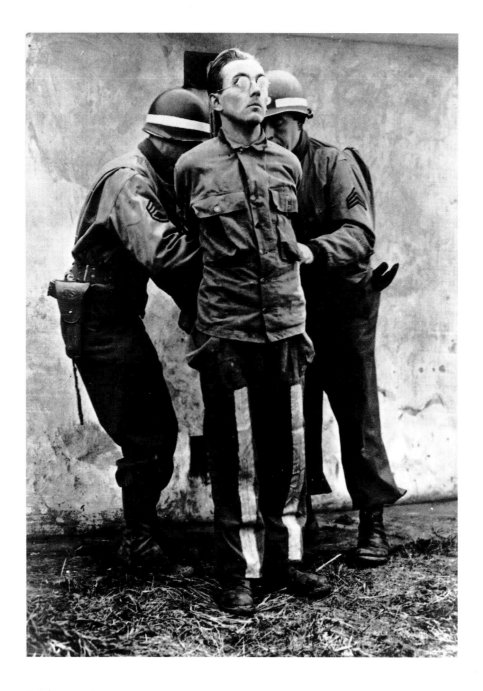

EXECUTED AS A SPY

U.S. military police tie a German officer cadet to a stake for execution by firing squad after he disguised himself as an American soldier and penetrated Allied lines during the Battle of the Bulge.

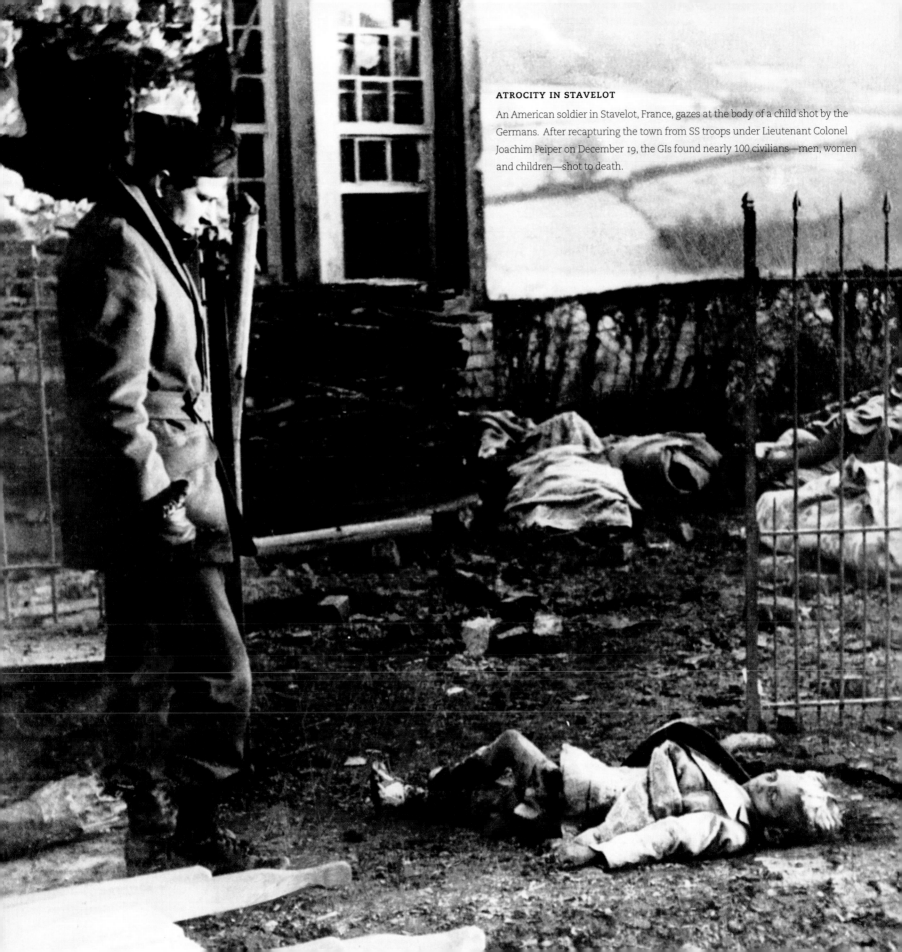

ATROCITY IN STAVELOT

An American soldier in Stavelot, France, gazes at the body of a child shot by the Germans. After recapturing the town from SS troops under Lieutenant Colonel Joachim Peiper on December 19, the GIs found nearly 100 civilians—men, women and children—shot to death.

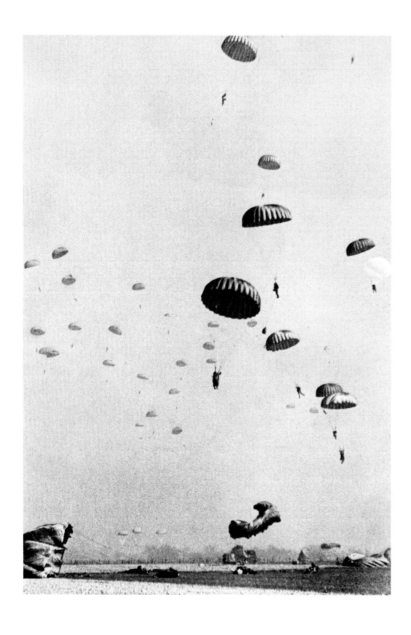

DESCENDING ON GERMANY

Vulnerable paratroopers drift down over Germany during an airborne assault in March 1945 accompanied by photographer Robert Capa. "The moments between your jump and landing," Capa said, "are 24 hours in any man's life."

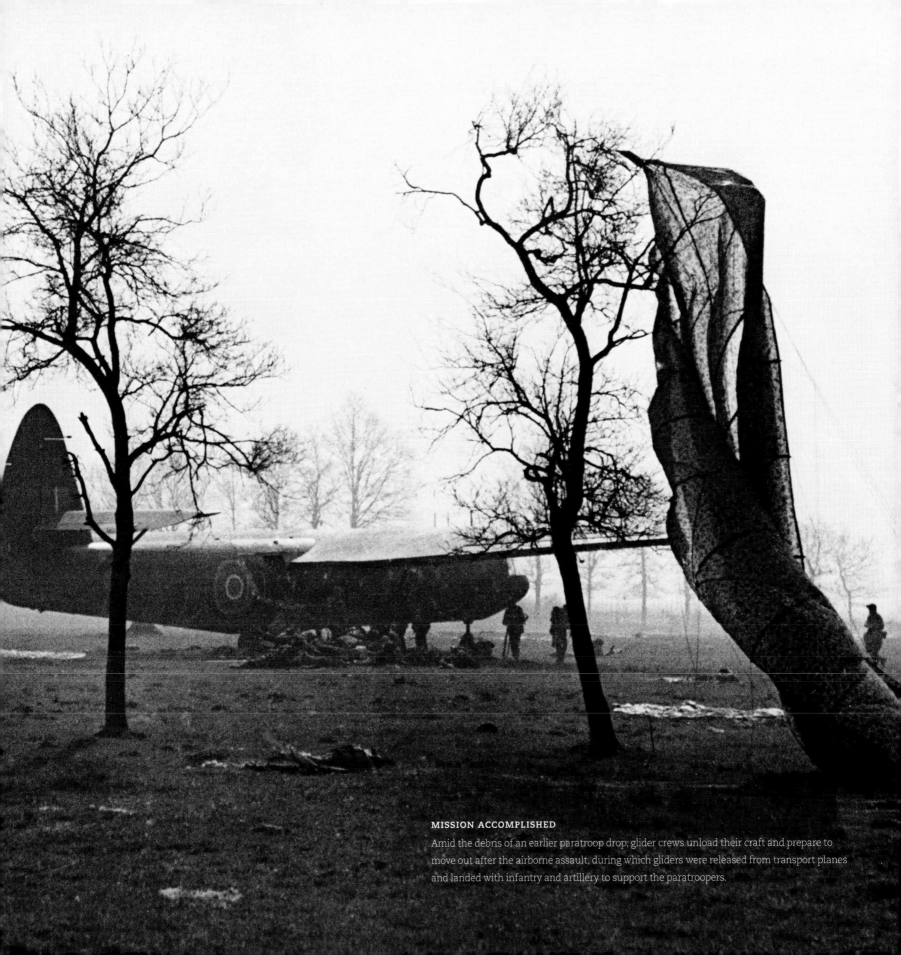

MISSION ACCOMPLISHED

Amid the debris of an earlier paratroop drop, glider crews unload their craft and prepare to move out after the airborne assault, during which gliders were released from transport planes and landed with infantry and artillery to support the paratroopers.

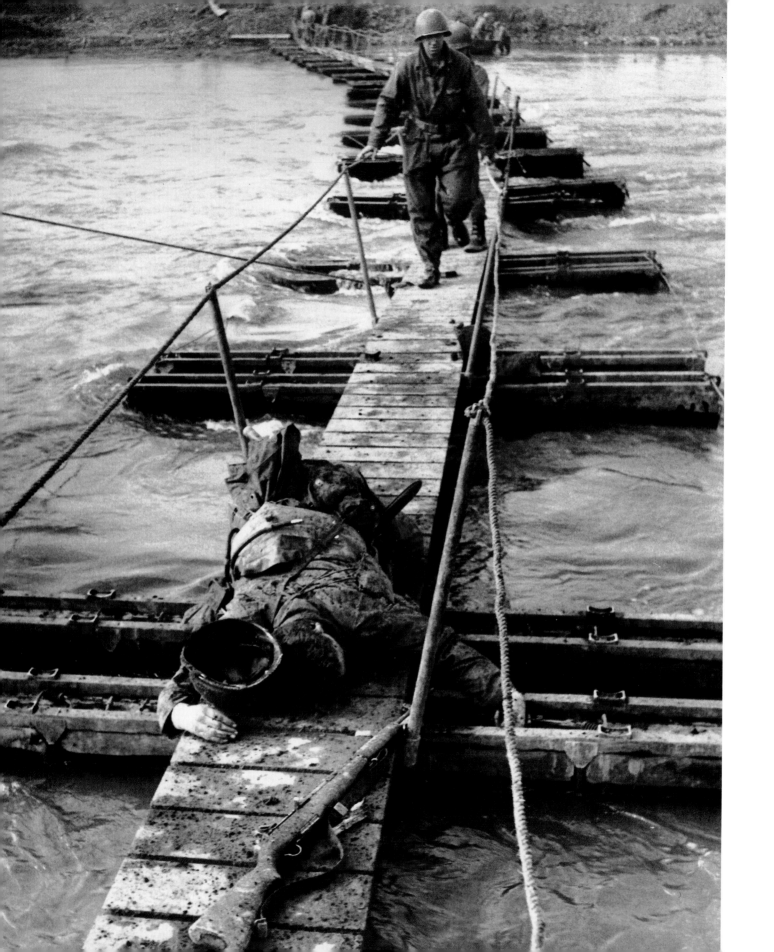

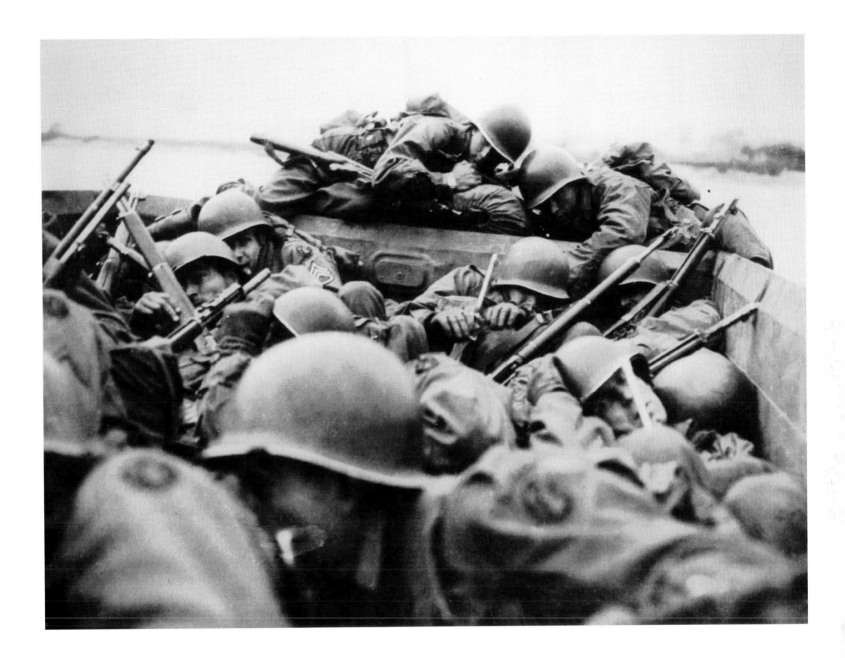

DEADLY PATHWAY

A dead American soldier hit by mortar fire blocks the path of GIs crossing a footbridge strung by army engineers over the Roer River, marking the border between Belgium and Germany.

ACROSS THE RHINE

Chugging across the Rhine in an assault boat in late March, GIs hunker down to avoid small-arms fire from Germans on the east bank.

CLAIMING A TROPHY

U.S. Seventh Army troops enjoy the view from atop a captured 274 mm railroad gun in Germany. Countless cannon and vehicles were abandoned by fleeing Germans.

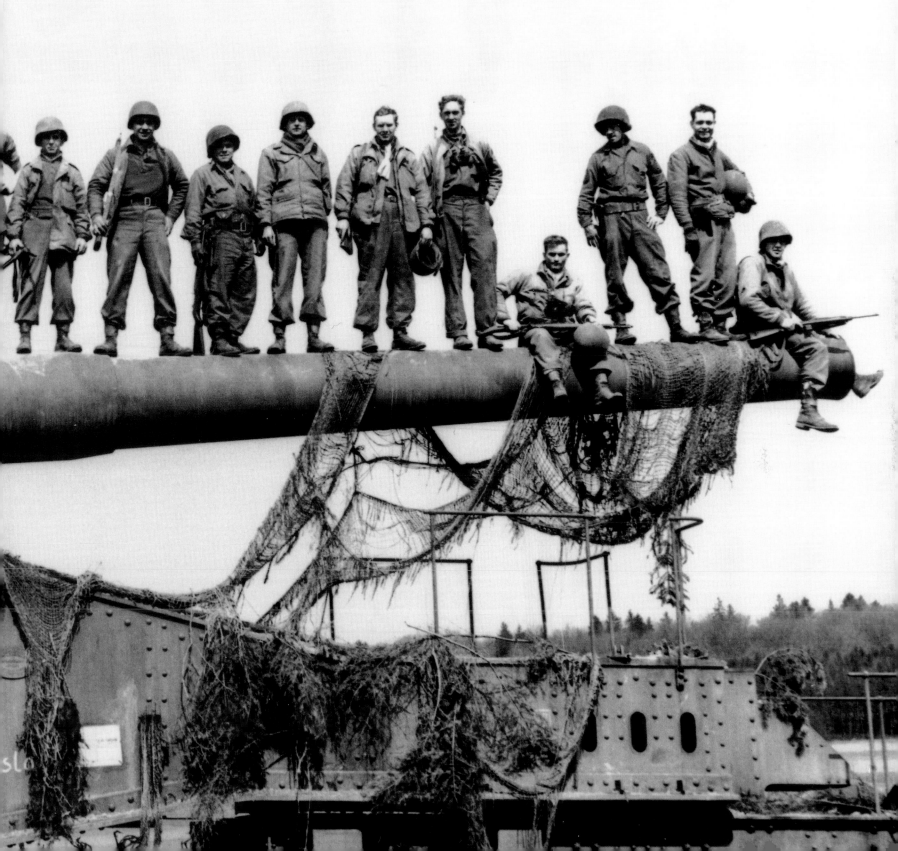

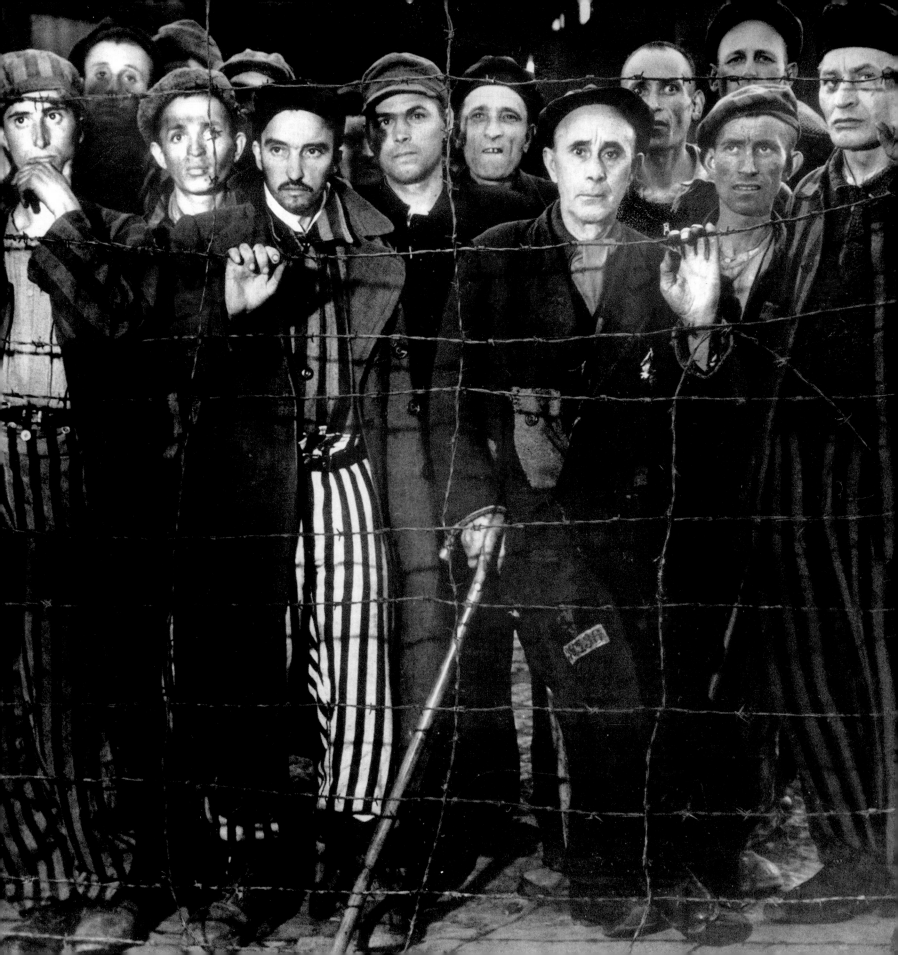

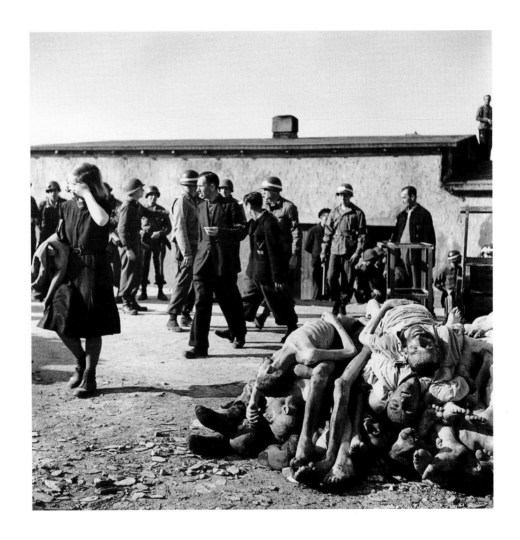

TOO TERRIBLE TO WITNESS

Residents from the nearby city of Weimar walk with eyes averted past the piled-up corpses of Buchenwald victims after being summoned by General Patton to witness evidence of Nazi atrocities.

SURVIVORS AT BUCHENWALD

Survivors peer through a barbed wire fence at Buchenwald, a concentration camp in Germany liberated by American troops in April 1945.

Fall of the Third Reich

"WE SHALL NOT CAPITULATE," HITLER VOWED as his regime crumbled and his nation faced defeat. "We may be destroyed, but if we are, we shall drag a world with us—a world in flames." In fact, it was Hitler's own people who suffered most as a result of his refusal to surrender. As the war reached its fiery climax in 1945, Germans faced fearful retribution from a nation that Hitler had set out to annihilate—the Soviet Union. Ever since Stalingrad, the Red Army had been pushing the invaders back toward their own borders. In July 1943, Hitler's vaunted panzers had tried to stem the tide by waging a massive tank battle at Kursk, only to discover that Russian armor was now superior to their own. Buoyed by the victory, the Red Army went on that winter to break the prolonged siege of Leningrad, where nearly a million people had died of starvation.

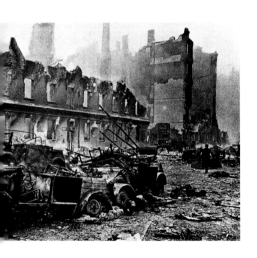

All told, Russia lost 7 million civilians and 10 million soldiers before the Red Army surged across Germany's Eastern frontier in early 1945. Vindictive Soviet troops brutalized the populace, raping women and burning villages. German civilians and soldiers fled westward in the hope of reaching Allied occupation zones, where they could expect better treatment. To defend Berlin, Hitler resorted to enlisting women and children. "They should be placed in the second line," Goebbels wrote, "then the men in the front will lose all desire to withdraw." The city's irregular defense force fought furiously, inflicting 300,000 casualties on the advancing Soviets, but the outcome was inevitable. On April 30, Hitler committed suicide in his Berlin bunker, and Goebbels and others who stayed with him to the end followed suit. Admiral Karl Dönitz succeeded Hitler as head of state and surrendered to the Allies on May 7. The world that Hitler had vowed to leave in flames instead erupted in celebrations.

FALL OF BERLIN
Hours after the May 2 cease-fire in Berlin, a pedestrian wearily maneuvers among vehicles and bodies on the Friedrichstrasse, a major boulevard that the last days of fighting had turned into a battleground. The devastation to the buildings was caused by Russian shelling and by earlier British and American air raids.

RECRUITS FOR A DOOMED CAUSE
In the last weeks of the war, Hitler reviews teenage Eastern Front veterans, typical of the units that were left to defend Berlin.

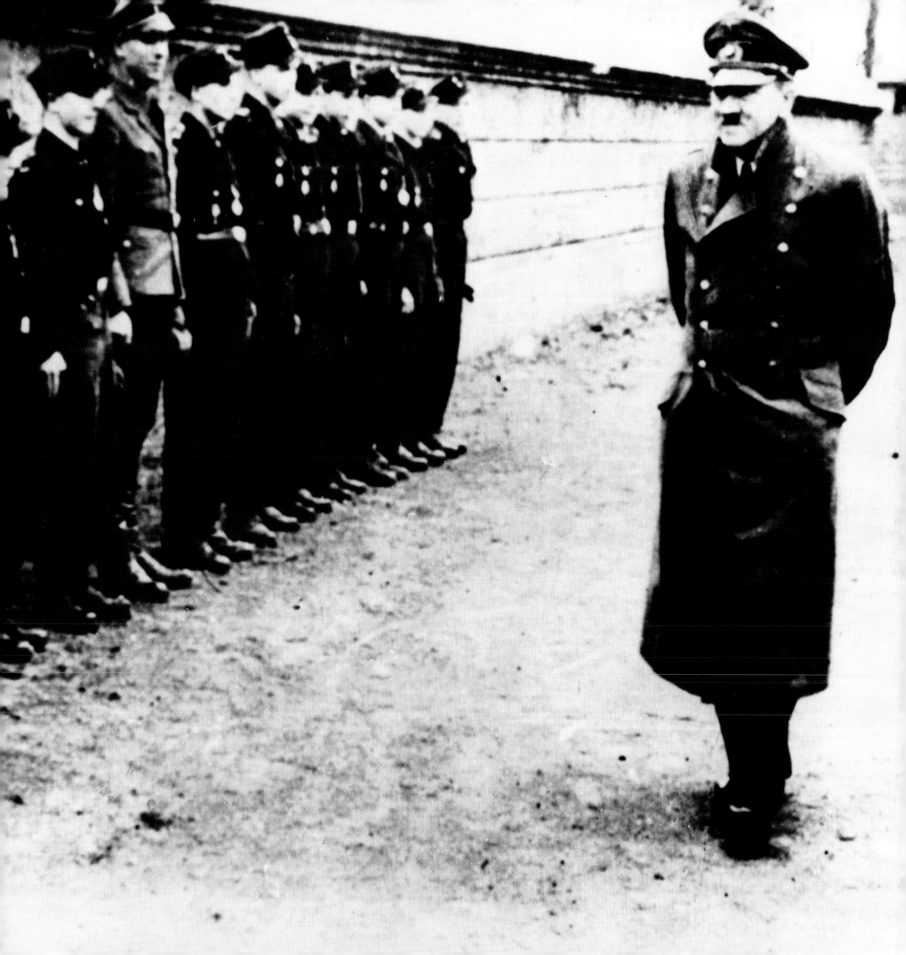

"Our troops are sweeping forward like a mighty river that knows no barriers and washes away all obstacles."

A SOVIET CORRESPONDENT,
with the Red Army in 1944

BREAKING THE SIEGE
Shouting and brandishing a submachine gun, a Soviet officer waves his men forward in January 1944 during the offensive that broke the siege of Leningrad.

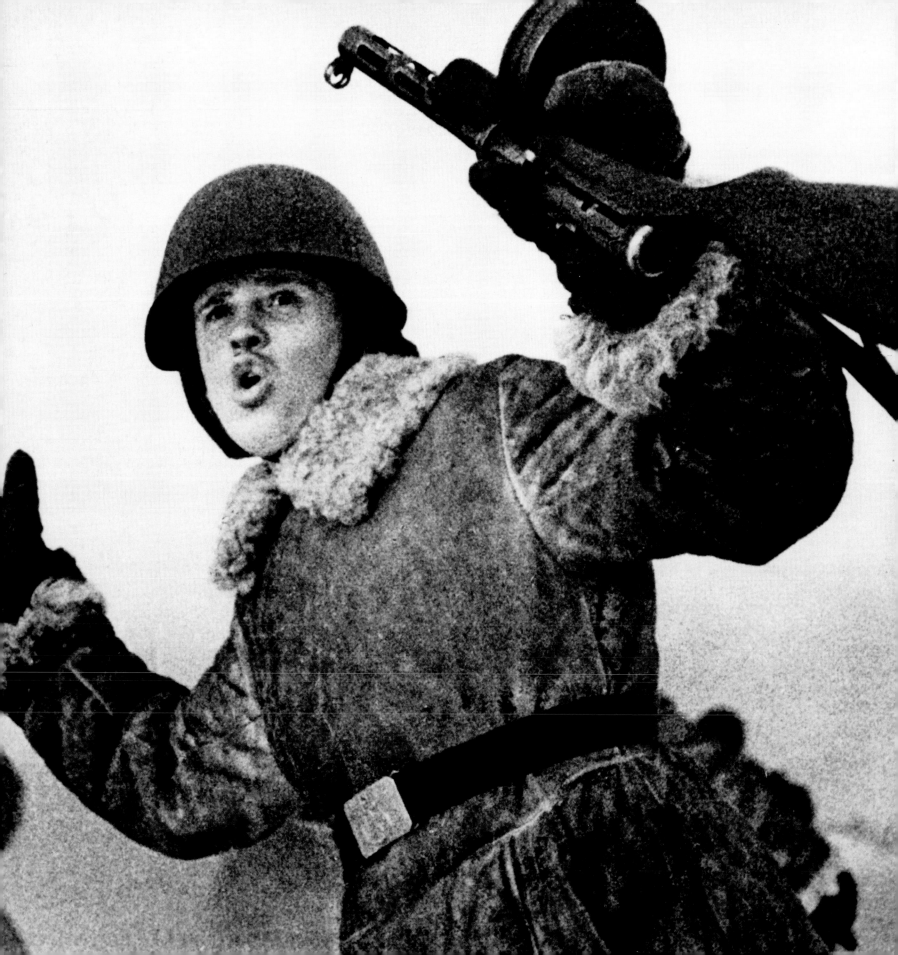

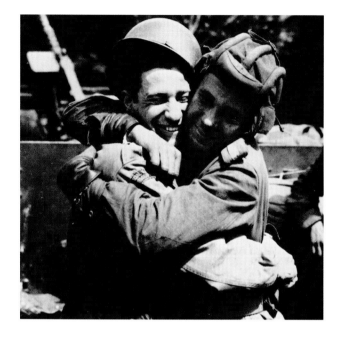

TRIUMPHANT BEAR HUG

An American soldier *(above, left)* meeting up with a Soviet counterpart in Germany in late April 1945 receives the traditional Russian greeting—a bone-bruising bear hug.

SOVIET WELCOMING COMMITTEE

Russians, including women bearing bouquets, greet American GIs at the Elbe River about 75 miles south of Berlin, as the two sides meet on April 25.

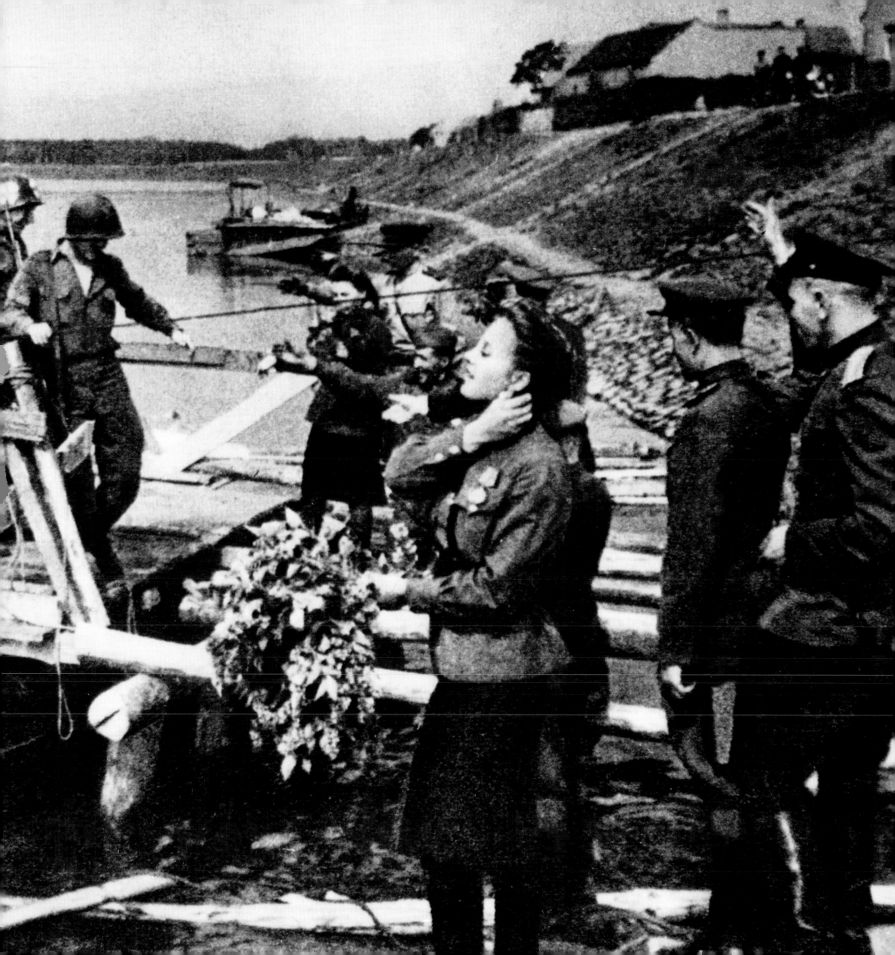

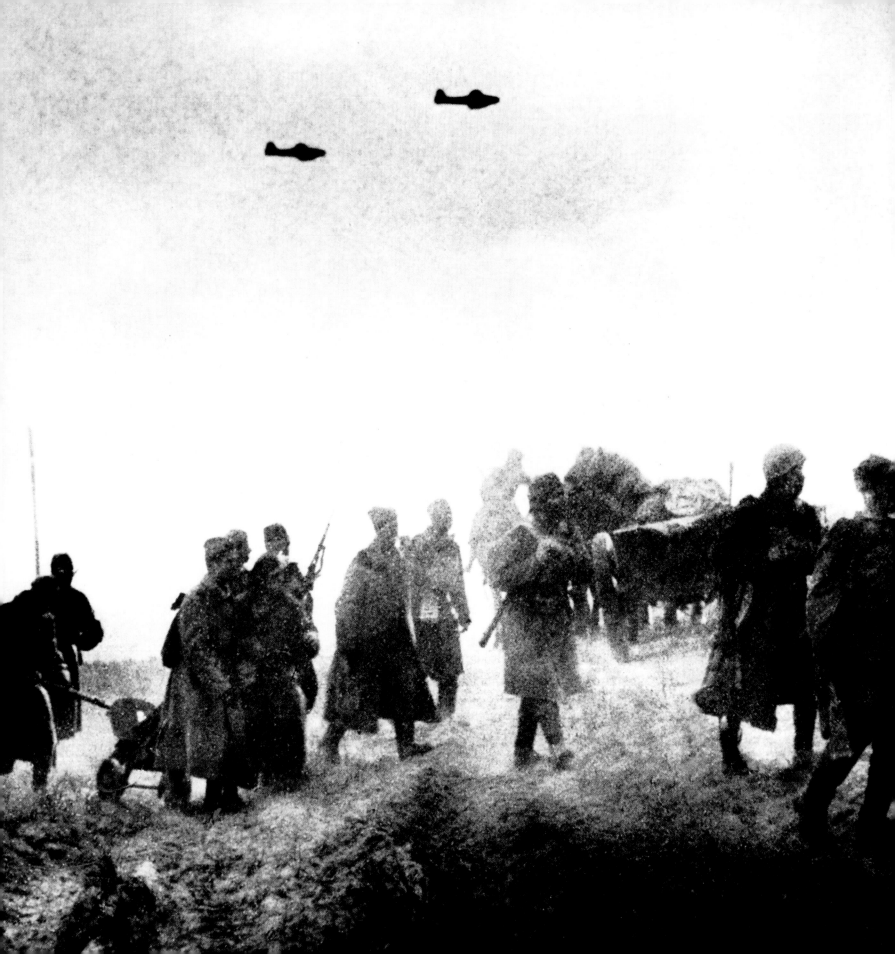

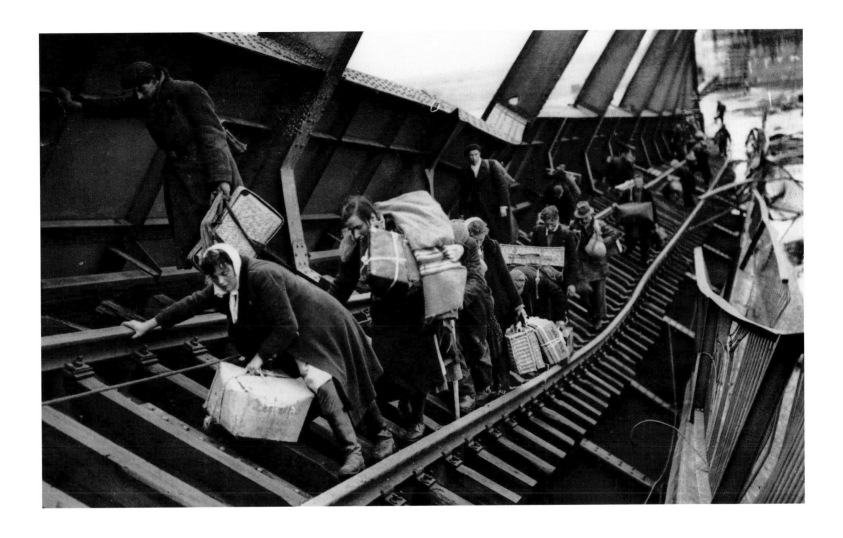

IVAN AT THE DOOR

Red Army infantrymen trudge through a dusty field on their way to Berlin in April. "Ivan is almost at the door," warned a radioman at a German command center nearby.

FLEEING WEST

German civilians cross a ruined railroad bridge across the Elbe River in an effort to escape the Soviet occupation zone and find refuge with the Allies.

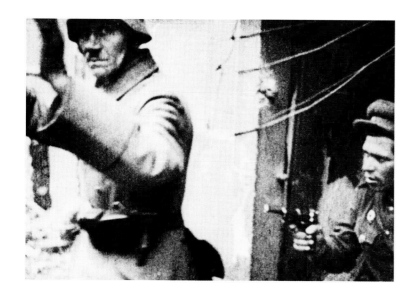

CAPTURED IN BERLIN

Hands held high, a captured German is covered by a Red Army officer in Berlin. The Soviets took 70,000 prisoners of war in the city.

SPRINT TO VICTORY

Russian infantrymen under fire race past a dead German soldier to reach the far side of a rubble-strewn street near the center of Berlin. Soviet tanks and artillery had softened up German defenses, but foot soldiers had to carry the fight against hundreds of stubbornly held German redoubts.

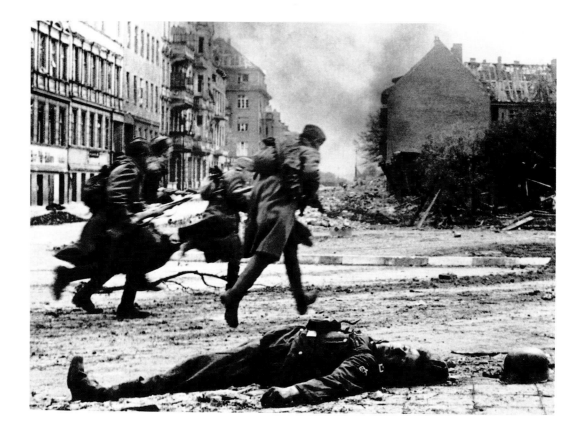

MESSAGE FOR THE CONQUERORS
Russian self-propelled guns rumble down a street in the embattled capital past a defiant message, "Berlin shall remain German."

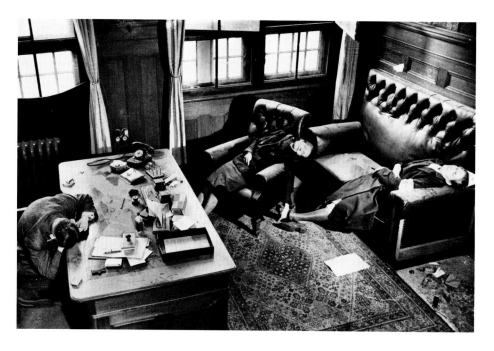

DYING WITH THE REGIME

The mayor of Leipzig, Alfred Freyberg, and his wife and sister lie dead in his office after taking poison when U.S. troops entered the city. Most German officials ignored warnings of Allied brutality issued by the crumbling regime and took their chances with the conquerors.

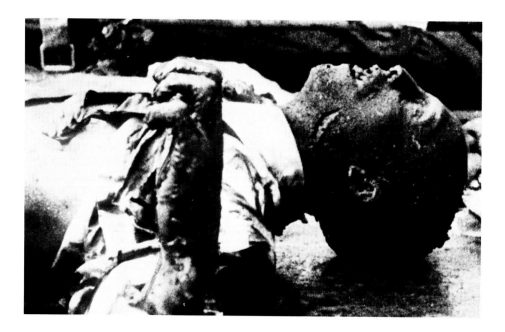

SHARING HITLER'S FATE

The scorched remains of German propaganda minister Joseph Goebbels lie outside Hitler's bunker. Goebbels and his wife died at their own hand along with their six children on May 1.

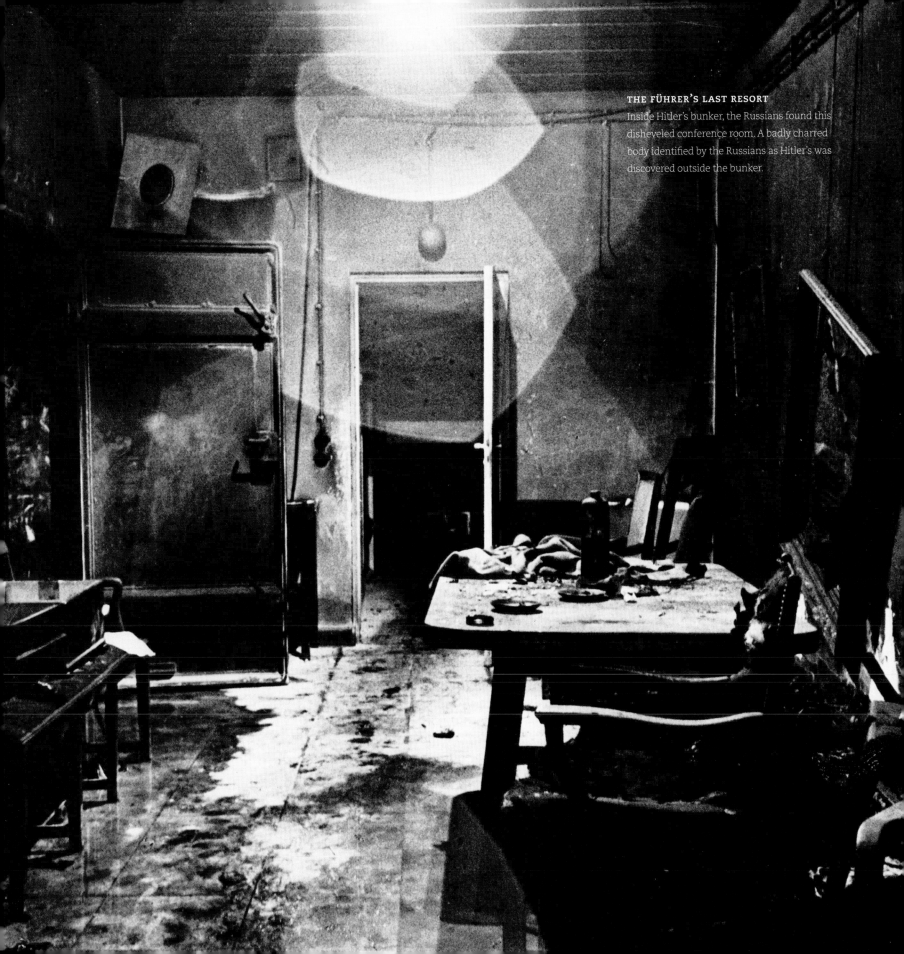

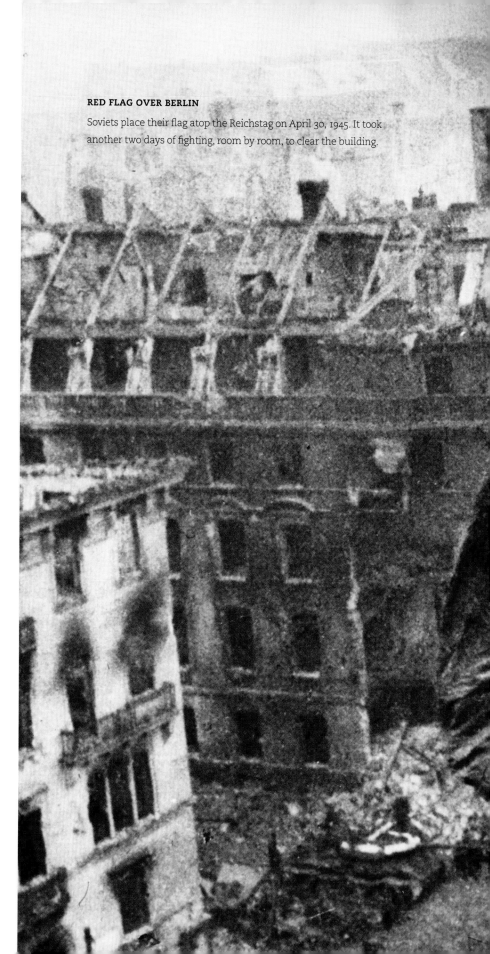

RED FLAG OVER BERLIN

Soviets place their flag atop the Reichstag on April 30, 1945. It took another two days of fighting, room by room, to clear the building.

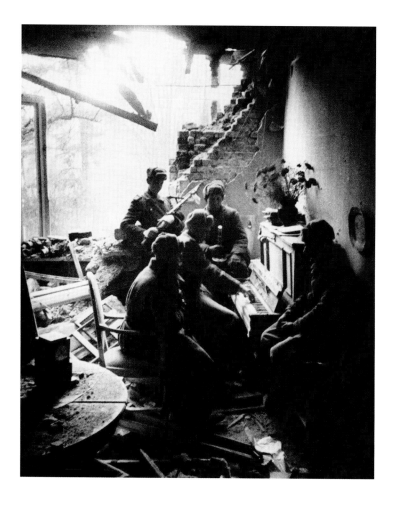

PLAYING IN THE RUINS

In a Berlin building ripped apart by shellfire, a Red Army soldier entertains his comrades by playing a piano topped with a vase of flowers that somehow escaped destruction.

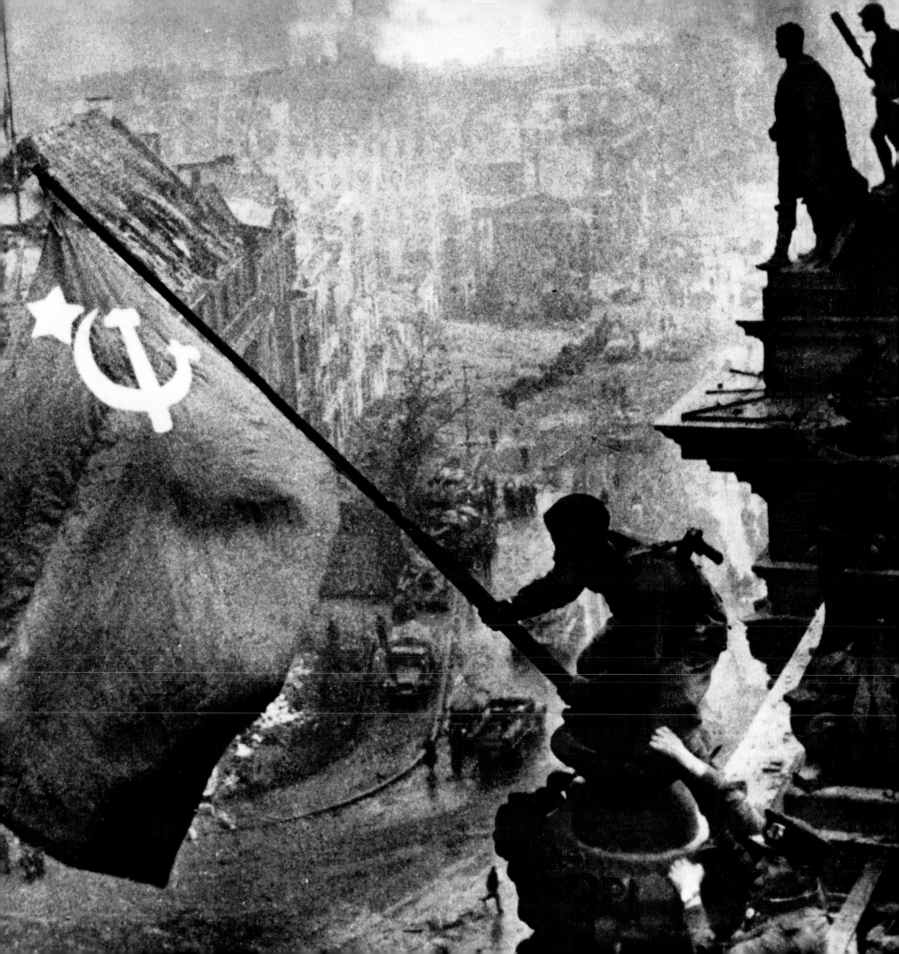

HAILING VICTORY IN EUROPE
Beneath a replica of the Statue of Liberty, thousands of New Yorkers flood Times Square to celebrate Germany's surrender on May 7, 1945.

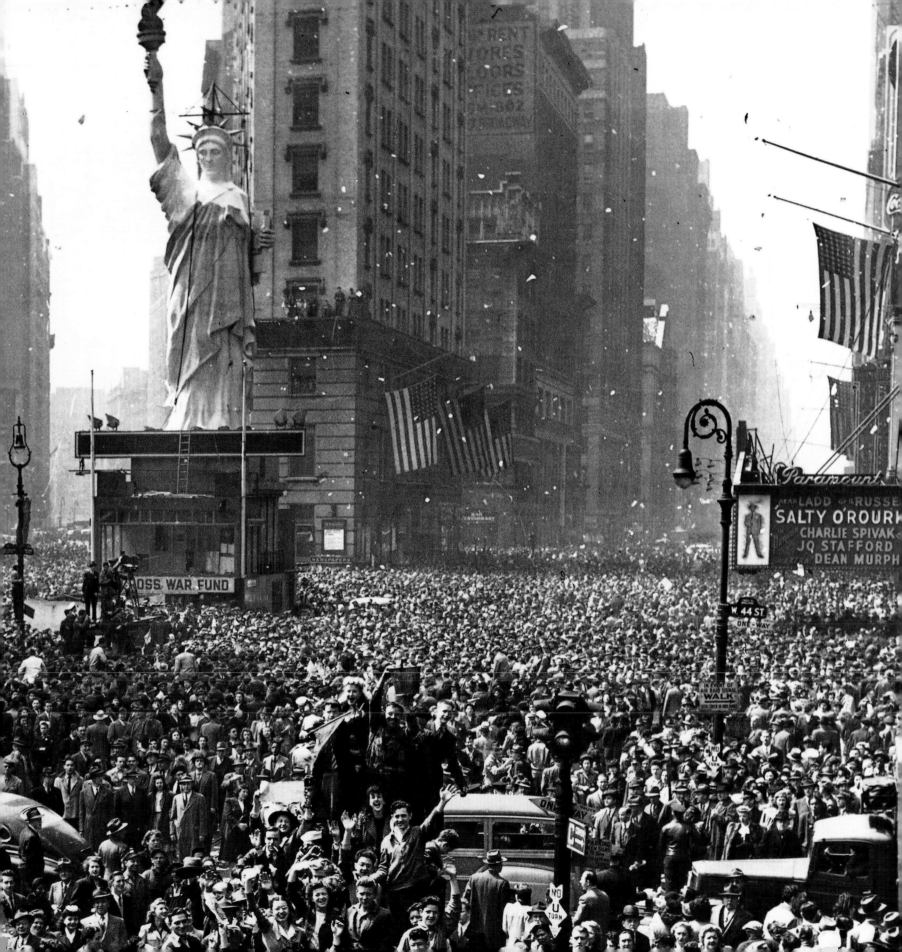

Fall of Japan

WORD THAT GERMANY HAD SURRENDERED offered little solace to those waging war on Japan. The regime in Tokyo showed no signs of yielding, despite the punishment inflicted by B-29 bombers on the Japanese capital, where one recent firebombing had killed 100,000 people. General Curtis LeMay proposed to "bomb and burn them until they quit." But other commanders believed the Japanese would not accept defeat until American troops conquered their homeland. Estimates of horrendous casualties if the U.S. invaded Japan chilled President Harry Truman, thrust into the role of commander-in-chief by Roosevelt's death in April 1945. When Truman learned in July that scientists with the top-secret Manhattan Project had perfected an atomic bomb, he resolved to use the weapon if Japan failed to surrender. In the end, it took two A-bombs—one dropped on Hiroshima on August 6 and the second on Nagasaki three days later—to shatter Japanese resistance and impel Emperor Hirohito to call an end to the war.

For the victors, the joy that greeted news of Japan's defeat on August 14 was tempered by the realization that the world was forever altered—as evidenced by reports of the dire effects of radiation poisoning at Hiroshima and Nagasaki. Yet revelations that the Japanese had brutally mistreated Allied prisoners of war served as a reminder for many that destroying the Axis was a greater good than any evil done to achieve that end. "Think of the survivors of the German death camps cheering our troops, and then think of Nagasaki," wrote Robert Miller of the U.S. Army Air Corps in a letter to his wife. "The war was insane but we had to fight it—and to the finish." General MacArthur, presiding over Japan's formal surrender on September 2, expressed the hope of all who had endured this harrowing conflict that "a better world shall emerge out of the blood and carnage of the past."

MASKED FOR WAR
Wearing gas masks, Buddhist priests from Tokyo's Asakusa Temple join uniformed civil defense workers in an air-raid drill held before the attack on Pearl Harbor.

BOMBERS OVER FUJI
The snowy flanks of Mount Fuji present a spectacular backdrop to a flight of B-29s forming for a raid on the Japanese homeland in 1945. The highest peak in Japan, at 12,389 feet, and less than 15 minutes flying time from Tokyo, Mount Fuji became a regular rendezvous point for American bombers.

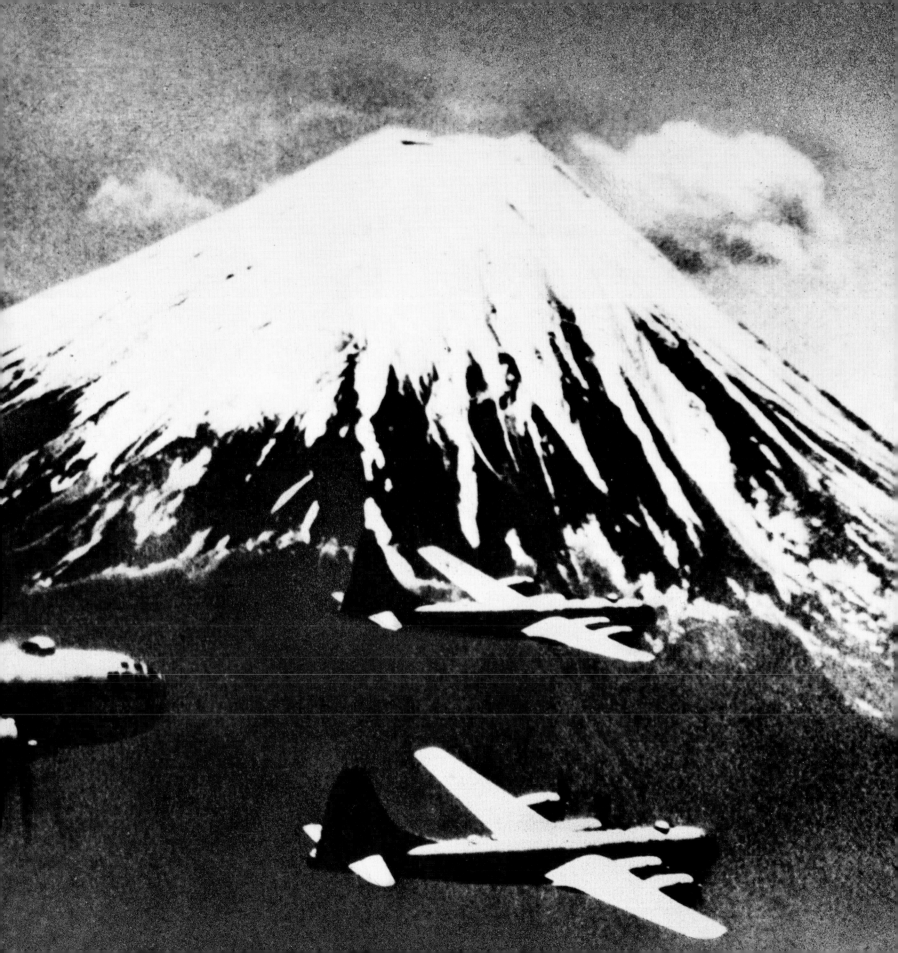

> *"Japan has sowed the wind.*
> *Now let it reap the whirlwind."*

GENERAL HENRY "HAP" ARNOLD,
Commanding General of the U.S. Army Air Forces

SUPERFORTRESS IN THE SPOTLIGHT
Japanese searchlights pin a B-29 Superfortress in their cross beams
as packets of incendiaries dropped by bombers explode, raining
flame on the city of Sakai on July 10, 1945.

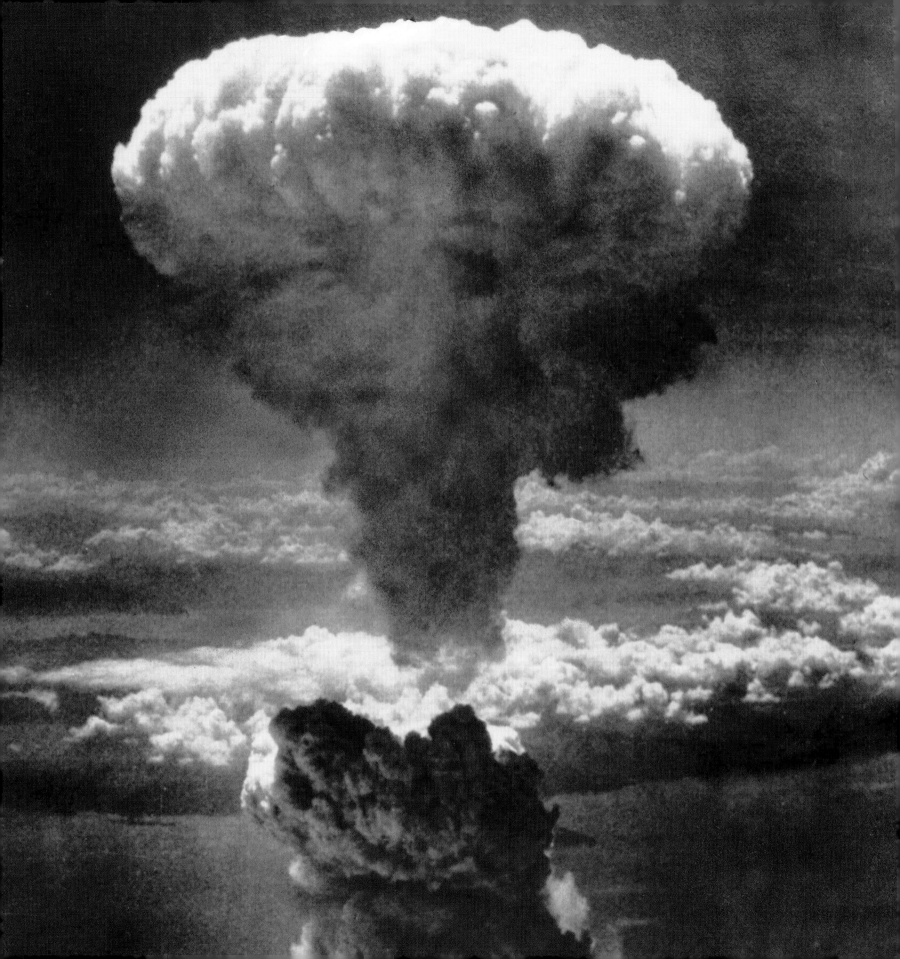

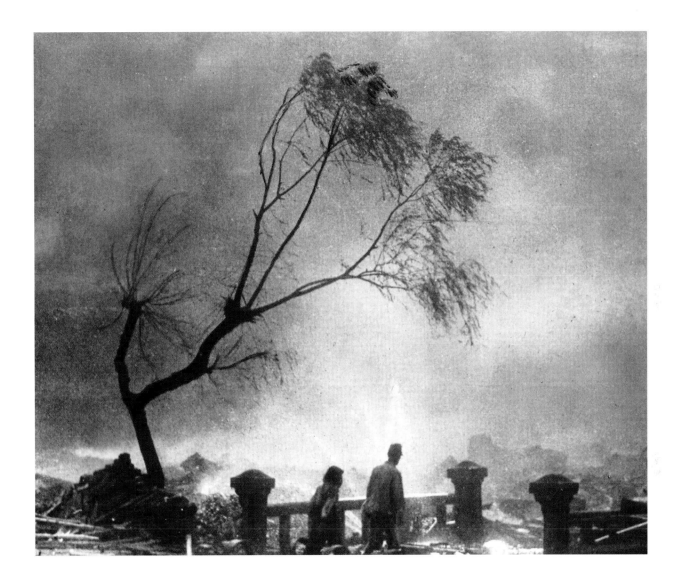

ARMAGEDDON AT NAGASAKI

A radioactive cloud mushrooms over Nagasaki on August 9, 1945, three days after the first atomic bomb destroyed Hiroshima.

NUCLEAR INFERNO

Survivors tread the smoldering ruins of Nagasaki shortly after the blast, which killed 35,000 people immediately and left many others gravely ill or wounded.

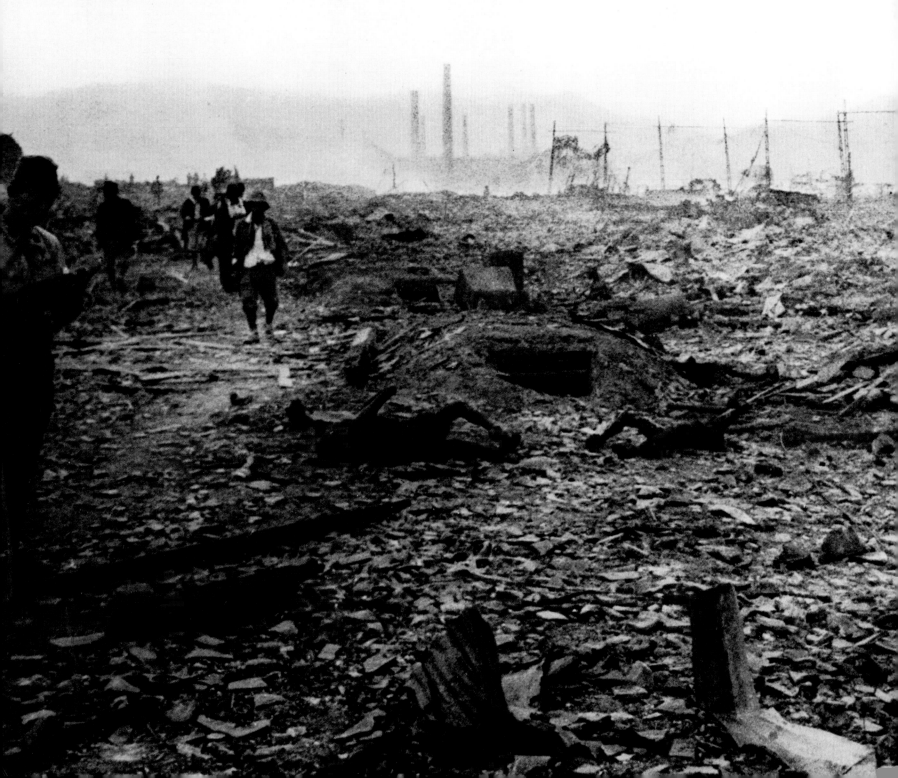

RADIOACTIVE GRAVEYARD

Government officials survey corpses amid the rubble of Nagasaki 24 hours after the blast. The city, one official remarked, was "like a graveyard with not a tombstone left standing."

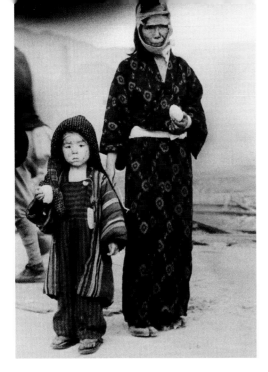

DAZED SURVIVORS

Their faces blank from horror and shock, a bandaged mother and her son in Nagasaki clutch their emergency ration—balls of boiled rice distributed by a relief group.

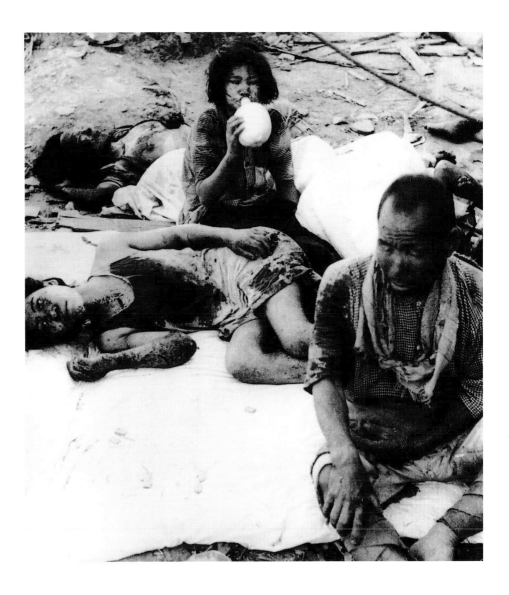

A MOUNTING TOLL

A woman seated amid motionless victims of the Nagasaki bombing sips water from a canteen. By December 1945, the death toll here had reached 70,000.

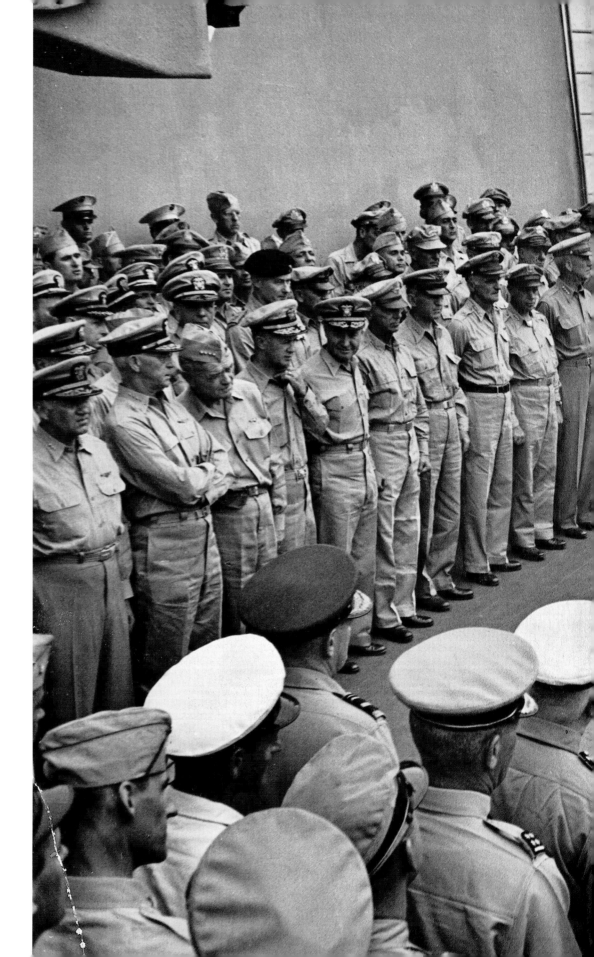

ENDORSING THE SURRENDER

Aboard the battleship *Missouri* on September 2, 1945,
Japanese representatives formalize their surrender
by signing the required documents while General
MacArthur *(far right)* and other Allied commanders
look on.

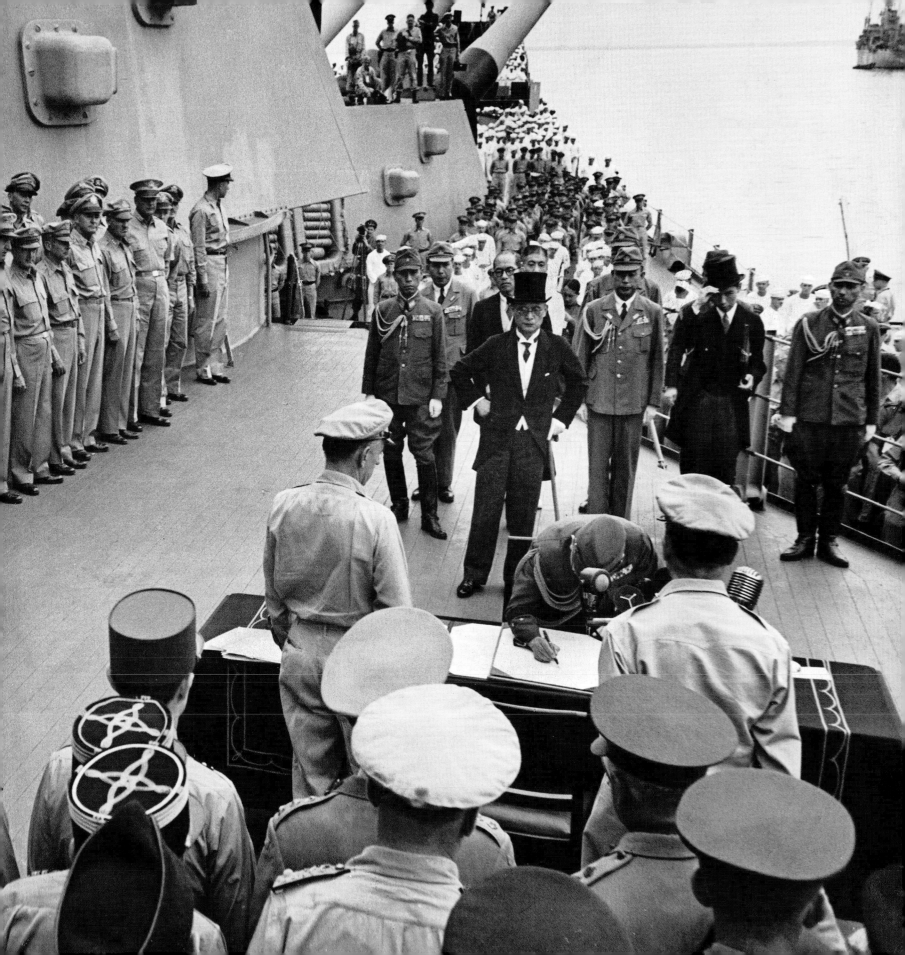

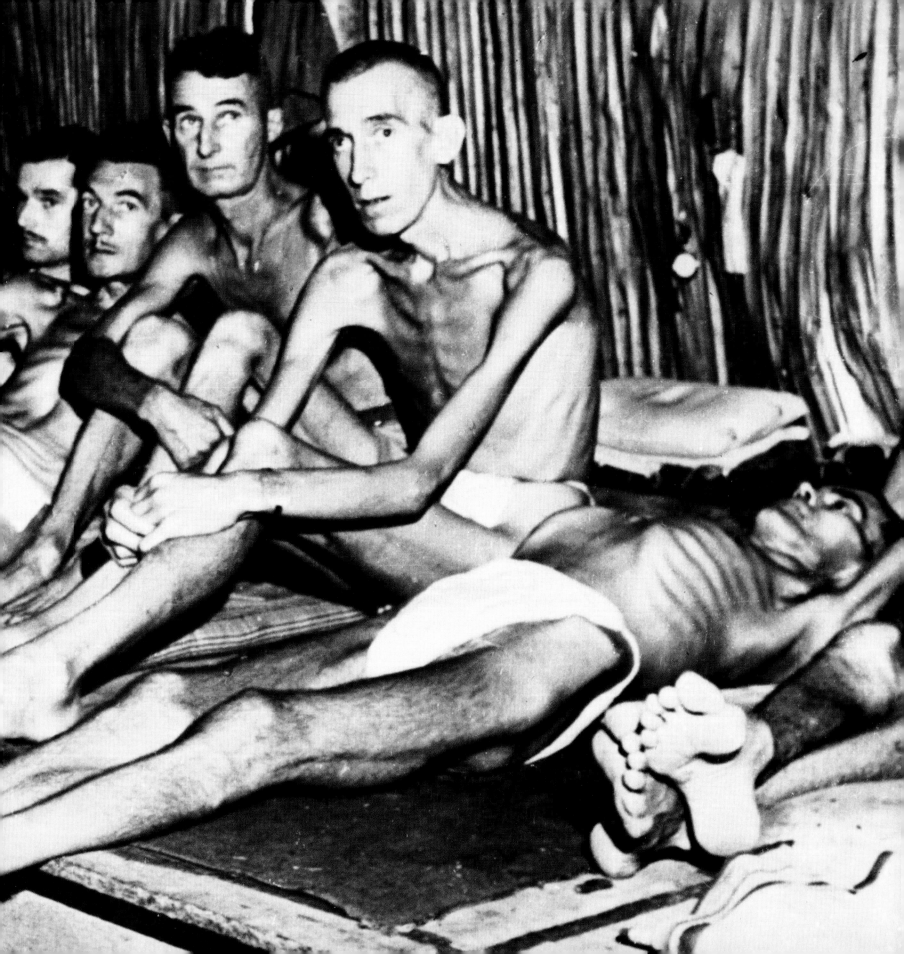

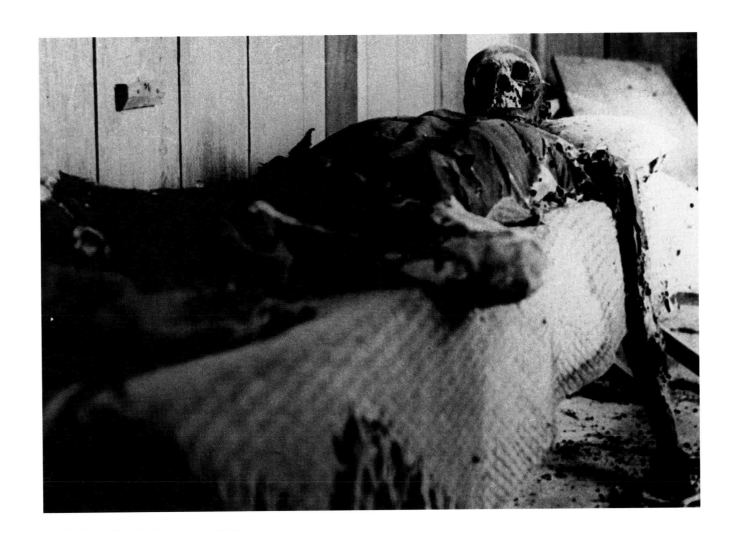

VICTIMS OF NEGLECT

Too weak to rise from their beds at Changi camp in Singapore, prisoners neglected to the point of starvation by their Japanese captors stare vacantly in this photograph taken after they were rescued.

LEFT TO DIE

One of 150 corpses found by American liberators at Davao in the Philippines in June 1945, this prisoner of war died of disease or hunger sometime after September 1944, when the Japanese abandoned the camp. Under heavy U.S. bombing, the Japanese took along only prisoners who were strong enough to travel—and to work.

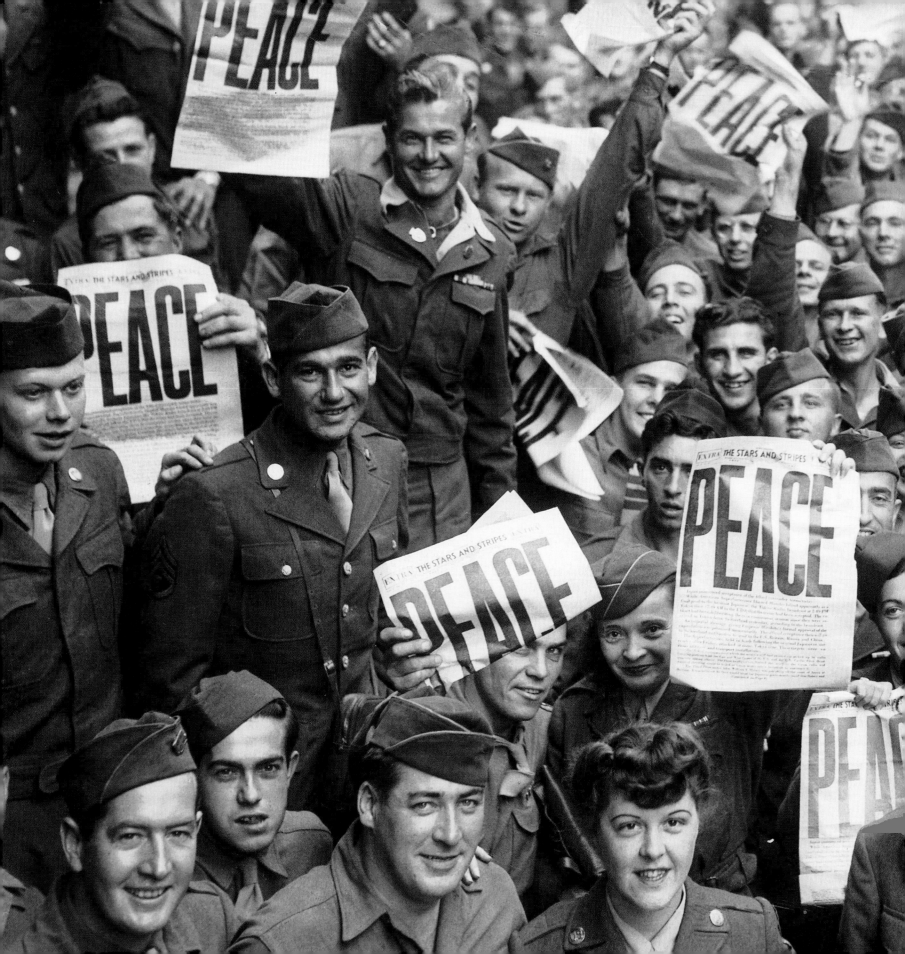

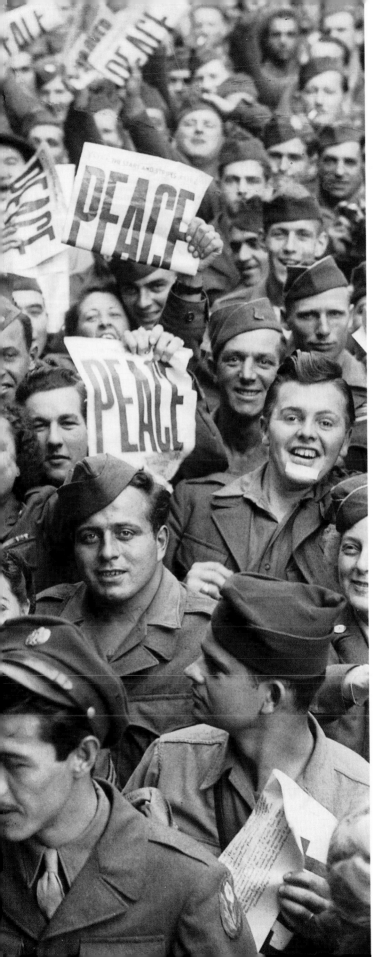

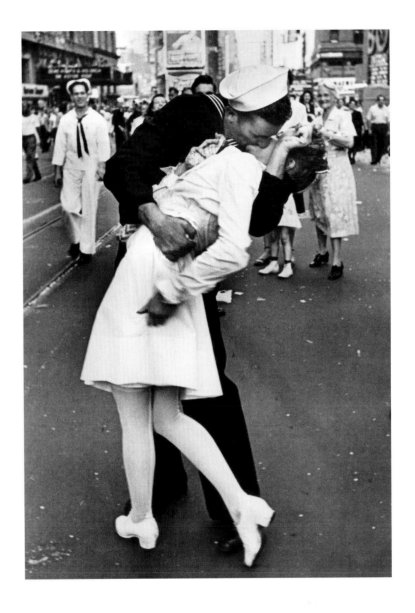

EMBRACE ON V-J DAY
Passersby in Times Square grin as a jubilant sailor locks nurse Edith Shain in a victory embrace on V-J Day—August 14, 1945—the date President Truman announced Japan's surrender. One GI called it the "kissingest day in history."

THE PEACE THEY FOUGHT FOR
Celebrating V-J Day far from home, U.S. soldiers and servicewomen in Paris display copies of the newspaper *Stars and Stripes* proclaiming "PEACE."

PICTURE CREDITS

Credits from left to right are separated by semicolons, from top to bottom by dashes.

COVER: Bettmann/Corbis. **2:** W. Eugene Smith, © The Heirs of W. Eugene Smith, Courtesy Black Star Inc., New York Collection, Center for Creative Photography, The University of Arizona. **5:** U.S. Air Force.

IMAGES OF WAR: 6, 7: AP/Wide World Photos. **8, 9:** Library of Congress, Neg. No. USZ-62-45642. **10, 11:** Peter Stackpole/Time Life Pictures/Getty Images. **12, 13:** Dmitri Kessel/Time Life Pictures/Getty Images. **14, 15:** Bundesarchiv, Koblenz. **16, 17:** U.S. Coast Guard. **18, 19:** Imperial War Museum, London. **20, 21:** U.S. Marine Corps, Neg. No. 63461. **22, 23:** Collection Roger-Viollet. **24, 25:** Frank Scherschel/Time Life Pictures/Getty Images.

PHOTOGRAPHERS UNDER FIRE: 27: Robert Capa/Magnum Photos; David Scherman/ Time Life Pictures/Getty Images. **28:** Robert Capa/Magnum Photos. **30, 31:** Bettmann/ Corbis; W. Eugene Smith/Time Life Pictures/Getty Images. **32:** Lou Lowery–U.S. Marine Corps; AP/Wide World Photos. **33:** AP/Wide World Photos.

THE GATHERING STORM: 34, 35: Bundesarchiv, Koblenz; Taxi/Getty Images. **36, 37:** Keystone Press Agency Inc. **38, 39:** Bettmann/Corbis; Hulton Archives/Getty Images –Research Library, Getty Research Institute, Los Angeles (920024)/Keystone Press Agency. **40, 41:** David Seymour/Magnum Photos; Robert Capa/Magnum Photos. **42, 43:** Bettmann/Corbis; AP/Wide World Photos. **44, 45:** PA Photos; CTK.

DESTINY IN THEIR HANDS: 47: AP/Wide World Photos. **49:** Yousuf Karsh/Retna/ Camera Press. **51:** Collection Roger-Viollet. **52:** CEKAP, Rome. **54:** AP/Wide World Photos. **57:** Brown Brothers, Sterling, PA.

BLITZKRIEG: 58, 59: Popperfoto/Retrofile.com; ullstein bild. **60, 61:** Bettmann/Corbis; AP/Wide World Photos–ullstein bild. **62, 63:** Bettmann/Corbis(2). **64, 65:** Süddeutscher Verlag, Bilderdienst, Munich; Bildarchiv Preussischer Kulturbesitz, Berlin. **66, 67:** Heinrich Hoffman/Time Life Pictures/Getty Images. **68, 69:** Time Life Pictures/Getty Images; Research Library, Getty Research Institute, Los Angeles (920024). **70, 71:** Bildarchiv Preussischer Kulturbesitz, Berlin, Heinrich Hoffman; Fox Movietone News, Inc.

BATTLE OF BRITAIN: 72, 73: Imperial War Museum, London, Neg. No. BH 1306; Bettmann/Corbis. **74, 75:** William Vandivert/Time Life Pictures/Getty Images; AP/Wide World Photos. **76, 77:** Imperial War Museum, London; Hulton Archives/Getty Images. **78, 79:** Popperfoto/Retrofile.com; Hulton Archives/Getty Images.

WAR IN THE BALKANS: 80, 81: Bildarchiv Preussischer Kulturbesitz, Berlin; Bildarchiv Preussischer Kulturbesitz, Berlin. **82, 83:** Foto-Fantug, Belgrade; Archive of Serbia and Montenegro–Fototeca Storica Nazionale, Milan. **84, 85:** George Skrigin, Belgrade.

RUSSIA BESIEGED: 86, 87: Bundesarchiv, Koblenz; Library of Congress. **88, 89:** Carell, Paul: Unternehmen Barbarossa, c:F.A. Herbig Verlagsbuchhandlung GmbH, München. **90, 91:** Farabola, Milan. **92:** Fototeca Storica Nazionale, Milan—Bundesarchiv, Koblenz. **93:** Farabola, Milan. **94, 95:** Bibliothek Für Zeitgeschichte, Stuttgart. **96, 97:** Novosti/Sovfoto. **98, 99:** Sovfoto. **100, 101:** Bildarchiv Preussischer Kulturbesitz, Berlin; Sovfoto. **102, 103:** Sovfoto. **104, 105:** Demitri Baltermants/Sovfoto. **106, 107:** Collection Roger-Viollet; Demitri Baltermants/ Novosti/Sovfoto.

THE RISING SUN: 108, 109: Fox Movietone News, Inc.; U.S. Navy Department, Photo No. 80-G-71198/National Archives. **110, 111:** U.S. Naval Historical Center, Neg. No. NH 50930; Bettmann/Corbis. **112, 113:** National Archives, Neg. No. 080-G-19942; U.S. Navy, Neg. No. W-PH-67-13982. **114, 115:** U.S. Navy Department, Photo No. 80-G-19943/National Archives; Bettmann/Corbis. **116, 117:** Tsuguichi Koyanagi; Bettmann/Corbis. **118, 119:** Bettmann/Corbis; U.S. Marine Corps.

CARRIER WARFARE: 120, 121: National Archives, Neg. No. 342-FH-3A2972; Photoworld. **122, 123:** National Archives, Neg. No. 80-G-7413; U.S. Navy Department, Photo No. 80-G-7397/National Archives. **124, 125:** National Archives; National Archives, Neg. No. 80-G-14384.

HOME FRONT: USA: 126, 127: The Boeing Co. Archives, Seattle, WA; Bettmann/Corbis. **128, 129:** AP/Wide World Photos. **130, 131:** National Archives, Neg. No. 80-G-472375; George Strock/Time Life Pictures/Getty Images. **132, 133:** Alfred Eisenstaedt/Time Life Pictures/Getty Images, Courtesy Kate Sheenan Hartson; Alfred Eisenstaedt/Time Life Pictures/Getty Images; Los Angeles Times Photo. **134, 135:** War Relocation Authority, National Archives (2)–Photograph by Toyo Miyatake, Copyright by Archie Miyatake, all rights reserved. **136, 137:** George Karger/Time Life Pictures/Getty Images; AP/Wide World Photo. **138, 139:** Margaret Bourke-White/Time Life Pictures/Getty Images; Library of Congress. **140, 141:** U.S. Navy/National Archives.

BATTLE OF THE ATLANTIC: 142, 143: Courtesy Kurt Diggins, copied by Henry Groskinsky; Popperfoto/Retrofile.com, copied by Henry Groskinsky. **144, 145:** Arthur Grimm/Bildarchiv Preussischer Kulturbesitz, Berlin; Imperial War Museum, London, Neg. No. FX4000. **146, 147:** Bundesarchiv, Koblenz Neg. No. 87/88/78; Dever from Black Star for LIFE. **148, 149:** Bettmann/Corbis.

WAR IN THE DESERT: 150, 151: Collection Roger-Viollet; ullstein bild. **152, 153:** Bildarchiv Preussischer Kulturbesitz, Berlin; Imperial War Museum, London. **154, 155:** Imperial War Museum, London.

ROAD TO STALINGRAD: 156, 157: Bundesarchiv, Koblenz Neg. No. Z18-510-22; Sovfoto. **158, 159:** Novosti/Sovfoto. **160, 161:** Sovfoto; ullstein bild. **162, 163:** Sovfoto; Bettmann/Corbis. **164, 165:** Geogi Zelma/ Sovfoto.

HOLOCAUST: 166, 167: National Archives; USHMM. 168, 169: Bildarchiv Preussischer Kulturbesitz, Berlin; David Rubinger, from The Archives of the Ghetto Fighter's House, Israel. 170, 171: Bildarchiv Preussischer Kulturbesitz, Berlin; Archives of the YIVO Institute for Jewish Research–Sovfoto/copied by Henry Beville. 172, 173: Netherlands Institute for War Documentation; Archives Amicale de Mathausen, Paris; David Rubinger, Yad Vashem Archive, Jerusalem. 174, 175: Tass/Sovfoto.

ISLAND FIGHTING: 176, 177: Ralph Morse/Time Life Pictures/Getty Images; U.S. Marine Corps. 178, 179: National Archives Neg. No. 127-N-74085; U.S. Marine Corps. 180, 181: George Struck/Time Life Pictures/Getty Images; Time Life Pictures/Getty Images; Australian War Memorial, photo by George Silk, No. 014028. 182, 183: Library of Congress, Neg. No. LC-USZ62-98194; U.S. Army. 184, 185: U.S. Air Force; U.S. Navy/Time Life Pictures/Getty Images. 186, 187: U.S. Navy, Courtesy Fred Freeman. 188: U.S. Navy, Courtesy Fred Freeman (6). 189: U.S. Navy, Courtesy Fred Freeman; U.S. Navy/National Archives–U.S. Navy/National Archives; U.S. Navy, Courtesy Fred Freeman–U.S. Navy/National Archives; U.S. Navy, Courtesy Fred Freeman.

CHINA, BURMA, INDIA: 190, 191: AP/Wide World Photos; Carl Mydans/Time Life Pictures/Getty Images. 192, 193: George Rodger/Magnum Photos; The Mainichi Newspapers; U.S. Army. 194, 195: U.S. Air Force; William Vandivert/Time Life Pictures/Getty Images. 196, 197: William Vandivert/Time Life Pictures/Getty Images; U.S. Army (2).

ITALIAN CAMPAIGN: 198, 199: Imperial War Museum, London; Sandro Aurisuchio de Val. 200, 201: Hulton Archives/Getty Images; E.C.P. Armées, Paris. 202, 203: King Features Syndicate Inc. 204, 205: U.S. Army; U.S. Army Air Force Photo. 206, 207: Fototeca Storica Nazionale, Milan; Bettmann/Corbis(2).

AIR WAR IN EUROPE: 208, 209: U.S. Air Force (2). 210, 211: British Official/Imperial War Museum, London; National Archives, Neg. No. NWDNS-208-YE-7. 212, 213: National Archives, Neg. No. 208-N-32987; U.S. Air Force (3). 214, 215: Süddeutscher Verlag Bilderdienst; Imperial War Museum, London, Neg. No. C3371. 216, 217: ullstein bild (2).

D-DAY: 218, 219: Ralph Morse/Time Life Pictures/Getty Images; U.S. Army. 220, 221: Bundesarchiv, Koblenz; ullstein bild. 222, 223: Courtesy Hellmut Lang, Captain (Ret.), Schwäbisch-Gmünd; AP/Wide World Photos. 224, 225: Robert Capa/Magnum Photos. 226, 227: U.S. Coast Guard, Neg. No. 2517. 228, 229: Imperial War Museum, London, Neg. No. B-6782; National Archives, Neg. No. 111-SC-191933; Bettmann/Corbis. 230, 231: Bob Landry/Time Life Pictures/Getty Images. 232, 233: U.S. Army (2); Bob Landry/Time Life Pictures/Getty Images.

RETURN TO THE PHILIPPINES: 234, 235: W. Eugene Smith/Time Life Pictures/Getty Images; Carl Mydans/Time Life Pictures/Getty Images. 236, 237: Bettmann Corbis.

238, 239: U.S. Naval Historical Center, Neg. No. NH73070. 240, 241: NHK, Japan; National Archives, Neg. No. 80-G700580; National Archives, Neg. No. 80-G-46891Z. 242, 243: Time Life Pictures/Getty Images; U.S. Army.

THE ROAD TO TOKYO: 244, 245: W. Eugene Smith/Time Life Pictures/Getty Images (2). 246, 247: U.S. Navy/National Archives; U.S. Air Force. 248, 249: Louis R. Lowery/U.S. Marine Corps. 250, 251: Hulton Archives/Getty Images; W. Eugene Smith/Time Life Pictures/Getty Images. 252, 253: U.S. Marine Corps. 254, 255: Bettmann/Corbis; U.S. Navy/National Archives, Neg. No. 80-G-318560–U.S. Navy/National Archives, Neg. No. 80-G-328610.

ACROSS THE RHINE: 256, 257: National Archives, Neg. No. 208-F.S-3874.2; Bettmann/Corbis. 258, 259: Imperial War Museum, London; U.S. Army, Neg. No. SC-196304. 260, 261: Imperial War Museum, London, Neg. No. EA68789; Bettmann/Corbis. 262, 263: Robert Capa/Magnum Photos (2). 264, 265: George Silk/Time Life Pictures/Getty Images; National Archives, Neg. No. 208-YE-132. 266, 267: Time Life Pictures/Getty Images. 268, 269: Margaret Bourke-White/Time Life Pictures/Getty Images (2).

FALL OF THE THIRD REICH: 270, 271: G. Petrusov/Sovfoto; Bildarchiv Preussischer Kulturbesitz, Berlin, Heinrich Hoffmann. 272, 273: Novosti/Sovfoto. 274, 275: AP/Wide World Photos; Yevgeni Khaldei/Sovfoto. 276, 277: Ivan Shagin/Tass/Sovfoto; Imperial War Museum, London, Neg. No. KY12151F. 278: Landesbildstelle, Berlin–Ivan Shagin/Magnum Photos. 279: Sovfoto. 280: Margaret Bourke-White/Time Life Pictures/Getty Images–Sovfoto. 281: William Vandivert/Time Life Pictures/Getty Images. 282, 283: Dimitri Baltermants/Sovfoto; Yevgeni Khaldei/Sovfoto. 284, 285: AP/Wide World Photos.

FALL OF JAPAN: 286, 287: AP/Wide World Photos; U.S. Air Force. 288, 289: Photographer unknown. 290, 291: O.W.I./National Archives; Yosuke Yamahata/Shogo Yamahata. 292, 293: Yosuke Yamahata/Shogo Yamahata; Yosuke Yamahata/Magnum Photos; Yosuke Yamahata/Shogo Yamahata. 294, 295: Carl Mydans/Time Life Pictures/Getty Images. 296, 297: Australian War Memorial, No. 019199; U.S. Army, Courtesy Eugene C. Jacobs. 298, 299: U.S. Army, Neg. No. SC210241; Alfred Eisenstaedt/Time Life Pictures/Getty Images.

INDEX

Numerals in bold indicate an illustration
of the subject mentioned.